FRANÇOIS ARMANET
ÉLISABETH QUIN

THE
KILLER
DETAIL

DEFINING MOMENTS IN FASHION

*Sartorial Icons
from Cary Grant to Kate Moss*

—

Foreword by
AZZEDINE ALAÏA

Flammarion

CONTENTS

I was raised in Tunisia by some marvelous and extravagant women, and upon my arrival in Paris, I was welcomed by two muses: the writer Louise de Vilmorin, who referred to me as her "mirror," and the great Arletty. Neither of them could care less about being fashionable, they were independent and incredibly stylish. Artists have always inspired me and made me dream. The fashion world tries to catch up with them: their creativity, brilliance, and even their sense of humor have continually fueled street style. We, the designers, who race against the breakneck pace of fashion, can (almost) never compete!

Browsing through this book by my friends Élisabeth and François was delightful and brought back memories of Madonna, Grace Jones, Lauren Bacall, Faye Dunaway (who made Pipelette of rue de Moussy crack up), and Greta Garbo—impressively simple. I've loved and dressed them all. Rediscovering Miles Davis's aristocratic silhouette, Elvis's Pompadour, Delon's allure, Goude's sly tricks, Andy Warhol's insatiable curiosity, as well as the edgy Chet Baker—with whom Bruce Weber and I spent the last days before he died—touched me deeply. *The Killer Detail* is an impeccable lesson in style.

AZZEDINE ALAÏA

— INTRODUCTION —

Stendhal once said that the charming flaw is what crystallizes our desire.
In the same way, the "killer detail" is the arbiter of elegance. It's the unique touch
that attracts our attention, emphasizes an attitude, and perfects a style. It creates
a stand-out feature, expressing a moment of creativity that determines a certain
brand of chic; a dash of individuality that can verge on bad taste.
The killer details in this book denote an era, offering an alternate perspective
to that of haute couture. To illustrate the allure of a century of Western fashion,
we have chosen icons ranging from Marlene Dietrich to Chloë Sevigny,
from F. Scott Fitzgerald to Diana Ross, from Pablo Picasso to Patti Smith,
from Greta Garbo to Miles Davis, and from André Breton to Andy Warhol.
The celebrity photographs—never before assembled together—comprise a highly
original fashion show of writers and artists. These are the individuals who dared
to stand out, challenging our perspectives, reinventing the benchmarks,
and anticipating trends that are then reinterpreted on the streets. And what about
the details? They are revealed in unusual poses, outrageous or dramatic effects—
intuitive gestures that encapsulate the essence of the times, the grit of everyday
life. And the sparks that inspire fashions to come.
These ephemeral moments where everything changes are captured
by the greatest photographers of their time: Robert Capa, Dominique Issermann,
Robert Mapplethorpe, Gisèle Freund, Lucien Clergue, Helmut Newton,
Jean-Marie Périer, William Claxton, Peter Lindbergh, and Elliott Erwitt, among
many others. Their sharp eyes have focused on the killer detail, whether
a hatband, the knotted belt of a trench coat, the mesh of a T-shirt,
the transparency of a blouse, the sexual innuendo of a jacket buttonhole,
the lacing on a polo shirt, or the heel of a desperate stiletto.
Within these details lies the beauty of gestures that leave their imprint
on the present and that stand the test of time.
Dressed to kill, from hats to shoes, this book peels back
the layers of style, performing a full wardrobe inspection
on fashion details from head to toe.

FRANÇOIS ARMANET
ÉLISABETH QUIN

SOPHIA
LOREN

After World War II, French fashion (was there any other?) launched collections that summed up the spirit of the times and women's desire for freedom: Christian Dior's 1947 Corolle collection (the "corolla" referred to rebirth after the dark days of war, and the image of women as budding flowers), followed by the 1953 Tulipe collection, also by Dior, which featured the bust, and his 1954 H-line, whose geometric form liberated the waist; Jacques Fath's 1955 Plongeuse collection; and Yves Saint Laurent's 1958 Trapèze collection for Dior, which allowed women to move freely. When space-race fever took hold in the US and the USSR, people instantly went crazy for futuristic collections by Courrèges, Pierre Cardin, and Paco Rabanne, who designed vivid dresses for fantasy beanpole women married to fantasy astronauts downing fantasy pills in fantasy bubble houses designed by Antti Lovag.

But Sophia Loren was not swallowing any of that. The absolute goddess of world cinema formed a collection all by herself—the "Curves collection," voluptuously curvilinear like everything in this photo. Just look at the flared neck of the small woolen jacket, her chin with its delicate dimple, her cheekbones from the high Asian steppes, almond-shaped eyes elongated into infinity by Nefertiti-style lines of kohl, huge outlined mouth, assertive nose (which she happily did not have redone, despite insistent suggestions by a Roman cameraman and by Carlo Ponti during a screen test in 1952), "cat-eye" glasses, and finally the hat, whose perfect rotundity seems designed to emphasize the oval of a "marvelously vulpine, almost satanic face," as actor Richard Burton put it.

It's an odd hat, which has something of a balaclava or a soldier's helmet about it, like the pure gold helmet from the third millennium BCE discovered in Ur, in Mesopotamia; and the ancient Persian or Hittite hats that offered protection from the cold during crossings of the Indus. Navigating in more temperate climates—Paris, Rome, Haifa, where she had just filmed *Judith*, or Hollywood—in town Sophia Loren wore a very couture version of the unisex outdoor hat, made popular by skiers and swimmers in the '50s.

The curved line provided the shortest route between Sofia Villani Scicolone and Sophia Loren. Sofia was born in 1934, the illegitimate daughter of a married man and a Greta Garbo-lookalike mother. She won a beauty pageant at the age of fourteen that opened the way to appearing in photo-romances, and then in the movies, with *Quo Vadis* in 1951, using the pseudonym Sofia Lazzaro (Lazzaro after Lazarus, as her beauty was considered such to raise the dead). As Sophia Loren, she was the first foreign actress to win an Oscar for her role in *Two Women* by Vittorio de Sica in 1960. She was also unforgettable in *Heller in Pink Tights*, poisonous in *Black Orchid*, and the woman who signed up to a real *Marriage Italian-Style* despite papal objections, with her "Pygmalion, brother, father, and lover," Carlo Ponti. In 1966, with an irresistible, charming sense of mischief, she played an Eastern spy in Stanley Donen's comedy, *Arabesque*. In 1972, Mick Jagger and Keith Richards, bewitched by this Latin beauty, so far removed from their usual muses (Anita Pallenberg and Marianne Faithfull), wrote a song inspired by her, "Pass the Wine" (it ends, unsurprisingly, with "Let's make some love"), while the ever-garrulous Richard Burton described the Italian's astonishing gait as "swaying like rain." As for Sophia: "Everything you see I owe to spaghetti!" Although probably apocryphal, the quote reveals her legendary sense of humor. One thing is certain: triumphant in her war helmet, Sophia is Queen. Long may she reign.

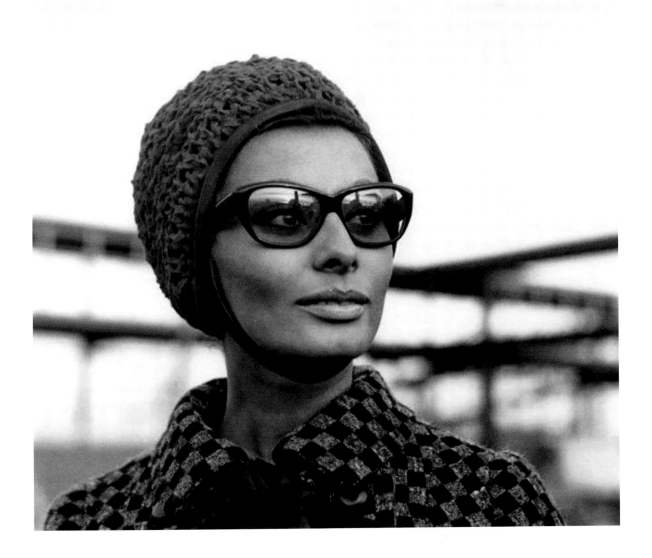

PAUL
BOWLES

— TANGIER, 1973 — TESSA CODRINGTON

Paul Bowles almost ended up in exile in Mexico; had he done so, he would not have written *The Sheltering Sky*, his dark masterpiece on the exoticism of North Africa as idealized by crazy, gullible Westerners, and would not have been photographed at the age of sixty-five, kneeling on the roof of a building in Tangier, wearing a little Berber hat.

In 1931, Gertrude Stein suggested to Paul Bowles that he take a trip to Tangier. Given the powerful influence of this interwar literary oracle, Bowles obeyed, staying there for two months with composer Aaron Copland. But a year later, Stein suggested he go and live in Mexico. The twenty-two-year-old American felt that this piece of advice was driven by Gertrude's ill-will,[1] and he chose Tangier instead as the final haven for his self-imposed exile, in order to be as far, "spiritually and geographically," from his native land as possible.[2] Over the course of fifty-two years Bowles became both the greatest and most misunderstood ambassador for Tangier, city of dubious glamour.

Allegedly part of Tangier high society, Bowles actually evaded the jet-set led by Cecil Beaton and Barbara Hutton. He never went out drinking, instead he received guests in his modest three-room apartment and gained fame throughout the Maghreb region. Introduced as the godfather of the literary outlaws of the Beat Generation who got stranded in Tangier from 1957 on—Burroughs, Ginsberg, Corso, Orlovsky—he spent little time with them. He was a prolific yet little-known composer of chamber music—including the lovely "Cabin," a ballad Bowles wrote based on the poems of Tennessee Williams. Between 1959 and 1961 he traveled all over the Maghreb, working as an ethnomusicologist, recording on his Nagra the traditional music of joujouka and of the Rif country before it became extinct (the Bowles collection is housed at the Library of Congress in Washington, D.C.). He only published four

novels, but translated Sartre, Borges, and Ponge, and collaborated with a generation of Moroccan storytellers: Mrabet (*M'Hashish*), Choukri (*For Bread Alone*), and Yacoubi (*The Man and the Woman*).

The greatest misconception concerns his work: Bowles, the white man feeding off black thoughts under the turquoise Tangier sun. Closer to Beckett than to T. E. Lawrence,[3] according to Norman Mailer "he let in the murder, the drugs, the incest, the death of the Square ... the call of the orgy, the end of civilization,"[4] and he saw writing as a destructive weapon. "Who doesn't want to destroy the world? I mean, look at it!"[5]

The luminous, peaceful clothes of the nihilist dandy, dreaming of Armageddon in Western civilization, are all the more striking in this photo taken by Tessa Codrington, during a summer lunch in honor of Tennessee Williams. White pants, white socks, ecru turtleneck, light sable flannel jacket: British elegance for a nervous American who never flew, and who only took the boat so he could travel with ten or twenty suitcases containing clothes for all climates. Kneeling like an unbeliever who adored the call of the muezzin, the top note is his Berber hat in crocheted cotton, a version of the *hajj* cap worn by pilgrims returning from Mecca.

Fitting naturally into the Western silhouette, the traditional Amazigh (or Berber) hat subtly signals Bowles's dual cultural persuasion—without illusions. The sky, which he seems to be examining through his sunglasses, is empty. "No sheltering sky...." We are all alone, our only protection, a piece of white cloth.

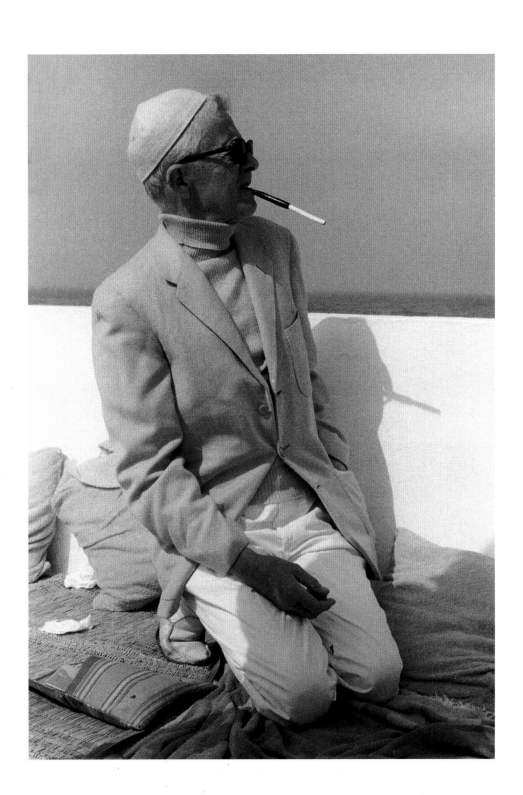

FRANK
SINATRA

— LOS ANGELES, APRIL 1954 — SID AVERY

The Voice, aged thirty-eight, is at Capitol studios in Hollywood recording his album *Swing Easy!* Ever since 1940, and more than twenty years before Beatlemania, Sinatra had caused hysteria among the bobby-soxers, those crowds of teenagers wearing white turned-down ankle socks. At the beginning of the '50s he hit a brief rough patch, but in 1954 was back in the saddle, thanks to an Oscar awarded that year for his performance as the soldier Maggio in *From Here to Eternity* (a helping hand from the Mafia was rumored to have clinched him the role). From now on, the weakling with a perforated eardrum but perfect pitch was the Pack master, the undisputed leader of the Rat Pack, a group that previously orbited around Humphrey Bogart. As James Ellroy wrote in *American Tabloid*, "Sinatra and those Rat Pack guys"[1]—Dean Martin, Sammy Davis Jr., and the others—were in the spotlight, dressed like royalty, with shirts and suits made to measure by Sy Devore, tailor to the stars, in his store on Vine Street near Sunset Boulevard. He even opened an outlet at the Sands Hotel and Casino in Las Vegas, where the Pack used to hang out. Ol' Blue Eyes had made Bing Crosby, King of the Crooners, seem old hat. Sinatra was cooler, sharper, more wicked. A man of the people, with a cigarette in one hand and a glass of whiskey in the other, he held the public in the palm of his hand, and his unique sense of rhythm provided the soundtrack for the dreams of the triumphant middle classes. Fascinated with power, the godfather of showbiz also had other ambitions, and so

Peter Lawford introduced him into the closed circle of the Kennedy clan. The Italian Sinatra had principles: he refused to sing in clubs that wouldn't employ blacks, and he campaigned for Jack Kennedy. He was the voice of America, but also expressed its dark side. Associated with the Kennedy legend, he would be summarily expelled from this enchanted world because of his dangerous liaisons with the Mafia godfathers Lucky Luciano and later Sam Giancana.

Even when he turned into an old reactionary, he remained the epitome of style and charm. For him, the tuxedo was a way of life, and wearing a handkerchief in his breast pocket (orange was his favorite color) was a daily ritual. In this picture by Sid Avery, photographer of Hollywood legends, Frankie wears a pinky ring, tie (always) loose, and gold cufflinks. His gray hat with a pearlized satin band (perhaps it's from Lock and Co., the London hatmaker to Beau Brummell and Oscar Wilde?) is a trilby, and Sinatra could wear one like nobody else. The name trilby (cousin to the fedora, which has a wider brim) comes from the novel of the same name by George du Maurier (the story of an artist's model who, under hypnosis, becomes a talented singer), which was adapted for the stage in 1894 and enjoyed such success that it gave its name to the actress's hat. The first of Sinatra's "sixteen style rules" was devoted to the hat: "It takes two hands to put on a hat the right way: back brim curled up, front tugged down to a couple of inches above the right brow."[2] Hat's off.

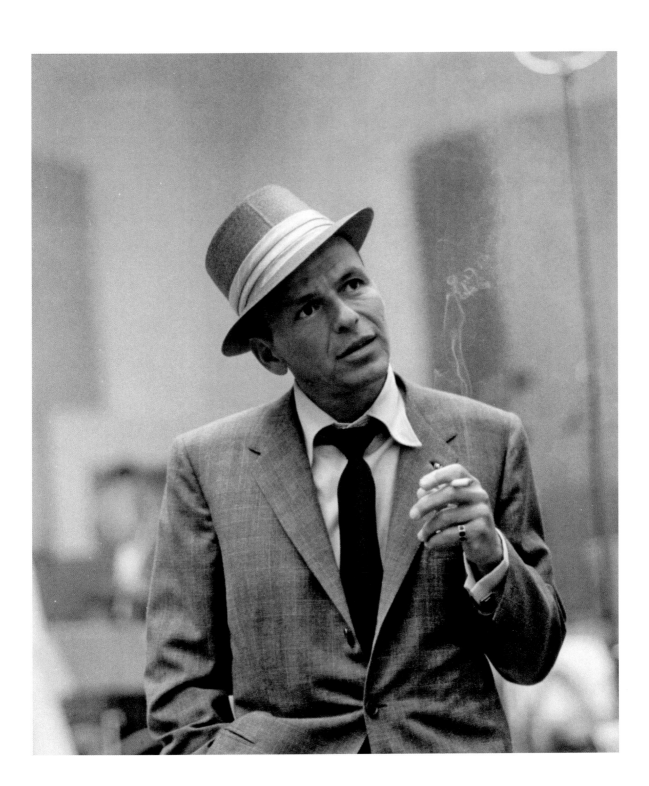

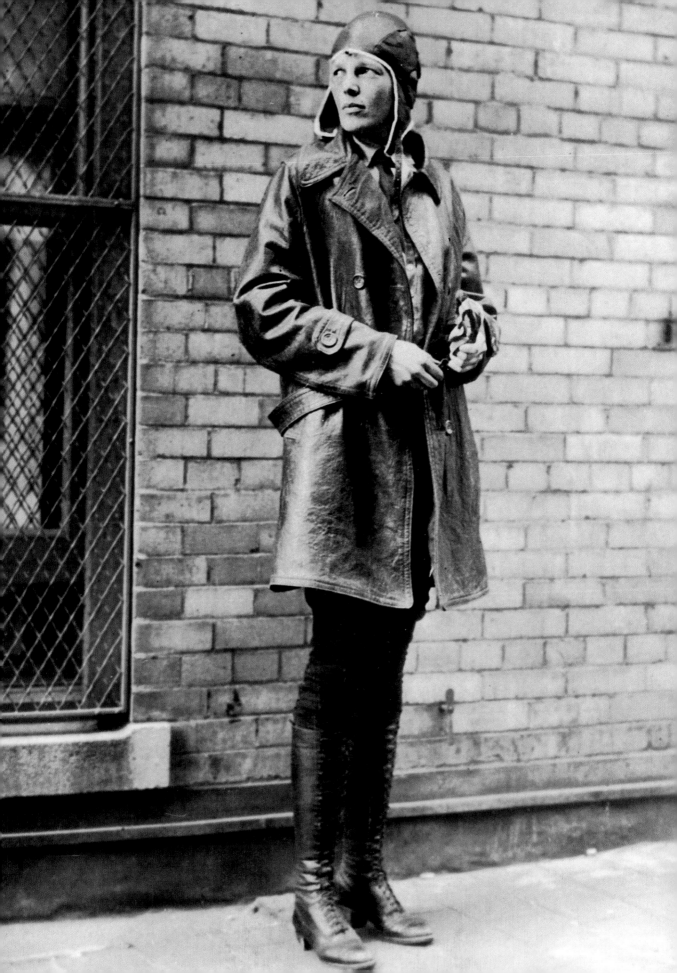

AMELIA
EARHART

— UNITED STATES, 1928

Amelia Earhart, the female Icarus, known as Lady Lindy (after Charles Lindbergh, whom people claimed she looked like) was queen of the skies. A curly-haired faun with pale eyes, Earhart was beautiful as well as intrepid. She made her first flight at the age of ten, had her first flying lesson at fourteen, and bought her first plane at fifteen, a yellow Kinner Airster biplane she called "the Canary" (her car was nicknamed "the Yellow Peril"). With pioneering spirit, she chalked up a list of heroic records: in 1928 the first transatlantic flight by a woman ("I was just baggage, like a sack of potatoes"[1]); in 1932 the first solo transatlantic flight; in 1935, the first solo flight between California and Hawaii, and more. A militant advocate for women's rights, she was president of the Ninety-Nines (the organization for women pilots) and also worked as an editor for *Cosmopolitan* magazine, encouraging '20s girls to take to the skies and push back the boundaries imposed on their sex.

Her disappearance, at only forty years old, in July 1937, over the Pacific during the first around-the-world flight by a woman, produced countless outlandish theories. Earhart and Fred Noonan's Lockheed Electra, it was claimed, had dropped down a hole in the space-time continuum; Earhart had been a spy intercepted by the Japanese; Earhart had started a new life incognito on a Pacific atoll. But she was not lost to the world: Earhart remained a superb role model for generations of girls—and tomboys—who were determined to grasp the joystick of life with both hands; she was also a perennial source of fashion inspiration. This beautiful woman dressed like a boy for reasons of comfort. Before becoming the first international celebrity to associate her name with a clothing range, the Active Living line (sold in the United States under the logo "A.E." until the business collapsed following the 1929 Wall Street crash), Earhart made her own clothes by raiding boys' closets.

She hijacked knee-length flying boots from the wardrobes of World War I flying aces such as Guynemer, Fonck, Luftberry, and Rickenbacker. Her three-quarter-length, double-breasted belted jacket is typical of pilots' leather-gear, protective shells that proved indispensable in cockpits that were open to the skies until the end of the '30s. (Mermoz and Saint-Exupéry wore the same style jacket; Romain Gary lost his during the fall of France and almost died of sorrow.) Underneath her jacket (sometimes replaced by a leather blouson, which caught the eye of Hollywood costume designers during the '30s) Amelia is wearing a long-sleeved shirt with a brightly colored scarf—the "Earhart touch." As for the hat she's wearing in the photo, a soft leather head-hugging skullcap, it's an American style that appeared at the end of World War I, and whose descendants lived on into World War II with the addition of earphones sewn onto the hat. More than seventy years after Amelia's disappearance, her boyish aviator look is regularly revisited by the fashion world. The latest fan, Jean-Paul Gaultier, created flying hats in luxury leather for Hermès in 2009—hats with airs and graces for angels of speed.

MARGUERITE DURAS

— TROUVILLE, SEPTEMBER 4, 1993 — DOMINIQUE ISSERMANN

Marguerite Duras sits enthroned on French literature and on a squat velvet armchair in the Grand Lobby of the Hôtel des Roches Noires in Trouville, Normandy.

Facing her, with her back to the sea, is photographer Dominique Issermann, Duras's friend, who lived next door at the Roches Noires. The writer won the Prix Goncourt for *The Lover* in 1984, wrote the screenplay for *Hiroshima Mon Amour*, and directed the movie *India Song*. She was also a reteller of news stories (the "little Gregory" murder case, *Les Viaducs de la Seine-et-Oise*), and a *grande dame* of letters who was often parodied (twice by novelist Patrick Rambaud) but also idolized. She would be seventy-nine in just a few months. "Old already and crazy with writing," face "laid waste,"[1] weakened by respiratory failure, crumpled like a Chinese figurine and looking like she'd thrown on any old thing, Duras is nevertheless in control and shoots a challenging look at Issermann, who has made her take off her "portholes"—those famous tortoise-shell glasses. Also absent are the three diamonds Marguerite wore on her left hand. "I spent seven years in the Communist Party and I adore sparklers!" she joked. Thirty years after leaving the Party she said: "Communism is a form of autism."[2] But she kept the diamonds. It's capital, after all.

Let's take a closer look at Marguerite's outfit, her absurd mix-and-match approach to dressing: platform espadrilles; black-and-white tweed skirt; wool shirt in multicolored plaid; leopard-print chiffon scarf "knotted high at the throat by Yann Andréa, Marguerite's lover, to hide the evidence of her tracheotomy."[3] And to top it all off, a flat cotton cap, bought by the photographer at Comptoir de la Chine on boulevard Saint-Germain. Inspired by the military kepi, the cap appeared in the Ukraine in the nineteenth century, quickly becoming the people's favorite headgear—beloved by workmen, sailors, those enjoying paid leave for the first time in 1936, working-class Parisians, railroad men, farmers, and cyclists. Marguerite's Mao cap, however, is a nod towards her childhood spent in Indochina, to her novel *The Sea Wall,* set in Kampot, to the Chinese lover she had when she was fifteen, to her mentally ill mother, and to the sea that haunts her work. "I've always been beside the sea in my books."[4]

In Trouville, the sand, the water, and the light reminded her of the Mekong,[5] the favorite terrain of Duras's writing: it was here that she wrote her masterpiece *The Ravishing of Lol Stein* in 1963. Trouville and the Hôtel des Roches Noires belong to literary legend: Marcel Proust regularly stayed here with his mother between 1893 and 1898, when the building was still a luxury hotel, one of "the endless hotels, now put a stop to … and the cool dark corridors, the now-deserted rooms where so many books were written and so much love made."[6] Proust slept in room 105. Marguerite's apartment, bought in 1963, was number 110. We might wonder whether the pseudonym Duras (Marguerite's real name was Donnadieu; she changed it in 1943) comes from Duras, her father's village in the Lot-et-Garonne department of France, or from the novel by Proust (whom Marguerite adored), in which we encounter a Duc de Duras, the second husband of Madame Verdurin. In 1993, the year this photo was taken, Marguerite published *Écrire* [Writing], her meditation on the "labor" that was killing her but also keeping her alive: "Writing is like finding oneself in a hole, at the bottom of a hole, in almost total solitude, and discovering that only writing will save you."[7]

Writing in Trou-ville means writing in "Hole-Town." A native of Duras is called a Duraquois. Dour, perhaps? In Marguerite's case, dour and doomed. And it's all for "The Dour Desire to Endure."[8] She died three years after this photo was taken, in Paris.

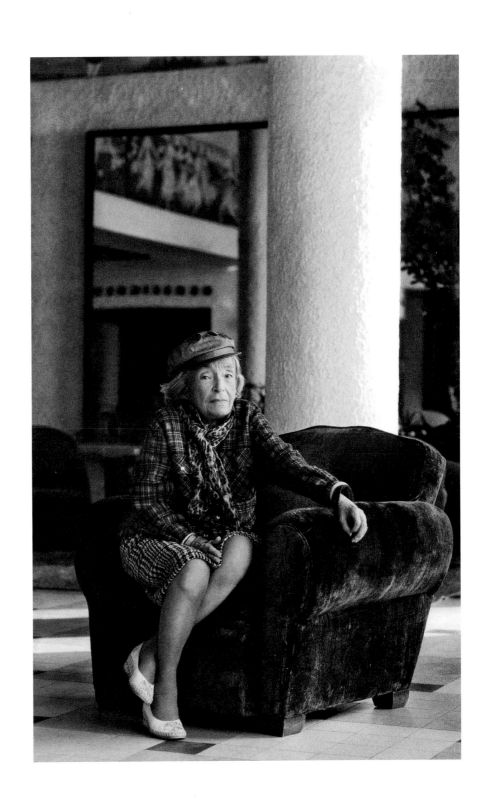

THELONIOUS

MONK

— NEW YORK, SEPTEMBER 1947 — WILLIAM P. GOTTLIEB

They stand smiling in front of Minton's Playhouse, on the ground floor of the Cecil Hotel in Harlem. There, in the '40s, at jam session after jam session (outlawed by the Musicians' Union), modern jazz, or bebop, was invented. At Minton's you didn't dance, you came to listen to the music, to eat spareribs in the back room—the cook was amazing—and to witness dueling trumpets and instrumental jousting by the champions: Charlie Parker, Dizzy Gillespie, Charlie Christian, and the others. It was the hipsters' meeting place, those bebop fans who adopted their heroes' style—their clothes, the way they talked, their drugs, and their fondness for interracial sex. While the musicians in the big swing bands all wore a uniform, the princes of bop stood out from the crowd, like the musketeers in this photo. On the right, Teddy Hill—former sax player and band leader—master of ceremonies at Minton's. On the left, Thelonious Monk, the house piano player: he was thirty and had just cut a record on the Blue Note label. Astonishingly, the "Blue Monk" has knotted a scarf over the top of his tie. A fan of the most improbable and varied kinds of headgear, from an astrakhan toque to a Chinese hat, he had brought back from a trip to France (a haven of peace for jazzmen during the era of segregation) a black lid that set a precedent among his friends. A flat hat in a wool knit (later made out of felt for waterproofing) worn by shepherds in the Béarn region, this beret (from the Gascon word berret) was the emblem of France, just as much as wine and baguettes, and Monk wears it like a member of the French Resistance, decorated with the proud pin of the Free French Forces. Thelonious, Dizzy, and trumpet player Howard McGhee started the fashion for dark glasses, which they wore day and night. Howard (second from left), in the short, brightly colored tie, had a chaotic career because of his heroin problems; he accompanied Bird to California and was, like Dizzy, a disciple of Roy Eldridge (on his left). Roy, nicknamed "Little Jazz," also a trumpet player at the crossover between swing and bop, isn't wearing the obligatory double-breasted suit, and slips his hand into the weird pocket on his sweater. A very cool hand among four aces of bop.

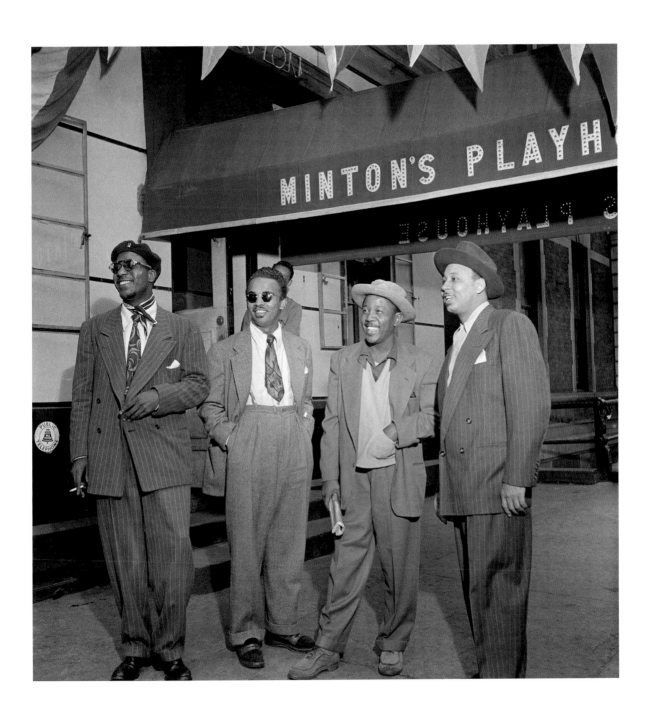

MARIANNE
FAITHFULL

— LONDON, 1969 — RAY BRIGDEN

Faithful to her reputation, she's wearing a silver fox fur coat. She became known as Venus in Furs after the police found her naked under a fur rug when they searched Redlands, Keith Richards's country house in West Sussex on February 12, 1967. It was a drug raid that landed Marianne on the front page of the tabloids, under the headline "Naked Girl at Stones' Party" and, four months later, landed Jagger and Richards a night behind bars and a drug sentence. The poisoned legend of The Stones collided with the rise of this beautiful girl, product of the marriage between Major Robert Glynn Faithfull and the Austrian baroness Eva von Sacher-Masoch, a former ballerina and great-niece of the writer who gave his name to masochism. A Pre-Raphaelite beauty, with strawberry blond hair, porcelain complexion, coral lips, and child-like face, Marianne, following her parents' divorce, was educated as a boarder at St. Joseph's Convent School, where she suffered from tuberculosis. Her first success came at the age of seventeen with "As Tears Go By," the very first song ever written by Jagger and Richards. The following year, in 1965, she married John Dunbar, gave birth to Nicholas (who is seen smiling here, in a woolen hat, Harris tweed overcoat and, slung across his body, a BEA bag from the now-defunct airline, British European Airways), and left her husband to move in with Brian Jones and Anita Pallenberg. She told the *New Musical Express*: "My first move was to get a Rolling Stone as a boyfriend. I slept with three and decided the lead singer was the best bet."[1]

So for four years, from 1966, she lived with Mick, sharing love, crazy nights, and their Chelsea nest on Cheyne Walk (number forty-eight; Keith lived at number three). In 1968 Marianne mounted costar Alain Delon in *The Girl on a Motorcycle* (a movie also known as *Naked Under Leather*, which indeed she was), and Mick made the ambiguous movie *Performance*. In 1969, the year this photo was taken, she released "Sister Morphine," which was received with complete indifference, selling only five hundred copies. Although she had written the song with Jagger and Richards, she would only be credited for it in 1974. It was symptomatic of her descent into the hell of hard drugs. A downward-spiraling muse, she was Venus holding up the mirror to her age, with her snakeskin ankle boots, Indian scarf, carpet bag, hipster flares, wide belt, and blouse bought at Granny Takes a Trip, the first psychedelic boutique in London, at 488 King's Road (opened in 1966, sold at the end of 1969). She's also sporting a scarlet velvet wide-brimmed hat from Biba (created in 1964 by Barbara Hulanicki, who popularized the miniskirt), whose new temple had just opened on Kensington High Street with a mixture of art nouveau and rock'n'roll decadence. The light years of Swinging London were really over. The year 1970 was an annus horribilis for Marianne: she left Mick, lost custody of her son, and attempted suicide. Nine years later she reemerged from the ashes, her husky voice altered by years of all manner of abuse. *Broken English*. Broken but still alive.

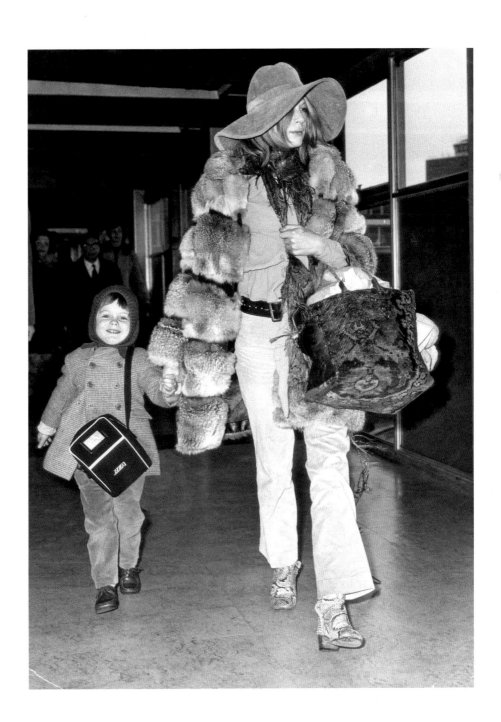

WILLY
DeVILLE

— NEW YORK, 1980 — LYNN GOLDSMITH

Willy had just returned from Paris. An old dream for William Borsey, whose group, before taking the name Mink DeVille and becoming one of the pillars of CBGB's, the temple of New York punk, had been called Billy De Sade and the Marquis. A devotee of Edith Piaf, Charles Dumont, and accordion music, who considered traditional French music to be the roots of American rock, Willy recorded *Le Chat Bleu* in Paris, a sublime album that Capitol Records hated and yet, faced with the tremendous success of the imported version in the United States, they ended up releasing in 1980. Movie director and photographer Lynn Goldsmith immortalized Willy the dandy as a pirate of the Caribbean, long before Keith Richards and his disciple Johnny Depp revived the look. Here he sports Long John Silver's earring, Zorro's mustache, and a chin tuft like Jean Lafitte, that French buccaneer celebrated by Byron in his poem "The Corsair," who plundered the Gulf of Mexico, winning the Battle of New Orleans against the English in 1815 alongside General Andrew Jackson, future president of the United States. New Orleans was where, in 1988, Willy would take up residence in the French Quarter, a stone's throw from Bourbon Street (brass bands, swamp blues, and voodoo). For twelve years he divided his time between his Louisiana home and the Casa de Suenos plantation at Picayune in southern Mississippi, which he bought with the royalties from his mariachi version of "Hey Joe." A Southern gentleman, Willy abandoned his Rhett Butler-style made-to-measure suits for a riding jacket in crushed velvet. Knotted over his long Apache hair is a bandana—whose name comes from the Hindi *bandhana* (meaning "to tie up"), a cotton scarf usually with a paisley pattern, used by cowboys and outlaws to keep out the dust. Then, in the '70s, worn in the back jeans pocket, it became the gay indicator of sexual preference, and at the start of the '90s, a sign of gang membership. It recalls both proud warriors such as Cochise, who wore a headband around his forehead, and the Parisian *apaches*, those Belle Époque hooligans who hung out in eastern Paris, in Belleville and the Bastille, dressed like aristos. Willy wears a hat over his bandana, a fedora that we might imagine as a tribute to the hat worn by the divine Sarah Bernhardt during her numerous visits to New Orleans at the end of the nineteenth century (where the eccentric actress adopted Ali-Gaga the alligator who slept in her bed and died from drinking too much champagne.) The *Coup de Grâce* singer's lost causes have the spirit of Latino rhythms and Cajun music, mixed with a bit of Delta soul and the perfume of a libertine. Willy in his bandana: Belleville *apache* and lord of the bayou.

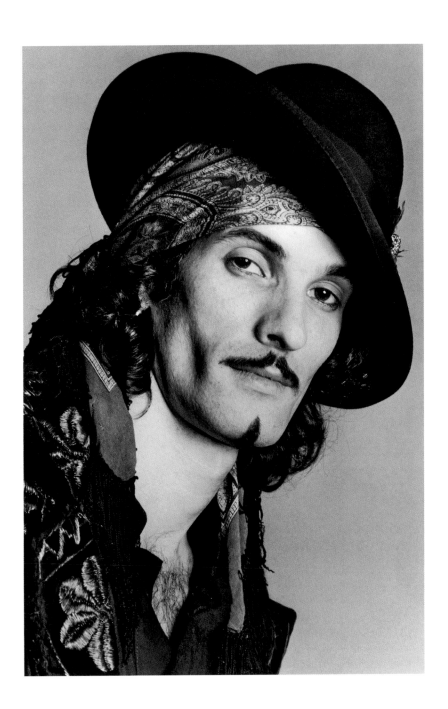

JACKIE
ONASSIS

— CAPRI, 1970 — SETTIMIO GARRITANO

"Touched by the Sun."[1] The sandals are made in the workshop of Amedeo Canfora (traditional family sandal-makers founded in 1946, Via Camerelle, 3, Capri), and Jackie owned a dozen pairs, which she kept in the Hotel Quisisana or in her dressing-room on the yacht *Christina*. Her white pants are carefully ironed and the T-shirt is black, of course—the other way round makes you look like a waiter. There's the Gucci purse with its short canvas strap and fawn-colored leather, which comes from Rome, and which would be named after their famous client, the Hermès scarf worn street-style like a pirate's bandana, and finally the Nina Ricci glasses, model 3203, which are made to measure. The Jackie O frames (known as "fly" glasses for their resemblance to the insect's completely panoramic compound eyes) were emblematic of the philosophy that characterized her style: how to turn an imperfection into a huge asset. Her eyes were so far apart that it took several weeks to make a pair of glasses with a sufficiently wide bridge. Likewise, Jackie, who hated showing her legs and her chest, adopted the covered-up look early on, wearing simple, concealing clothes. This off-limits, snatched photo was taken in the backstreets of Capri by Jackie's official paparazzo, Settimio Garritano, who would shoot her thousands of times (harmlessly) between 1968 and 1972.

Her silhouette is the essence of a nervous, almost ascetic elegance associated with the luxurious lifestyle of the '70s jet-set, a whirl of captains of industry, young WASP women, the European *demi-monde*, and the *litterati glitterati* who sailed to and fro between the Med, the Caribbean, the Aegean Sea, and the Hamptons.

Jackie Kennedy was the legendary muse of this world: a woman who was decidedly free in her movements, even if they displeased puritan America, which hadn't forgiven her for marrying Aristotle Onassis in 1968, just five years after the assassination of John F. Kennedy. Truman Capote, generally no prude, called her the "American geisha."[2]

At five foot seven, with her tall, ultra-slender figure, every ten years Jackie quietly accomplished a veritable stylistic revolution. And so her innocent look of absolute faith in America, the Ivy League Bostonian style of the '50s, ended when Jackie arrived at the White House. In 1960, Halston, then Oleg Cassini (who Jackie called "my secretary of style"), created a silhouette for her that has become iconic: A-line sleeveless trapeze dresses, tunic dresses, smooth wool overcoats, and suits with three-quarter sleeves (including the Chanel outfit in pink bouclé wool that was worn on that fateful day in 1963), accessorized with Roger Vivier flats, pillbox hats, matching purses, and delicate pearl necklaces. When worn by Jackie, the leopard-skin overcoat given to her by President Haile Selassie seemed rather tame.

In the beginning of the '70s, Jackie broke free, became a European, and invented a kind of minimalist glamour that sized-up, yet secretly scoffed at the multi-colored hippy style: flared jeans, in black or white; black crew-neck sweaters; bare feet; kaftans designed by Lilly Pulitzer; monochrome one-shoulder evening gowns created by Halston; and oversized sunglasses, for seeing without being seen. We've not seen anything more chic since. But cracks began to appear in *la dolce vita*. Alexander, Aristotle Onassis's son, died in a plane crash, and Jackie and Ari separated in the glare of the world's media. Skorpios and Capri were over, and the eternal summer came to an end. Jackie went back to New York and took her Burberry trench coats and her black leather raincoats out of mothballs. Into each new life some rain must fall.

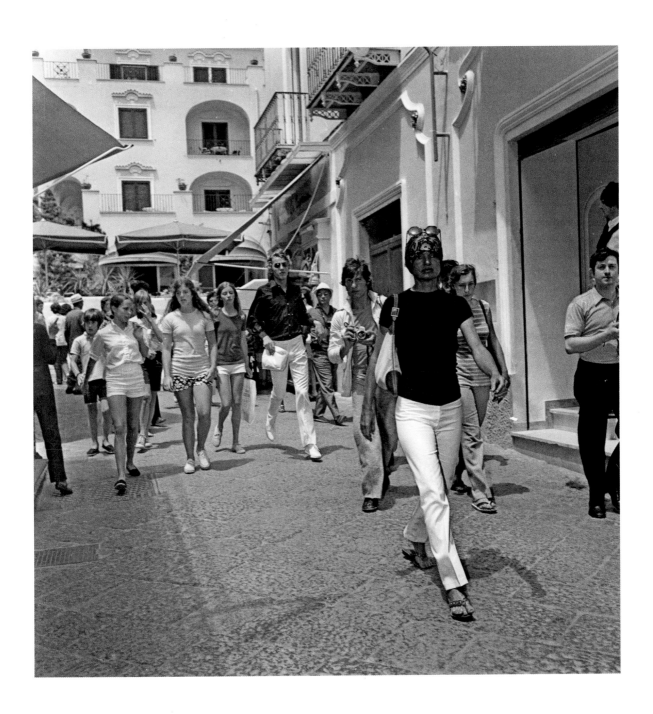

GRETA
GARBO

— CULVER CITY, 1925 — MARC WANAMAKER

On the left the idol, on the right the mascot. On the rough-hewn wooden armchair, we see the "sad goddess with wide eyes full of golden darkness." [1] On the log, there's a docile animal. Is it a silent dialogue with no need for words? Leo, the Metro-Goldwyn-Mayer lion (real name Slats), looks as if he's about to bow his head in allegiance. As for Greta, is she pretending to be a bit scared as she leans over to her right, or is she really worried? Volney Phifer, MGM's animal trainer, made sure that this photo session went ahead peacefully. The studio had been created through the fusion of the Metro, Goldwyn, and Mayer companies in 1924, and was run by a pair of geniuses, Louis B. Mayer and Irving Thalberg (the latter nicknamed "the Boy Wonder," and portrayed by F. Scott Fitzgerald as the monastic, melancholic Monroe Stahr in *The Last Tycoon*). They had just acquired a brand new recruit, the Swedish Greta Lovisa Gustafsson, known as Greta Garbo. She was twenty, spoke not a word of English, and had started out as a kind of Nordic Cosette, working as a soap-lather girl in a barbershop, before being spotted by Mauritz Stiller, who offered her a part in *The Saga of Gosta Berling*. Mayer brought her to Hollywood, where the star system set to work polishing the rough diamond: new teeth, a drastic diet of spinach, an English coach, deportment lessons. Silent movies were to be her opportunity, and Garbo's "mystique" bewitched audiences in three movies: *Torrent*, *The Temptress*, and *Flesh and the Devil*, all made in 1926. Did Garbo flutter her heavy eyelids? Her partner in *Flesh and the Devil*, John Gilbert, asked her to marry him, to no avail. An ecstatic public drowned in her alabaster face, but Garbo, the marble sphinx, said nothing, becoming the object of a frenzied cult that was greatly increased by her reclusive reputation. Her "sense of European ennui," her "existential depression" [2] fascinated America, that land of positivism. Her first words in 1930's *Anna Christie* ("Garbo talks!" screamed the publicity posters) proved worthy: "Gimme a whiskey, ginger ale on the side, and don't be stingy, baby." Her voice is weary and husky, like a marmoreal Messalina promising delights, desires, and agonizing pain. Between 1926 and 1935 Garbo was one of the biggest box-office actresses, and one of the best paid; she was MGM's treasure. Nevertheless, "Miss Garbo at first didn't like playing the exotic, the sophisticate, the woman of the world. She used to complain: 'Mr. Thalberg, I am just a young gur-rl!'" [3] said Norma Shearer sarcastically. Shearer was the wife of the MGM wizard, herself an actress, and Garbo was her rival. As for Garbo, she had no rivals. She was made of different stuff, immemorial, and breathed a rarified atmosphere. But here, in fall 1925, Garbo had not yet become the icon magnified by William Daniels's lights. She wears the flapper uniform of cloche hat, below-the-knee skirts, and Mary Janes, and looks like a young, rather plain emigré with a thrift shop wardrobe. The fur-trimmed coat doesn't exactly exude luxury. Is the portrait intended to look "made in Sweden"? Hardly likely, given the lion by her side. Was the studio trying to tug at our heartstrings with this rather cheap Hollywood version of Saint Blandina and the lions? Or was it making a philosophical point about contrasts between the animal world and civilization? Perhaps the message was subliminal: here, wild nature, whether African or Scandinavian, can be tamed and made docile. But MGM would be beaten at its own little game: Garbo was untamable, and acknowledged her bisexuality at a time when one's private life belonged to the studio; she would never sign autographs, never respond to fan mail, and refused to promote her movies. "I want to be alone," was her famous reply in *Grand Hotel* (1932), her mantra, and her Holy Grail. She gave up making movies in 1941, at the age of thirty-six, following the muted reaction to Cukor's *Two-Faced Woman*—a movie she called "my grave." [4]

The Hollywood career of Slats, the MGM lion, lasted eleven years, until he was replaced by a lookalike called Jackie in 1928. The career of the divine Garbo lasted just over sixteen years. Was she replaceable? On that score, Garbo has had the last laugh.

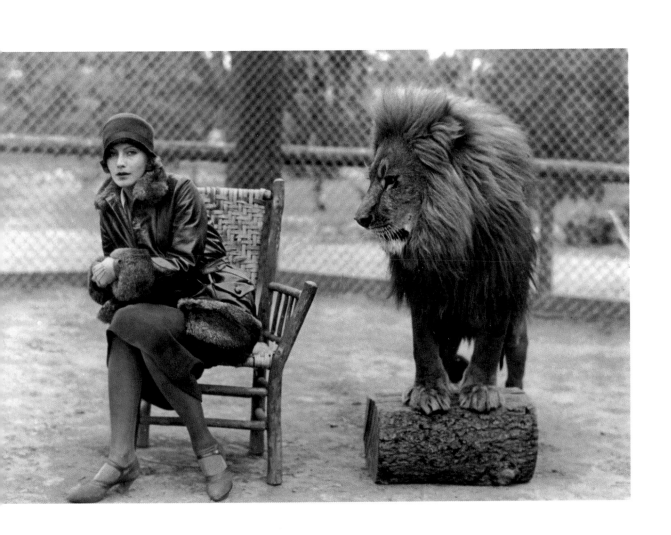

MARVIN
GAYE

— DETROIT, 1971 — JIM HENDIN

Spring 1971, the Prince of Motown created a masterpiece. The previous year, Marvin Gaye sank into a long period of depression after the death of his favorite duet partner, singer Tammi Terrell, following her long illness. *What's Going On*, the first soul concept album, produced after a hard-fought battle with depression, was the source of his redemption. His younger brother, Frankie, had just returned from the Vietnam war and Marvin looked at his country through the eyes of a war veteran. He sang of America's open wounds: the poverty of the ghetto, racial strife, the ravages wrought by drugs, injustice, and ecological threats. Love and suffering. Jim Hendin, a photographer specializing in Motown, shot the album cover. It's a volcanic, vulnerable image of Marvin, drenched in the acid rain of the human condition. Marvin, with the voice of an angel (by turns falsetto, tenor, or baritone), torn between the torments of the flesh and the forces of mysticism, struggles against his demons—a Christ flayed by the Mephisthophelean points of his upturned collar.

As if in mourning, in vinyl black oilskin. Which reminds us, in 1971, the year of Blaxploitation, of the raincoat belonging to private investigator Shaft. A shiny oilskin that combines the sex appeal of Black Power and the pimp look of Harlem's freedmen with an haute couture version (from Mary Quant to Saint Laurent) of the sailor's topcoat, treated in the old days with linseed oil. An oilskin of burning coals for the singer of "God is Love," who changed his name from Gay to Gaye to distinguish himself from his father, the Reverend Marvin Gay Sr., a minister in the Pentecostal sect, The House of God. It was difficult to escape from a nightmarish childhood. His father beat him violently, and Marvin sought refuge in gospel music. "Father, father/ You see, war is not the answer/ For only love can conquer hate." [1] On April 1, 1984, the day before his forty-fifth birthday, Marvin, living in seclusion at his parents' house, wrecked by coke and angel dust, was shot and killed by his father with the Smith & Wesson Marvin had given him as a Christmas present.

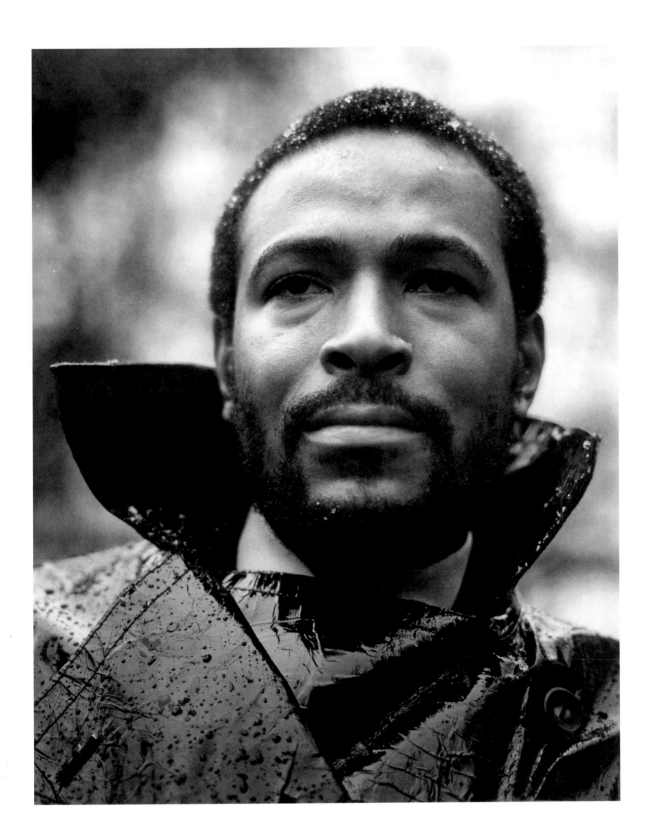

CAROLE LOMBARD
AND CLARK GABLE

— LOS ANGELES, JUNE 1938

A nineteenth-century French tailor once described clothes as an idea that encompasses a man. In this photo, what encompasses the woman in the form of a man's overcoat is a feeling of warmth, in every sense of the word. Carole Lombard arrived on the set of the movie *Too Hot to Handle* to lend moral support to her partner of just one year, Clark Gable. It was a long and chilly night. Between takes, the lovers waited in a corner of the Warner Bros. parking lot. Clark, the star of the movie, looks like a babushka under both a tartan wrap and a blanket. Carole is curled up in his overcoat—made of wool in small houndstooth check, cape-like in its capaciousness. Clark Gable, known for his elegance, had custom ordered it from Savile Row where the most sought-after wools—cashmere, vicuña, camel-hair, alpaca—were made to measure for him by Huntsman or Lesley & Roberts. What is this amusing game of gender-swapping—the lady in a man's overcoat and the gentleman looking like a parody of an elderly woman? A wonderful snapshot reflecting the richness and uniqueness of the Gable–Lombard relationship. Raised as a tomboy in Indiana, Carole Lombard became the best-paid Hollywood star during the '30s, with her fees higher even than Gable's. She shone in the greatest screwball comedies of the decade: Gregory La Cava's *My Man Godfrey* for which she received an Oscar nomination, Howard Hawks's *Twentieth Century*, and William A. Wellman's *Nothing Sacred*.

In town, her style was sporty and casual. She wore pants as often as possible. She went hunting and fishing, she gardened in overalls, and slept under a tent if required, all to Clark Gable's delight. Her rough-and-ready liveliness and humor were legendary (Lombard once ridiculed Gable's nickname, "King of Hollywood," saying "If Clark had one inch less, he'd be the Queen of Hollywood!").

In short she heralded of the '40s generation of "tough cookies" such as Lauren Bacall, Katharine Hepburn, Rosalind Russell, or Slim Keith (a.k.a. Mrs. Howard Hawks)—women who fought against the Hollywood stereotyping that wanted to reduce them to china dolls.

They married in March 1939, enchanting and impressing everyone with their harmonious relationship. They admired and respected each other, made each other laugh, inspired each other, and resolved their differences by means of their very own modus operandi—with flights of doves, symbolizing the return of peace. Carole Lombard was Clark Gable's grand passion and his best friend. They were one of those couples who practiced equality before the concept was even invented.

Clark and Carole called each other "Pa" and "Ma," but they never had a child and did not grow old together. While she was filming *To Be or Not To Be*, directed by Ernest Lubitsch, Carole Lombard took part in a rally supporting US troops, as the country had just entered the war. Her plane crashed in the Nevada desert on January 16, 1942. She was thirty-three years old. Inconsolable, Clark Gable enlisted just a few months later, fighting heroically in the US Air Force. Although he remarried twice, Gable asked to be buried alongside Carole Lombard in a cemetery in Glendale, California.

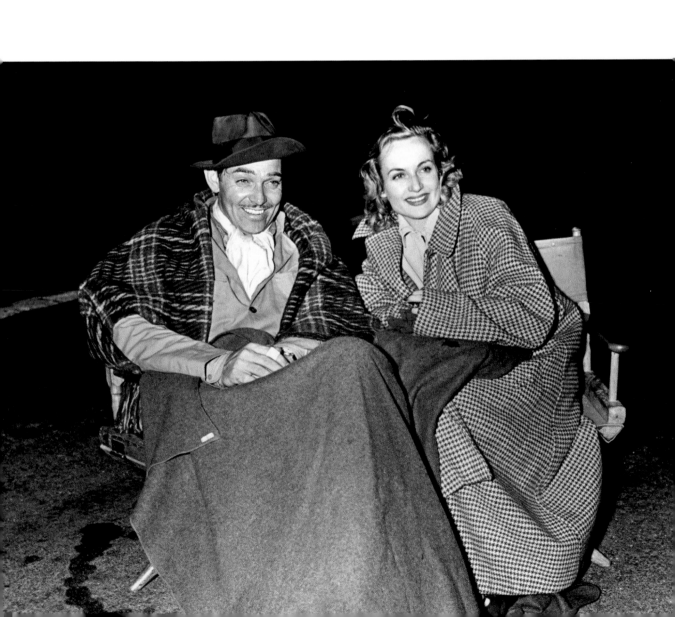

LAUREN
BACALL

— LONDON, JUNE 1953 — ROBERT CAPA

The private eye may be American, but his raincoat is British. The trench coat will forever be associated with Bogart in *The Big Sleep*, at night in *Casablanca*, and in the rain in *The Barefoot Contessa*. In Robert Capa's photo it's Lauren Bacall wearing her belt knotted, Bogart style. When this photo was taken, the American photographer of Hungarian origin, who chose his pseudonym in reference to Frank Capra, had less than a year to live. Cofounder of the Magnum photo agency, he covered the Spanish Civil War, and was the only photographer on Omaha Beach during the Normandy landings; he would die alongside French troops in Indochina. He said: "War is like an aging actress: more and more dangerous and less and less photogenic."[1] On this day, June 2, 1953, Capa photographed "The Look" as she attended the coronation of Queen Elizabeth II, cine camera in hand. Bogart had married Bacall some eight years earlier. They made four movies together and when they kissed on screen, it was the real thing. They had found each other in 1944 on the set of *To Have and Have Not*. Howard Hawks had hired Bacall, a young nineteen-year-old model, after seeing her on the cover of *Harper's Bazaar*. He loved her cheeky sensuality, her eloquent charm, and her captivating voice. When Bogart died in 1957 at the age of fifty-seven, Bacall placed in his coffin a whistle engraved with the words: "If you need me, whistle."[2]

Here, in the London rain, Lauren keeps dry in her trench coat. Was the original trench made by Burberry's or Aquascutum? "All you have to do is ask me."[3] The two manufacturers are both by appointment to Her Majesty and for over a century have both claimed paternity of the original trench coat, which takes its name from the muddy trenches of World War I. So what are the facts? Aquascutum lays claim to John Emery who, in 1853, registered a patent for waterproof wool and supplied capes and overcoats to British troops during the Crimean War. As for Thomas Burberry, in 1879 he patented gabardine, a fabric made of dense, waterproof fibers, and saw his overcoats adopted by officers during the Boer War. In 1914 both manufacturers fulfilled orders from the War Office. The trench coat, reserved for officers, does its job: epaulette tabs to hold the strap of a pair of binoculars, to attach rank insignia, or to slip a side cap under; copper D-rings on the belt to carry map folders or sword sheathes (not, as widely believed, for hanging grenades on); a shoulder flap to rest the rifle stock on; and a double thickness of fabric over the upper body for extra waterproofing. To complete the coat's protective qualities, wrist straps can seal the ends of the sleeves, and a chin strap covers the neck. The trench coat was so timeless that it was soon being worn by civilians.

But rather than either of these two contenders for the trench crown, should we prefer the Grenfell trench coat, sold by J.C. Cording & Co. of 19 Piccadilly (who during the '60s created a famous window display showing a shoe half-submerged in a water tank)? Let's not dig ourselves into a ditch: if Burberry's and Aquascutum are the Jaguar and the Rover of trench coats, the Rolls Royce is a trench coat by Wright & Peel, a company now unfortunately missing in action.

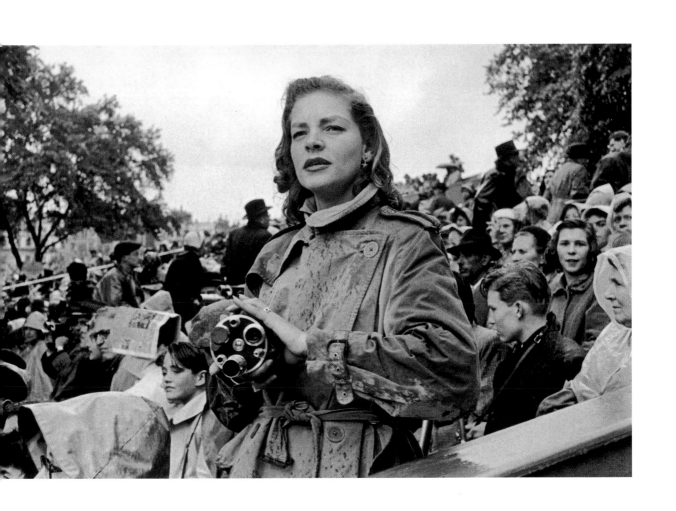

THE KILLS

— LONDON, FEBRUARY 2008 — MARVIN SCOTT JARRETT

What could be the reasons for wearing this plaid coat in screaming turquoise? Is it an allusion to The Kills' cover version of The Velvet Underground's "Pale Blue Eyes"? It clashes—to say the least—with her bright fireman-red pants. What is this trench coat? A Burberry? A "Blurberry?" Army surplus tat? It's both mysterious and a knock out. Alison Mosshart looks away, while Jamie Hince cautiously gives photographer Marvin Scott Jarrett, the fiery boss of *Nylon* magazine, the once over. The Kills' message echoes to their body language: "Keep On Your Mean Side." Despite the critical and commercial success of their four nihilist rock albums, which they made at home, independently, outside of the studio system, and despite their flirtation with fashion (they were the unsmiling faces of Zadig & Voltaire in 2010), and the media circus around Kate Moss and Jamie Hince's romance, The Kills remain purveyors of dirty, romantic, desperate rock. "Pouting, with gypsy fringe or razored hair, turned-up collar, exuding the bad vibes of sex and a punch-up round the back of the bumper cars." [1] The Kills convey idealism distilled into bootleg, a cross-dressing style that exudes an I-couldn't-care-less cool. These gangling sugar dandies certainly work a wicked charm.

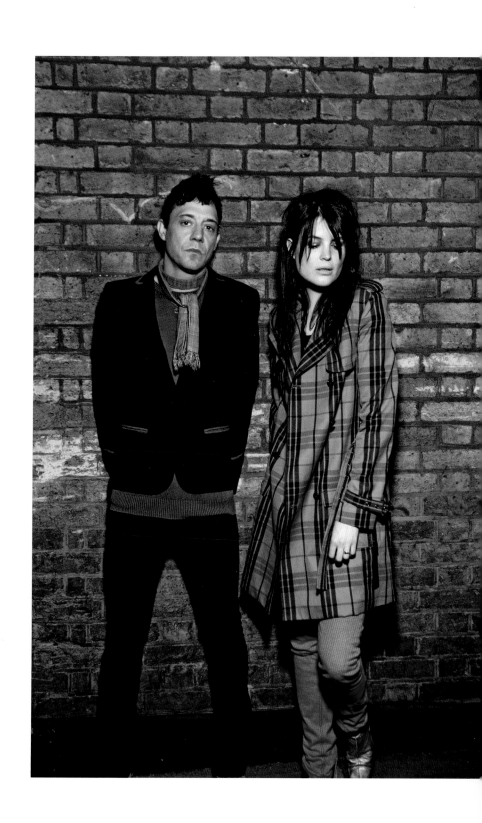

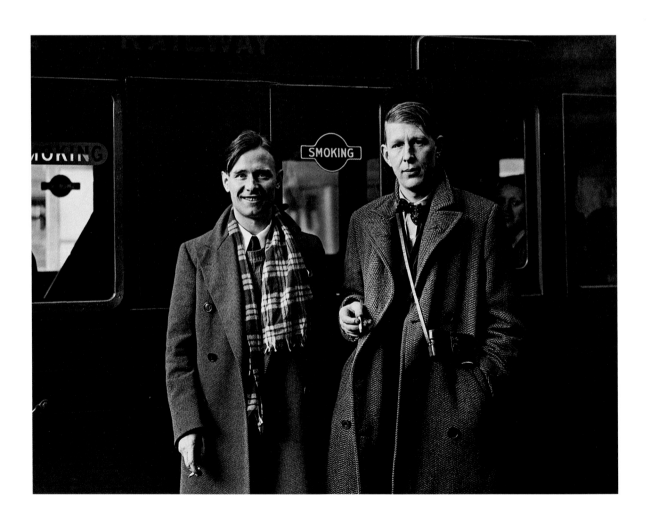

CHRISTOPHER
ISHERWOOD
AND W. H. AUDEN

— LONDON, 1938

What's on the checklist? Herringbone, windowpane, or polka dots—let your imagination run wild. Novelist Christopher Isherwood and poet W. H. Auden—friends, occasional lovers, accomplices, coauthors of plays and stories—are setting off on an expedition that will take them via Hong Kong to China, where, commissioned by Faber & Faber (who had published Auden's poems in 1930), they are planning to report on the Sino-Japanese War. "If we are killed on the Yellow River front, our deaths will be as provincial and meaningless as a motor-bus accident in Burton-on-Trent."[1] Isherwood would speak in German to his Chinese horses to stop himself from falling asleep; Auden would demand to be taken to the front in a rickshaw if necessary. The two comrades saw the Yellow River, got drunk regularly, fooled around surreptitiously with young Chinese men, drank tea with one of Chiang Kai-shek's three wives (the controversial and seductive Soong Mei-ling, known as Madame Chiang Kai-shek), met Zhou Enlai, and brought back a story that was witty, brave, and tinged with pacifism (Isherwood's father had been killed on the Continent during the second Battle of Ypres in 1915). Let's take a look at the camera Auden is wearing slung across his body. Maybe he had a checkered past as a photographer? His generously sized Chesterfield overcoat is made from a sturdy, thick tweed. The '30s sounded the death knell of the "beanpole" silhouettes typical of the '20s.[2]

Now men were supposed to look like men. Auden's polka-dot bowtie looks odd worn with his traveling clothes. Both men's ties are tucked inside cashmere sweaters, and Isherwood's scarf looks well traveled—in first-class comfort. Since the end of the '20s Isherwood and Auden had had itchy feet. Longing to live their homosexual lives in peace without fear of insult or worse, they set up home in Weimar Berlin, between 1929 and 1933. Berlin was a permissive Eden, with an underworld where all sexual and emotional permutations were possible, in spite of Section 175 of the German Criminal Code that outlawed "relations between men" (fought against by activist Magnus Hirschfeld), and the German Communists who judged homosexuality to be "anti-proletarian." Isherwood had gone to Berlin because "Berlin meant Boys,"[3] as it did for Auden. However, the latter brought back a girl whom he married (although they did not consummate the relationship). She was Erika Mann, daughter of Thomas Mann and persecuted for her lesbianism, but who would soon be the holder of a British passport thanks to Auden. In January 1938, on their return from China, the two friends ran off to New York, a year before their American exile, which would turn out to be highly controversial. Another episode in their checkered history.

MILES
DAVIS

— ORLY, FRANCE, NOVEMBER 1967 — CHRISTIAN ROSE

The Picasso of Jazz tuned his outfits to match his beauty. His dressing room, stuffed full of clothes and shoes, was legendary. That winter of 1967, Christian Rose, the well-known photographer of jazz musicians, was waiting for him at Orly airport. Miles was arriving from Italy for the next stage of his tour in France. With his second great quintet, which included saxophonist Wayne Shorter and pianist Herbie Hancock, he had once again reinvented his style. He was forty-one years old and no stranger to Italian and French fashions. Straight pants breaking neatly on ankle boots with heels, skinny tie, and French cuffs, leather case for his trumpet, he wears a riding jacket in Prince of Wales check, nipped in at his narrow boxer's waist. The riding jacket, a cross between a dress and an overcoat, originated in the mid-eighteenth century with English country gentlemen keen on horse riding, and was adopted in prerevolutionary France during an era of rampant Anglomania, where it was known as the *redingote*, a French corruption of "riding coat." This figure-hugging coat probably saw its heyday in 1811, the year of Beau Brummell's disgrace and of Napoleon's triumph—Napoleon's gray *redingote*, dull and egalitarian (and which he had had patched up), haunted the battlefields. Here, under the sign of the arbiter of fashion and of an emperor, we have a riding jacket for the genius of jazz.

At the age of nineteen, when Miles joined Bird's quintet, he already stood out from the crowd in the Brooks' three-piece suit he'd bought secondhand. In 1949 he revolutionized jazz with *Birth of the Cool*, went to Paris, and fell in love with Juliette Gréco—the existentialist singer dressed in black from head to toe—and brought back with him a look of radically modern austerity. In 1955, the hard-bopper, who had just signed with Columbia, had the means to enhance his wardrobe with a visit to tailor Charlie Davidson in Cambridge, Massachusetts, where his store—Andover Shop at 22 Holyoke Street—was the Boston epicentre for the Ivy League style that Anita O'Day and Chet Baker wore: jackets with natural shoulders, tweed in winter, madras or seersucker in summer, button-down-collar shirts in bright colors, and Weejun loafers from G. H. Bass. The latter earned Miles the title "Warlord of the Weejuns," coined by George Frazier, a famous contributor to *Esquire*—the first jazz critic to write a regular column in a daily newspaper, and a great friend of Charlie Davidson. A perfect silhouette for a unique sound. In 1959, Miles recorded his masterpiece *Kind of Blue*; in 1961, *GQ* magazine named him "Fashion Personality of the Month."

Here in 1967, he has released *Miles Smiles* and *Sorcerer*, and has just met the model Betty Marbry, whom he would marry the following year, and divorce the year after. She introduced him to Hendrix and Sly Stone. Miles went electric on *In a Silent Way*, and jazz-rock went into orbit. He inclined towards the more psychedelic outfits of *Bitches Brew*, and from the beginning of the '70s worked a funky look in fur coats, flashy flares, and oversized or hexagonal diva-style glasses. The Man with the Horn—source of numerous jazz revolutions, creating fusions between generations of musical prodigies, and of as many lessons in style: definitely radiating.

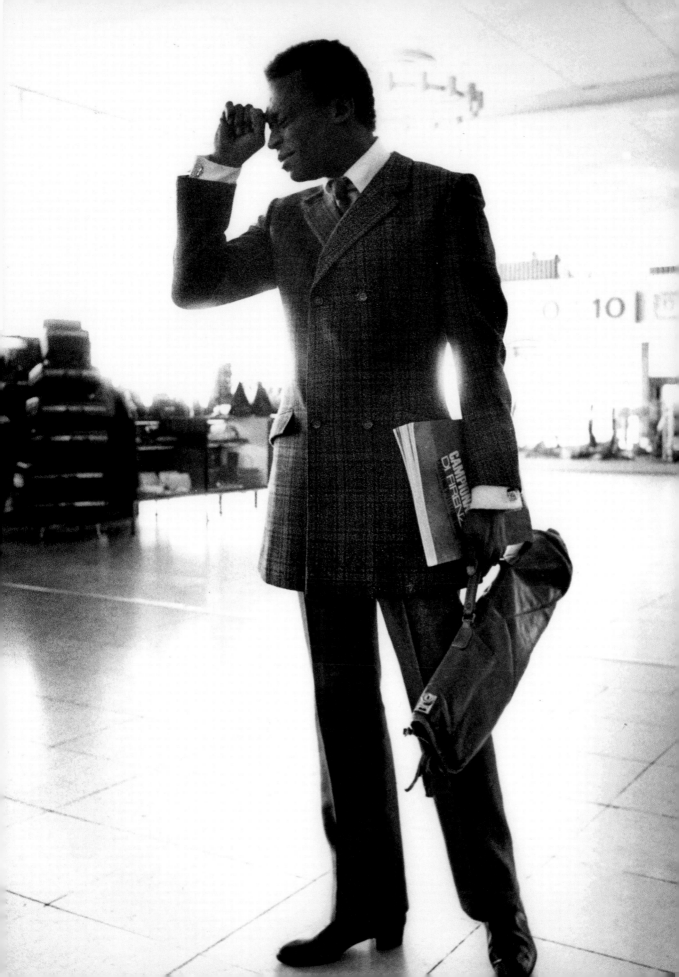

BRIAN
JONES

WITH KEITH RICHARDS AND CHARLIE WATTS

— LONDON, JANUARY 1967 — GERED MANKOWITZ

He's dressed in a tight-fitting Chesterfield overcoat with a small velvet collar, wearing aristocratic-style medals (*Honi soit qui mal y pense*, ages before Mick was knighted by the Prince of Wales), a gold-colored scarf fastened with a pin, and a woman's hat (Anita's?); he exudes the whiff of scandal and decadent arrogance. Brian Jones was the prince of Joujouka, member and scion of the Dandy Club—that long line of fashionable eccentrics that descended from Beau Brummell to Oscar Wilde. This is one of the last photos of The Stones taken by Gered Mankowitz, who had been following them since their US tour in October 1965. Mankowitz had produced two superb album covers (in black and white for *Out of Our Heads/December's Children*, and in color for *Between the Buttons*, which shows the group emerging from the fall mists of Primrose Hill, after an all-nighter in the studio). This photo was taken, a month before they recorded *Their Satanic Majesties Request*, in their dressing room, just before they went out on stage for the TV show *Sunday Night at the London Palladium.* (The Stones would be lambasted by the press for refusing to acknowledge the public at the end of the broadcast.) Smoking away, Charlie is his usual taciturn self. A fan of Elvin Jones, Charlie Parker, and Fred Astaire, he's wearing a black turtleneck sweater and tailored Savile Row jacket (a faithful customer of Henry Poole and Dege & Skinner, Charlie had an impressive wardrobe and bought his shoes at G. J. Cleverley, then on Cork Street). In striped flares and floral psychedelic jacket, Keith lowers his eyes; Brian has turned his back on him. The founder of The Rolling Stones (who invented their name and chose its members), Jones had become more and more distant every day. Hostilities had increased since the Glimmer Twins had taken control (Mick had started composing songs with Keith), marginalizing Brian. Worse, Anita Pallenberg, the love of Brian's life, had left him and ran off with Keith from the Hotel El-Minzah in Tangier one night in March 1967. A diabolical trio combined with morbid jealousy,

and exacerbated by Anita. In *Life*, his wonderful autobiography, Keith talks in detail about the love-hate aspect of Brian and Anita as a couple, and their crazy violence: "All this time they had grown to look like each other; their hair and clothes were becoming identical. They'd merged their personas, stylistically at least."[1] Two demonic blond angels, who swapped clothes. It was a mirroring of looks as disturbing as that of Alain and Nathalie Delon. Brian was a child prodigy. Keith, who had been knocked sideways the first time he saw Brian playing slide guitar (at the time Brian was calling himself "Elmo Lewis," claiming to be the reincarnation of the Bluesman Elmore James), still remembers: "So we got to rely on him *not* being there, and if he turned up, it was a miracle. When he was there and came to life, he was incredibly nimble. He could pick up any instruments that were lying around and come up with something."[2] Brian could play everything: saxophone (the first instrument his parents gave him), sitar, accordion, oboe, mellotron, marimba, dulcimer, flute, organ, cello, xylophone, piano, harpsichord, vibraphone, autoharp, banjo, kazoo, and more. In May 1967, Brian was arrested for possession of cocaine, marijuana, and amphetamines, accelerating an infernal downward spiral in his relationship with The Stones that saw his contributions become sporadic, with frequent absences due to illness. On June 8, 1969 Mick, Keith, and Charlie told him he was fired; the next day Brian officially announced that he was leaving the group. On the night of July 2/3 he was found at the bottom of the swimming pool at the property he owned, Cotchford Farm in Sussex, where A. A. Milne, the author of *Winnie the Pooh*, had ended his days. He was twenty-seven years old, a fatal age for rock 'n' roll (Jim, Janis, Jimi, then Kurt and Amy were to follow). Three days later The Stones paid tribute to him in Hyde Park and, releasing a flight of white butterflies, Jagger read the *Adonaïs,* the poem that Shelley had written as a memorial to Keats: "He is not dead, he doth not sleep/He hath awakened from the dream of life."[3]

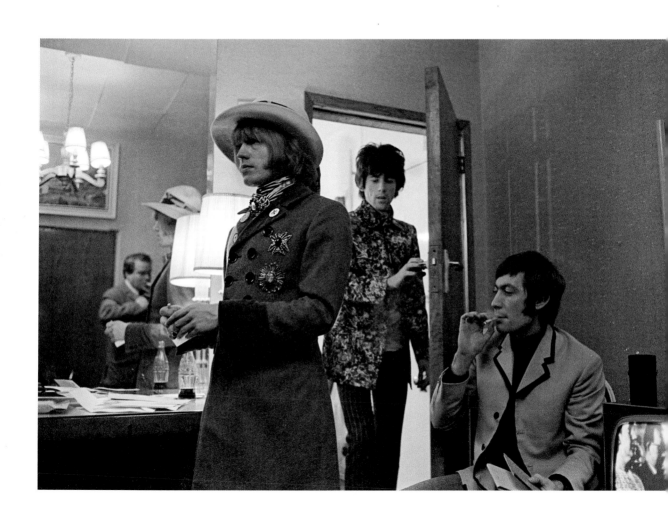

LOUISE
BOURGEOIS

— NEW YORK, 1982 — ROBERT MAPPLETHORPE

We'd be willing to bet that Robert Mapplethorpe, the photographer who glorified male sexuality, was astonished by the free spirit of Louise Bourgeois, who was seventy-one when this portrait was taken. Flashing a mischievous smile at the photographer, the greatest sculptress of the second half of the twentieth century has tucked a twenty-four-inch phallus under her arm as if it were a stick of French bread or a swaddled baby, a defenseless, powerless little thing that one could make short work of.

"The phallus is the object of my tenderness,"[1] Louise Bourgeois said. This one is made of latex and covered with a rubber skin; its tip is pierced by a metal hook, and at the base it mushrooms out as if two buttocks or breasts were attached to it. It's a monstrous hybrid, a vertiginous metaphor. The phallus has a name, *La Fillette* [little girl], and is nicknamed "Poupée" [doll] or "Petite Louise" [little Louise]. It was spawned with love (and envy, Freud would say) in 1968, the year of the sexual revolution. Spawned by a mother bear, so it would seem.

The coat is ugly, intentionally so. We're a long way from elegant furs—lynx, ermine (the royal fur), vair (nordic squirrel fur), sable, mink—and a million miles away from fur as an indicator of social status. Could it be black goatskin? This coat could have come straight from the costume department of *Planet of the Apes* (made—also in 1968—by Franklin J. Schaffner). It humorously evokes the transition from the hairiness of *australopithecus afarensis* (three million years BCE, the direct ancestor of *homo habilis*, *erectus*, and *sapiens*) to the (nearly) hairless human. It explores the dichotomy between the bestial, the impure, even the evil (in Greek mythology, Hades, god of the underworld, came to meet the dead dressed in a black wolfskin) and the good, the smooth, and the hairless.

Fur means protection (the Inuit, those "living Lascaux" as Jean Malaurie put it, were the first humans to make clothes out of fur three thousand years ago[2]). But it is also a trophy stripped from the animal, transferring power, courage, and brute force at the same time.

Louise Bourgeois, here as hirsute as if she were living in prehistoric caves, appropriates and plays around with *two* symbols of masculinity: hairiness and the phallus. A female monster with a great sense of humor, Bourgeois, who was also a wife and mother, shows how power and vulnerability, virility and femininity, the animal and the human— these supposedly opposite poles—have mutated, interchanged, and sometimes blended throughout the twentieth century, just like the forms she created in her art.

"In my art I am the assassin.... As an artist I am a powerful person. In real life, I feel like a mouse behind the radiator."[3]

Louise Bourgeois, a unique combination of the human and the ani-male.

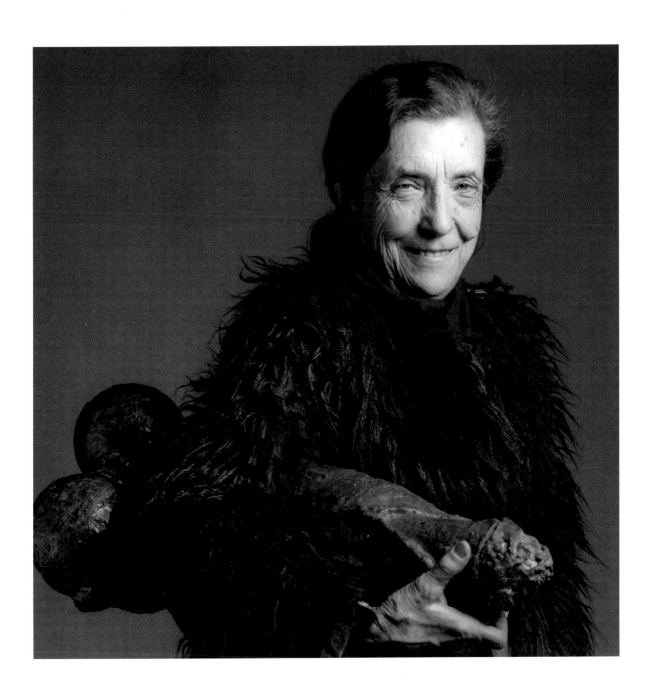

CARY GRANT

— LONDON, APRIL 30, 1946

That spring, Archibald Alexander Leach (who chose his pseudonym Cary Grant as a tribute to the initials C and G of Clark Gable and Gary Cooper), a native Bristolian who became a naturalized American in 1942, stopped over in London before going to visit his mother Elsie, resident in a psychiatric hospital in Bristol. Young Archie was nine years old when his mother descended into depression. His father, who left her a year later, told Archie at the time that his mother was dead, and he only found out she was still alive twenty years later. In this postwar period, when the land of his birth had barely recovered from its wounds, Grant was a safe bet. His chin dimple, that "angel's mark," turned the heads of Marlene Dietrich, Mae West, Katharine Hepburn, Joan Fontaine, and Ingrid Bergman; when this photograph was taken, he had just filmed *Notorious*, the second of four films—*Suspicion* was the first—with director Alfred Hitchcock, who said of Grant that he was "the only actor I ever loved in my whole life." [1]

Here, he's forty-two, six foot two inches tall, and is elegance personified. Grant bought his clothes at Kilgour, French & Stanbury, tailors of 8 Savile Row. Up until the mid-nineteenth century this Mayfair street was home to a body of medical and military organizations. Then it turned into a temple to the body itself as The Row became home to the master tailors of the British Empire. During the interwar years, the aristocratic clientele had given way to Hollywood stars. The new style ambassadors, Fairbanks, Astaire, Cooper, and Gable filled their wardrobes from Savile Row stores. Doesn't Cary look wonderful? The collar of his white shirt follows the lines of the waistcoat of his three-piece suit; his Chesterfield overcoat (invented by Lord Stanhope, the 6th Earl of Chesterfield, whose friend Lord Byron said that he preferred French elegance to English rusticness [2]) without any kind of belt, with set-in sleeves (not raglan), and with perfectly proportioned lapels, possesses suitable fullness and length, falling below the knee. Its anthracite color harmonizes with the cloth of the suit and the hat, a felt trilby (ribbon bow worn on the left, of course). It all amounts to an impeccably classic style where nothing looks too new (perhaps his valet had worn in the outfit over the course of a few weeks?). So where's the killer detail? You guessed it: nowhere. The silhouette brings together a sense of composure, insolence, and detachment. We can just detect a hint of cruelty and restlessness in the man who was romantically associated with Randolph Scott, and who married five times, but who was also found guilty of domestic violence. The dark lining inside the perfect suit.

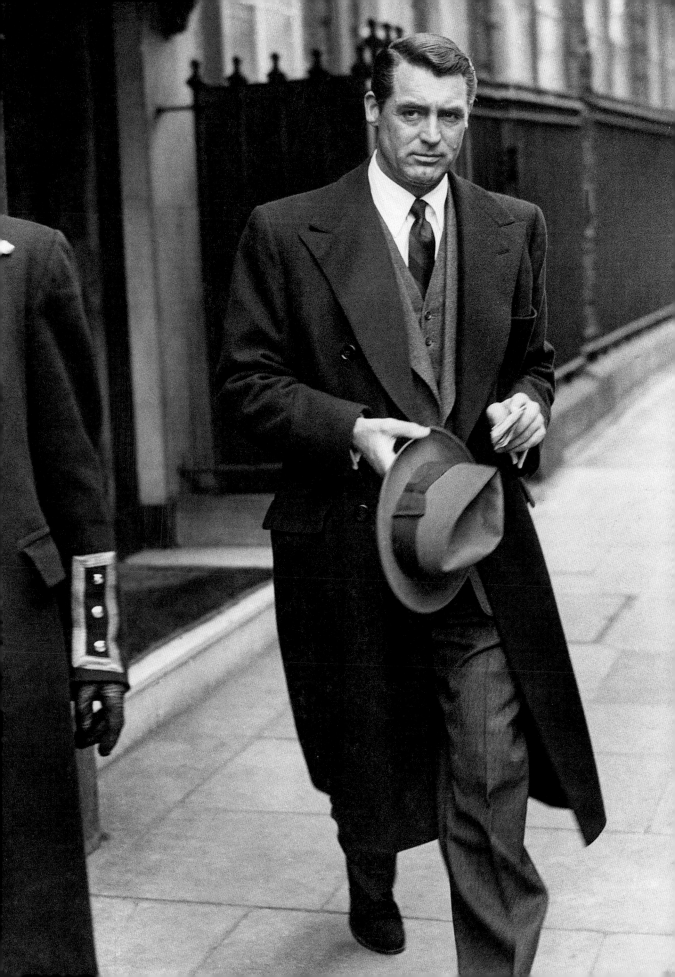

JAMES
BROWN

— NEW YORK, APRIL 1967 — JEAN-MARIE PÉRIER

That spring, photographer Jean-Marie Périer was on Mr. Dynamite's American tour. To hell with Flower Power! Ready for the fight, with his boxer's build, gazing defiantly out at the horizon, impeccable "conk" hairstyle (derived from Congolene, a hair-straightening gel containing lye), glossy anthracite suit, narrow 7/8 pants, short almost bolero-style jacket, solitaire on his pinky, James Brown poses next to his private jet at Long Island airport. A workaholic, and obsessed with details (he changed his costume and shoes several times during a performance) to the extent of bullying his Famous Flames (he'd make his group line up for uniform inspection and distributed fines for lateness, counterfeit cash, or drug use), Brown—Soul Brother No. 1—put on an amazing show. He roared, shook, and howled like a force of nature, stirring up the spirits of Africa in savage rites. He jumped like a demon, stamped his feet, sweated buckets, improvised cat-like movements, and did splits (Prince and Michael Jackson would carry on where he left off). His shows were characterized by frenzy and ritual, such as the town crier introduction ("Are you ready for star time?") or the "cape routine" finale. In a trance-like state that looked almost like a heart attack, people would rush towards him, while he rejected all offers of help, collapsed again, rose to his knees, was dragged from the stage, covered with a boxer's cape, which he rejected while singing "Please, Please, Please"; then he recovered, collapsed again, and called them back with a new leopard-print cape, to the strains of "I Got You (I Feel Good)." Magnificent. After his 1962 concert at the Apollo Theater in Harlem he was able to win over white and black audiences alike, as Périer witnessed: "He had a box with an annual subscription and when he arrived, the show stopped and the entire theater stood to salute him."[1]

In 1967, when the Black Panther Party opened its first office in Oakland, California, James Brown was the voice and the pride of the black community. Born in poverty, abandoned by his mother at the age of two, handed over at the age of six by his father to his aunt who ran a brothel, he got a taste of prison at the age of sixteen after an armed robbery. Then he formed a gospel quartet and acquired the nickname Music Box. He supported the civil rights movement and his work for education among black youth—"Don't be a Dropout"—found a large, receptive audience. He had known the cotton fields, the ghetto, and jail, and when he began advocating success at school as a way of fighting racism, people listened. "Float like a butterfly, sting like a bee."[2] In June 1967, Muhammad Ali was stripped of his world heavyweight champion title for refusing to join the army in the middle of the Vietnam War, his reason being that he had never suffered racial abuse from the Vietnamese. But then when Ali—born Cassius Clay, then became Cassius X (in homage to his mentor Malcolm X), then Muhammad—made a point of being seen with the leaders of the Nation of Islam, the Godfather of Soul went his own way. In 1968, he released "Say It Loud—I'm Black and I'm Proud," his hymn to the black community, and the day after Martin Luther King, Jr.'s death he declared on TV that he would lay down his own life to stop the bloodshed. In Boston, where he was giving a concert, his appeal for calm was heard by the rioters. The reaction was such that he was invited to preach his message of peace in Rochester, NY, and Washington, D.C., inspiring his audiences. Spokesman for his people, invited by President Johnson to the White House, he appeared on the cover of *Look* magazine under the headline: "Is This The Most Important Black Man in America?"[3]

In 1970, he invented funk with "Get Up (I Feel Like Being a) Sex Machine," which would become the most frequently sampled track among rappers. Running the show, with his Afro haircut, he traded his wool and silk suits for skin-tight flares, and on his jumpsuits, cut low in the torso (to reveal his dark brown six-pack), embroidered in diamanté, there sparkled the letters SEX.
"A Man's Man's Man's World"!

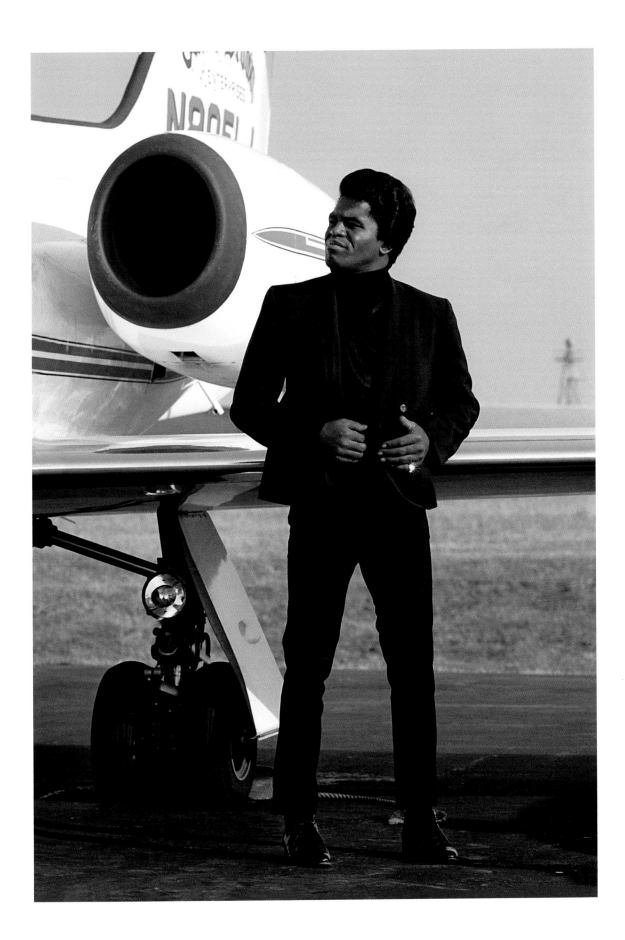

GRAM PARSONS

— CALIFORNIA, 1969 — JIM McCRARY

Gram Parsons was to his own blend of country rock—which he called "Cosmic American Music"—what Hank Williams was to country: a flamboyant desperado who revolutionized the genre. For *A Gilded Palace of Sin*, the Flying Burrito Brothers' first album, Parsons had a made-to-measure Nudie suit tailored. The embroidery was not to the taste of conservative Nashville: marijuana leaves, pills, poppies, two naked women, and, on the back, a large Christian cross. Nudie Cohn—a Ukrainian Jew who had emigrated to America as a child to escape the tsarist pogroms and settled in Hollywood at the start of the '40s—had opened a new boutique on Lankershim Boulevard: Nudie's Rodeo Tailors. We have him to thank for Roy Rogers's flashy outfits, Elvis's gold-lamé tuxedo, and Hank Williams's white suit decorated with musical notes. Parsons, who had converted The Byrds to bluegrass on *Sweetheart of the Rodeo*, and introduced his stoner buddy Keith Richards to country music, died in a motel at the age of twenty-six, from an overdose of alcohol and morphine. In accordance with his wishes, the ashes of this "grievous angel" were scattered in the Joshua Tree desert, where he used to escape to search for UFOs. His friend Phil Kaufman, who had stolen his body from the airport, filled the coffin with gasoline, threw in a match, and bowed down in front of a magnificent fireball. All that remained was the Nudie jacket, which now occupies pride of place in the Country Music Hall of Fame. In Nashville.

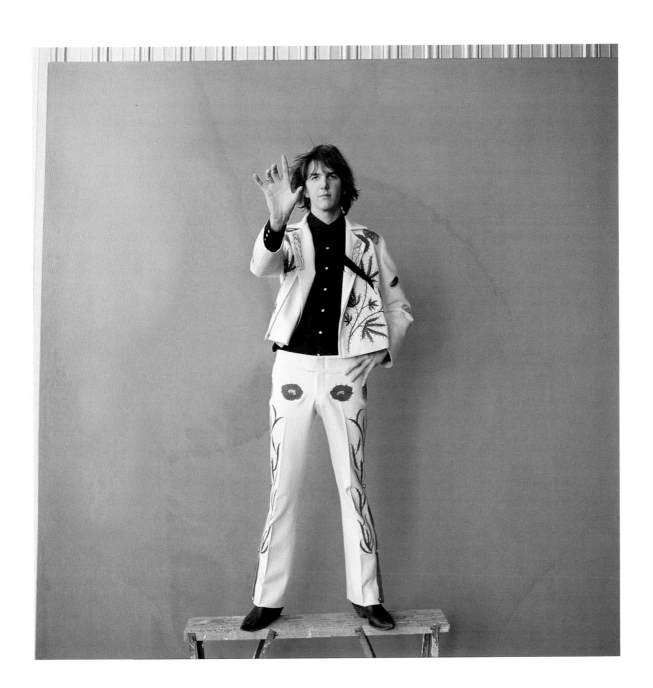

MARLENE
DIETRICH

They're on the march. A blue angel—of indeterminate sex, appropriately—surrounded by a host of men (the husband Rudolf Sieber, known as Rudi; the agent; the assistants—her stooges, perhaps?) has alighted from the Berlin train at Paris's Saint-Lazare station. They're enough to wake the dead. Striding along we see two slender female legs in men's pants—it's a revolution! In Paris in 1933 you had to have talent, and an acute sense of your own importance, to attempt to stand up to the Parisian police force—the era's ardent arbiters of bigoted morality—who enforced to the letter the ban on women wearing pants. (The law, which was introduced in 1800, was only repealed on January 31, 2013!) And Marlene Dietrich knew that no one from the cop shop— as her future lover Jean Gabin called the police force—would have dared slap handcuffs on Agent X27—the name of Marlene's character in *Dishonored*—or even less, lock up Lola-Lola, the Blue Angel (made for love "von kopf bis fuss"—from head to toe), whether in a flimsy negligée or a tux. But the trick of wearing pants was all grist to the mill. Even the American press reported Marlene's transgression, saying, "She is also apparently the first male impersonator to be under a government cloud since Christina of Sweden, or about three centuries ago!"[1]

At the age of thirty-two, when Hitler had just seized power in Germany, the irrepressible Dietrich, a fierce opponent of Nazism, was the jewel in Paramount's crown. Since 1930, the studio had been exploiting her magnetic, cerebral, even bisexual sex appeal in exotic colonial dramas directed by Josef von Sternberg. Marlene dressed in men's clothes both on the streets and on screen. An expression of feminism? Or, more likely, her love of comfort and the media attention that this disconcerting cross-dressing guaranteed her. For a Berliner, pants also symbolized the former Weimar Republic—artistic, decadent—with its monocled lesbians in pants, and its female and male impersonators in cabaret. Ultimately, pants were the favorite clothes of the emancipated girls of the '20s; Coco Chanel created some in jersey (albeit informed by her own flimsy brand of feminism, saying that "a woman in pants will never make a handsome man"[2]). It took the democratization of open-air sports in the '30s, women doing the jobs of men who had gone to fight in World War II, and feminist theorists' condemnation of the system of patriarchal domination in the '50s, before women could free themselves once and for all and put on their best friend—pants—without the risk of being called "sir" in the street (as had happened to Sarah Bernhardt in the previous century). Hollywood, whose studios were all run by men, promoted moral progress and women's conquest of pants by (two-breasted) amazons such as Greta Garbo, Katharine Hepburn, and Joan Crawford. And of course, the peerless Marlene Dietrich.

During Marlene's time in Paris, the German ambassador Roland Koester offered to make her the top female movie star of the Third Reich. Marlene accepted on condition that Josef von Sternberg, and he alone, direct her. When this was refused, she replied scathingly: "Am I to understand that you refuse to let Monsieur von Sternberg make a movie in your country because he is a Jew?"[3]

A name that begins with a caress and ends with the crack of a whip?[4] Marlene Dietrich was the incarnation of woman-power.

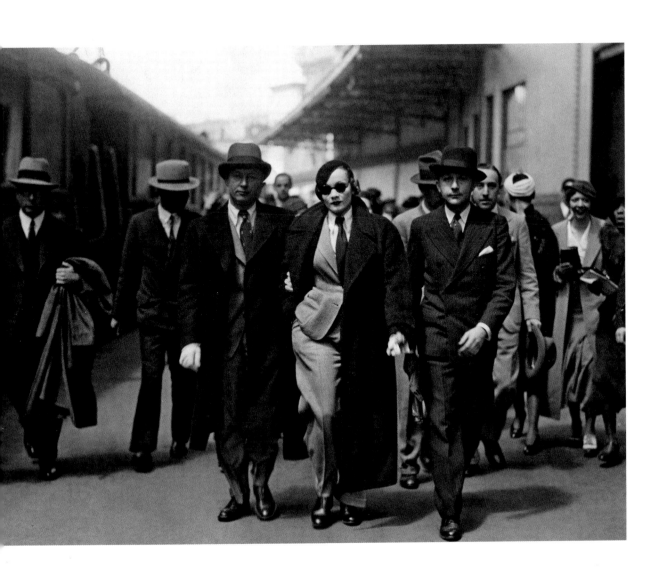

LEONARD
COHEN

— PARIS, 1984 — DOMINIQUE ISSERMANN

1984. *Various Positions*. Sitting lopsided on a bench, living between two continents, in self-imposed exile for love, "hallelujah", Leonard Cohen is fifty. In his dark eyes we see a burning confession addressed to photographer Dominique Issermann—"I'm your man"—four years before the album that he would dedicate to her ("All these songs for you, D.I.") was released. They had met two years earlier on Hydra in Greece. They moved between one or the other's houses, or shared hotels, whether in Los Angeles, Montreal, New York, Paris, Trouville, or Hydra. "An overseas relationship, that's kind of the way I'd characterize our life,"[1] Issermann told us. Leonard loved Paris; it was a place where he could write and meditate. From her studio at the Villa Alésia, they often went to the Luxembourg Gardens where Issermann took photos of him. "He's a very good model. He's just there; he doesn't try to make love to the camera."[2] Here lies his heart.

In 2011, Dominique recalled this incendiary moment: "I was taken with the little string bracelet made by his daughter Lorca. This fragile thread of childhood contrasts with the really masculine Texan boots that he used to buy in Los Angeles, or sometimes Montreal. I always saw him wearing boots and a suit.

It's nothing like the way cowboys or businessmen in Texas wear them. His outfits come from Greece. Discovering the Cyclades, the islands, and Hydra, totally dazzled him. He was fascinated by the men who lived on the islands and their appearance. Those old Greek men, dressed impeccably, who sit for hours in the restaurants of the little ports, never taking off their hats despite the blazing heat. It was this fierce dignity and simplicity that inspired him. Leonard invented this look of a ship-owner without a ship, a look that was more Middle Eastern than Texan. He had his suits made by Greek tailors. I can also see in his austere appearance something of the ceremonial costume worn on Shabbat. The shirt is very probably from agnès b., as that's where I used to buy them for him."[3]

And what about this nomadic couple's luggage? "Leonard is very fond of suitcases. He has a huge collection of them. They're still those I bought for him and which he continues to lug around. Always the Globe-Trotter brand in navy blue or black, in cardboard or fiberboard, old-fashioned suitcases with straps."[4] Embarkation for Cythera?

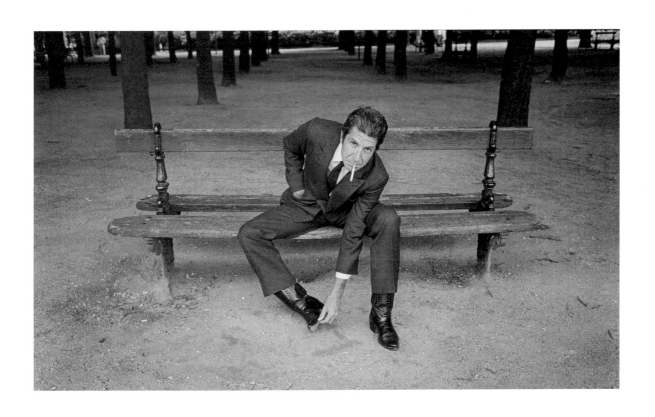

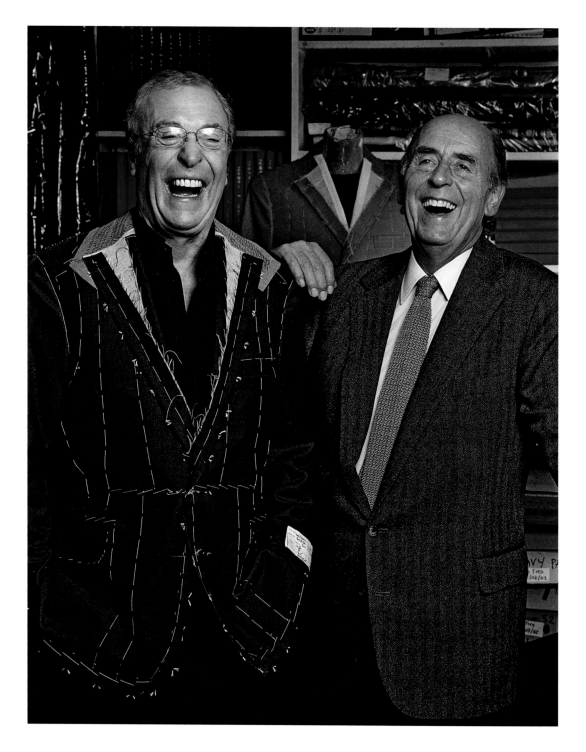

MICHAEL CAINE

— LONDON, 2005 — CLIVE ARROWSMITH

A garment works if it hangs well. It's that simple. And the simpler it is, the less you notice it. Nothing should stand out: that's the key to a silhouette's mystique, which goes beyond the clothes themselves and transcends them. Comfort, balance: the search for harmony in style can be a road to Damascus, littered with turning points. In the case of the suit, that pillar of the male wardrobe, you find that road via the tailor. He creates the bespoke, made-to-measure suit: a unique, hand-sewn item that should adapt to your individual morphology, making the most of your faults and imperfections (rather than covering them up) and of the advantages that nature has bestowed upon you. This edifice, the framework of the suit, lies in the magic hands of your tailor.

Fundamentally the suit has changed little since the '30s. The cut, above all, takes precedence over the fabric, followed by the color: these are the three indispensable elements for a suit worthy of the name. And then there are the details. The jacket resting on the shoulders: should it build them up or follow their natural slope? Single- or double-breasted; with a vent, two vents, or none at all? If the lapels are discreet, do you need flap pockets or patch pockets? Pants should break on the top of the shoe, but what about darts? None, two, or four? Four, but then what? Turned inwards to flatten the stomach and emphasize the groin, or outwards, hiding the groin, but hanging less neatly? Apart from the obvious principles (a shorter jacket makes the legs look longer), stick to your morphology and to your tailor's magic chalk marks. A minimum of twenty-four measurements and three fittings are absolutely necessary. Kind of a drag? Well, these two, photographed by Clive Arrowsmith—a friend of the Beatles during their time in Liverpool and a famous fashion photographer—seem to be as thick as thieves.

Michael Caine and his tailor, Douglas Hayward, are in stitches. The same age—in their sixties— same Cockney accent, fans of football and beer, working-class heroes turned gentlemen. Best friends for over forty years. Maurice Joseph Micklewhite, who took the name Michael Caine in honor of *The Caine Mutiny* starring his idol Humphrey Bogart, was knighted in 2000. Douglas Hayward was one of the young guns who shook up the old guard of Savile Row during the Swinging London era, introducing the more slim-fitting silhouettes and sloping shoulders of the "Continental look," characteristic of French and Italian tailors. His shop at 95 Mount Street, which opened in 1967—at the time when Pierre Cardin was inventing designer prêt-à-porter across the Channel—was an immediate success. His salon for receiving clients was on the first floor. In 1966, he dressed Caine in the movie *Alfie*, and was the inspiration for Caine's playboy role. He would work with Caine again in 1969, designing his friend's suits for the cult movie *The Italian Job*. Michael Caine and Terence Stamp, his loyal clients since the early '60s, sent Richard Burton and Peter Sellers to him. David Hemmings, Albert Finney, Dirk Bogarde, Rex Harrison, and Alec Guinness joined the club, soon followed by Americans Steve McQueen, Faye Dunaway, and the Rat Pack. A close-knit circle of creative friends that was clearly tailor-made.

THE WHO

— LONDON, MARCH 20, 1966 — COLIN JONES

"Talkin' 'bout my g-g-generation." This single image of The Who tells us everything about Mod fashion. It is 1966, the culmination and the end of the Mods, and the start of psychedelia. Two years earlier, on the beaches of Brighton, fierce battles between Rockers (rock'n'roll, black biker jackets, Triumph, Norton, and BSA motorbikes) and Mods (pop music and rhythm'n'blues, meticulously tailored clothes, customized Vespas and Lambrettas) had hit the front pages. Who were these Mods? To begin with, at the end of the '50s, they were fans of modern jazz (Miles Davis and Dave Brubeck)—hence their nickname "Modernists"—who hated the Chris Barber-style Dixieland revival that was fashionable at the time, and who cared about their clothes. In 1957, John Stephen, the future King of Carnaby Street, opened his first boutique, called His Clothes, at number 5, its facade painted canary yellow. But it was only in 1963, when the pop hurricane struck, that the Mod style really began to define itself. It was all about a bright-colored tailored shirt with button-down collar, polo shirt (Fred Perry), or skin-tight turtleneck, 7/8 pants (slim-fit jeans or Sta-Prest pants with permanent center crease), fitted jackets (preferably in madras or seersucker), desert boots (Clark's), or ankle boots like The Beatles wore. The more elitist Mods referred to each other as "faces" or "high numbers," to distinguish themselves from the rest, known as the "numbers." They spent hours on Carnaby Street or King's Road, stoked up on amphetamines, and going crazy at the Marquee or the Flamingo. The iconic groups were The Small Faces, The Kinks, The Yardbirds, The Troggs (with their striped suits), and The Who. But before they came out with their speed-fueled stuttering hymn to a generation, Pete Townshend and John Entwistle, both students at Ealing College of Art in London (along with Ron Wood) where they soaked up pop art, formed their first group playing, of all things, Dixieland jazz. In 1966, The Who had already been blazing on stage for two years: Roger Daltrey swung his mic, Pete Townshend strummed his guitar before shattering it on his amp, and Keith Moon smashed his drums, while John Entwistle's bass held it all together. This photo reveals suppressed rage and compulsive elegance: Keith wears Op Art, the chevron pattern on his pants vibrating with the zebra-patterned bull's-eye on his T-shirt (and obligatory gold chain); John is deadpan in harlequin-pattern racing silks; Roger, the former sheet-metal worker turned City gent, swaggers in violet stripes; Pete wears a jacket made from a Union Jack (but it was John who put the flag on the cover of *My Generation*). It's a provocation that has been recycled ad infinitum, from Oasis to the Spice Girls, from Vivienne Westwood to Alexander McQueen. Each generation has its standard-bearer. Rule Britannia? "Yeah. I hope I die before I get old." [1] Keith and John are dead, Roger is still touring with *Quadrophenia*, and Pete's gone partially deaf.

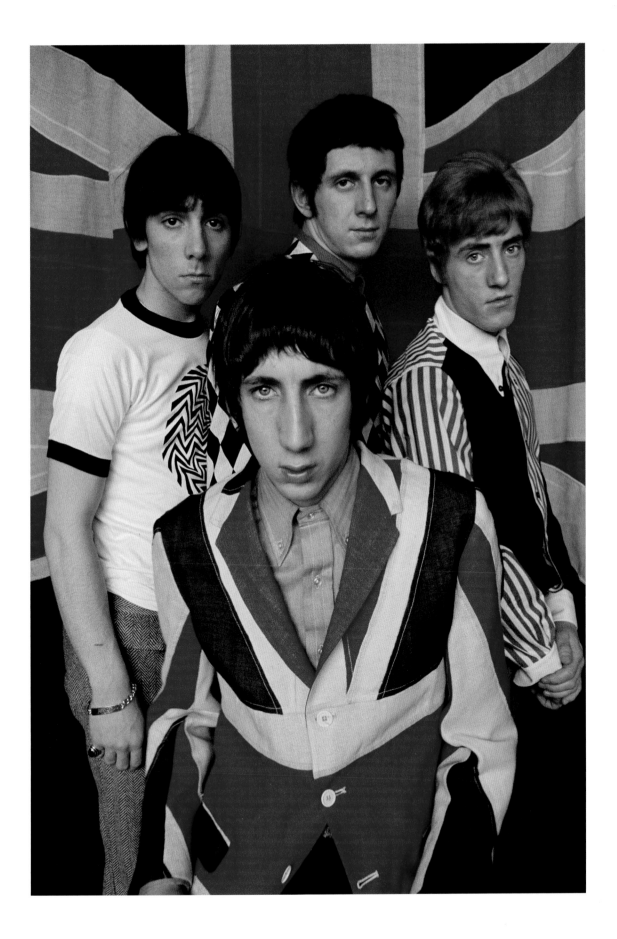

JIMI HENDRIX

— PARIS, 1967 — ALAIN DISTER

The Beatles were only playing dress up, as multicolored Sergeant Peppers. But for Hendrix, the hussar's dolman jacket fitted him like a glove. Was it the prestige of the uniform? More like anti-militarist irreverence, psychedelic eccentricity, and the "*decadance*" of the British Empire. In exile in London, self-confident and theatrical, Hendrix had amazed the capital during Christmas 1966, to the extent that a long-running rumor had it that Eric Clapton, knocked sideways by Jimi's genius, had given him his hussar's jacket (wool with four-stranded frogging). In March 1967, the guitar hero was looking for such a jacket at the Saint-Ouen flea market in Paris, in the company of photographer Alain Dister. He had just released "Purple Haze," his second single; he had just forty months left to live, forty months of revolutions in sound and exploits—solos played with his teeth, orgasmic immolation of his Stratocaster at Monterey, a distorted performance of the American national anthem at Woodstock, an apocalyptic version of "Machine Gun" at the Fillmore. An electric horseman fusing with his instrument. "Any hussar who does not die by thirty is a blackguard," [1] said General Lasalle, the most successful French hussar of the Napoleonic period, a seducer, a lover of strong drink, founder of the Society of Alcoholics, possessor of exceptional bravery at the head of his "infernal brigade," and killed at the Battle of Wagram, as he rode, alone, after the retreating enemy. After imbibing a cocktail of alcohol and barbiturates, Jimi choked on his own vomit at the Samarkand Hotel, at the age of twenty-seven. The right age to sound the last trumpet.

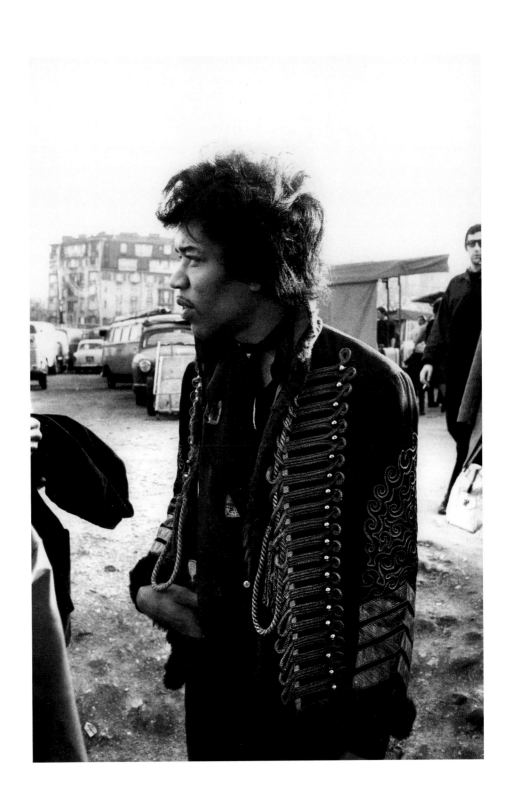

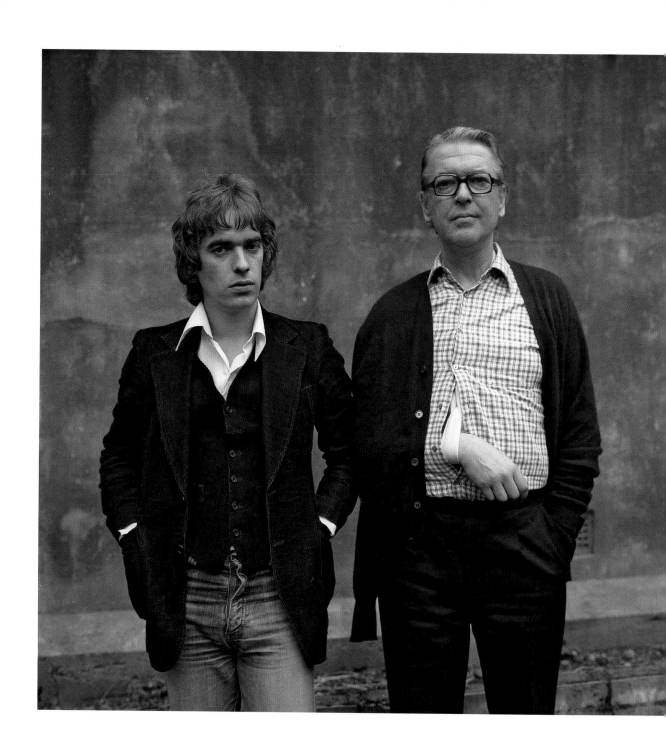

MARTIN AND KINGSLEY
AMIS

— LONDON, 1975 — DMITRI KASTERINE

Two legendary writers, father and son: Kingsley, fifty-three years old, Angry Young Man turned old fogey, and Martin, twenty-six, *enfant terrible* of British letters whom the *New York Times* dubbed one of the masters of the "new unpleasantness." Kingsley, wearing a cardigan of lambswool or cashmere and anthracite flannel pants, arm in a sling (did he fall during a drinking binge?), his hand poking out strangely from his Viyella shirt, that comfortable fabric of small, colored check on a cream background (80% cotton and 20% merino wool) invented in 1893 by Henry Ernest Hollins and originally made of 55% merino wool and 45% cotton. Martin has his hands in the pockets of his narrow, black velvet jacket, bought at Granny Takes a Trip, with a matching vest and tight-fitting jeans. The wry irony of the father contrasts with the son's black look. It's a portrait by Dmitri Kasterine—whose long experience as a photographer on the sets of obsessive director Stanley Kubrick suggests his suitability for the task—that doesn't make a misstep. Here, side by side, are the stiff conservative—in the year when, to everyone's surprise, the Iron Lady took over as leader of the Tory Party—and the arrogant young gun, riding the comet's tail of Swinging London, and already well-known for his series of affairs with actresses and models. Two worlds, two generations who no longer have anything in common. Kingsley, whose first novel, *Lucky Jim*—a vitriolic portrait of the conformism of university life in postwar England—had catapulted him to stardom as one of the Angry Young Men of letters, was now accused by critics of being out-of-touch, alcoholic, embittered, and a misogynist. Martin—who had published his first novel,

The Rachel Papers, at the age of twenty-four, the (largely autobiographical) story of a brilliant, manipulative, and sex-obsessed teenager about to go up to Oxford—had just published *Dead Babies* and was being feted like a rock star. Kingsley didn't like his son's books (apart from his first), and Martin's literary father-figures were Saul Bellow and Nabokov. Sir Kingsley died in 1995. When, thirteen years later, we interviewed his son on the publication of *House of Meetings*, a fictional pendant to *Koba the Dread*, his essay on Stalin's crimes, we pointed out to him: "Your father joined the Communist Party in Oxford in 1941 and remained a member until 1956. And—coincidentally—your novel takes place during this time." He replied: "That didn't even cross my mind. When my characters were in the gulag, my father was playing the perfect little communist. In his books, my father wrote that there are two types of people: those who appeal to the opposite sex and those who don't. It's a huge distinction. Personally, I prefer to contrast those people who have ideological or religious motivations with those who have none. When he rejected communism, my father never imagined that the ideology that would replace it would be anticommunism, which is also a dangerous kind of ideology. I have always rejected any kind of political affiliation. This difference between me and my father has always interested me; he felt the need to belong which I don't feel at all." [1] And in *Experience*, the memoir by Martin that reveals the strange relationship he had with his father, we can see this photo by Kasterine, which hangs today in the National Portrait Gallery in London.

JEAN COCTEAU

— FRANCE, 1942 — RAYMOND VOINQUEL

He wrote: "Fashion is what goes out of fashion."[1] But he was always in fashion. This "frivolous prince," who published his first collection of poems at the age of twenty, was involved in all the arts: literature, theater, music, cinema, painting, drawing, and ceramics, all created with brio, intuition, and magic. In 1942, in the dark days of the occupation of France, he kept a journal, prepared the tragic *Renaud et Armide* for the Comédie Française, wrote the screenplay for *Love Eternal* (featuring Jean Marais in a jacquard jumper, whose pattern was published and then knitted throughout France). Swarms of girls buzzed in the gardens of the Palais-Royal beneath the windows of his Parisian apartment on rue de Montpensier (where he lived from 1939 to his death), eager for a glance at "Jeannot"—Marais had become his lover after they met at the auditions for *Oedipus Rex* (1937). The collaborationist press, which had had a field day over his play *The Typewriter* (in which a small provincial town falls victim to blackmail), dragged Cocteau's name through the mud, and the Resistance wasn't any friendlier when he welcomed Arno Breker, the Führer's favorite sculptor, to his Paris exhibition (the chivalrous Jean Marais joined General Leclerc's Second Armored Division). In 1939, Raymond Voinquel, the great on-set photographer (Carné, Ophüls, Guitry, Duvivier) and light portraitist, had Marais (and Louis Jourdan) pose nude to illustrate excerpts from Paul Valéry's immortal poem "Fragments of 'Narcissus'." During the war, Voinquel joined Studio Harcourt (preserving the right to sign his photographs with his own name). For Cocteau, Voinquel chooses a chiaroscuro, his face in shadow, a frail silhouette with slightly padded shoulders, a slender hand on his heart, the other holding a cigarette emitting a thin trail of smoke, the light focused on the poet's turned-back jacket sleeves, the detail that was his eternal hallmark. Devastating in its invisibility, this mysterious, gracious gesture revealed Cocteau's elegance. Two white patches of a poplin shirt (by Charvet?) emerge from the sweater, echoed by the silky stripes of the lining in the tweed jacket (a wool fabric from Scotland named for the river Tweed that runs through the Borders) that is made-to-measure (by Cifonelli?). None of the four cuff buttonholes is fastened. Custom dictates that the shirt cuff should be at most one half inch longer than the jacket sleeve, a remnant of the craze for lace cuffs during Louis XIV's time. But Cocteau goes further and really rolls up his coat sleeves. It's the pose of a painter, the turned-back cuffs of the journeyman poet who said: "Nothing bold can exist without disobeying the rules."[2] All his life, in the theater as well as in his movies, Cocteau took particular care over his sets and costumes. He worked with the greatest artists, from Picasso in the ballet *Parade* to Pierre Cardin, who designed the masks and costumes for *Beauty and the Beast*. His faithful friend and patroness, Coco Chanel, made the costumes for *Antigone*, *The Blue Train*, and *Orpheus*. For Elsa Schiaparelli, Cocteau designed a jacket embroidered with a female face on the shoulder, a hand caressing the waist, and a shock of blond hair cascading down the sleeve. He also made an evening coat on which two female profiles turn into a vase of roses; and a brooch in the shape of an eye, with a pupil in periwinkle blue glass and a white pearl tear. And what better tribute to Cocteau than Saint Laurent's creation for his fall/winter 1980 collection: a pink jacket on the back of which, embroidered by Lesage, are verses taken from Cocteau's poem "Batterie" [Drums], which he had fun playing at the Paris cabaret Le Boeuf sur le Toit: "Soleil, moi, je suis noir dedans et rose dehors, fais la métamorphose." ("Sun, I am, dark within and pink without, do the metamorphosis.")

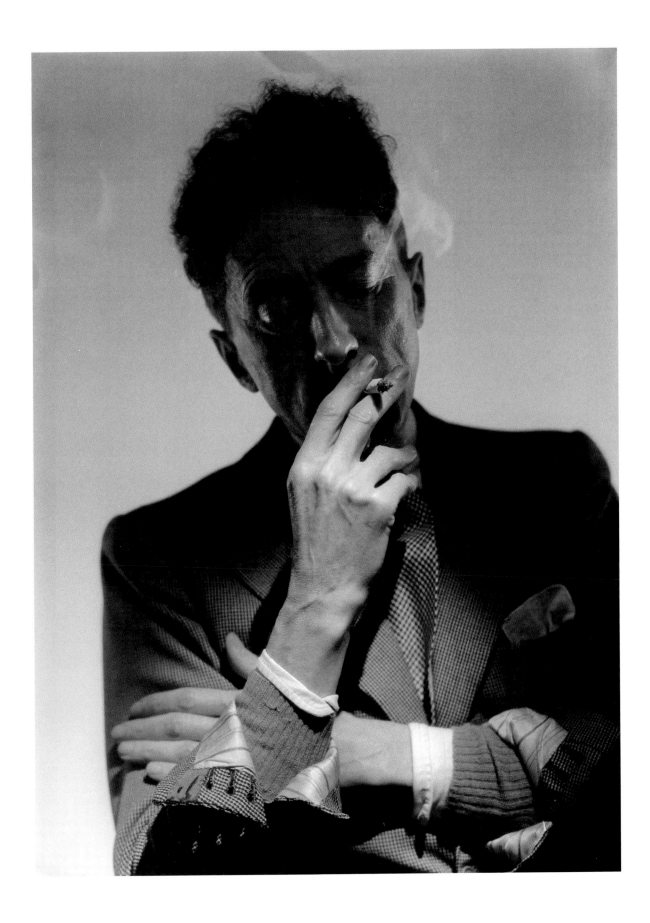

BRYAN FERRY

— ENGLAND, JULY 1974 — ANWAR HUSSAIN

Two years before this picture was taken, the lead singer of Roxy Music burst upon the world of glam rock, dressed in a zebra-print jacket, with his chic—and unique—cocktail of art-house rock, glamorous soul, and dandyish irony. *Re-Make/Re-Model* was emblazoned on the album cover, with model Kari-Ann Muller sporting a retro kitsch outfit. It became a trademark; Amanda Lear, Jerry Hall, Lucy Helmore, Kate Moss—one after the other, models and muses would appear on the album covers of Roxy Music and Bryan Ferry, many of whom were also Bryan's girlfriends. The Roxy look was carefully crafted with stylist Antony Price, and it would continue over the course of eight albums. In 1974, Bryan released his second solo album, *Another Time, Another Place*. Anwar Hussain, cult photographer who would one day make it as an official photographer to the British royal family, immortalizes Ferry in a white tuxedo and red cummerbund (a large belt originating in Afghanistan). Ferry's character had been established: a provocative crooner, a heartbroken heartbreaker, timelessly stylish. In 1987, he released *Bête Noire*, and when, at the time, we asked him for his definition of elegance, he replied, "It's about proportion, about choice whether in women, flowers, clothes. . . . The most elegant people I know are effeminate men. As a teenager I already had a very sophisticated taste for certain clothes, for the visual vocabulary that creates a personality." [1] Talking about his working-class background, he added, "I felt like a delicate orchid lost on parched ground." Hence the white tuxedo—a sartorial choice that we can almost forgive. A tuxedo should be black, of course: single- or double-breasted, with a shawl collar or notched silk lapels (never satin); black pants with matching ribbon, white shirt, black bow tie, and, if desired, a cummerbund (black, of course). The night, as baron and poet Edward Bulwer-Lytton—nicknamed the "radical dandy"—so memorably described it in the first line of his otherwise forgotten novel *Paul Clifford*, is dark—dark and stormy, as it happens.

The first tuxedo (known to the French as *le smoking* because of the jacket the English wore in their smoking rooms, so as not to drag the smell of tobacco back into the lounge) appeared in 1860, tailored on Savile Row by Henry Poole & Co. The Prince of Wales, the future Edward VII, wore it for the first time either at a dinner at the Royal Yacht Club in Cowes, or, according to other sources, at an informal evening at his Sandringham residence. The dinner jacket, as it is still called in the UK, crossed the Atlantic in 1886 and took the name of tuxedo when Griswold Lorillard, son of a New York tobacco magnate who had founded the Tuxedo Park club, caused a scandal at the annual Autumn Ball by appearing in a scarlet jacket. The most reliable version of that particular ball, however, credits James Potter, back from a stay in London, where he had met the Prince of Wales and had had a tuxedo made by Henry Poole. However, we have to wait until 1920 for another Prince of Wales, the future Edward VIII and Duke of Windsor, to invent the dark blue tuxedo, and it was not until after World War II that the traditional white tie and tails made way for the tux. And for Ferry, ringmaster in his white tropical tuxedo, who also said, "I've always had a European—or a white—sensibility, but a deep love of black American music, ever since the day I heard Billie Holliday," [2] it provided him with his "re-make/re-model" fantasy.

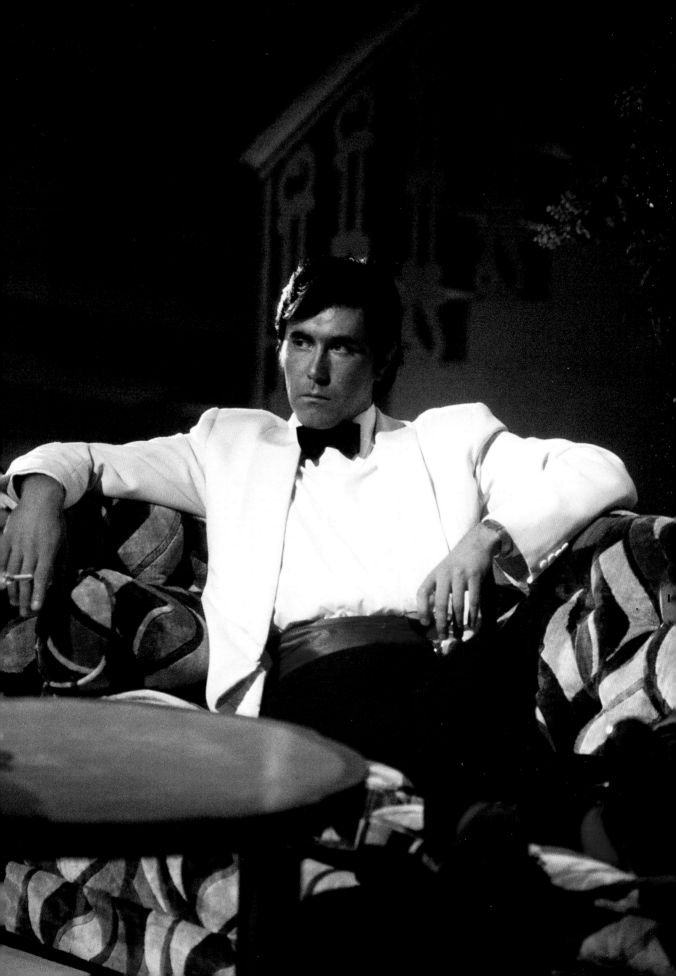

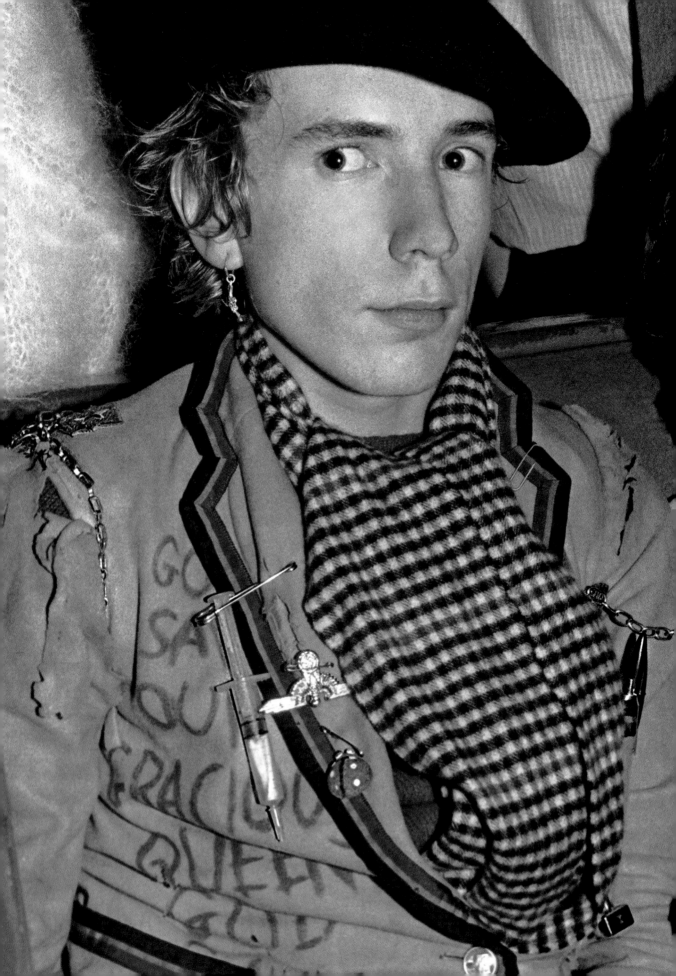

JOHNNY
ROTTEN

— LONDON, OCTOBER 1976 — BOB GRUEN

It's been several months since a motley collection of creatures started to appear at Louise's, 61 Poland Street, a Soho lesbian club run by Louise, an outrageous old lady and great friend of Francis Bacon with a French elegance. Latex sheath dresses, bondage revised and reissued, ripped fishnet tights, garbage bags, dog-collars, piercings, slashed T-shirts. Mohican, porcupine-style haircuts in layers of flashy color. Siouxsie Sioux, Sid Vicious, and Mick Jones turned up in their Doc Martens. On this particular October evening, Malcolm McLaren brought photographer Bob Gruen to take a photo of Johnny Rotten, on whom he was taking a huge gamble. (McLaren had met Gruen when he was attempting to manage the New York Dolls, those offspring of Lou Reed and Iggy Pop, who, with the Ramones, Patti Smith, Tom Verlaine, and Richard Hell—apostles of the "Blank Generation"—were inventing their own version of punk stateside.) Rotten was a little brat with dyed green hair and a frayed sweater, a squatter who was afraid of nothing, and whom McLaren had unearthed in the store called SEX, at that unfashionable end of the King's Road known as World's End. SEX: the huge pink latex letters emblazoned over the entrance, the latest in many names for the boutique Vivienne Westwood had first created in 1970. "In the Back of the Paradise Garage" was renamed "Let it Rock" in 1971, "Too Fast To Live, Too Young To Die" in 1973, and finally "SEX" in 1975. Vivienne's designs for Teddy-Boy outfits made way for her own inventions. Her specialties were zippered T-shirts, decorated with rhinestones, cigarette burns, swastikas, and provocative slogans ("Karl Marx Anarchy" or "Destroy"). SEX became the headquarters of punk, where Vivienne inspired and was inspired by her models. Malcolm, streetwise and brought up on Dada and the Situationists, wanted to make both money and chaos. What better way than by starting his own rock group? And so the Sex Pistols were formed, named in reference to the store. In John Lydon, who changed his name to Rotten, McLaren found his singer. Bob Gruen photographs him wearing a beret and a slashed schoolboy's blazer, with all its associations of revolt. Safety pins, syringe, chains for epaulettes, and marker-pen scrawl: "God Save Our Gracious Queen." The Sex Pistols performed for the first time on stage in June, and the first punk festival took place in September. Their first single, "Anarchy in the UK," wasn't released until November, when punk took off. The flower-power utopia had failed to materialize—death to hippies! Unemployment was soaring—"No Future!" One incident sparked it off. On December 1, 1976, Rotten and his band spat out a hail of expletives never before heard on TV. "The Filth and the Fury" was the headline in the *Daily Mirror* [1] and the "Anarchy" single was boycotted. There was scandal, outrage, and condemnation from the establishment, while young Britain began to pogo. In light of such publicity, Vivienne's boutique was renamed Seditionaries and the price of its clothes rocketed. Why stop when things were going so well? On May 27, 1977, the seditious Pistols released their new single on the eve of the Queen's jubilee: "God Save the Queen/The fascist regime/They made you a moron/Potential H-bomb." The album cover hijacked the official portrait of the Queen and stuck a safety pin through her lip. To the outrage of the establishment, the single hit the top of the charts with the speed of sound, and the *Sunday Mirror*'s headline demanded "Punish the Punks." [2] A gang of fascists attacked Johnny with a machete, slicing the tendons of his left hand. He would never play the guitar again, but "Never Mind the Bollocks," their one and only studio album finally hit the record stores in October 1977. In an irreparable clash with McLaren, Rotten left the Pistols in January and became John Lydon again. Vivienne launched her *haute couture* career. The commercialization of punk had begun.

DIANA
ROSS

WITH MARY WILSON, FLORENCE BALLARD, AND BERRY GORDY

— LE BOURGET, FRANCE, APRIL 1965

She's not yet the supreme diva, not yet Miss Ross, Diana "Eross," the sparkling goddess of the 1970s, nor, according to *Billboard* magazine, "Female Entertainer of the Century."[1] She's not yet godmother to Bambi, the King of Pop—who denied that his single "Dirty Diana"[2] was a tribute to his protector. No, in 1965, Diana is a twenty-one-year-old singer with a barley-sugar voice and ambition of steel. She's with The Supremes' two backup singers on the 1965 Motown Tour. On the menu are concerts in London and Paris, and filming a video for the single "Where Did Our Love Go?" on the Champs-Élysées, where they dance among the Citroëns and Peugeots only to be interrupted by a cop who's impervious to the three girls' charms.[3]

"Ooh baby love!" During the 1960s, the number of girl groups crooning doo-wop, clicking their fingers, and singing a smooth kind of R'n'B numbered in the dozens (Bobettes, Chantels, Vandellas, Ronettes, Marvelettes, etc.). But The Supremes made their mark on the history of American music between 1961 and 1970 because they had something extra—they had style, which Diana forged for the trio. Born in 1944 in Detroit, as a kid she lived and breathed music, singing in church, bumping into Smokey Robinson in the stairwells of the projects, imitating Etta James in front of the mirror, but all the time dreaming of becoming a fashion designer. She studied at Cass Technical High School, taking classes in fashion design, and she made friends with two other singing students, Florence Ballard and Mary Wilson, who invited Diana to join their group, The Primettes. Mamma Ross approved, but Daddy didn't. Diana ignored him and started hanging out at Hitsville, Motown's headquarters. She was sixteen when Berry Gordy, the young founder of the rival Stax label (the black sound of Memphis) signed the girls up. The Supremes were born, creating a phenomenal roster of hits crafted by the Holland brothers and Lamont Dozier ("Stop In The Name

of Love" and "Back In My Arms Again" in spring 1965), and inventing an iconic look consisting of wigs, false eyelashes, sequined lamé evening gowns, and sharp suits in rainbow colors. Diana scoured *Vogue* and *Harper's Bazaar*, and chose their stage outfits, hairdos, and makeup. Scarcely older than a child herself, Ross the Boss was still playing with her dolls. Black America, and especially white America, adored her, Ed Sullivan raised an eyebrow, and The Supremes amassed hit after number one hit in the charts. Jackpot for Motown.

In this photo, Mary Wilson, on the left, in her pantsuit and cute little first-class-cabin cap, seems to be auditioning for the role of airline hostess in the movie *2001: A Space Odyssey*. Florence Ballard, on the right, in skirt suit and stilettos, is channeling Jackie O. In the middle, Diana, the queen of hearts photographed by Berry Gordy, is the natural star in her fur, skirt suit, hairpiece, and jewelry. The soul sisters might have been singing in unison here, but it didn't last long: two years later the balance of egos was disturbed; the group was rebaptized Diana Ross and the Supremes; Florence Ballard was fired; and the mischievous girly charm of the early days evaporated. In December 1970, without a trace of irony, the group's last single "Someday We'll Be Together" was released. Finally alone, Miss Ross could shake loose her tresses and pour herself into Bob Mackie's gold-lamé dresses, Halston's asymmetrical furs, and the sunray-pleated, jewel-encrusted dresses she adored. "Ain't No Mountain High Enough": in 1975 the glamour puss took charge of the costumes Bob Mackie designed for the movie *Mahogany* and for her camp character, Tracy Chambers, nicknamed Mahogany, a young working-class girl who becomes a model and star fashion designer in Rome. It was a movie that did nothing for the feminist movement, but it was an opportunity for Diana to realize her teenage fantasy—of becoming a diva, in the fashion world.

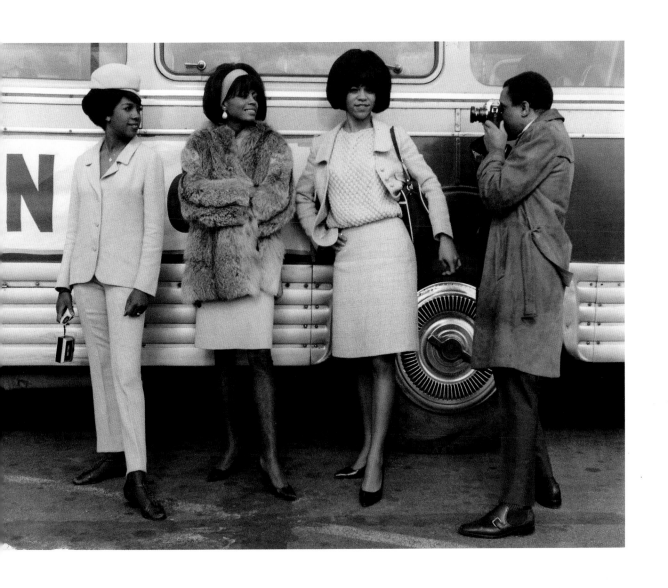

JULIE CHRISTIE

— ENGLAND, 1968 — BOB WILLOUGHBY

New-born chick? Lemon? Canary? The sun? It's so bright you could get a tan standing too long in front of this photo. Julie Christie's dress is certainly yellow, but it was also available in shocking pink, electric blue, apple green, and turquoise. The Pop fashion of Swinging London—that magical detour at the start of the '60s that was born not far from Carnaby Street and spread like euphoric wildfire on the streets of the western world's capital cities—didn't go in for subtlety. It just had to pack a punch, and produce the "wham" effect of a painting by Roy Lichtenstein, one of the elder statesmen of pop art. In 1964, Andy Warhol designed a Brillo Box dress in the same yellow as Julie Christie's frock.

With her breathtaking beauty, it took just two movies for the young English girl (born in colonial India, on a tea plantation in Assam) to become the icon of Swinging London: she was a last-minute replacement for Shirley MacLaine in John Schlesinger's *Darling*, a decadent fairy tale set in the capital of fun. And she did it well—her role as a scatter-brained, cynical model, butterflying between men, earned her an Oscar at just twenty-four. *Doctor Zhivago*, David Lean's melodrama with music by Maurice Jarre, launched Julie, as Lara, and the song "Lara's Theme," into the stratosphere. An It Girl who had The Knack,[1] Christie was also a trendsetter. In 1967, *Time* magazine, who invented the term "Swinging London," considered that "what Julie Christie wears has more real impact on fashion than all the clothes of the 10 Best-Dressed women combined."[2] Ironically, Christie admitted in 2007: "In the '60s, ... I never felt that I was cool enough, or that I was dressed right.... I could never quite get away from this anxiety."[3] Between 1964 and 1968, Carnaby Street and Chelsea were the center of the world—almost. English models looked like overgrown children: Twiggy, Jean "the Shrimp"

Shrimpton, Penelope Tree, and Patti Boyd (George Harrison's wife) could all have been the girl next door. And whatever happened to breasts? They'd been left behind in the '50s with the New Look. The new fashion designers were self-styled, as young as their customers, and party lovers who followed their instincts. They were a generation who created a revolution: Mary Quant, John Bates, Thea Porter, Ossie Clark, Zandra Rhodes, Foale & Tuffin, Bellville Sassoon, Bill Blass, Jean Muir, and Caroline Charles.

The future was bright, and these girls flourished in their place in the sun, growing better in very short, sleeveless trapeze dresses in the bright colors of optimism. These brazen British birds wore their dresses with little blouses, low-heeled shoes from Rayne or Russell & Bromley, and a Gloverall duffle-coat. In 1965, Courrèges, Yves Saint Laurent, Pierre Cardin, and Paco Rabanne brought this look to France, some of them refining it into couture, while others went the way of Futurist and Op Art experimentation. "Picture yourself in a boat on a river/With tangerine trees and marmalade skies/Somebody calls you, you answer quite slowly/A girl with kaleidoscope eyes." In "Lucy in the Sky With Diamonds" (1967), The Beatles marked the end of the exuberant era of Pop. In 1968 Julie was still glowing in sun-yellow hues, but the carefree attitude was ebbing away, the rainbow bubble was about to burst and Pop fashion, which was rather unsexy, with its crackling colors and its neat-and-tidy appeal, would soon be swept aside by the anti-Vietnam War-and-peace-and-love hippie style. Julie Christie titillated her fans in *Petulia*, a psychedelic movie by Richard Lester, the iconic director of Swinging London who made The Beatles' movies (*A Hard Day's Night* [1964] and *Help* [1965]) and who invented ... The Knack.

JEANNE
MOREAU

— PARIS, AUGUST 1962

The (future) bride wore black. Wearing a little black dress and talking to a crowd of captivated reporters about whether or not she was going to marry couturier Pierre Cardin (who created her costumes in Joseph Losey's *Eva* of 1962), one wonders if Jeanne Moreau knows that she's paying tribute to one of her lover's competitors. During the '20s, Coco Chanel rescued the color black from purgatory (mourning clothes, maids' uniforms, camouflage for the lower classes) and thrust it into the spotlight. Black is queen of the night, a powerful political and moral choice, equally prized by kings (from the Medicis to Charles V, Holy Roman Emperor) and Puritans, but also an ambiguous choice,[1] shared by seventeenth-century pirates, nineteenth-century anarchists, and the leather-jacketed rebels of the mid-twentieth century. Black became, and would remain, the symbol both of luxury and of a minimalist aesthetic, thanks to a little black dress that imitated nothing. After World War I, young women began to escape male domination: flappers and other liberated women of the '20s smoked, drove cars, danced, and made the most of the Roaring Twenties. ("I think you're hard and selfish and you haven't a feminine quality in you," one of Fitzgerald's characters complained of this new breed of woman.[2]) The corset was kaput, waists were set free, and ankles got an airing. Certainly not the last to pick up the scent of the fresh breezes of liberation, Coco Chanel (who wore striped Breton shirts, sailor pants, and costume jewelry before anyone else) came up with what was a crazy idea in 1926. Inspired by the ascetic clothes worn by the nuns in the orphanage where she had been brought up

(the Cistercian abbey of Aubazine in Corrèze), Chanel designed a cocktail dress that was revolutionary in its simplicity: an unwaisted, long-sleeved, knee-length crêpe-de-Chine tube—completely black. In its October 1, 1926 issue US *Vogue* reproduced the dress with the caption: "The Chanel 'Ford'! The frock that all the world will wear is model 817,"[3] an allusion to the Model T which had emerged from the Ford production line in 1908, designed by Henry Ford to be *the* universal vehicle, both economical and democratic, and famously available only in black. "Any customer can have a car painted any colour he wants so long as it is black,"[4] the industrialist (half) joked. In November 1926 *Vogue* announced that Chanel's little black dress was the "uniform for the modern woman."[5] A year later, the last Model T Ford rolled off the production lines, replaced by the Model A. Chanel's little black dress has, however, proved indestructible, and has been revisited by every fashion designer on the planet, from Pierre Cardin to Givenchy—who confected Audrey Hepburn's dress in *Breakfast at Tiffany's* (1959)—from Albert Elbaz to Miuccia Prada, Marc Jacobs, or Rei Kawakubo for Comme des Garçons.

In 2010 the acronym LBD, meaning "Little Black Dress," appeared for the first time in the *Oxford English Dictionary*. Perhaps it's time the Academie Française awarded similar accolade to the Petite Robe Noire!

BIANCA AND MICK
JAGGER

— VENICE, JUNE 2, 1971

Scampi fritti and *sticky fingers*. During his honeymoon with Bianca in Venice, the most outrageous rock star on the planet had conformed to middle-class conventions. Newlywed Mick is wearing sneakers, appropriately enough for Jumping Jack Flash, a cap by Gavroche, and a suit tailored by the brilliant Tommy Nutter of Savile Row. Nutter knew very well what Mick liked—and allowed him to show off his assets with a clinging pair of pants, a nod to the tumescent zipper on the cover of *Sticky Fingers*, which had been released in April 1971 and was designed by Andy Warhol featuring Corey Tipping's crotch. But in this photo it's Bianca who grabs our attention because of her stunning bone structure and her vestal-like appearance in white ankle boots, white cape, and huge sunglasses. The cape envelops and protects her (she's five months pregnant), but also looks like a wedding dress, or a shroud for lovers past. Bianca Perez-Mora-Macias—a Nicaraguan model and graduate of Paris's prestigious school of political science, as well as of the "schools" of Michael Caine (London) and Eddie Barclay (Paris)—wasn't even a Stones groupie. She had been invited to their after-show party at the Olympia in Paris in 1970, where movie director Donald Cammell had introduced her to Mick. There was barely time for her mother to ask the famous question "Would you let your daughter marry a Rolling Stone?"[1] before she flew off to Saint-Tropez on May 13, 1971 with Mick (who had recently become a French tax exile). In the land of Bardot, Bianca made her debut as a new icon of the "gypset" (a combination of gypsy and jet set) as represented by Talitha Getty in Marrakech and Loulou de la Falaise, Yves Saint Laurent's muse, in Paris. Bianca said "I do" as a luxury-style gypsy, wearing a see-through blouse and sequined turban to the town hall, then a wide-brimmed hat with flowers and short Saint Laurent skirt suit, nude under her jacket, at the Chapelle Sainte-Anne. The media went crazy. But still: you can't always get what you want.[2] The couple parted company in 1973, and were divorced in 1978, with Bianca Jagger commenting bitterly some years later: "My marriage was over on the wedding day." But in this photo, in Venice, under the arcades of Saint Mark's Square, Bianca, twenty-five, and Mick, twenty-eight, were the most exciting couple of the 1970s. Their resemblance to each other is striking: both are skinny, with predatory jaws, and huge mouths. They exude animal energy, class, and unpredictability.

With or without Mick, Bianca maintained her role as queen of the New York jet set (a group that included Truman Capote, Lee Radziwill, Liza Minnelli, and Andy Warhol), creating "a style of her own" according to a *Vogue* headline in 1974.[3] She wore masses of furs, amazing plumed hats, sequined turbans, *gandouras*, silk caftans by Bill Gibb, gypsy-style lace dresses, black or white tuxedos by Saint Laurent, and gold-handled canes in silver or ivory, not forgetting the famous asymmetric gowns designed by her friend Halston. It was a tricky combination but it worked, mixing neoclassical glamour, bohemian haute couture, and the exhibitionist style of the glitter-ball years.

Her arrival at Studio 54—temple to disco, powder-puff land of Oz, supercharged bordello—on May 2, 1977, riding a white horse and dressed in a poppy-red Halston dress, cemented her legendary reputation.

Forty years later, Sir Mick is giving private concerts for audiences of businessmen. Bianca has become a tireless activist for human rights and ecological causes, and is still globe-trotting in her leisurewear. The ultimate "soul survivor"?[4]

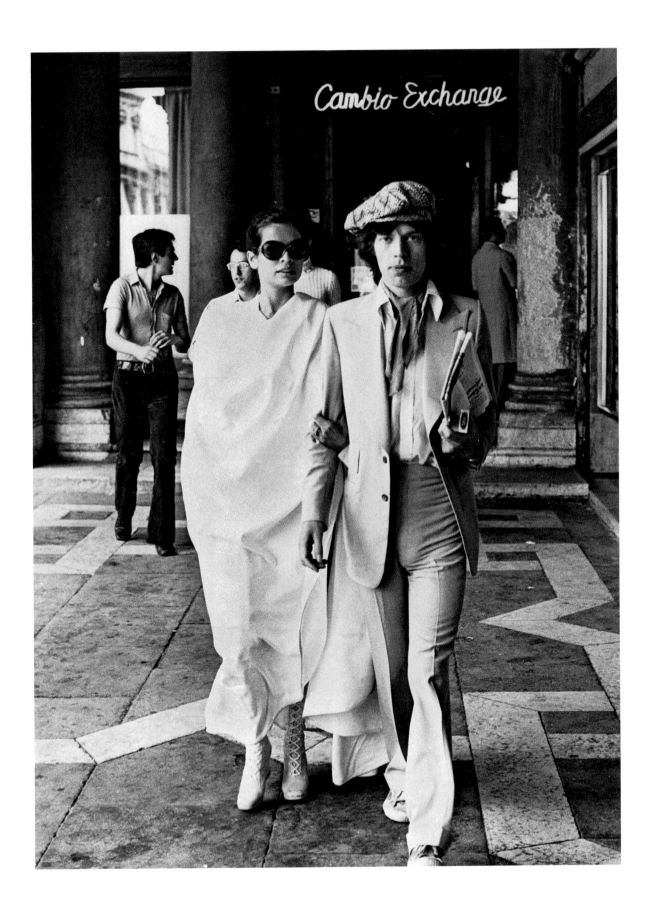

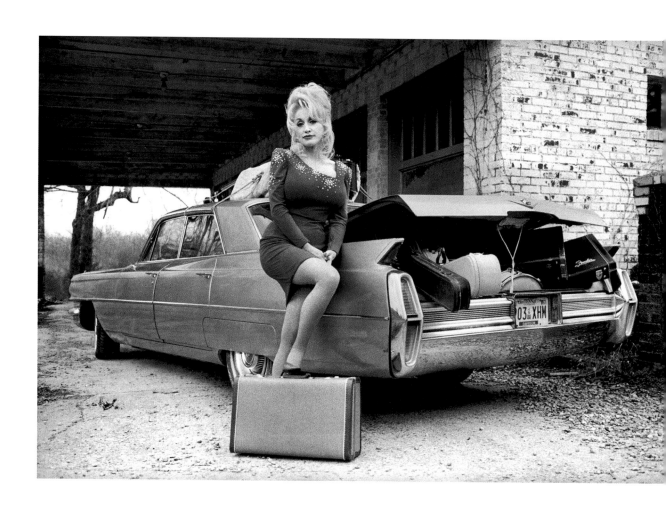

DOLLY PARTON

— JOELTON, TENNESSEE, DECEMBER 1997 — JIM HERRINGTON

She's all-American, with proud fins and a streamlined chassis—a 1964 four-door Cadillac DeVille sedan. This was a time when gas prices were laughable, and when Detroit hadn't yet been invaded by the Japanese. The half-open trunk is overflowing with suitcases. Dolly Parton was recording *Hungry Again*, an album that went back to her roots in Appalachian music, and which she had written by herself, at home in the land of Davy Crockett, Jack Daniel's, Nashville, and Memphis—her birthplace in Tennessee. Her guitarist had shown her the portfolio of a friend, photographer Jim Herrington. Seeing his picture of a dead opossum that he'd found in his garden, she had hesitated, but then something clicked: she wanted a portrait of herself that was as honest as possible, and decided to ask Herrington to create the cover of her album. The shoot took place in Joelton, a suburb of Nashville, and Dolly, who had just turned fifty, took it in stride as usual. Since her first album, *Hello, I'm Dolly*, the singer, as doll-like as her name suggests, had been collecting platinum discs, and even had a Barbie made in her image in 1970. But the queen of country music hadn't forgotten her roots—in a dirt-poor family of farmers living in a hamlet at the foot of the Great Smoky Mountains, in Pentecostalist country, with twelve siblings.

As a businesswoman, Dolly bought up a bankrupt amusement park, turning it into Dollywood—with three million visitors per year—and also set up a foundation helping children to learn to read. The false, oversized eyelashes, over-the-top makeup, sparkly lipstick, sequined dresses, breasts covered in stars and stripes, plastic surgery—it's all done in total sincerity. Dolly is known for her natural artifice. And for her redneck sense of humor, as she retorted to Oprah Winfrey in November 2003: "If I have one more facelift, I'll have a beard." In "Backwoods Barbie" she sings: "I grew up poor and ragged, just a simple country girl/I wanted to be pretty more than anything in the world/Like Barbie or the models in the Frederick's catalog." Frederick's of Hollywood—which was opened in 1947 on Hollywood Boulevard by Frederick Mellinger, inventor of the push-up bra—was a temple to lingerie whose D-cups and seductive baby-doll nighties were the stuff of little Dolly's dreams. But what is most affecting about this extraordinary body, which has by now been completely remade from head to toe, are the cheap tights wrinkling imperceptibly around her ankles, and which, catching the light, almost look like a bandage underneath the nylon. All the glamour of a country girl.

GRACE JONES

— PARIS, 1985

"Women can be traced back to ancient times," noted writer Alexandre Vialatte, in one of his typically ironic comments.[1] As indeed can the dress. Derived from the Greco-Roman tunic (which at the time was little more than a rectangle folded simply and sewn at one side), the dress or robe was worn by both men and women up until the end of the fifteenth century, before being designated an item of female clothing.

As for Grace Jones, doesn't her evening dress, a sumptuous cyclamen sheath, lend her the appearance of a vestal virgin? Thus we come full circle, and we're tempted to conclude with Vialatte's immortal words: "And this is how Allah is great."[2] But this would deprive us of certain details both technical (the laces for example) and biographical (how the daughter of a Jamaican preacher born in Spanish Town became a diva with an android's body).

Singing in her father's church did nothing to set Grace on the road to salvation, but she did discover that her voice had a range of two-and-a-half octaves, and could extend from soprano to contralto and back again. As a young model in New York, Grace began sculpting her iron body by means of boxing, bodybuilding, and jumping rope, cut off her dreadlocks, adopted her famous GI crop, and, in 1975, released an anti-disco single, "I Need a Man." With her husky voice, she switched roles constantly like a "brutal cannibal" orchestrated by Jean-Paul Goude, who played Pygmalion to her tigress. This hit factory worked overtime during the '80s, producing "My Jamaican Guy," "Nightclubbing," "Pull Up To The Bumper," "Slave To The Rhythm," and "La Vie en Rose." A rose with thorns, as Grace is considered a prickly character, even if her response is: "I am not a rock star, I am a soft person!"[3]

Grace, the sacred monster, met a brilliant little Tunisian who soon dressed her in a more feminine style. Sculptor of curves and designer of revolutionary Lycra-based fabrics, Azzedine Alaïa is adored by the women for whom he creates "second skin" dresses. The press called him the King of Cling, and with Grace, the Disco Queen, he had an immediate understanding. In 1987, Jones starred in a James Bond movie, *A View To a Kill*, dressed almost exclusively in Alaïa. In this photo the lacing on the sheath dress recalls the system for fastening a corset—that machine for control and correction used "to model and enhance the female figure"[4] (according to historian Farid Chenoune), the awful corset that Jean-Jacques Rousseau wanted to destroy long before French couturier Paul Poiret. "It is not attractive to see a woman cut in half like a wasp," Rousseau wrote in 1762 in *Émile, or On Education*.[5]

As for the top-knot on this sheath dress (named after the casing into which one slides a blade), the soft hood was Grace Jones's favorite accessory, as she explained: "I don't feel completely dressed without something on my head."[6]

Let's give the final word to Joan Juliet Buck, editor-in-chief of French *Vogue*: "It took nerve to dress like an Alaïa woman, and patience to undress."[7] A portrait of Grace through thick and thin?

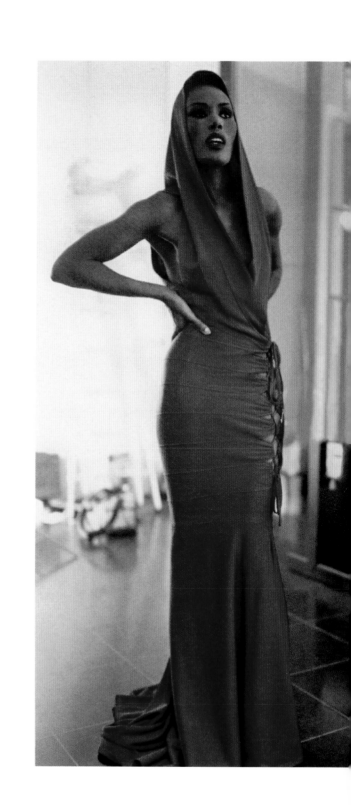

STEVE McQUEEN

— LOS ANGELES, 1964 — WILLIAM CLAXTON

"Star fucker/Yes you are," as The Stones sang in 1973 in "Star Star." At that time Steve McQueen was the highest paid actor in the world. His roles in a dozen movies—from a bounty hunter with a sawn-off Winchester in *Wanted: Dead or Alive* (ninety-four episodes shown between 1958 and 1961) to the ex-con on the run in *The Getaway* (1972)—the "Cincinnati Kid" personified an American dream in the decade that saw many of them broken. His style conveyed stubborn nonchalance and repressed violence, and his unique facial expression displayed a mixture of childlike malice and indifference. Surrounded by mystery and contradiction, this taciturn rebel and archetypal maverick also defended the Vietnam War and voted Republican. He smoked marijuana almost every day, regularly took heroin and cocaine, and drank like a fish. Steve was scarred at an early age: his father, a stunt man, abandoned him when he was a mere six months old; his mother was a prostitute and an alcoholic. He became a teenage delinquent. After a few years living on the streets, at the age of seventeen, Steve enlisted in the merchant marine, and then joined the US Marines as an engineer (his role in *The Sand Pebbles* wasn't just acting). The counterculture may have been in full swing, but fast cars were still the stuff of dreams. The '60s were strange years, a decade of speed. Steve lived his passion for motor racing as a driver on screen and on the racing circuits. He drove a Ford Mustang in *Bullitt*, a Porsche in the 12 Hours of Sebring race, and a Triumph Trophy 650 in *The Great Escape* and in the Enduro World Championship. He flew planes, including a Pitcairn biplane that had belonged to Eddie Rickenbacker, the World War I flying ace. When McQueen quit Hollywood at the peak of his career, he went off to race motorbikes, crisscrossing the country in a mobile home, and riding his BSA Hornet or one of the vintage Indian motor bikes from his vast collection of three hundred motorcycles. No wonder he became a legend.

We still find the southpaw's showiness impressive. More than thirty years after his death, the King of Cool remains a darling of the fashion crowd. Not so much for his Edwardian-style suit in *The Thomas Crown Affair* (tailored by Douglas Hayward of Savile Row), but for his perfect interpretation of the Ivy League look, that American WASP style of casual elegance. Steve could wear the basics like no one else: T-shirt, sweatshirt (with cut-off sleeves in *The Great Escape*), chinos, desert boots, sunglasses (Persol 714s with blue-tinted lenses in *Thomas Crown*), and Harrington jacket, as in this picture taken by photographer William Claxton, who wrote a wonderful book on McQueen. What sweet harmony: a V-neck ecru cashmere sweater, white American Oxford shirt (with button-down collar), and the famous G9 blouson, here in a putty color (but which Steve also liked to wear in navy blue). It's a light cotton waterproof windbreaker, with a two-button stand-up collar, raglan sleeves, ribbed cuffs, slanted flap pockets, and zipper fastening, created by John and Isaac Miller in Manchester in 1937, and sold under the Baracuta label. The proof of authenticity lies in its tartan lining in the colors of the Fraser clan (with the blessing, given in 1938, of Simon Fraser, the twenty-fourth Lord Lovat). Elvis wore a Harrington in *King Creole*, but it was Steve McQueen, wearing a G9, who made the cover of *Life* magazine in 1963, on one of his Triumph motorcycles. The following year Ryan O'Neal stole the limelight sporting just such a jacket in the TV series *Peyton Place*, so much so that the character he played, Rodney Harrington, gave his name to it. In England, the Mods made a cult of the jacket, which would be kept alive for future generations by The Clash and Oasis. Only one other blouson competes with the Harrington for top billing: the McGregor Anti-Freeze as worn by James Dean in *Rebel Without a Cause*: it's red, one hundred percent nylon but, unlike the Baracuta, without ribbing and with a classic collar. The story goes that it was bought at Matson's on Hollywood Boulevard, the store that dressed the gang called the Athenians, whose leader, Frank Mazzola, had been hired by director Nicholas Ray to advise on the authenticity of the clothes and cars in the movie. So what's it to be: a '50s Anti-Freeze or a '60s Harrington? Such a duel would leave Steve completely cold.

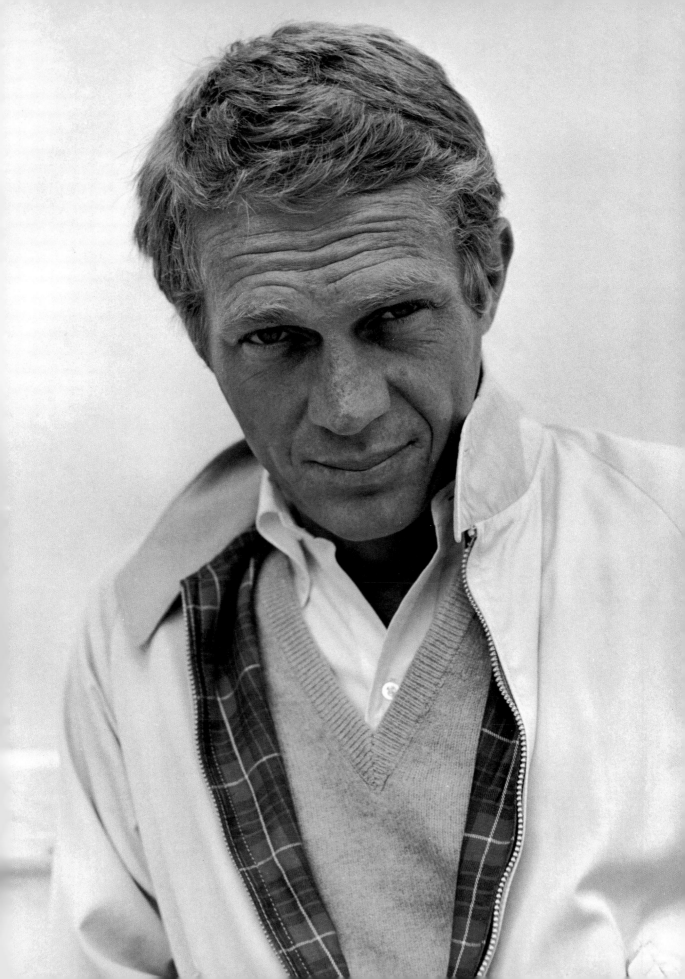

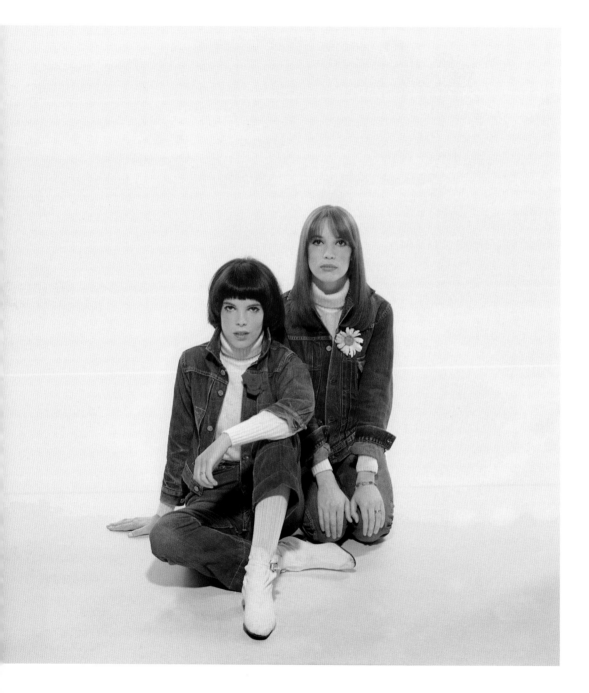

DANI AND ZOUZOU

— PARIS, 1966 — JEAN-MARIE PÉRIER

Same seductive, androgynous look, same original given name. In the foreground, with a Stones-style mop of hair, Danièle Graule, known as Dani. Kneeling, with her Françoise Hardy-style bangs, Danielle Ciarlet, known as Zouzou because of her lisp, and nicknamed the Twister by *Paris-Match*, for her wild-child dancing. In London, it was Marianne Faithfull and Anita Pallenberg; in Paris, it was Dani and Zouzou. Sixties icons with a devilish side, they were models at the Catherine Harlé agency (so well known in its day that it featured in Jacques Dutronc's song "The Playboys"); muses at the hottest nightclubs, such as Régine or Castel, and appeared on the arms of the hippest scenesters, such as Jean-Paul Goude, Brian Jones, or Jean-Marie Périer. The latter took this photo of them at Studio Carnot in Paris for *Mademoiselle Âge Tendre*, the magazine launched in fall of 1964 by Daniel Filipacchi after the success of his publication *Salut les Copains,* and where Périer's sister Anne-Marie would later become editor in chief. The magazine had its finger on the pulse of youth culture: girls fought over it, in its pages the stars of *yé-yé* talked about fashion and beauty, and director Jean-Luc Godard, in his movie *Masculin Féminin,* filmed the first Miss *Âge Tendre* chosen by readers.

Zouzou and Dani: the cinema adored them. Zouzou cut her first single in 1964; Dani had just released "Garçon manqué" [Tom Boy]. While they await a future that includes *Love in the Afternoon* (the film that Zouzou made with director Éric Rohmer) and *Day for Night* (which Dani made with director François Truffaut), hard drugs, cruel relationships, the counterculture, and L'Aventure (the nightclub Dani opened in Paris), they look fearless in their American Levi's jean jackets.

What is the origin of the word "jeans"? It's a corruption of the English word "Genoese" meaning cotton made in Genoa for long-distance sailors. The material—denim—is a kind of serge "de Nîmes" (from Nîmes, France), famous for its hard-wearing qualities. The color—indigo—comes from India, the source of the purplish-blue plant of the same name. In short, jeans are universal. Zouzou is wearing a 557XX jacket, known as the Truckers' jacket. It was the first V-stitch blouson jacket. Created in 1962, it was shrink-resistant, with two flap pockets on the upper chest, and V-shaped stitching running from the waistband, which gave the jacket its unusual waistline. Dani has chosen an already vintage 1953 style, the pleat-front 507XX. Both are magnificent, even if we still have a weakness for the Lee Slim Rider jacket (with its two parallel rows of stitching rising up like a pleat from the waistband to the pockets), and its winter version the Storm Rider, as worn by Marilyn in *The Misfits*. But here, in the spring of 1966, our girls sport a budding grove in their buttonholes: a daisy for flower-child Zouzou, a rose for Dani—who went on to open the famous Paris flower shop *Au nom de la rose*.

CHLOË
SEVIGNY

Even before she had made a movie, Jay McInerney, writing in *The New Yorker,* dubbed her the It Girl of the moment, "one of the coolest girls in the world."[1] The chronicler of nightlife in *Bright Lights, Big City* hit the nail on the head, pinpointing that indefinable *je ne sais quoi* that is the mark of the true It Girl. Chloë went on to forge a red-hot reputation (sex and drugs), with a whiff of scandal (lesbianism, on-screen fellatio), along the way acquiring a gay fan club and rocker boyfriends, and she became both a muse of indie cinema and the heroine of a popular TV series, while having a solid base in the fashion world, both as model and hip designer. This is Chloë Sevigny—whose name sounds like a French marchioness in a disenchanted world—a tomboy who was born in Darien, Connecticut. "I was kind of a depressed teenager."[2] In 1993, at the age of eighteen, she'd been hired by *Sassy* magazine, first as a model then as a writer, when she won the part of an adolescent who finds out she is HIV positive in Larry Clark's movie *Kids*, written by then boyfriend Harmony Korine, whom she'd met at skaters' raves in Washington Square. The actress (who has worked with Woody Allen, David Fincher, Jim Jarmusch, and Lars von Trier, among others) has racked up some controversial roles: a transsexual's girlfriend in *Boys Don't Cry*; a lesbian in *If These Walls Could Talk 2*; the young wife of a polygamous Mormon in the TV series *Big Love*; and a transsexual contract killer in the British TV series *Hit & Miss*. But it was her unsimulated fellation of Vincent Gallo in *The Brown Bunny* (2003) that, instead of delivering a fatal blow to her career as anticipated, would establish her infamous status. At the same time she admitted to several same-sex experiences ("I still kiss girls occasionally, but I wouldn't say I was bisexual"[3]) while making it clear where her interests lay. (When asked if she could ever see herself in a relationship with a woman she replied "Probably not, no. I need more meat and potatoes—with more of the meat part, I guess,"[4] while also confessing in *Playboy* magazine: "I want a guy who is masculine, good with his hands and able to build stuff and who [has] survival skills. I like an imposing man, like a lumberjack"[5]).

Her use of crude language and her contemporary, subversive style inspired the '90s and the first decade of the twenty-first century: revisiting the punk and grunge look in shorts and Doc Martens, wearing baby-doll dresses with Texan boots, or modeling on the runway for Miu-Miu, Lanvin, Balenciaga, Tom Ford, Yves Saint Laurent, Chanel, and Chloé, before designing her own collection for Opening Ceremony. It's a mixture of genres that could be summed up in the Perfecto she is wearing here, like Lou Reed walking on the wild side. This black leather jacket for bad boys has metamorphosed into a catwalk standard for women (designed by Gaultier, Mugler, Montana, Chanel, Balenciaga, and others). A century ago, in 1913, Irving and Jack Schott, sons of a Russian immigrant, started their business on Manhattan's Lower East Side. In 1928, commissioned by the Harley Davidson dealer on Long Island, Irving designed a leather jacket with a zippered fastening that he called "Perfecto," after the name of his favorite Havana cigar. Just after World War II, he launched model 613, known as the "One Star" because of the silver star on each epaulette. Made in thick horsehide (today it's tailored in cowhide), its half-belt fastens in front with a rectangular metal buckle. With its slanting zippered pockets, a wallet pocket with flap, snap fasteners on the collar, and zippered wrists to protect against the elements, it is indeed a perfect jacket that became the symbol of rockers, greasers, and bikers in the mid-'50s. At Christmas 1953 there was *The Wild One*, featuring Brando's Perfecto (with "Johnny" written on the left shoulder), as he played the leader of the Black Rebel Motorcycle Club riding his Triumph Thunderbird. The black leather jacket, synonymous with young thugs and shunned by polite society, comes back to take center-stage every time a generation rebels. From Gene Vincent to The Ramones, from Vince Taylor to The Clash, from '60s lefties to the gay leather scene, the unisex Perfecto, its design unchanged over sixty years, brazenly stakes its claim even today as the bad boy—or girl—of haute couture.

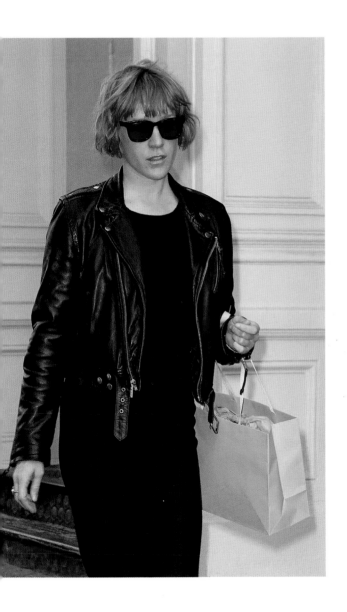

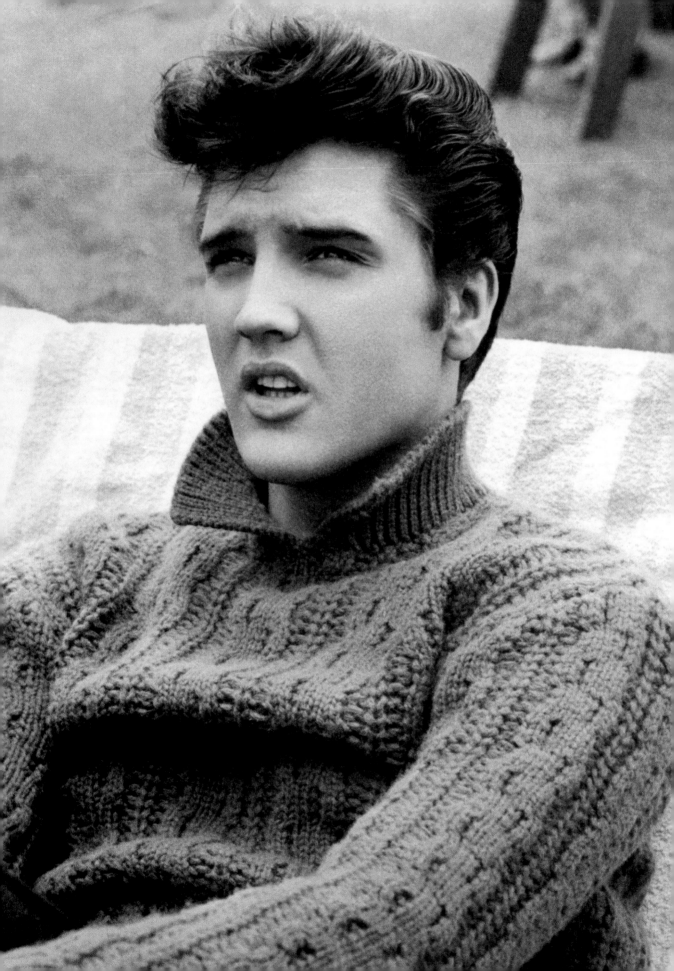

ELVIS
PRESLEY

The sun is shining, as usual, on the MGM Studios in Culver City. Filming is underway on *Jailhouse Rock*, the teen idol's third movie. He's just swung his hips with feline grace on "Baby I Don't Care" (one of four numbers written for the occasion by Leiber and Stoller). Beside the pool, on a deckchair, Elvis is relaxing. In a sweater. For this movie sequence, the crew members are all wearing swimsuits. (And check out the musicians accompanying Elvis in Hawaiian shirts—they are wearing sunglasses in some shots and not in others!) Nothing, however, can stop the King, the incarnation of style. This pine-green sweater (the pine tree, king of the forest), cable-knit (made by Gladys, his beloved mother?) would be copied in its thousands by his fans. Worn, like him, with the collar turned up, of course: just like Elvis also wore his shirts. Elvis loved clothes, and he loved mixing them up. For his first audition at Sun studios he turned up in white nubuck shoes, black shirt, and pink pants, a daring favorite color at a time when no man would risk it and later the color of his Cadillac. From the time of his first hit, he bought his clothes at Lansky Brothers, 126 Beale Street, the top tailor in Memphis, or in Hollywood at Sy Devore, "tailor to the stars," who dressed the Rat Pack. He loved flashy colors, hated jeans as they reminded him of his poverty-stricken childhood, and had a taste for uniforms (a reminder of the Reserve Officers' Training Corps where he served in his teens),

medals, and military gear. Later, on stage he'd give free rein to his passion: wide, ornate belts, scarves, bracelets, a whole hardware store with, in pride of place, the ring he'd had engraved with TCB (Taking Care of Business), featuring an 11.5-karat solitaire diamond surrounded by brilliants.

In Las Vegas (six hundred shows between 1969 and 1976), to the strains of "Thus Spake Zarathustra," he came on stage in his jumpsuit and cape embroidered with rubies and diamonds, a confusion of kitsch that immortalized his drug-bloated figure. But in this photo, in spring 1957, the King had just been born. In March, with the royalties earned from "Heartbreak Hotel," he bought a beautiful house on Highway 51 in Memphis, which he christened Graceland. The previous fall, when he appeared on the Ed Sullivan Show, he had dyed his light brown hair jet black. With his Brylcreemed quiff scented with coconut oil (made by White & Black of Memphis), top lip curled into a sneer, and baby cheeks, the Pelvis exuded sex appeal. With his collar turned up— "Baby, I don't care," indeed. Six months later he would be drafted. And as for John Lennon, that "jealous guy," it was easy for him to say, "Elvis died the day he went into the Army." [1]

JANE
RUSSELL

— CALIFORNIA, 1942 — ELIOT ELISOFON

Jane Russell found God at the age of five,[1] and Howard Hughes at the age of nineteen. She prayed to the former, expecting nothing in return, and begged the latter, a sex maniac obsessed with breasts, to keep his hands to himself. God never abandoned Jane, and Hughes made her famous for "two great reasons,"[2] as he feverishly put it in 1941 on the posters for his "sex western" *The Outlaw.* Jane Russell's career raises a titillating question worthy of Woody Allen: can one be a Catholic sex symbol, and reconcile the rosary with hosiery? Jane Russell accomplished this feat because she never stopped reading the Bible nor talking about it at the very active Hollywood Christian Group,[3] while all the time ferrying her phenomenal physique (38D-24-36) from movie to movie (twenty-four in total), and from scandals to prohibitions. *The Outlaw*— where she refused to wear the bra designed for her by Howard Hughes's aeronautical engineers—was banned for years. *The French Line*—where she sang wearing a swimsuit— outraged the Catholic Church, who declared that watching Jane Russell was a mortal sin. Accordingly, the image she chose for photographer Eliot Elisofon, just after the scandal of *The Outlaw*, was that of a Sunday fisherman, not a pneumatic fishwife.

Jane Russell has just turned twenty-one, and it's a bit of a challenge to believe in her all-out passion for rod-and-reel fishing, although we approve of her plain and wholesome sweater, with its echo of the traditional knitwear worn by garlic merchants in Les Halles market in nineteenth century Paris. A fitted version of the garment was adopted by those Hollywood dream girls dubbed "Sweater Girls" during the '40s and '50s: Lana Turner, Jayne Mansfield, Marilyn Monroe, Mamie van Doren, and Jane Russell knew that a sweater one or two sizes too small and clinging to an Obus bra was a lethal weapon, hand-knitted sex appeal. The Hollywood version of Molière's line: "Cover this breast which I cannot behold." Groucho Marx, who costarred with Jane Russell in *Double Dynamite* (a smart-aleck title, thought up in 1951 by—guess who?—the producer Howard Hughes), might have recanted on his famous line "I don't want to belong to any club that will accept me as a member" and agreed instead—warmly—to join the Sweater Girls' club.

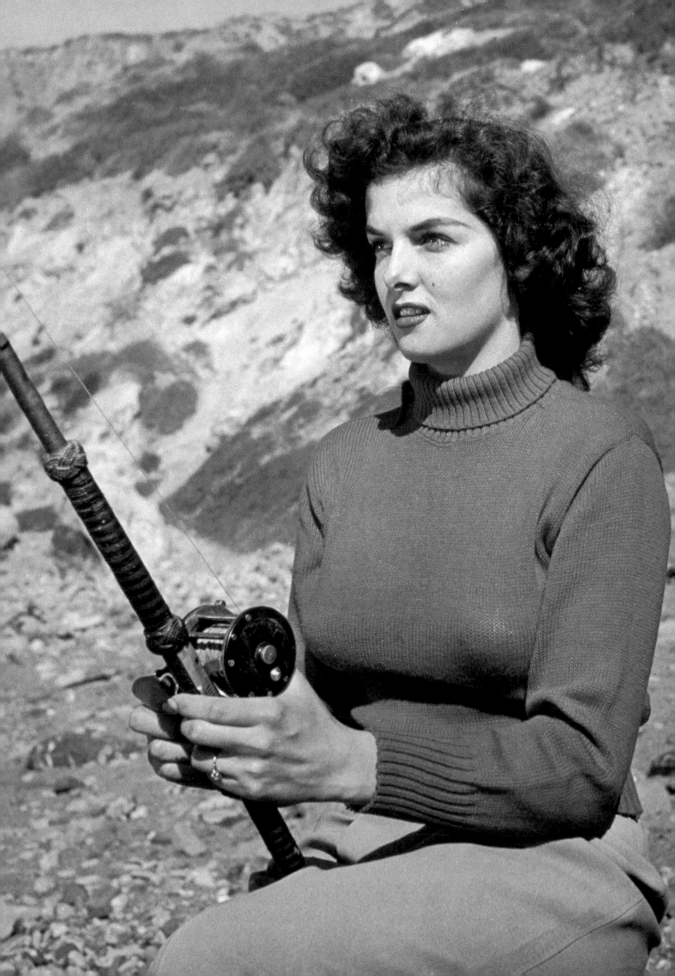

BRUCE
SPRINGSTEEN

— ASBURY PARK, NEW JERSEY, DECEMBER 1974 — MARY ALFIERI

He's twenty-five, with the thin beard of a young Christ, and already he's acquired a nickname. "The Boss" has just recorded *The Wild, the Innocent, and the E Street Shuffle*, his second album, and for now has only enjoyed some local success. He sings for blue-collar workers—about their fleeting love affairs, their wasted lives, their nighttime adventures in the working-class suburbs—he sings for the hobos and the immigrants, for all those whose American dream is falling apart. On the release of his album, *The Ghost of Tom Joad*, Springsteen told us: "I've always identified with the hero of *The Grapes of Wrath*. Someone without any political education but who understands things through his own experiences, and tries to save those around him. As for me, I've tried to untangle the meaning of what I'd been through from the vantage point of my roots. I don't try to create characters to send a message. All I'm trying to do is to let my characters tell their story."[1] Bruce had traveled across the US in the back of a truck, wrapped up in a sleeping bag; he'd known all about prison and at times he'd gone hungry. Born to run, the Asbury Park wanderer burned some rubber in the asphalt jungle, hitting the gas as he drove through the beat-up suburbs of the motor cities, passing through neon-lit nowheresvilles, past the technicolor diner signs. Cars and motorcycles still symbolize the freedom of the road, and racing stolen wheels embodies the rebel law of the streets. On Saturday nights you can down beers at the street-corner bar while talking about your pipe dreams. Young photographer

Mary Alfieri took a bus to visit Bruce in Long Branch. He didn't have a car, so they hitched to Asbury Park. After a stroll on the boardwalk, Bruce warmed up playing pinball. Here he's wearing a dark brown blouson jacket in durable, thick horsehide, an unusual style with two slanted pockets on the sides and a zippered breast pocket. It's neither a flight jacket (the famous A-2 worn by the US Air Force), nor a rocker's black Perfecto—the two mythical leathers of the USA. Perhaps it is a style made by Schott Bros., the bad boys' legendary brand for rebels without a cause, for Hell's Angels, and for motorcycle cops riding Harleys. In the word "Cuba" on the pinball machine in the center should we see a tribute to Irving Schott who, in 1928, named the Perfecto jacket after his favorite Cuban cigar? But it's not the jacket that is Bruce's innovation here, it's his "hoodie" (reminiscent of Robin Hood's?). While the Russell company made the first fleece cotton sweatshirt at the start of the '20s, the Champion brand invented the hooded version (with adjustable drawstring opening and front zipper) in the '30s, worn by sportsmen to avoid catching cold after a sweaty workout. We had to wait for the tail end of the '70s and the birth of hip-hop (a reaction against disco) for the proletarian hoodie to become a symbol of New York rappers and, soon after, of all young men in the projects. Wearing a hood lays claim to exclusion and keeps you hidden from surveillance cameras. If this is this an outlaw's hoodie, it's quintessentially Bruce.

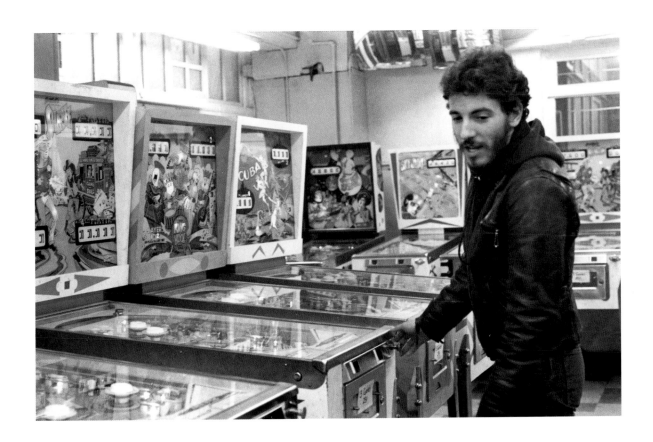

GABRIELE
D'ANNUNZIO

Neither red like Garibaldi, nor black like Mussolini, D'Annunzio's shirt is white. The immaculate white that indicates good breeding, distinct from the blue collar of the working classes, at least up until World War I. The young prodigy, who published his first collection of poems at the age of sixteen, had by the age of forty-five become the epitome of the dandy. In 1889, a year before Oscar Wilde's *The Picture of Dorian Gray*, D'Annunzio's first novel, *The Child of Pleasure*, explored the secrets of decadence and beauty. That insatiable quest animated both the writings of the politically driven aesthete and the life of this scandalous prince with his torrid love affairs. In 1908, the "divine" Eleonora Duse—rival of Sarah Bernhardt and D'Annunzio's great passion who acted in numerous plays by him—left the theater. Saddled with debts and pursued by his mistresses, D'Annunzio was on the verge of fleeing into exile in France when this photograph was taken. Although he was constantly challenging bourgeois taste in the arts, this photo shows a man of classical—even respectable—elegance, still buttoned up in the stiff collars of the new century. He appears very straightlaced, like his starched St. Andrew collar, steep and as round as a factory chimney.

At the end of the nineteenth century, with the Industrial Revolution in full swing, stiff collars became higher and higher. According to legend, the invention of the separate or detachable collar goes back to 1827 when Hannah Montague, a housewife from Troy, New York, fed up with laundering her husband's shirts and struggling to scrub dirt off the collar of an otherwise unsoiled shirt, cut the collar off and washed it separately.

The Reverend Ebenezer Brown marketed the idea, and Troy became the home to detachable-collar factories that soon made the fortune of the Arrow brand, and for whom the "Arrow Collar Man," the WASP gentlemen seen in Arrow's advertisements (from 1905 to 1931), remains a famous image. On the other side of the Atlantic, it was Charvet in France who came up with the detachable collar in 1838, the date when Christofle Charvet opened the first store selling made-to-measure shirts. Charvet attained worldwide fame when the company, based at the Place Vendôme in Paris and shirtmaker to the Jockey Club, became the official supplier to the Prince of Wales, the future King Edward VII. The detachable collar was ubiquitous until World War I sounded its death knell.

With a flower in his buttonhole and a serious expression, immersed in Nietzsche or Dante, did D'Annunzio foresee the hell of the coming war that would turn him into a hero? He would campaign for his country to fight alongside the Allies, take up aviation and lose an eye in an accident, and seize Fiume to found an independent state, all before declaring war on Italy. In 1922, adored by Italy's then-ruling National Fascist Party, he retired to his house on Lake Garda, but fell victim to a strange accident that left him an invalid. In 1938, the anti-Nazi "superman-artist" died, his illusions long abandoned and filled with loathing for black and brown shirts.

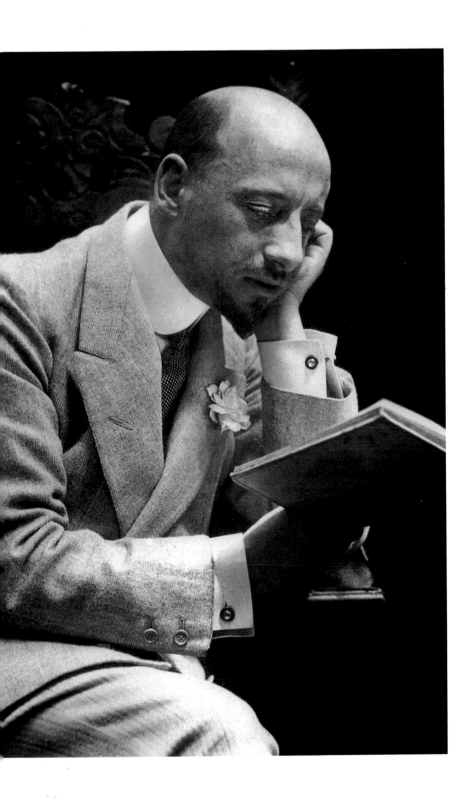

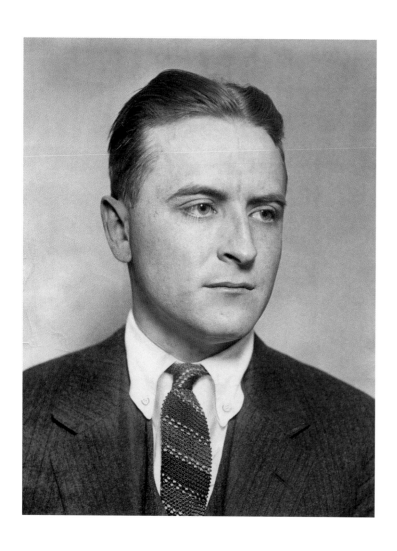

F. SCOTT FITZGERALD

— UNITED STATES, 1927

In Jay Gatsby's cabinets the shirts were "piled like bricks." When he began unfolding them, throwing them one by one in a carousel of colors, coral, apple-green, lavender, and faint orange, Daisy buried her face in them and began to sob convulsively at the sight of so many beautiful shirts. Fitzgerald had written *The Great Gatsby* on the French Riviera, publishing it in 1925, two years before this photo was taken. Zelda had not yet descended into schizophrenia, but Scott was already drinking like a fish, struggling as usual with his financial difficulties, the '20s roaring on, before it all came crashing down. "There are no second acts in American lives," wrote Fitzgerald.[1] He gazes worriedly at the future, upright in his three-piece, pinstriped flannel suit. The knot of his knitted tie seems to strangle him, but the points of his shirt collar extend over his jacket—wearing a button-down collar at this time displays a certain amount of informality. This collar, with two mother-of-pearl buttons, soft (without stays), with its pragmatic, comfortable, typically American elegance, is not really made for a tie. It was John Brooks, the grandson of the founder of the New York company who, noticing that English polo players buttoned down the points of their collars to stop them from flapping as they galloped, launched the button-down collar in 1896. The stiff "false collar" was still the height of fashion at the time, and, subversively, Ivy League students soon began favoring the Brooks model of shirt. Fitzgerald, who left Princeton in 1917 to join the army, adopted the style.

The white fabric is Oxford cotton, recognizable by its basket-weave. Created in Oxford by a French Protestant weaver who had emigrated to England after the revocation of the Edict of Nantes in 1598, this fabric is characterized by a soft weft that accentuates the woven effect, made even more noticeable when the warp is colored (like those wonderful pink or light blue Oxfords). Cotton Oxford has a supple, delicate, and luminous feel, softer than its rival, poplin (a corruption of the word *papelino*, a fabric made in the one-time papal city Avignon), which has a finer thread but a unified structure (Sea Island is one of the finer examples).

Fitzgerald was named after his ancestor Francis Scott Key, lyricist of the American national anthem "The Star-Spangled Banner." Draped in an Oxford shirt Fitzgerald died in poverty in 1940, the incarnation of the American dream gone sour, the dark side of paradise. "Absolutely, old sport."

BOB
DYLAN

— NEW YORK, WINTER 1965-66

It's been just over a year. Between March 1965 and May 1966, in three important albums, Dylan went electric and changed the face of rock. The trilogy of the decade began with *Bringing It All Back Home* (acoustic one side; electric the other). On the album sleeve (designed by Daniel Kramer), clutching a Persian cat to his chest and wearing French cuffs and cufflinks, Dylan sports a hairstyle that would make anyone with frizz issues feel better. The second installment, *Highway 61 Revisited*, kicks off with "Like a Rolling Stone." On the sleeve, designed, once again, by Kramer, Bob's satin, psychedelic shirt is open over a T-shirt emblazoned with a motorcycle (a Triumph Bonneville, the one on which he had his mysterious accident in 1966 in the Catskills, at the time an artistic colony not far from Woodstock). *Blonde on Blonde,* the first double album in rock history, closes with "Sad-Eyed Lady of the Lowlands," a track that lasts more than eleven minutes: a first. The cover opens vertically to reveal a blurry image of Dylan wearing a black-and-white check scarf. The photo was taken by Jerry Schatzberg, one of the first photographers to bring fashion to the streets, and who met Bob in the summer of 1965 while he was recording *Highway 61*. Dylan had just performed at the Newport Folk Festival, where—in his black leather jacket, fighting for civil rights as one-half of the ideal couple with Joan Baez—he had scandalized the folk community by performing an electric version of "Like a Rolling Stone," followed by an amphetamine-driven rendering of "Phantom Engineer." In the *Blonde on Blonde* era, Dylan became a rock star who was inaccessible to mere mortals. Schatzberg recalls: "At the time, his way of dressing—his suede jacket, his shirts, his tight jeans, and his boots—was straight out of Carnaby Street. All the kids wanted to look like him."[1] In the photos inside the album cover, he doffs his black Wayfarers and we can see the childlike face of the genius, fooling around with a pair of pliers in one hand and a painting of a severe-looking nineteenth century woman in the other, for a surrealist touch. A bit of a dandy, wearing a dark brown suede jacket, Bobby has buttoned the two points of his collar together. This is an original, sophisticated collar style called the tab collar, in which a small flap of material joins each side of the collar with a small button or snap, or the pin collar (very popular in the '20s), where a gold or silver bar slides through an eyelet on each point of the collar to fasten it down underneath the tie. Dylan had been a pin-sharp dresser before his accident and his planned, rural retreat. What seemed like an eternity later—at Christmas 1967—he was reborn with a shorn head and a cherub's beard, in an acoustically sober style.

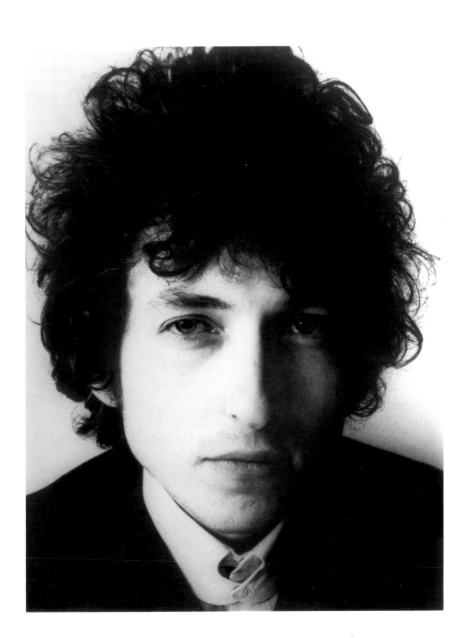

PATTI
SMITH

— NEW YORK, 1978 — ROBERT MAPPLETHORPE

A Baudelairean cat stares into the lens. Pale face, as in a painting by El Greco, piercing gaze, a charming squint in her left eye, thin arms, large hands: the passion and androgynous charm of Patti Smith is captured by Robert Mapplethorpe, who never stopped photographing her. "Robert and I were irrevocably entwined, like ... the sister and brother in Cocteau's *Les Enfants Terribles*," [1] she wrote in *Just Kids*, the wonderful book in which she traces their loving friendship over the course of more than twenty years. It tells of their meeting in the summer of 1967 (the summer John Coltrane died) and continues until Robert's death in 1989. The dreams and the ascendency of two kindred spirits, interchangeably artist and muse. In 1978, Patti and Robert exhibited together for the first and last time. "Because the Night" was a hit, and Robert proudly said to Patti: "You got famous before me." [2] He dramatizes her once more, in a black or violet-colored shirt with artfully torn right sleeve, on her wrist a ribbon bound up with several childhood talismans, and a pair of scissors poised to cut her jet-black hair. It's a photo that recalls their life at the Chelsea Hotel, and the day in February 1970 when Patti "took up the scissors, machete-ing my way out of the folk era," [3] and when "my Keith Richards haircut was a real discourse magnet." [4] Robert "approached dressing like living art," [5] and so Patti searched for her own look: striped sailor shirt and red scarf like Yves Montand in *The Wages of Fear*, sweater and black tights like

Audrey Hepburn in *Funny Face*, tab-collar shirts and the Dylan swagger of *Don't Look Back*. It was a whole universe full of references. It culminated in Robert's famous portrait for the cover of *Horses* in 1975, when one album, one song ("Gloria"), and one Camus-inspired first line ("Jesus died for somebody's sins but not mine"), made Patti the icon of the Blank Generation. In *Just Kids* she writes: "I went to the Salvation Army on the Bowery and bought a stack of white shirts.... the one I really liked was neatly pressed with a monogram below the breast pocket. It reminded me of a Brassaï shot of Jean Genet wearing a white monogrammed shirt with rolled-up sleeves.... I cut the cuffs off the sleeves to wear under my black jacket adorned with the horse pin that Allen Lanier had given me.... I flung my jacket over my shoulder, Frank Sinatra style. I was full of references. [Robert] was full of light and shadow." [6] Robert, who had photographed the cover image for *Kodak*, her first collection of poems, also took the photo for Patti's 1988 comeback album, *Dream of Life*, where she has "hair ... braided like Frida Kahlo's," [7] and his last photo, where she's holding her daughter Jesse in her arms, was taken just before he died of AIDS. Patti and Robert, together forever, hand in glove.

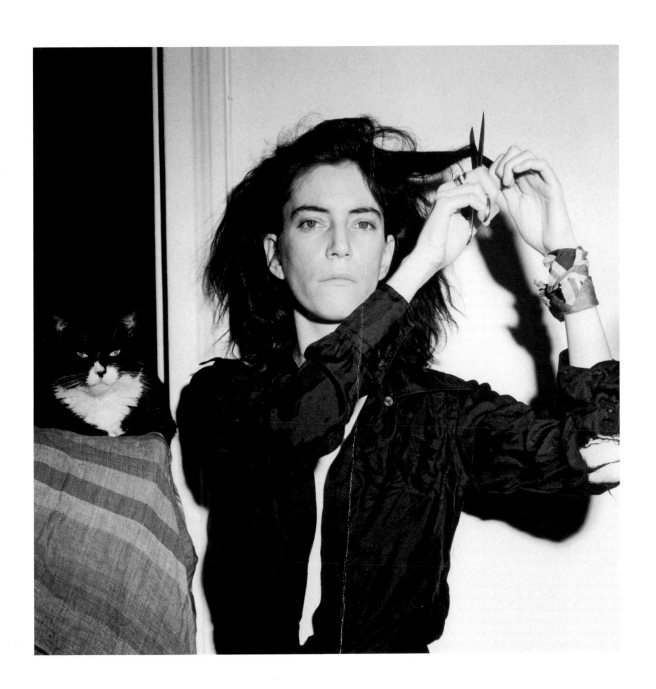

GRACE KELLY

— CANNES, 1955

Affairs and tales, and fairy tales. It's May 1955. Grace Kelly, the epitome of the American East Coast princess, is twenty-six. She was born in Philadelphia with a silver spoon in her mouth. Her uncle, dramatist George Kelly, who won the Pulitzer Prize for *Craig's Wife*, was impressed by the young girl's burgeoning imagination and encouraged her to become an actress. She moved seamlessly from Broadway to Hollywood, as if in a dream. After a minor role as Gary Cooper's Quaker wife in *High Noon* (1952), and a clinch with Clark Gable in John Ford's *Mogambo*, this "snow-covered volcano" caught the eye of Alfred Hitchcock, that English devil disguised as everyone's favorite uncle. Together they made a string of movies: *Dial M for Murder*, *Rear Window* (an intimate view of "marriage 'til death do us part,"[1] in which a domestic crime is witnessed by two newlyweds-to-be; the film made Kelly's career) and *To Catch a Thief*, costarring Cary Grant (who adored Kelly, and described her as the incarnation of serenity[2]) set on the French Riviera, where she discovered a fairyland, a pocket-sized kingdom called Monaco. In 1955, Kelly was the highest-paid actress in America. She won an Oscar for *The Country Girl*, and Bob Hope—Hollywood's crown prince, if such a thing exists—quipped during the Oscar ceremony: "We'll be presenting some new awards tonight … to the producer who made a movie without Grace Kelly." Grace introduced *The Country Girl* at the Cannes Festival and during the reception she met Prince Rainier. What followed proves that life can imitate art. In 1956, Grace Kelly played a princess in *The Swan*, and the same year held the "marriage of the century" in Monaco. In her last movie, *High Society* (1956), Grace Kelly incarnates patrician elegance—Kelly, Astor, Vanderbilt & Co.—that couturier Oleg Cassini called "the Bryn Mawr look," after the elite women's college in Pennsylvania. Grace managed to play an *ingénue*, an inaccessible woman, a romantic socialite, and a lady (not a lady bountiful) all at the same time. She was the upper crust of the upper class, the crème de la crème. Her mentor, Hitchcock, extolled her "sexual elegance" and confided bluntly to François Truffaut: "You know why I favor sophisticated blondes in my films? We're after the drawing-room type, the real ladies who become whores once they're in the bedroom."[3] With her little ballerina's chignon, the alternative solution to an ash blond blow-dry, her Dior New Look silhouette, and triple string of pearls, Kelly the Ice Princess was at her peak, and created a look much-copied but never bettered. (At the end of the '90s, Gwyneth Paltrow would be inspired by this look, as would January Jones's costume designer for her Betty Draper character in the TV series *Mad Men*.) Here, Grace's style is flirty: cropped toreador-style Capri pants that emphasize her girlish figure, a ruffled white blouse—a variation on the Bettina by Givenchy—and pixie slippers that look like they were made for Shakespeare's Puck, the mischievous goblin in *A Midsummer Night's Dream*.

She is carrying neither a handbag nor a clutch, as it would spoil her perfect silhouette. And certainly not an Hermès bag. That would not come until the following year when the future princess would flatten the famous *sac à dépêches* designed in 1935 by Hermès to her stomach, shielding her early, as yet unannounced pregnancy (or perhaps drawing attention to it). A paparazzo sold the photo to *Life* magazine, and the bag sold out immediately. Grace Kelly had invented—albeit reluctantly—the first It Bag of the twentieth century: the Kelly bag.

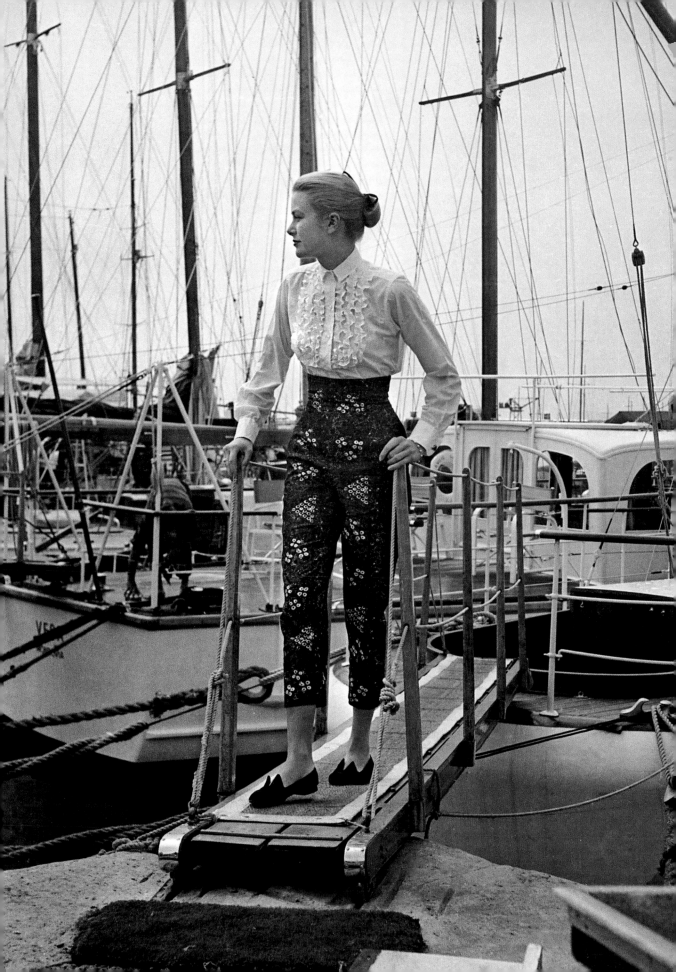

ALAIN
DELON

— CANNES, 1960 — GILLES TRAVERSO

A face in the shadows. Too dazzling in its beauty. The sand is warm, the sea is at his feet. He is twenty-five, engaged to actress Romy Schneider, and in Cannes to promote René Clément's movie *Purple Noon*, adapted from Patricia Highsmith's novel *The Talented Mr. Ripley*. He was playing the impostor Tom Ripley, a feline character in murky waters. This year, 1960, marked the start of Delon's golden era. An incomparable decade, with one masterpiece each year: *Rocco and his Brothers*, *Eclipse*, *The Leopard*, and *Le Cercle rouge* (directed by Visconti, Antonioni, or Melville). A male Brigitte Bardot, brown-haired and with piercing blue eyes, Delon was the epitome of France, as classic as Jean Gabin and as modern as Jean-Paul Belmondo, Delon's alter ego, whose career took off that very same year with *Breathless*. If Belmondo's charming rebelliousness was the incarnation of the New Wave, Delon—too proud, too *gaulliste*?—would only give in to it thirty years later, when he made the movie *Nouvelle Vague* with Godard. Another paradox: in the angry '60s that became more and more youth-oriented as the years went by, Delon created a conservative, timeless style. It's the outfit he created for Melville's *Le Samouraï*: trench coat, gray felt Borsalino hat with a black band, black tie, and white shirt. An iconic outfit that brought him idol status in China and in Japan—where he was dubbed the "samurai of spring." In this photo by Gilles Traverso (scion of a dynasty of Cannes photographers), Delon's wild youthfulness denotes a legend in the making. Radiant in *Purple Noon*, wearing an off-white, slim-fit suit like no one else, showing off his naked torso through his shirt, left wide open, as if buttons didn't exist, Delon chose, here, a white shirt with a classic collar in fine poplin. Was it tailored by Luigi Borrelli, the Neapolitan shirtmaker, during the filming of *Purple Noon* in Ischia? Or perhaps it came from Jermyn Street, that temple of shirtmaking in London since the nineteenth century (London shirtmakers come in pairs: Turnbull & Asser, Hilditch & Key, New & Lingwood.) It's hard to believe that Delon, a man of taste, an experienced collector—from Rembrandt Bugatti to the Cobra movement; from the great vintages of Bordeaux to classic watches—would have left his choice of shirt to chance. Nor, considering the depth of his patriotism, would he have chosen any other company than Charvet (who are very discreet about their client list). Charvet, the specialist in royal trousseaux, who also supplied shirts to Baudelaire, Verlaine, Proust, and Coco Chanel before outfitting John F. Kennedy and Charles de Gaulle. Charvet, with its headquarters on Paris's place Vendôme designed by Mansart in honor of Louis XIV, the Sun King—the perfect brand for Delon, the rising star.

SIGOURNEY
WEAVER

— UNITED STATES, 1995 — HELMUT NEWTON

With her square jaw, mouth like a scar, and prominent chin, she stares out against the backdrop of a stormy sky, as if to say "what the hell do ya think you're doing?" It's no laughing matter. And if you risked a suggestive comment about the wet shirt, revealing Sigourney Weaver's magnificent breasts, she'd probably punch you. The setting is perfect. Helmut Newton, a connoisseur of phallic women, found the perfect accomplice in Sigourney Weaver, at the height of her fame after playing Ripley in several *Alien* films, and appearing in *Ghostbusters*, and *Working Girl* in the '80s. Newton captured, through her, an image of '90s femininity—hard, disturbing, muscular, castrating—and debunked more than a few stereotypes. Let's start with the lack of smile, which doesn't make her any less sexy; then move on to the damp clothing, a nod to bimbo culture and its mammary-enhancing accessory: the wet T-shirt. But if Sigourney Weaver's shirt is wet it's more likely to be soaked with sweat, the sweat of a job well done, given the actress's formidable cinematic achievements, such as exterminating deadly creatures in outer space at different stages in their development, chasing after ghosts as they disappear like eels, standing up to poachers and saving mountain gorillas from extinction.

This statuesque, six-foot woman knows how to break into a sweat when it comes to defending a certain idea of humanity, civilization, and equality, off screen as well as on. Ellen Ripley, her character in *Alien*, has been ranked the fifth coolest hero in twentieth-century American pop culture, and the eighth best hero in the history of American cinema.[1] To Dian Fossey, champion and foster mother of mountain gorillas, Sigourney Weaver was her greatest ambassador. Weaver (who was born Susan in 1949 and at the age of fourteen took her deliciously old-fashioned and convoluted name from Sigourney Howard, a minor character in *The Great Gatsby*[2]) became a committed environmentalist in the early twenty-first century, drawing particular attention to the unbridled exploitation of the oceans. A combat girl with hard nipples, Weaver posed frequently for Helmut Newton during the '80s, whether dressed in a man's suit, in a one-piece wet-look swimsuit, in an asymmetrical see-through dress, or in a bodysuit. And usually she's smiling. But we prefer to see her in this wet shirt, her face hermetically sealed like a door on the spaceship Nostromo. Simultaneously severe and sexy.

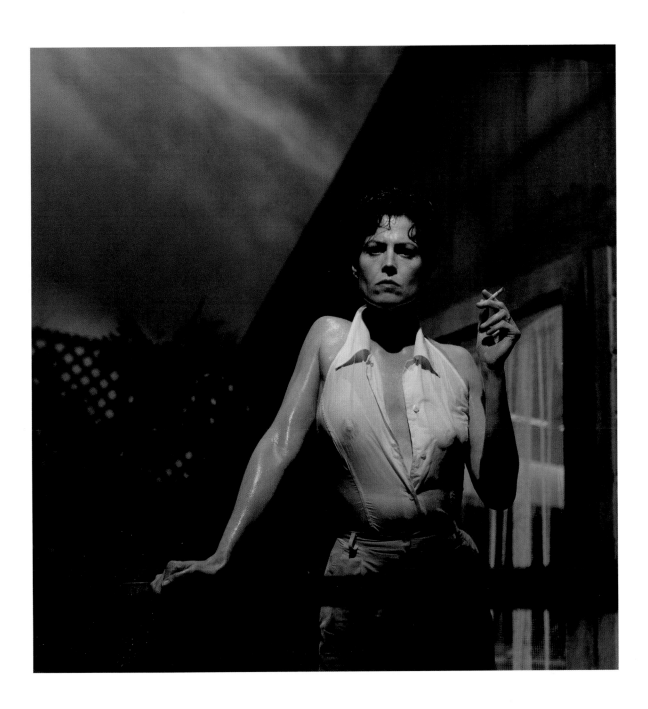

ANAÏS NIN

Delta of Anaïs. With her Spanish *dueña*'s mantilla, black lace blouse, and listless hand like a wilted flower, she looks like a becalmed dancer or a martyred nun. It's a picture that's rich with contradictions, just like the tumultuous life of Angela Anaïs Juana Antolina Rosa Edelmira Nin y Culmell, daughter of a Catalan father and a Danish–Cuban mother, who always wanted to live life according to "the miracles of excess."[1] From the miracle of crazy love to excess of all kinds, Anaïs Nin's life certainly had plenty of it: abandoned in 1913 by her father, who thought she was ugly, and with whom she had an incestuous relationship, wealth until the crash of 1929, poverty, exile. From her adolescence onwards Anaïs was transported by reading and writing, and she kept a diary from the age of eleven. She had sexual friendships with great artists: French playwright and poet Antonin Artaud (he described her as a "lusty decadent"[2]); American writer Edmund Wilson; forbidden affairs with her own psychoanalysts, Otto Rank and René Allendy; and a passionate relationship with Henry Miller, "a source of restlessness, creation, pain, fermentation."[3] She flirted narcissistically and poisonously with Miller's wife, June, entered into a second marriage with her "child"[4] Rupert Pole without divorcing Hugo Guiler ("to hell with taste!"[5]), and to tie it all together, she published a diary that covers half a century (fifteen thousand pages in the archives), novels, and short stories. The latter include the notorious erotic tales published posthumously in the book *Delta of Venus*. When the great portrait photographer Carl Van Vechten took this photo, Anaïs Nin was working every day on these nefarious texts in order to fulfill a commission from Henry Miller, who had himself been commissioned by a mysterious collector to write erotic stories. Miller had had enough (somewhat unbelievably for the author of *Tropic of Cancer*, *Sexus*, and *Nexus*) and handed the baby on to his former mistress.

Penniless, Nin needed to earn a dollar a page, but she became disillusioned: "Another telephone call. 'The old man is pleased. Concentrate on sex. Leave out the poetry.'"[6] Nin persisted, exploring "a world that had been the domain of men,"[7] while at the same time recovering from an abortion she had undergone at the end of August 1940, and which she described as "torture," "a crime," and a "humiliation."[8] This was the paradox of Nin: she could write "The men could see the moisture oozing from her"[9] in *The Basque and Bijou*, while denouncing "the atmosphere of underworld bootlegging, a racket"[10] of illegal abortions—which would guarantee her canonization among certain feminists.

In this portrait, where she seems to hesitate between two worlds, the tangible and the ephemeral; is her blouse embroidered in Barcelona lace, named for the capital city where she lived as a child? As worn by Anaïs Nin, lace—which reveals as much as it obscures and that seems to be made of a single line of black ink drawn on the skin itself—operates as a metaphor. It was invented in the sixteenth century (in Venice and Antwerp) and first adopted by men for their collars and enormous ruffs. It was used by seventeenth-century women to cover the face, and became a symbol of feminine seduction during the eighteenth century thanks to Louis XV's mistress Madame de Pompadour, who adored it. (She popularized *engageantes*, lace cuffs that extended the sleeve and served to draw attention to the hands). Lace embroidery is both a lie and a trick, just like Nin herself, who needed to be "conceal[ed] from the world,"[11] and revealed to herself through writing.

"No wonder I am rarely natural in life. Natural to what, true to which condition of soul, to which layer? How can I be sincere if each moment I must choose between five or six souls?"[12] A lover's soul, a nun's soul, and finally the soul of a praying mantis.

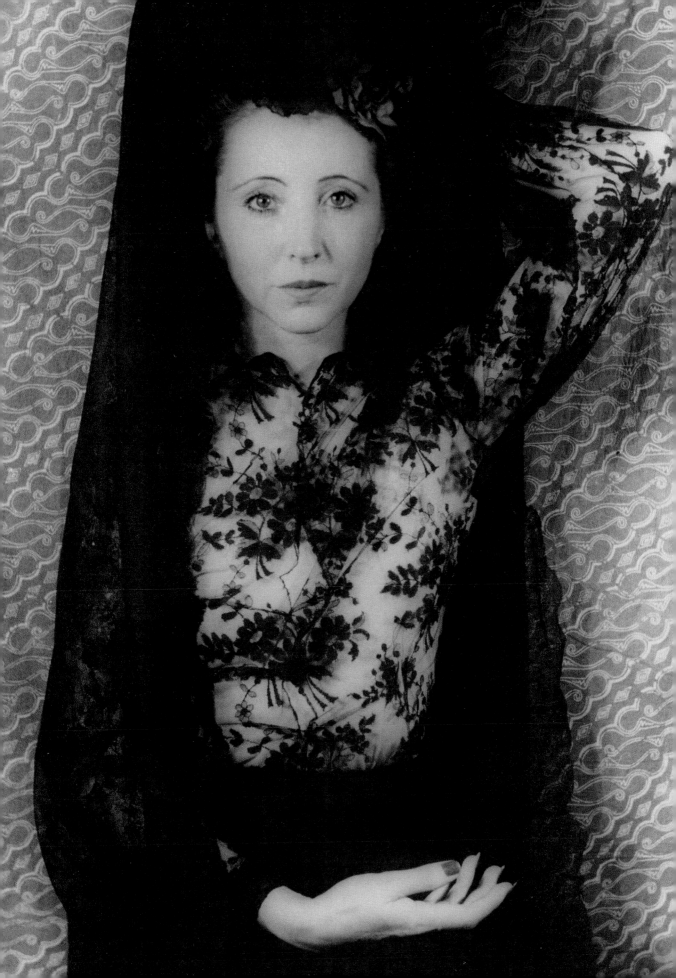

FRED
ASTAIRE
AND BING CROSBY

— HOLLYWOOD, 1945

He is forty-six and has spent more than forty years on the stage. He is filming *Blue Skies* with Bing Crosby, the number one crooner (his "White Christmas" is everyone's favorite), and has announced that it will be his last film (after a very brief retirement he will go on to make another twenty-two, including *The Band Wagon*). In front of the younger man, Astaire is rehearsing "Puttin' on the Ritz," his new show-stopping number. Rudolf Nureyev, Michael Jackson, and even the prodigious Nicholas Brothers all acknowledged their debt to Fred Astaire, the glorious dancer born Fred Austerlitz. He displayed rhythmic virtuosity, conveying emotion in suspended animation, and had an innate and unsurpassed elegance linked to a drive for perfection. In 1904, at the age of five, long before he teamed up with Ginger Rogers to create the ideal couple, Fred Astaire (Astaire = a star?) danced his first steps on stage with his elder sister Adele. The duo set Broadway alight in 1917, then, after the war, they did the same on the London stage, until Adele married Lord Charles Cavendish in 1932, following the triumph of *The Band Wagon*. Ever since his first visit to London, Astaire, a Brooks Brothers customer since his teens, had been a convert to the "London cut" of Savile Row. As the new heart throb of Covent Garden, and feted by the fashionable social circle of the Prince of Wales, Astaire ordered his first suit at Anderson & Sheppard in 1923. Founded in 1906, the company distinguished itself from its rivals by calling itself "civil tailors" who did not make military uniforms. They dressed the future Edward VIII, won over anyone who was anyone in Hollywood (Douglas Fairbanks, Gary Cooper, Charlie Chaplin), and would go on to garner an illustrious clientele, from Picasso to Francis Bacon, from Duke Ellington to Bryan Ferry. Fred Astaire, who wore his own clothes when dancing, was the incarnation of the new Savile Row classicism, whether on screen or in town.

This perfectionist—known to go back to his tailor a dozen times to have his suits adjusted by fractions of an inch—combined a relaxed style with a sense of formality. He loved dark, sober colors, and supple, light fabrics ("There's nothing that makes me feel quite as well as a light overcoat of dark blue vicuna," he told *GQ* magazine[1]), and the kind of cut that didn't inhibit his freedom of movement. He chose pants a little shorter than he should, so as not to impede his gait, while adopting a high-waisted cut that lengthened his legs and emphasized his elegant torso, widened with padded shoulders. Like the Prince of Wales, Astaire reserved any imaginative embellishments for his accessories: touches of dazzling color for his socks, pocket handkerchief, buttonhole flower, and two-tone shoes (which he loved). His tie was always subtle, but he could be surprising in his use of scarves or old ties as belts, a trick passed on by Douglas Fairbanks, which, Astaire explained, came from the fact that he lost so much weight dancing: the silk allowed him to adjust the waistband down to a fraction of an inch.

In this photo Fred takes flight, scarf at his neck and with a tie, used as a belt, matching his star-patterned socks. Bing, sitting in an armchair, snaps his fingers in time. And his outfit doesn't spoil the effect either: blazer (tailored by Huntsman of Savile Row, where he is a regular?), tartan socks, white nubuck Derby shoes, and club tie, American style. In the UK, where club ties became more widespread after World War I, worn by soldiers in their regimental colors in civilian dress and by members of British universities, the stripes went from left to right, while, curiously—and perhaps an echo of driving on the left versus driving on the right—Brooks Brothers, who popularized them in America, flipped the stripes so they ran from right to left. But here, caught in mid-air, the prince of musical comedy couldn't care less. With Fred the clothes themselves danced—what you might call a stitch in time.

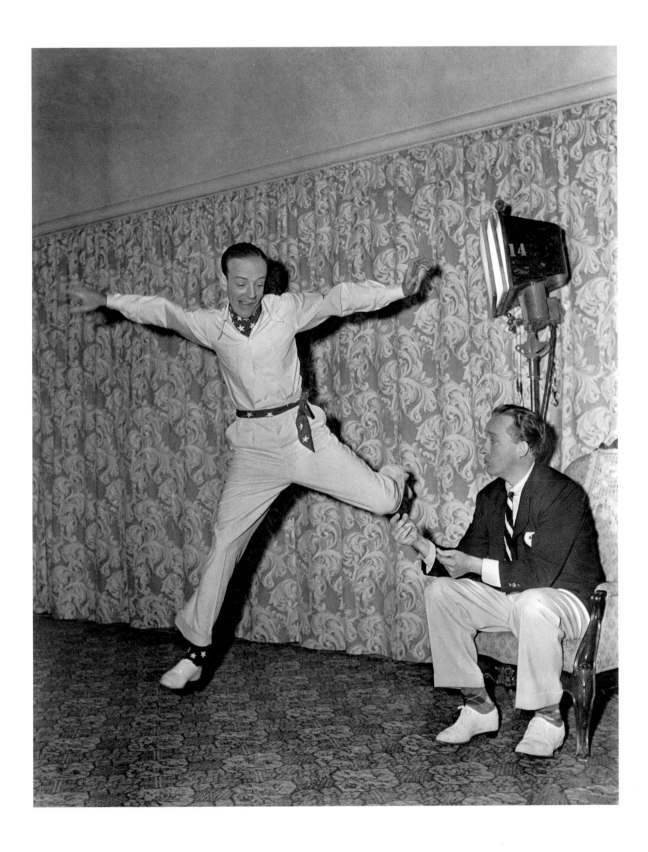

CHARLIE
PARKER

— LOS ANGELES, JUNE 1952 — ESTHER BUBLEY

"In itself the tie is all about originality and innocence: imitation or subjection to rules renders it faded, frozen, and dead. To get it right requires neither study nor work; rather the tie is worn spontaneously, with instinct and inspiration. A tie worn well is one of the characteristics of genius that can be discerned and admired but that can be neither analyzed nor taught." This definition was written almost a century before Bird was born, in the chapter Balzac, author of *The Human Comedy*, devotes to the tie in his *Treatise on Elegant Living*. It is so perfectly suited to Charlie Parker's brilliance that we can presume to compare these two giants—the inventor of the modern novel and the inventor of bebop. Two huge personalities, two portly figures, they both led lives of devastating profligacy. In Balzac's case, it was his gargantuan consumption of coffee. As for Bird (who earned the nickname because of his legendary appetite for fried chicken), it was his addiction, since his youth, to alcohol, morphine, and then heroin. The more Charlie worried about getting his fix on time, the less he cared about his clothes (unlike Dizzy, his partner and cocreator of bebop). But in this photo by Esther Bubley, he cuts an imposing figure. Bubley, an American reporter, had just taken part in a MoMA exhibition organized by Edward Steichen, director of the photography department of that New York institution,

and she was now immortalizing the famous Norman Granz jam sessions in Los Angeles, with Parker in Olympian form. Alongside Bird were two other alto saxophonists, Benny Carter and Johnny Hodges, Bird's idols from way back; Ben Webster, a tenor sax from Duke Ellington's orchestra; and Oscar Peterson at the piano. It was an awesome session. As both a stunning melodist and an extraordinary improviser, Bird was in his element. Sitting on his sax case, legs splayed, in his comfortable black shoes (no need to bend down to lace them up), he's in "Parker's Mood." His summer-weight suit is not creased as it usually is, and his hitched-up pants (with classic inch-and-a-half cuffs) reveal socks rolled over his ankle. In his left hand he has a handkerchief to mop up perspiration, and in his right he holds a cigarette—he's obviously got staying power. His knit tie, kept short, '40s style, stops halfway down his belly. It's tied, but the shirt collar is undone, as if the powerful neck of the prodigy of swing couldn't possibly be imprisoned by any strip of fabric. "Chasin' the Bird"? The fragile elegance of a colossus.

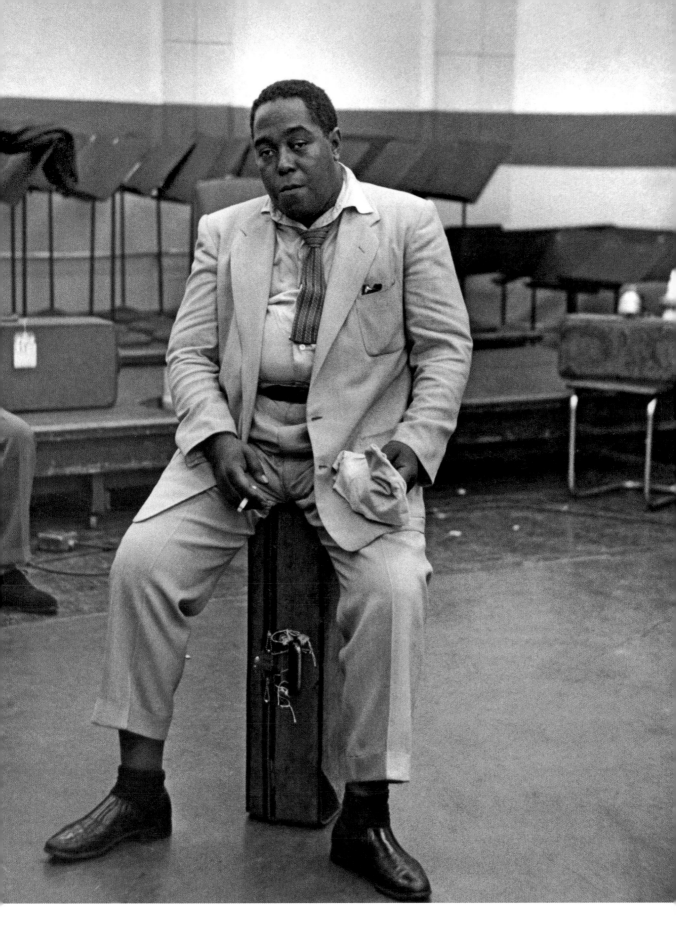

JACK LONDON

— MELBOURNE, 1908

Eyes glowing like the aurora borealis, square-jawed, hand-rolled cigarette in the corner of his mouth, the shadow of an ironic smile—Jack London looks challengingly out at us. The shirt is immaculate, the Sunday flannel suit says success, but the tweed cap and the hands stuffed into his pockets look working class. Staring straight into the lens, Jack is no stranger to the process. From his assignments as a war correspondent on the Korean front during the Russo-Japanese War, sailing to Australia on his boat, *The Snark,* or tackling Cape Horn on a voyage in 1912, he brought back some twelve thousand photographs, taken with his Kodak 3A camera—a folding camera with bellows that never left his side. He knew all about poverty: a poor childhood, wanderings, and vagrancy from the age of fifteen. London certainly got around: seal-hunter, oyster pirate, prospecting for gold in the Klondike. Arrested and imprisoned for vagrancy in 1894, London became a militant socialist and a member of the Oakland branch of the Socialist Labor Party. In 1903 *The Call of the Wild* brought him fame and glory. *The People of the Abyss* drew on first-hand accounts of the marginalized people of London's East End, after which he left to cover the Boer War. He explored, denounced, bore witness.

His experiences provided fertile material for his adventure novels, and his assignments inspired his socialist writings. *The Road* was a response to *White Fang.* The former vagabond, one of the first American writers to make a good living from his writing, got a taste for fame, but the author of *Martin Eden* remained a "savage," burning the candle at both ends, and he would die at the age of forty, consumed by alcoholism.

In this photo his tie flaps about like a revolutionary flag. A knotted silk scarf, a thug's cravat—yet respectable at the same time—it evokes the original characteristic of the necktie. In 1630, Louis XIII of France imported Croatian mercenaries into his hussar regiment who were remarkable for the distinctive way they wore their scarves. Such was their style that the fashion for the "cravat" (a corruption of the phrase "à la croate") caught on at the French court, replacing the lace ruff. In 1666, Louis XIV conferred the name of "Royal Cravates" on the regiment, and created the post of "cravatier," who had the great honor of choosing and adjusting the Sun King's necktie. Two and a half centuries later, Jack London, *A Son of the Sun*, can't help glowing with pride.

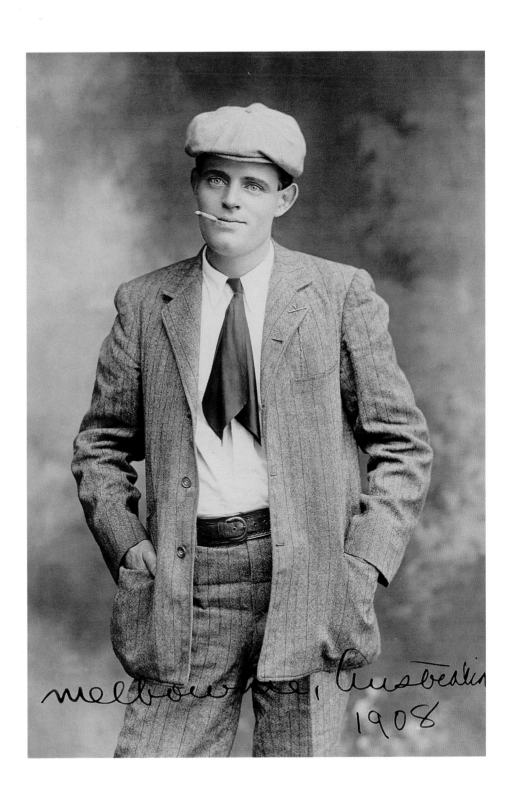

Melbourne, Australia
1908

CHET BAKER

— UNITED STATES, 1987 — BRUCE WEBER

We've come a long way since the young archangel—fragile rebel without a cause and teen idol—was idealized in photos taken by his friend William Claxton. The trumpeter was twenty-four years old when his album *Chet Baker Sings* set America on fire. As beautiful as Apollo, the James Dean of jazz roared off in his Studebaker (designed by Raymond Loewy) and turned his contemporaries green with envy of his astonishing talent. When he was ten and a choirboy, his father, a former guitarist, gave him a trombone that he swapped for a trumpet. Chet was only twenty-one when Charlie Parker picked him to accompany him on his West Coast tour. Baker had enlisted in the army at sixteen but deserted from a disciplinary battalion; the trumpet prodigy had just been exempted for "psychiatric reasons." The following year, in 1952, he played with saxophonist Gerry Mulligan, and their version of "My Funny Valentine," with Chet's extraordinarily restrained yet sensual solo, became an instant hit. Was it Mulligan who turned Chet onto heroin? Chet would remain a junkie for the rest of his life. Arrested numerous times for drug possession, sentenced to a year in an Italian prison, kicked out of Germany and England for the same offenses, Chet pawned his trumpet many times to buy his fix. In 1966, a scuffle with some dealers as he was leaving a nightclub left him in the gutter, with split lips, a fractured jaw, and shattered teeth. The enforced silence

lasted for three years. In May 1988—on a very unlucky Friday the thirteenth—he fell to his death from the window of a second-floor room in the Prins Hendrik hotel in Amsterdam, with enough drugs inside him to knock out a horse. The year before, the American photographer Bruce Weber—a great admirer of Chet since the age of sixteen, when he bought *Chet Baker Sings* featuring "Let's Get Lost"—made his superb documentary with the same tragic title. When he was making the movie, Chet had only a year to live. Close shaven, hair slicked back, lines etched onto his chiseled face. A marble-hewn junkie living a life of Pasolini-esque self-destruction. Sharp, neat, unflappable. Dressed entirely in black: blouson jacket, pants, shirt. For contrast, a black-and-white tie with stripes like prison bars, its cropped end stopping at the belt line. Skinny. Modern. Rock 'n' roll.

In fact, this contemporary-looking tie first appeared as early as 1924, when the American tailor Jesse Langsdorf developed two simultaneous inventions that he patented under the Resilio brand. He cut the tie diagonally on the bias of the silk, that is, at a forty-five-degree angle, and from a single piece of fabric but in three sections that he sewed together. (Previously, when ties were cut along the grain of the fabric, they tended to fray and curl up.) Chet sang, "I'm old fashioned, I love the moonlight/I love the old-fashioned things." [1] Requiem for a tie.

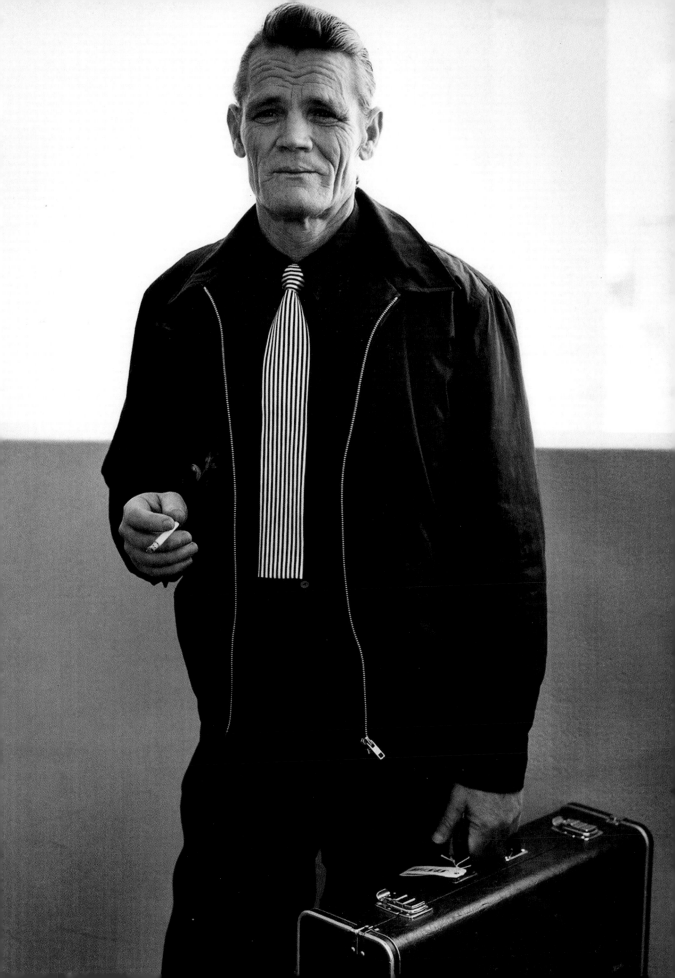

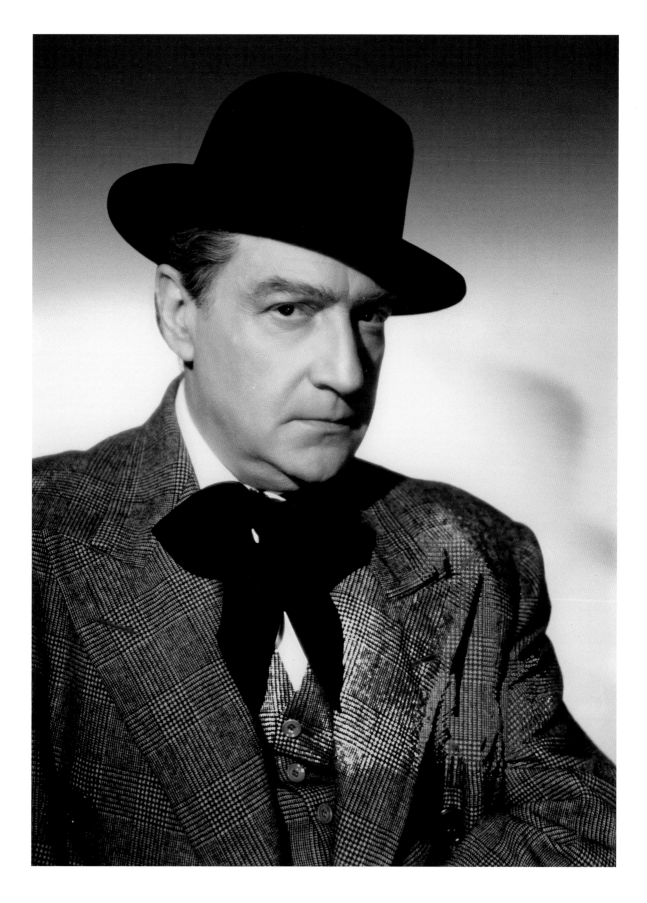

SACHA
GUITRY

For him, "luxury is a matter of money; elegance is a question of education." He wrote one hundred and twenty-four plays and a single novel (*The Story of a Cheat*), wrote and directed thirty-six movies, and acted in most of them, and married five actresses. The art of the epigram, the cruel jibe, the cutting reply, the biting wit: Guitry incarnated the French ability to be hateful and magnificent at the same time. "You don't get two chances to make a good first impression."[1] Sacha knew how to dress with care. His black felt hat (with upturned rigid brim) is worn at a rakish angle. It's a Homburg, a hat that takes its name from the Saarland spa town, and which was made fashionable at the dawn of the twentieth century by King Edward VII, a trendsetter famed for his Parisian transgressions. Between the wars the Homburg became the favorite headwear for diplomats of all persuasions. The French call the Homburg the Cronstadt (so much for the *entente cordiale*). Was this one made by Bates or James Locke in London, or by Motsch or Gelot in Paris, who competed for the title of the best

hatmaker in the world? And still in cross-channel mode, Guitry's suit is made of Prince-of-Wales check, a Scottish fabric in overlapping squares and stripes that create a subtle checkerboard effect, which was popularized in the '20s by the future King Edward VIII. As for the tie of our French prince of wit, it's an ascot (or in French, a "lavallière"), knotted like a bow tie, as worn by Louise de La Baume Le Blanc, Louis XIV's young mistress, who was made Duchess de la Vallière when the king cast her aside in preference to the Marquise de Montespan. To the great displeasure of the court, the woman Sainte-Beuve called the "perfect mistress" took herself off to a Carmelite convent and adopted the name Sister Louise of Mercy. There she lived for the last thirty-six years of her life. Oh, those royal affairs in Versailles. As for Guitry, the "lavallière" symbolized the literary wit of the women in French seventeenth-century salons—both tragic and theatrical.

SIMONE de BEAUVOIR

— PARIS, DECEMBER 6, 1954 — GISÈLE FREUND

Simone de Beauvoir, mischievous? It's not the first adjective that springs to mind to describe the existential philosopher and feminist theorist. But this portrait of her wearing a skirt and matching tie, while intimidating at first glance, is not without humor and wit. Simone's pose plays with the stereotype of the seductive woman—draped on a scarlet sofa, legs tucked modestly under to protect the object of male desire (also scarlet). In front of her—rather than a depiction of Psyche or a mirror, as in a classical painting—is a book: *The Mandarins*. This introspective, yet detached self-portrait exploring postwar intellectual life features Simone in the guise of psychiatrist Anne Dubreuilh, the wife of a committed writer (Sartre's twin), who is the object of fascination for journalist and resistant Henri Perron (a thinly disguised Albert Camus). Winner of the Prix Goncourt for *The Mandarins*, which she was awarded in 1954 on the day this photo was taken, Beauvoir was, at the age of forty-six, a powerful woman. With her tie, she's undoubtedly thumbing her nose retrospectively at her father, who regretted that she wasn't a boy and able to study at the École Polytechnique. He told her with bemusement: "You have a man's brain,"[1] with the subtext, "unfortunately in a woman's body." She's also flipping off all male chauvinists and oppressors, because, as she wrote in *The Second Sex*, "in the past all history has been made by males."[2] On May 1, 1949, with the publication of this book, which outlined both the theory and the struggle for equality of the sexes, Simone de Beauvoir dropped a bomb on self-satisfied postwar France. "How can she find independence within dependence?"[3] she asked the modern French woman, and, with that question, set in motion feminism in France. Without Beauvoir there would be no family planning, no Neuwirth law that legalized contraception in 1967, no "Manifesto of the 343 Bitches" in 1971, which claimed the right to abortion on demand, and no Veil law that decriminalized abortion in 1975, among other legal milestones. Condemning the historical alienation of women, advocating the freedom to have sex without fear of unwanted pregnancy, protesting in favor of equality between men and women, *The Second Sex* was blacklisted by the Catholic Church, but sold like hot cakes—twenty-two thousand copies in the first week—and provoked sexist comments from Parisian mandarins: "I've learned a lot about your boss's wife's vagina and clitoris,"[4] François Mauriac wrote to Roger Stéphane, a close friend of Sartre and Beauvoir. Mauriac drove his point home a little later in a hateful attack on feminists: "These educated fools marching their Louis XV high heels across all the sacred turf of our life, these pedantic, twittering idiots, they should be put to work in a nursery, wiping bottoms and emptying chamber pots until they die."[5]

Despite her father's wish that she had been born a boy, when she stated "one is not born, but rather becomes, woman,"[6] Beauvoir became the symbol of female emancipation, free to love both men and women beyond the monogamous context of bourgeois morality. Here the "boss's wife" wears a tie, a seemingly insignificant trophy snatched from the enemy camp, emptied of its magical properties, hardly more than a bit of dangling material. But it's a triumphant symbol because while a man cannot wear a skirt, Simone de Beauvoir, that modern woman in a skirt and tie, can have it both ways.

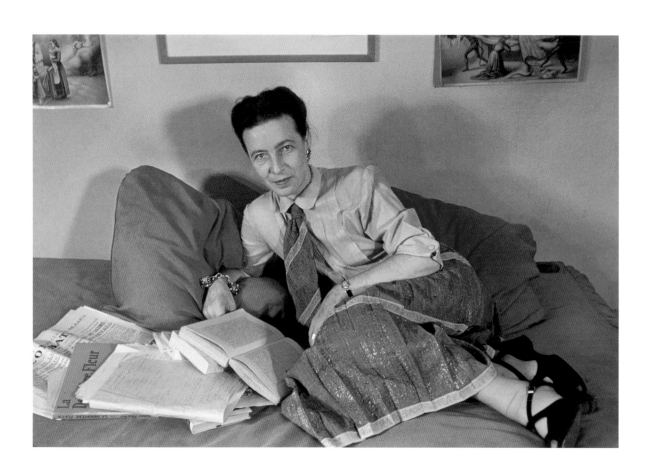

YUKIO
MISHIMA

It's the early '60s. At last, Yukio Mishima has become the man he dreamed of being, physically. This athlete's body modeled on classical Greek statues—which he discovered during his first trip to Athens in 1952—and shaped by intensive bodybuilding and martial arts (the writer held the rank of fifth dan in kendo) has become a work of art. Mishima can start to prepare for his ritual of death.

In his life as in his work—a life and work that are so closely interlinked that the last sentence of his final novel, *The Decay of the Angel*, written the very morning of his *seppuku* or *hara-kiri* on November 25, 1970, conjures up an empty garden, "a place where there is no memory, nor anything else"—everything of beauty awaits destruction. Everything that has found a miraculous balance between the contradictory forces that rule the universe, the Apollonian and the Dionysiac, must be destroyed. The same goes for the Temple of the Golden Pavilion, the subject of his most famous novel. And for Mishima himself. Death in beauty.

A narcissistic, Nietzschean warrior-writer, who could have adopted as his own the aphorism of French poet René Char: "What comes into the world to disturb nothing deserves neither attention nor patience,"[1] Mishima had not always been this sculpted man—"strength creates form"—with such powerfully taut muscles.

In fact, as mentioned in his autobiography, *Confessions of a Mask*, things started out rather badly for him. Kimitake Hiraoka, alias Yukio Mishima, was a puny, stunted child with a weak constitution. For a long time he was thought to have tuberculosis, and was raised by his half-crazy, aristocratic grandmother, who dressed him as a girl and made him sleep at the foot of her bed. "At the age of twelve, I had a true-love sweetheart, aged sixty."[2]

Twenty-five years later, the runt had metamorphosed into an Adonis thanks to his iron willpower and his submission to delectable sufferings. "Why could not I myself be something visibly beautiful and worthy of being looked at? For this purpose I had to make my body beautiful. When at last I came to own such a body, I wanted to display it to everyone, to show it off and to let it move in front of every eye, just like a child with a new toy."[3]

Mishima sculpted his body exactly like those of Shinji and Matsugae, the men in his novels, a body eroticized in the extreme, and in his case always dressed in Western clothes. The writer gave his lectures on literature in bankers' three-piece suits, cut his wedding cake wearing a tuxedo, and in summer wore T-shirts and unisex black or white polo shirts. But there was no crocodile embroidered on the chest of the author of *T nori-kai* [Long-Distance Riding Club] (1951). Mishima fetishized a feminine style of shirt with a lace-up neckline, which he associated with the military style jodhpur. Mishima with his chest trussed up, like a subtle reminder of the Japanese martial-art rituals (*hojojutsu*), also used in sadomasochistic, erotic games—and bondage. Think of the photos by Nobuyoshi Araki. The beauty of chains. *Kinbaku-bi*—"the beauty of tight binding." Not far removed from the character of the martyr. Was Mishima Saint Sebastian in a polo shirt?

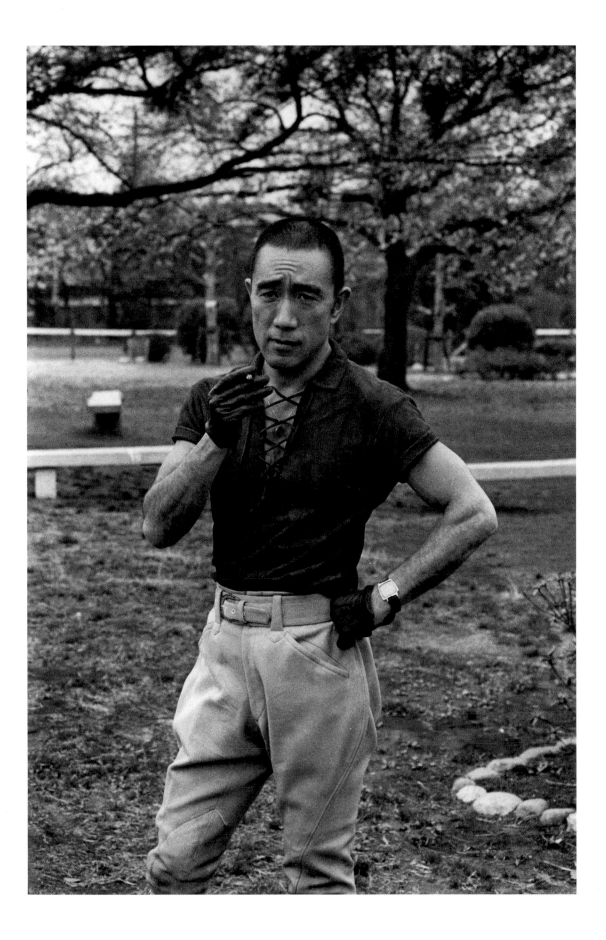

JOHN UPDIKE

— UNITED STATES, 1984 — THOMAS VICTOR

His swing was great. In *Golf Dreams*, Updike described his passion for the game, and we recall a memorable drive by Rabbit, Updike's literary double who reappeared every ten years between 1960 and 2001 to take the temperature of the United States. When the last episode of the Rabbit saga was published he told us: "Harry isn't my exact contemporary. He was born in February 1933, while my birthday is in March 1932. I consider him a younger brother, taller than me (he's six foot two-and-a-half, while I'm only five foot eleven-and-a-half). He's more sporty, more attractive, with a Scandinavian–American charm."[1] Looking at Updike in this photo by Thomas Victor, a photographer who captured the literary world and was himself a poet, we can imagine he's just returned from a round of golf, his eyes still scanning the green. He looks relaxed in his madras pants in a red, dark blue, and pink check, the traditional colors of this fabric that originally came from the Indies during the time of France's trading outposts. He's wearing a white polo shirt. On the pocket, over his little rabbit heart, is that a marijuana leaf we can see? No, it's a Japanese maple leaf in its autumnal elegance, the logo of the Boast brand, created in 1973 by Bill St. John, and fashionable at that time with East Coast preppies, golfers, and tennis players—as well as being adopted by Updike. Perhaps it's a sly reference by the author of the Maples stories, a bit of a boast by one of the rare writers to have won the Pulitzer prize twice, or perhaps a Harvard alumnus rebelling against the polo shirt champs Lacoste and Perry (the third man, Ralph Lauren, launched his polo collection in 1972).

The first logo to be used conspicuously on clothing made its debut on a polo shirt. It all started in 1933, when René Lacoste and André Gillier launched a "shirt" in loose-knit piqué cotton, with three buttons, short sleeves, and a soft collar. As a tennis player, Lacoste,

nicknamed the "Crocodile" by the US press as he never let go of his prey on court, had reached the end of his sporting career. The green crocodile sewn onto his blazer or shirt started with a bet by the captain of the French tennis team during a Davis Cup match in 1927, with a crocodile-skin suitcase as the prize. The Lacoste shirt (model 12.12), at first available only in white, was a hit on the tennis courts, the golf courses, and among the leisured classes who played these exclusive (as they were at that time) sports. Twenty years later, another famous tennis veteran also succeeded in turning his career around. The polo shirt by Brit Fred Perry first appeared at Wimbledon in 1952, recognizable by its embroidered laurel wreath and colored piping on the sleeves and collar. On the courts, Lacoste had won ten Grand Slam victories (seven singles and three men's doubles) between 1925 and 1929, while Perry had also won ten Grand Slams (eight singles and two men's doubles) from 1933 to 1936. And now the rivalry was being replayed on the field of sportswear. In the '60s, Mods endorsed the Fred Perry, subverting a shirt that had become synonymous with the middle-class elite. The same symbolic rehabilitation of Lacoste took place during the '90s among rappers in the projects. Logos and fakes were the order of the day—the perfect topic for an Updike essay in *The New Yorker*?

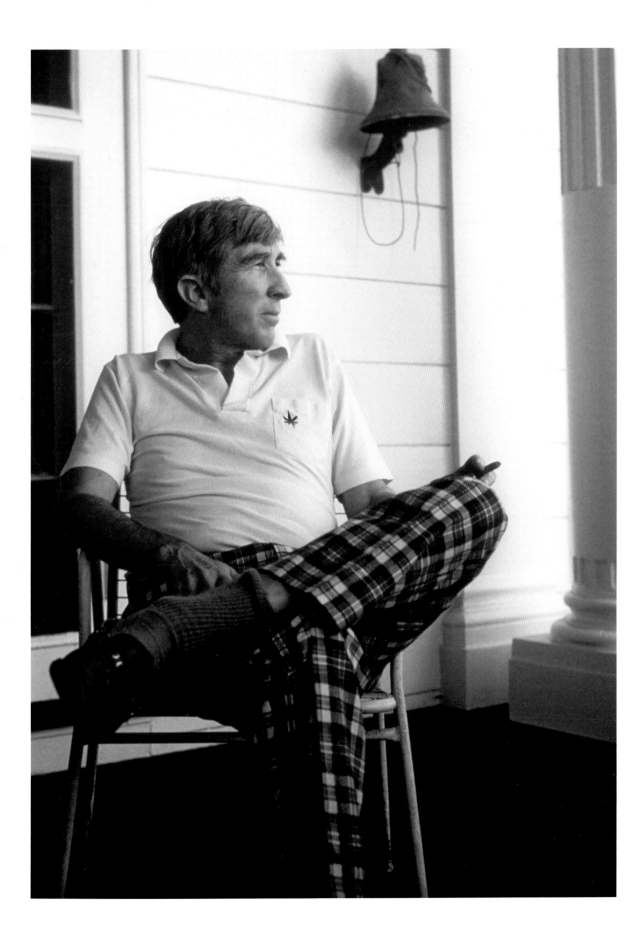

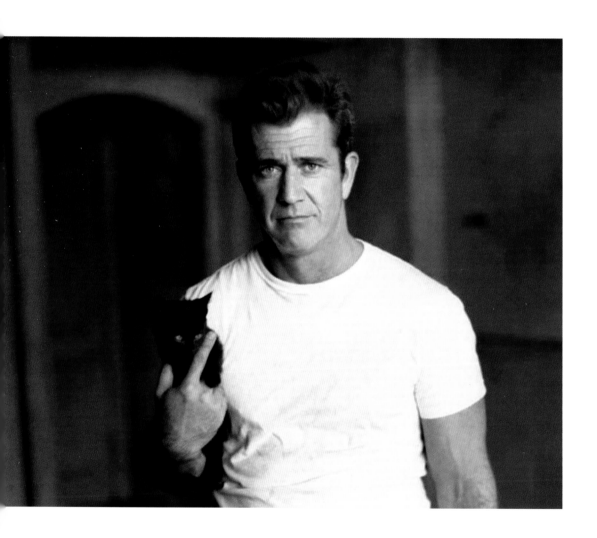

MEL
GIBSON

He's not always the epitome of elegance. But who else, since Brando in a T-shirt named desire, has shoulders broad enough to look manly while carrying a kitten in his arms? Five foot ten, with a direct handshake, thick hair, powerful neck, and sapphire-blue eyes, Mel Gibson doesn't mince his words. He'd played a horseman of the apocalypse traveling on roads devastated by a nuclear inferno, a good-looking war correspondent living dangerously in the febrile Indonesia of Sukarno, a *Bounty* mutineer (after three heavyweight predecessors: Brando, Gable, and Flynn), and a crazy cop with perfect hair going hell for leather after psychopaths and drug dealers, wearing his heart on his sleeve and laughing like a hyena. This year Mel was promoting *Lethal Weapon 4*, the last movie in the series featuring the most efficient duo in the LAPD. Born in New York, the actor emigrated to Australia at the age of twelve. "I was a kind of hybrid jumping from one culture to the other. It was an opportunity. You learn to adapt more quickly," he told us in 2000.[1] Over a decade of blockbusters, the kid known to his Australian mates as "Mad Mel" ("after a radio presenter who fascinated us, a character so eccentric he was fired. I wasn't mad, but quite precocious"[2]) became one of the highest paid stars in Hollywood. He was recognized as a talented director with an Oscar for *Braveheart*. In 2004, his *Passion of the Christ* (filmed in Aramaic, Hebrew, and Latin) became the biggest US box-office success of all time for a movie prohibited to children under seventeen.

Before the controversies and uncontrolled outbursts (a product of religion and alcohol), Mel poses here with a cat ("Roger, grab the cat," is the famous catchphrase in *Lethal Weapon 3*). A black cat and a white T-shirt. "No logo," as Naomi Klein would say.

There's nothing more minimalist than the T-shirt, which takes its name from its T-shaped silhouette. It was only after World War II that it became acceptable to wear it without anything on top. In the nineteenth century men's underwear was a combination of long-sleeved shirts and long underpants (worn either as one or two garments). The buttonless T-shirt is said to have been invented in 1898 in the US Navy during the Spanish–American War under the Caribbean and Filipino sun. But its current shape was perfected simultaneously for the British and US navies by three companies who remain holders of the title: Sunspel, founded by Thomas A. Hill in 1860 in Nottingham; Fruit of the Loom, founded in 1851 by Robert Knight in Rhode Island; and Hanes, founded in 1902 by John Wesley Hanes in Winston-Salem. Without a left-hand breast pocket (for a cigarette packet?), in dazzling white, Mel's T-shirt remains virginal. Mel, the good, the bad, and the handsome.

JANE
FONDA

— CAPE COD, SEPTEMBER 1984

When Jane emerged from the cold waters of the Atlantic, on a private beach at Hyannis Port, on Cape Cod, the T-shirt—that male undergarment transformed after World War II into a staple of boys' (and, in the '60s, girls') wardrobes—went back to its roots. A second skin, a bodysuit, for a sublime body. The wet T-shirt sculpts the figure of the Venus of fitness, whose book, *Jane Fonda's Workout*, and videos, which sold in their millions, converted Americans to the cult of the body during the '80s. Here, Jane is almost forty-four and looks like an Amazon with her sculpted breasts and hips, toned thighs, and navel of steel. She's been visiting the Kennedys with her husband Tom Hayden, a former student radical (he was one of the Chicago Eight in 1968) and a future Democrat senator. With Tom, Jane spearheaded many campaigns and wore numerous slogan-emblazoned T-shirts (it was during the '60s that the T-shirt became a medium for publicity or protest messages). Lady Jane Seymour Fonda (baptized with the name of Henry VIII's third wife) embraced causes by the truckload from the moment she became aware of the Vietnam War in 1968. A counterculture icon and two-time Oscar winner—for her feminist call-girl in therapy in *Klute* (1971) and Vietnam veteran's wife in *Coming Home* (1978)—Jane took up every cause (antinuclear, environment, women's rights, etc.), and spoke out in favor of Native Americans and the Black Panthers. Between 1970 and 1973 she was under FBI surveillance. Tom Hayden set up the Indochina Peace Campaign (whose initials—IPC—Jane would give to her production company) which mobilized anti-Vietnam protesters between 1972 and 1975. Jane was actively involved, and in July 1972 she went to North Vietnam to witness the American bombings. It was there that "Hanoi Jane" walked into a trap laid by Vietnamese officials for propaganda purposes.

The former Miss Army Recruiter of 1959, daughter of Henry, who was decorated during the war in the Pacific, was photographed sitting on an antiaircraft gun, wearing an army helmet: "I am Henry Fonda's privileged daughter who appears to be thumbing my nose at the country that has provided me these privileges. More than that, I am a woman, which makes my sitting there even more of a betrayal. A gender betrayal. *And* I am a woman who is seen as Barbarella, a character existing on some subliminal level as an embodiment of men's fantasies.... I carry this heavy in my heart. I always will,"[1] she wrote in *My Life So Far*, her poignant autobiography. In the book she also talks about her mother's suicide when Jane was twelve, and her long struggle with anorexia and bulimia that resulted from her lifelong belief that unless she was perfect she would not be loved. At the end of the summer of 1984, her second marriage was faltering. She felt "sexless and fallow." "Instead of dealing with my crisis in a real way, I got breast implants. I am ashamed of this, but I understand why I did it at the time. I somehow believed that if I *looked* more womanly, I would *become* more womanly. So much of my life had become a facade; what did it matter if I added my body to the list of falsehoods?"[2] A glorious confession from a warrior beauty.

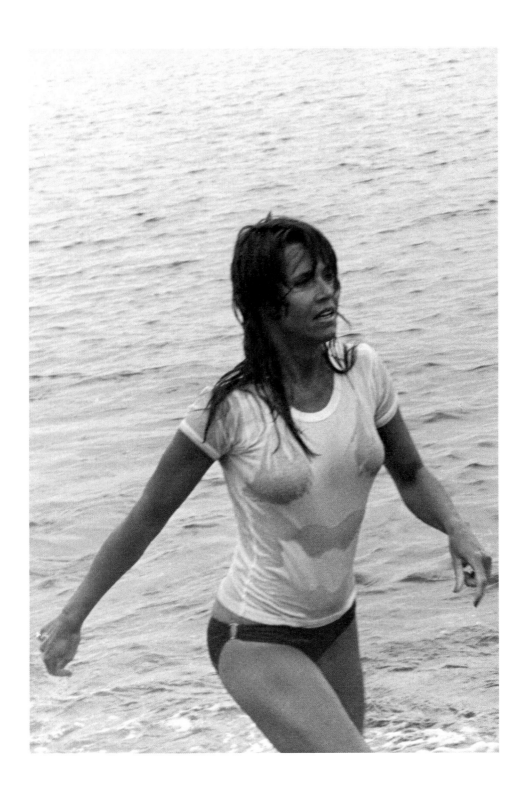

MARLON
BRANDO

— CALIFORNIA, 1950

In 1947, Marlon Brando was a sex symbol. In Tennessee Williams's *A Streetcar Named Desire*, he stunned Broadway audiences with a worn T-shirt, skin-tight Levi's, and a revolutionary performance. He was twenty-four, carted a raccoon around everywhere he went, and screwed around like a rabbit. In 1950, he was terrific as a paralyzed World War II veteran in Fred Zinnemann's *The Men*. In 1953, he was an idol in *The Wild One*, wearing his black Perfecto jacket astride his Triumph 6T Thunderbird: "What are you rebelling against, Johnny?" "Whaddaya got?"

In 1960, after Elia Kazan's *On the Waterfront* and *The Fugitive Kind*, he became a god. Having reached such heights, things could only go downhill: the descent would be hard, long, and ugly. His movies, from *The Bounty* to *Candy*,[1] held no interest for him any more, and vice versa. His political activities—protesting prison conditions in the US, promoting the causes of Native Americans and the Black Panthers—all met dead ends. After *The Godfather* (which offered him temporary redemption), then *Apocalypse Now* (his purgatory—and hell for Francis Ford Coppola), his infatuations—sex, money, and ice cream—were no longer amusing. His women, Anna Kashfi and then Rita Moreno, grew to hate him and became self-destructive. In 1990, his son Christian killed Drag, the fiancé of Cheyenne, Brando's daughter; she hanged herself in 1995. His destiny bore the earmarks of a Greek tragedy—a tragedy covered in cocktail sauce from Trader Vic's, the Polynesian-themed lounge in Los Angeles. His old age resembled a prolonged bout of flatulence, an act of flipping off cleanliness, civility, and death. It brought him down, alone, melancholic, and grossly obese, on July 1, 2004 in his bunker of a house on Mulholland Drive.

But in this photo, in 1950, Marlon is an actor named Desire.

One of the minor, yet enduring, myths of the twentieth century is the association of the short-sleeved T-shirt with Marlon Brando. As feline, seductive, and stunning as a god, the young Brando made the T-shirt his favorite item of clothing in the 1950s. In a simple T-shirt, Brando is handsome as a prince. In an A-shirt (also called a tank top in the US and a singlet elsewhere), he's Stanley Kowalski, the violent, complex, working-class antihero he played in *A Streetcar Named Desire*. "Now just remember what Huey Long said—that every man's a king—and I'm the king around here, and don't you forget it!"

The stevedore's A-shirt was invented in the nineteenth century by the porters in Paris's central market. Originally made of wool to keep the lower back warm while leaving the arms free, this item of underwear became standard for French soldiers during World War I, and was manufactured by Marcel Eisenberg's company in Roanne. In 1933, Eisenberg launched the "marcel," a mesh singlet for dockers, farm workers, and fans of open-air sports. It was a working-class look that was heroized—and eroticized—by Brando, taken up by actors (from James Dean to Yves Montand), sportsmen, bodybuilders (in "muscle shirts"), construction workers, and even American rappers in baggy pants. The American A-shirt is said to have acquired the deeply offensive epithet, "wifebeater," in reference to Stanley Kowalski, who beats his wife Stella in Tennessee William's play. Social racism and a sinister macho sense of humor? In 1949 Marlon Brando spent a long period in Paris, often hanging out in the central market until the very early morning, when the onion soup was served, with Nadine Trintignant and her brother Christian Marquand, his beloved friend.[2] Is it possible that, one night, Brando saw a "marcel" worn by one of those Herculean porters?

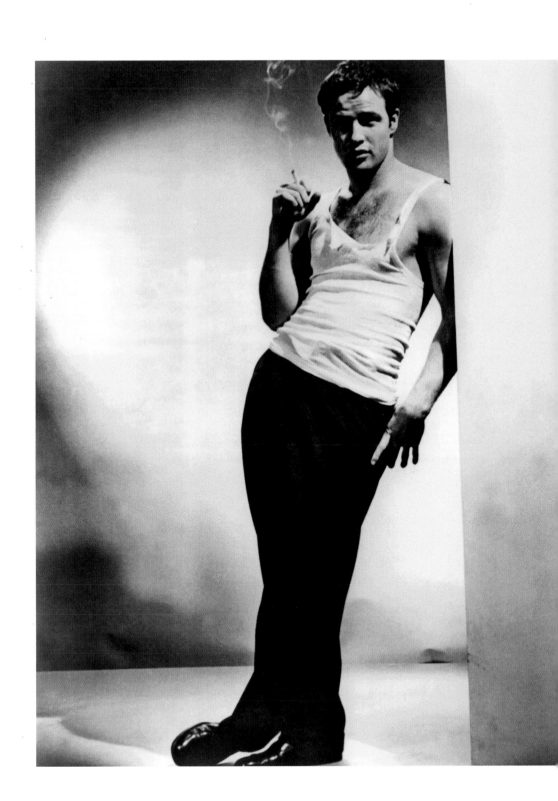

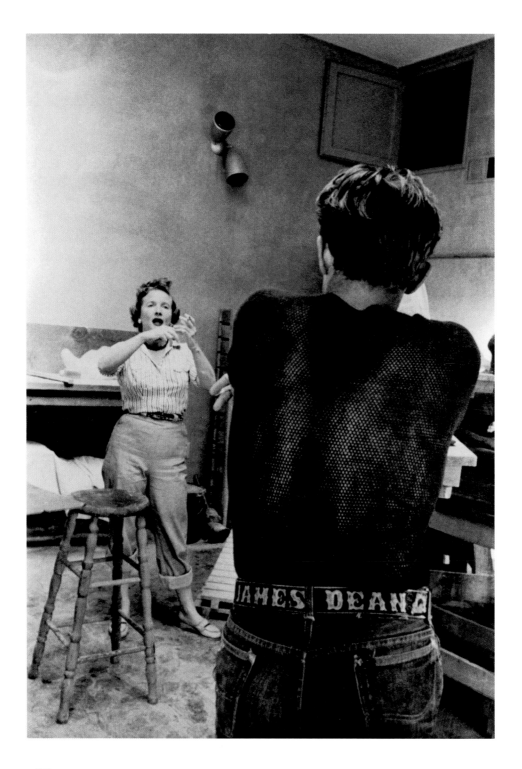

Leaning slightly to the right with his arms crossed high up and shoulders hunched, he is holding a cigarette between his index and middle fingers, which are pointing downwards. It's a challenging stance, and attests the miracle that was James Dean—an extraordinary pose combined with naturalness. The fragile moment when everything turned upside-down. From behind, even if his name wasn't engraved in the embossed leather of his cowboy belt, he'd be immediately recognizable. He's listening with concentration to Beulah Roth, the beloved wife of photographer Sanford Roth, who's telling him about one of her trips to Europe. The scene is not taking place at the Actors Studio, but in Sanford's studio; he was the photographer of intimate shots of Einstein, Stravinsky, Colette, and anyone who was anyone in Hollywood. The moment Jimmy met the Roths on the turbulent set of *Giant*, they struck up a friendship so intense that the young man, who had lost his mother at the age of nine, thought of them almost as his adoptive parents. James hasn't got long to live. Two weeks after filming *Giant*, he killed himself at 5:59 pm on September 30, 1955, on the road to Salinas in the Porsche Spyder with red leather seats that he had just bought and that he nicknamed "Little Bastard" (painted in bright red on the hood of the trunk). With his first paychecks he bought himself a Triumph Tiger motorcycle and a Porsche Super Speedster in which he won several trophies. The day of his death, Dean was hurrying to compete in a race at Salinas. Sanford Roth, who was following behind in Dean's Ford Country Squire station wagon, refused to take photos of the accident. Jimmy was dead, but the legend lives on. Twenty-four years old, the tragic speed of eternal adolescence. A short-sighted comet. And his clothes are like relics, revered by teenagers, copied over and over again, as he wore them in his three cult movies: worker's gloves in the back pockets of his Lee Rider jeans (the same as in this photo), and the Western shirt with cut-off sleeves as worn in *Giant*; the red McGregor jacket of *Rebel Without a Cause*, and the sable-colored V-neck sweater of *East of Eden*. All the basics Dean wore so well throughout his life are adored by every fashion victim: white T-shirt, Times Square overcoat (worn in the legendary photo of Dean walking in the rain), Jack Purcell sneakers (designed in 1935 by the Canadian badminton champion for the tire company B. F. Goodrich), peacoat, striped sailor shirt, chinos, leather jacket, Aviator sunglasses, orangey-tan leather work shoes, and greased leather biker's boots. It's the minimalist, cool look of '50s America. And in this photo he's wearing a black mesh T-shirt, blurring notions of gender identity. On the grave of James Byron Dean, a closet bisexual, who confessed to Elizabeth Taylor that he had been molested at the age of eleven by his minister, is a line from Antoine de Saint-Exupéry's *The Little Prince*: "What is essential is invisible to the eye."

PABLO PICASSO

— VALLAURIS, 1965 — LUCIEN CLERGUE

Inspiration. Perspiration. The minotaur is hot. Like Hephaistos in his burning forge, Pablo Picasso, at eighty-four years old, is busy at the kiln firing his ceramics in the Madoura pottery studio. His official potter, Jules Agard, can't be far away. In front of him is photographer Lucien Clergue, who has been documenting Picasso's life for about ten years.

Picasso discovered ceramics in Paris in 1904 when he took over Paco Durrio's studio at the Bateau-Lavoir in Montmartre, and the Basque artist, a great collector of modern art, showed Picasso stoneware pieces by Gauguin, "that magnificent and luxurious ceramicist."[1] In 1929, Picasso made several pieces, including the *Bathers* vase, with Jean van Dongen, brother of painter Kees, a former colleague from the Bateau-Lavoir. But the real creative explosion happened in 1946 when Picasso visited the Madoura factory in Vallauris and patiently learned the techniques of oxidation and how to work with slip to create color. Over twenty years, he produced 4,000 pieces, including 633 reproduced as limited editions: plates, vessels, vases, zoomorphic objects, female heads, trompe l'oeil dishes in the tradition of medieval Mudéjar ceramics from Málaga; a mixed, playful assemblage of objects, including *Crane* and *Girl Skipping*—all kinds of things fired Picasso's imagination. And to feel comfortable in front of a kiln heated to 1,280 degrees Celsius (2,336°F)—*que calor!*—what better than a mesh T-shirt? This white, fishnet number—for a miraculous artistic catch—is an unusual item in Picasso's wardrobe. He normally preferred a black-and-white-striped T-shirt (immortalized in André Villers' photo, where the painter is playing with a Colt 45 given to him by Gary Cooper in 1959), a sleeveless singlet, or a striped sailor shirt (as in Robert Doisneau's famous photo *Picasso's Bread Rolls*, taken in 1952). Picasso and the T-shirt were both strokes of twentieth-century genius: popular, universal, trans-generational, appreciated by anyone from seven to seventy-seven years old,

or more. Picasso claimed he did not seek, he found.[2] In the case of the T-shirt, there was some trial and error. In 1919, when the forerunner of the T-shirt (a cotton undergarment worn by sailors and soldiers) became the standard-issue shirt of the US Navy, Picasso had already invented Cubism with Georges Braque, painted *Les Demoiselles d'Avignon* in 1907, and created the sets and costumes for Diaghilev's Ballets Russes. In 1938, by the time the sailor's "gob shirt" appeared in the US in the Sears catalog, Picasso had painted *Guernica* (1937), *The Weeping Woman*, and a charcoal self-portrait in which he is wearing ... a striped sailor shirt. After World War II, the T-shirt returned to civilian life, with the movies popularizing its image, and thus its use. Dressed in a simple T-shirt, disguised as Popeye, as a bullfighter, a gypsy, or bare-chested and locked in a bestial struggle with his canvas—as in Henri-Georges Clouzot's movie *The Mystery of Picasso*—the painter maintained his magnetic aura, which the years did nothing to diminish. Nor did any minor irritations such as the publication, on January 1, 1965 of *Life with Picasso*—an unflattering autobiography by Françoise Gilot, Picasso's partner from 1944 to 1953—or the later publication of John Berger's essay *The Success and Failure of Picasso*. The latter demystified the "genius" who had become a "bourgeois" artist, claiming he didn't know how to reinvent himself. Nevertheless, Picasso continued to reign supreme at Notre-Dame-de-Vie, his love nest with Jacqueline Roque in Mougins, France, painting *Pissing Woman*—an homage to Rembrandt's *Woman Pissing* and to Dutch genre painting in general. The painting was of such astonishing insolence that an art historian deemed its sloppy facture, grotesque nature, and energetic touch representative of a kind of "art slang, which would be to the painting of the master what slang is to ordinary speech."[3] Even at the age of eighty-eight, it seems, Picasso was still telling everyone to piss off.

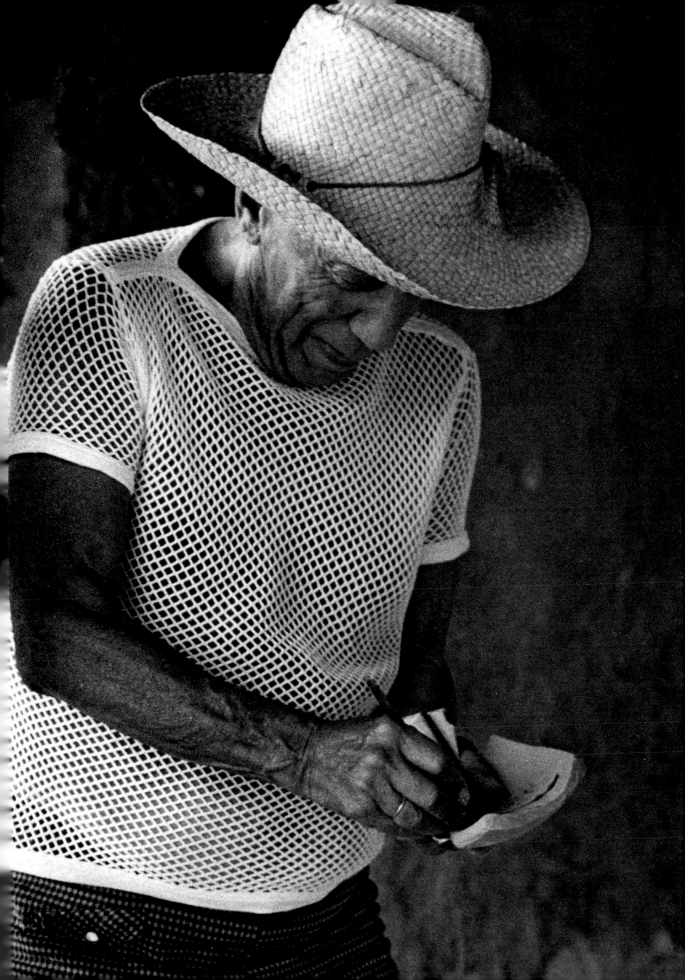

DEBBIE HARRY

— CONEY ISLAND, 1977 — BOB GRUEN

Atomic Babe, Deborah, known as Debbie, is thirty-two, sulky, peroxide, and adorable. Is she on her way to find:

(1) the bumper cars at Coney Island fairground?

(2) a taxi into Manhattan after a photo session with Bob Gruen?

(3) her fame and fortune?

Actually, forget the go-karts: this former go-go dancer (and sales clerk, and Playmate, and waitress at Max's in Kansas City), has a one-way ticket to fame thanks to Blondie's second album *Parallel Lines*, and Debbie's single "Heart of Glass," released a few months after this photo was taken.

The energetic, New York-born starlet, who had lived through some hard times at first (work as a backup singer, then a floundering solo career), had been a local underground diva with The Stilettos in 1974, before becoming hugely successful with the formation of Blondie in 1975. Posing like a sulky vamp, with bottle-blonde hair (an ironic nod to the temptress Eve myth of the Hollywood blonde), and an angelic kind of New Wave style, Debbie Harry created a hybrid look somewhere between trashy bimbo (denim mini-shorts, asymmetric T-shirt, and geriatric nurse-style clogs as here in Bob Gruen's photo) and DIY rock chick. She mixed day-glo colors with denim, put together vinyl and thigh-high boots, PVC and sequins, gilded bondage belts.

Rummaging in thrift shops and pawn shops, she made underground culture desirable and accessible for outsiders, the media, and the public in general.

"A living image of the unsung therapies of the American B movie culture—fashionwise, a parade of pulp-fiction goddesses from slightly ratty movie memories,"[1] Debbie was the sexy yet aggressive alternative to the Rimbaudesque look of Patti Smith, the other rock star on the New York scene at the end of the 1970s. "Hi! It's Deb. You know, when I woke up this morning, I had a realization about myself. I was always called Blondie, ever since I was a kid. What I realized is that at some point I became Dirty Harry. I couldn't be Blondie anymore, so I became Dirty Harry."[2]

Dirty Blondie? Only in the context of mind-bending puns. Even at the height of punk, Debbie Harry never wore ripped T-shirts, never had f-you slogans on her clothes. At the start of the 1980s the queen of alternative culture with the heart of glass personified a pretend-dirty glamour that owed a lot to stylist Stephen Sprouse (trained at Halston and Bill Blass), who designed her stage outfits.

"Call me!" We're missing one iconic item from Blondie Debbie's wardrobe: red stilettos, girly avatars of Dorothy's red shoes in *The Wizard of Oz*, perhaps? Shoes that Kate Moss, who owed a lot to Debbie, recycled twenty years later.

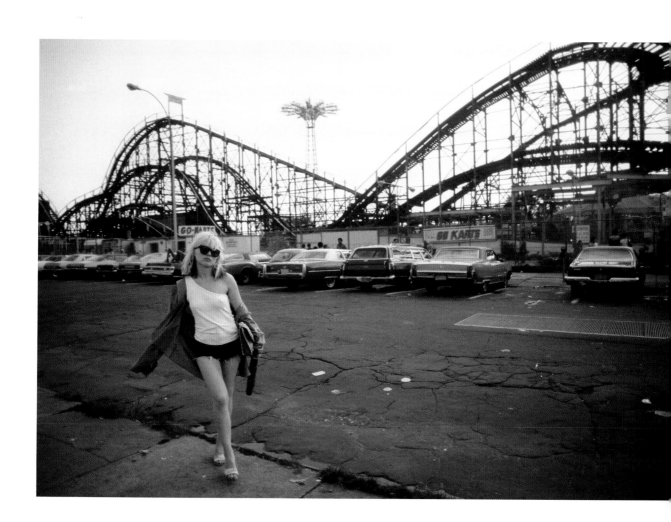

ANDY
WARHOL

— NEW YORK, 1981 — CHRISTOPHER MAKOS

Is it Marilyn Warhol? Three weeks after Monroe's death in August 1962, the artist and pop art theorist painted his famous *Marilyn Diptych*.[1] Duplicating Marilyn's smiling face twenty five times, twice (in color on the left hand side and in black and white on the right hand side), the work demystifies the star's singularity, and the unique status of the work of art itself, and marks the moment when consumer society began dealing in stars. Nineteen years later, over the course of two days and with the aid of eight wigs, Warhol and Christopher Makos, a young photographer who'd been hanging out at The Factory, created a series of "drag" portraits. The result was an artificial "blonde on blonde". Behind this session of performance art (perhaps even at its roots?) lay photos of Marcel Duchamp dressed up as a woman in 1921 for Man Ray's camera. Between the "artificiality of the dandy and the excesses of the diva,"[2] Rrose Sélavy found her worthy (and unworthy) successor in Lady Warhol. The crucial element in the metamorphosis of Andy Monroe in this role-playing game, which displayed the fashionably '80s aesthetics of camp—a taste for exaggeration and artifice—alongside the typically Warholian oscillation between media overexposure and disappearance of the self, is the platinum blond wig. It's a vivid quotation of Marilyn's hairstyle and hair color in *Gentlemen Prefer Blondes*. Warhol thought he was unattractive and even as a very young man he decided to remedy a handicap that deprived him of social success and emotional fulfillment. In 1956 he had a nose job and, around the same time, started to wear wigs to hide his graying, thinning hair. As an artist concerned with surfaces, Warhol never stopped scrutinizing his own appearance. His first work, a self-portrait with a deformed face and a finger up his nose, is called *The Lord Gave Me My Face But I Can Pick My Own Nose* (1948);[3] and his last, *Fright Wig* (1986), is a series of Polaroid self-portraits in a wig that resembles the locks of the Medusa in Caravaggio's painting. A portentous *vanitas*, this fright wig was made just a year before his death and made no attempt to look like real hair. This deliberate use of the counterfeit contributed to the creation of the Warhol brand. For movie director Derek Jarman it was a source of confusion: "the more it looked like a wig, the less it looked like a wig."[4] Made in New York by Paul Bicchichio using hair imported from Italy that was silvery-gray, blond, or white according to mood and availability, Warhol's hairpieces (he threw none of them away, and forty wigs are still in the archives of the Warhol Museum in Pittsburgh) didn't have much in common with the first historical male wigs. Around 1630, when King Louis XIII of France and his court revived wig-wearing, from when it had been very popular in classical times, the point was to look hairy, and therefore virile. This was indeed the case up until the French Revolution, which brought about a reduction in both the heads of the nobility and the income of wig-makers. Andy Warhol's wig is neither virile nor feminine. It is unique—ironic, given that Warhol was the artist of multiples. It exists in an "other world" of assertive sexual ambiguity (perhaps gentlemen prefer blondes wearing wigs?), and of gender confusion, the subject of much theorizing at US universities from the beginning of the 1990s on. "Warhol's wig depended on him. Abandoned in the vitrine, the prosthesis looks like a flattened jellyfish, a splayed broom, an apology."[5] The most amazing thing is that Warhol turned himself into Marilyn by sporting platinum blond hair similar to the style that made Jean Harlow famous, and which Marilyn copied. Warhol/Harlow—you just have to unscramble the letters. And there's no need to split hairs.

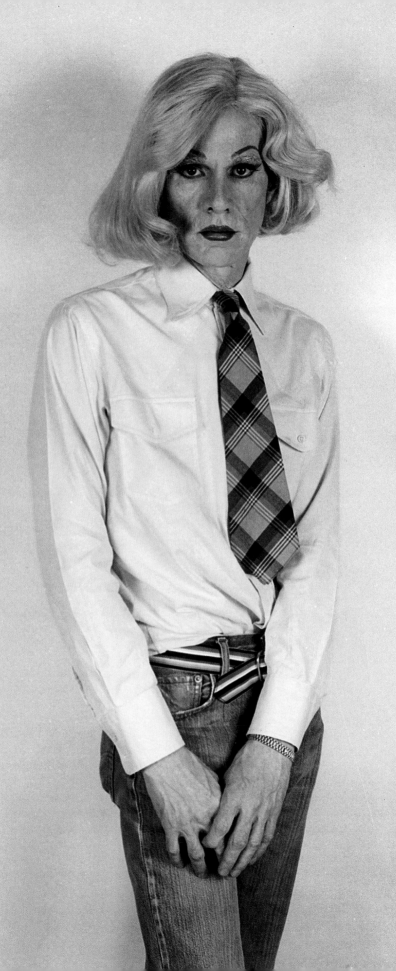

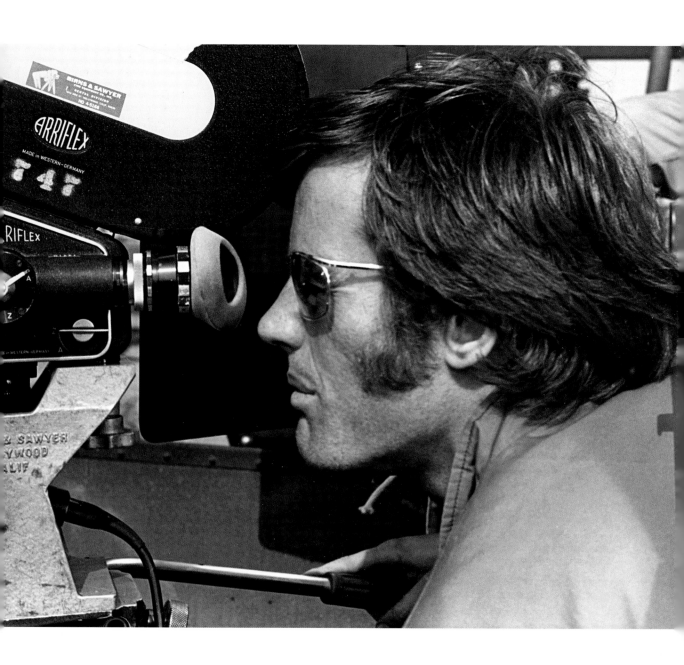

PETER
FONDA

— UNITED STATES, 1968

Filming began on February 22, 1968, in New Orleans at the start of Mardi Gras just before Peter Fonda's twenty-eighth birthday. This date always brought back bad memories of his eleventh birthday, when he accidentally shot himself in the stomach and almost died. ("I know what it's like to be dead,"[1] John Lennon apparently heard Peter say during an acid trip in L.A., and these words became the opening phrase of "She Said, She Said" on the album *Revolver*). Making *Easy Rider*, the archetypal road movie and cornerstone of the new Hollywood, had not been a barrel of laughs. Directed by Dennis Hopper, cowritten and coproduced with Peter, the movie's budget was tiny by comparison with the Roger Corman production the pair had acted in the previous year (*The Trip*, a psychedelic journey, in which Peter played an experimental TV director and Dennis played a dissolute drug dealer). At this time, Dennis, who had made his movie début alongside James Dean (in *Rebel Without a Cause* and then *Giant*), was a Hollywood outcast, while Peter, son of Henry, younger brother of Jane, and father of Bridget (who plays a child in the hippy community in *Easy Rider*), was more of an outsider than the well-brought-up product of an acting dynasty. They felt at home in the world of rock. "Don't Bogart the Joint my Friend,"[2] the original soundtrack is the best background music of the era. To play the two desperado freaks in *Easy Rider*, Wyatt and Billy (nods to Wyatt Earp and Billy the Kid), Peter and Dennis took their fashion inspiration from two members of The Byrds (Liberty-print shirts as worn by Jim McGuinn and the fringed waistcoats of David Crosby). In contrast with Dennis, the high plains rider dressed in buckskin, Peter flaunts a tremendous "Captain America" look: biker's slim-fit pants and black leather jacket (with horizontal white, black, and red stripes on the right side, the same on the left sleeve, and the Stars and Stripes on his back, repeated on his chopper and helmet). And then the sunglasses, shown here in profile looking down the viewfinder of the Arriflex camera: Ray-Ban Olympians, with gold frames and tinted lenses that Peter preferred to the Aviators he wore in *The Wild Angels*. What Steve McQueen was to Persols, Peter was to Ray-Bans—an icon. The brand (its name refers to blocking out the sun's rays) was created in 1936 (the year Hopper was born) when the optical company Bausch & Lomb (named for the two German immigrants who founded it in 1853) perfected a technique for making lenses that filter out ultraviolet and infrared light. They were made in dark-green glass as per the requirements of the US Air Force. Before they became accessories for mere mortals, these sunglasses met the needs of aircraft pilots or automobile drivers who were particularly exposed to the effects of sun and speed, and then were used in mountaineering and winter sports. Since time immemorial, Inuits have been protecting their eyes by means of glasses made from the ivory of walrus tusks, but it was only in 1929 that the first pair of sunglasses, Foster Grants, was sold by Sam Foster on the beaches of Atlantic City. However, like the Zippo lighter or Wrigley's chewing gum, it is Ray-Ban's tear-shaped Aviator sunglasses, immortalized by General MacArthur during the War in the Pacific, that symbolize post-World War II America. What's the competition? In 1952 Ray-Ban launched Wayfarers, quickly adopted by stars enjoying their seasons in the sun: James Dean, Audrey Hepburn in *Breakfast at Tiffany's*, Roy Orbison, and Bob Dylan. Then, in 1956, Olympians appeared. In desperation, fashion designers produced innumerable styles and models, from oversized "Jackie O" style to Lennon's granny glasses, psychedelic-era teashades, or shutter shades (glasses with little shutters as worn by Kanye West). But for real sunglass opticians, only the Italian Persol brand (*per il sole* means "for the sun") founded in 1917 by Giuseppe Ratti, or French Vuarnets, founded in 1957 by the Olympic ski champion (with Skylinx lenses invented by Roger Pouilloux) can offer any real competition to the American giant. Over the years the Milan-based group Luxottica brought everyone into the fold by buying up Ray-Ban, then Persol, and finally the baby of the sunglasses world, Oakley, founded in 1975 by Jim Jannard in California and adored by surfers and athletes alike. There was a time when the Ray-Ban logo didn't feature on the lenses—perhaps a time more suited to Peter Fonda, born to be wild.[3]

ANDRÉ
BRETON

WITH PHILIPPE SOUPAULT, JACQUES RIGAUT, BENJAMIN PÉRET, AND SERGE CHARCHOUNE

— PARIS, 1921

In spring 1921, André Breton was the passionate, masterful leader of the Paris branch of Dada, the movement that had originated in Zurich; as young André wrote to Tristan Tzara, we are "all presidents of Dada."[1] Since reading Tzara's *Dada Manifesto 1918*, Breton himself began to dream of a "dictatorship of the spirit,"[2] of a *coup d'état* that would sweep aside rotten old literature (such as the work of Anatole France), reactionary intellectuals (such as Maurice Barrès), and limited world views. He'd been a medical student and stretcher-bearer during the war, co-founder with Philippe Soupault (second from the right in this photo) of automatic writing (*Magnetic Fields*, 1919), director of *Littérature* magazine, and was funded by the bibliophile patron Jacques Doucet, for whom he assembled a collection of modern paintings (from Picasso to Braque) and manuscripts. But Breton loved painting and organized the first Paris exhibition of Max Ernst, a long-established Dadaist from Cologne. The exhibition's opening took place on May 3, 1921 at the bookstore Au sans pareil on avenue Kleber in Paris, attended by Tzara (who tried to avoid the photographers), but with no sign of Ernst. Like the works on offer ("anaplastic, anatomical, antizymic paintopaintings") the invitation was a joke: "FREE ADMISSION, hands in your pockets, EASY EXIT, painting under your arm. Ladies are requested to bring all their jewelry." And what about these men and all their monocles? Breton, Soupault, Rigaut, Péret, and Charchoune, soul brothers, wore monocles for all their Dada events. "With the blue eyeglasses of an angel they have excavated the inner life for a dime's worth of unanimous gratitude."[3] Dada denounces retinal art, long live the monocle! The monocle was worn in the spirit of imitation. Tristan Tzara, the nihilist, sported an "enormous monocle attached to a black ribbon,"[4]—the perfect symbol of zero, of nothingness, screwed to his cheek—paying homage to Breton's friend Jacques Vaché, who committed suicide in 1919, and who was known as the "glacial butterfly with the monocle." Yet it was simultaneously worn in ironic mimicry of that instrument of social intimidation so beloved of aristocrats, captains of industry, literary dandies (of the Long Mustache Club),[5] army men, and high society gents since the start of the nineteenth century. "One must know how to look with an eye bigger than a city."[6] Yes, you have to eye up those who are giving you the once over, and reflect back to them a sneering image of themselves. This transparent barrier, the "narcissistic accessory,"[7] enabling one to stand out from the crowd, to break from the norm, went so far as to haunt André Breton's unconscious: in his *Dream III*, dictated in 1923, the eye of a seagull shot down by a hunter and metamorphosed into a horse becomes a monocle at the moment when Paul Éluard's monocle breaks.[8] Breton saw this dream as a sign that Dada and its monocle no longer provided the means of seeing the future. In March 1922 André Breton left Dada[9] and launched the "nebulous movement"[10]—sessions of somnambulic writing during provoked sleep,[11] in which the words would "make love,"[12] and the few rare readers climax—before publishing his *Surrealist Manifesto* in 1924: death to realism, bring on the miraculous and childhood, "the omnipotence of dream, … the disinterested play of thought."[13] The time had definitely come to break the monocle and begin mining the gold of time in the seam of inner visions.

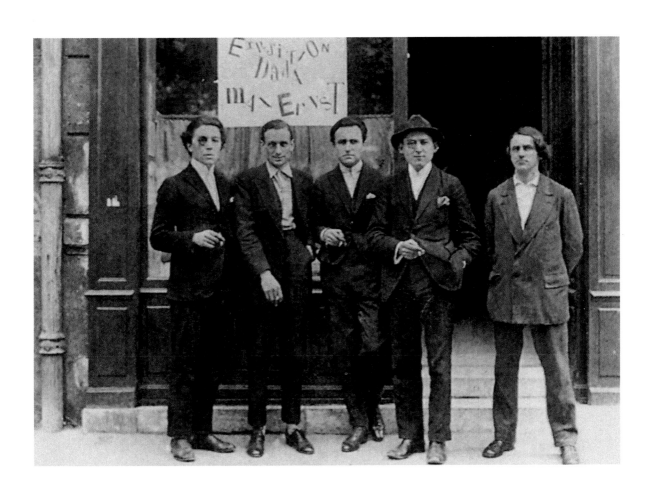

FRIDA
KAHLO

— COYOACÁN, 1939 — NICKOLAS MURAY

It's a "lobe" story as much as a love story. Frida Kahlo had just returned from France. At the suggestion of André Breton, with whom she had been staying in Paris, the Mexican artist showed her paintings at the Renou & Colle gallery in March 1939, alongside photos by Manuel Álvarez Bravo, and pieces of popular Mexican art belonging to Breton. Surrealism's philosopher had encountered Frida Kahlo's paintings a year before, during a voyage of discovery to Mexico undertaken on the advice of Antonin Artaud. "The home of black humor," "the surrealist location above all others"[1] captivated Breton, who saw a kernel of surrealism in Frida Kahlo's autobiographical, macabre, dreamlike, and sensual work. "The art of Frida Kahlo is a ribbon around a bomb," wrote Breton in the exhibition catalog *Mexique*. And it was a cluster bomb. In a letter sent to Nickolas Muray, the man who took this photo, Kahlo, who was resistant to any kind of assimilation—"I never painted dreams. I painted my own reality"[2]— described Breton and the Paris artists in florid terms: "They are a bunch of coocoo lunatic sons of bitches surrealists I'd rather be sitting in the dirt on the Toluca market selling tortillas than having to deal with those Parisian artistic assholes."[3] By contrast, the young woman appreciated Picasso's attentions when he gave her two ivory hands in the form of earrings on the evening the exhibition opened. Perhaps he got the idea from Dora Maar, his mistress who took a wonderful surrealist photo of a hand emerging from a shell, and who is wearing two ivory hands in the 1936 portrait of her by Man Ray. Hands can embrace or strangle, they can be an artist's creative hands, or they can destroy. To top it all, on her return to Coyoacán, Frida Kahlo developed an infection on her hand, possibly a psychosomatic reaction to the infidelities of her husband, Diego Rivera. Doctor Eloesser treated her hand: in the self-portrait that Frida dedicated to him in 1940 the hand-shaped earring given to her by Picasso is hanging from her left ear.

Anthropologists believe that ear-lobe piercing is the oldest kind of body modification: the oldest earrings found in Mesopotamia date from the twenty-sixth century BCE, and over the centuries earrings have symbolized fertility, wealth, adherence to a fraternity, or exclusion. Frida Kahlo's body had already undergone its own physical modification: she'd contracted polio at the age of eight, which resulted in a withered leg and foot; her spine had been broken in an accident, and she had to wear a steel corset for months. It was a tortured body that became the obsessive subject matter of her work. She painted herself for the first time from a hospital bed, looking at herself in a mirror on the ceiling. But Frida always took care to adorn herself with flowers and traditional Mexican jewels, culminating in the playful depiction of hands in this photo.

A woman and her self-portraits. She painted fifty-five of them between 1925 and 1954, all with eloquent titles: *Thinking about Death, With Necklace of Thorns, As a Wounded Deer, Very Ugly, Without Hope, Remembrance of the Open Wound, With Dr. Farrill, Time Flies*. And she loved being photographed by Nickolas Muray, a Hungarian living in exile in the Unites States. He was Frida's lover for ten years, from 1931 to 1941, then her confidant. Muray's highly pictorial compositions, echoing Mexican religious imagery, pay homage to the wild, downy beauty of his model. In this photo, Frida Kahlo is dressed in the costume of the Indians of the Tehuantepec region, an expression perhaps of Mexican pride and a political loathing of Yankee clothing. As she asserts her feminist credentials, she smiles dreamily. At her neck hang two ivory hands in an uncertain caress. And, like them, Frida Kahlo keeps us in suspense.

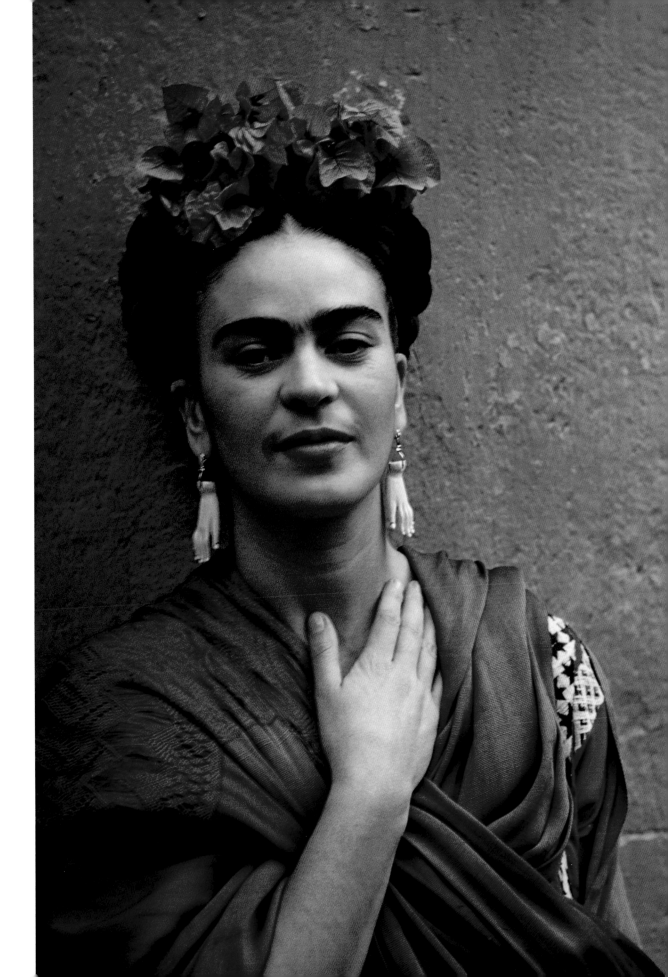

MARCEL
PROUST

— FRANCE, AROUND 1900

He dressed with care, but was not really elegant. Nevertheless, he bought his singlets (known in French as "marcels"), his shirts, and his jackets from Charvet, the "magic shirtmaker"[1] to the Prince of Wales, to the Jockey Club, to Robert de Montesquieu, and to international high society in general. His ties came from Charvet, of course, but also from the store called Au Carnaval de Venise on the boulevard des Capucines in Paris, the famous supplier to Charles Haas (the model for Charles Swann in *Remembrance of Things Past*). The expensive cattleya orchids he wore in his buttonhole were selected at Lachaume on rue Royale. Some of Proust's contemporaries thought he was nothing to look at. The publisher Gaston Gallimard disparaged his "tight-fitting and badly buttoned black clothes," and Léon Pierre-Quint thought that he had "the studied refinement of the dandy, tempered already with a loose carelessness as of an old medieval scholar."[2] Léon Daudet described him "muffled up in wools like a Chinese trinket ... sucking or fiddling with one side of his brown mustache."[3] Marcel Proust, sometimes nicknamed "the bee of heraldic flowers" and "Popelin Cadet" in the salons of the Saint-Germain district to which Robert de Montesquiou (the future Baron de Charlus in *Remembrance*) introduced him, was not a paragon of style. Sartorially he was completely unlike his hypnotic writing and his *Remembrance of Things Past* (constructed, in his own words "like a cathedral"), which transformed the base metal of everyday life into the gold of memory. In one of the rare color images of the writer, Proust is wearing a cattleya in his buttonhole, following the dictates of Belle Époque fashion. The orchid is not white, as in painter Jacques-Émile Blanche's portrait of Proust aged twenty-one, but variegated in white, purple, and a hint of pink.

When King Charles VIII of France marched into Naples in 1495, it is said that he pinned to his lapel a bouquet of violets given to him by the locals, and thus the origin of the floral buttonhole goes back to the fifteenth century. In another story, another French king—Louis XVI—wore in his buttonhole a potato flower given to him by Parmentier, the man who promoted potato cultivation in France. In the eighteenth century, the European aristocracy adopted this floral decoration, and the *Inco'yables*—the fashionable nobles during the French Directory period—almost toppled under the weight of their jungle of buttonholes. In the nineteenth century flowers such as carnations, roses, gardenias, and camellias were worn both during the day and in the evening, a daily custom that would disappear with the outbreak of World War I. The language of buttonholes now took on a political dimension in France: white flowers signified a monarchist; red carnations indicated a supporter of the anti-government Boulangist movement or a socialist. In France, after 1890, poppies were worn on May 1, while in 1920 they were adopted by the US, Britain, and commonwealth countries to commemorate the fallen of World War I. During the Belle Époque, a whole poetic language of affects flourished among the Symbolist, decadent dandies. Novelist Jules Barbey d'Aurevilly "sacrificed a rose every evening" in his buttonhole.[4] Proust, newly minted Knight of the Order of Spring,[5] could well have invented this language himself. From his adolescence onwards, flowers symbolized an awakening of the senses and sensuality: in *Jean Santeuil*, his unfinished first novel, masturbation is "a happiness as new, as ravishing, as little touched by all the common joys of life, as were the lilacs or the dark-complexioned iris."[6] This happiness was practiced in a room filled with the scent of pink horse chestnut. In *Remembrance of Things Past*, the room smells of iris and wild blackcurrants. Proust's first vision of the Comtesse Greffulhe and her hairstyle "with mauve orchids that slid down to the nape of her neck"[7] was a sensual and aesthetic epiphany that in 1913 he transposed onto Odette de Crecy's cattleyas. The flower becomes an all-encompassing metaphor of possession, pleasure, and the female genitals: "He tremblingly hoped, that evening ... that it was the possession of this woman that would emerge for him from their large mauve petals."[8] What did Marcel Proust wear in his buttonhole? His desire to write? His search for pleasure? Or the knowledge that everything fades and wilts, but can be brought back to life thanks to literature? In 1886 the fifteen-year-old Proust was asked, "How would you like to die?" He replied, "I would prefer not to."[9] A century later, he still lives on.

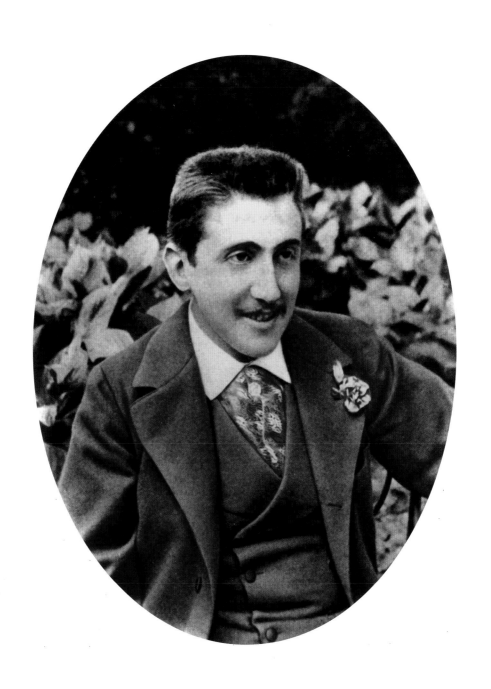

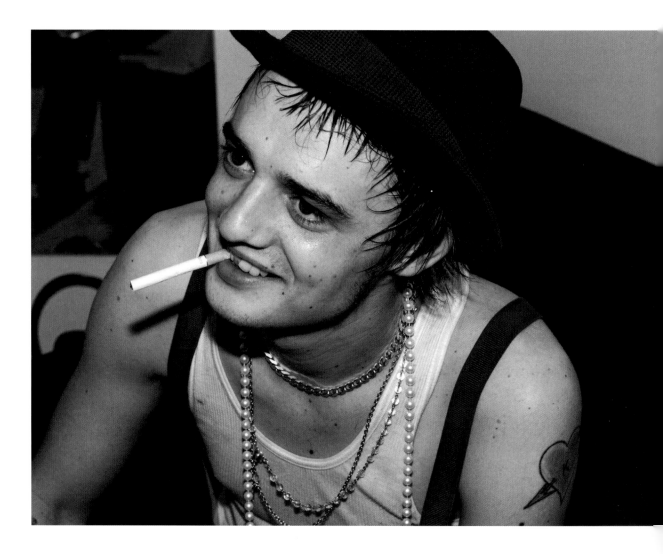

PETE

DOHERTY

— GREAT BRITAIN, 2005 — HEDI SLIMANE

With his pale complexion, dark-ringed eyes, greasy hair in rebellious wisps, and cigarette permanently hanging out of his mouth, this baby-faced punk, the new darling of the young century, smiles out at us. He's photographed by Hedi Slimane, Mr. Dior Homme himself—the apostle of the slim fit pants, the narrow-cut jacket, and the sharp tie, who inspired and followed Pete from The Libertines to Babyshambles (and who lived to write a book about it: *London Birth of a Cult*). All the elements of Pete's style are here: the trilby (when he's not wearing a fedora), suspenders (which he prefers buttoned), intertwined chains and chokers (including a long, ambiguous pearl necklace), the singlet (which he alternates with Lacoste or Fred Perry polo shirts), and the tattoo (a heart bearing the letter K pierced by an arrow). The year this photo was taken—2005— Pete met Kate in January (over the course of the next two years the couple's drug-fuelled escapades would delight the tabloids), was kicked out of The Libertines by Carl Barât (whose apartment he had burgled two years earlier), and completed *Down in Albion*, Babyshambles's first album. Born in 1979, the year punk died, Pete was a child of The Sex Pistols, The Clash, and The Smiths. He adored Wilde, Baudelaire, Blake, Genet, Huysmans, and De Quincey, and had everything going for him. And the troubled artist would go for it all.

Eagerly awaited albums, reunions on and off, relapses (heroin, crack, and cocaine), arrests for drunkenness, jail sentences, and a collection of poems. He put on exhibitions of paintings made with his own blood, and collected top models. He was a real fashion plate, and so the world of ready-to-wear snapped him up. From 2007 to 2008 he was Roberto Cavalli's muse, and in 2010 he appeared in a three-piece Harris tweed suit, designed by Marina MacLean, with a Chanel shirt and tie. He soon turned himself into a stylist, designing jewelry for Hannah Martin and the capsule collection Musset Rock for The Kooples. But it's through his tattoos, that heroic mark on the skin, that he best incarnates most of all our age of narcissistic radicalization. The days when tattoos (from the Tahitian word *tatau* meaning to mark or draw) were the preserve of jailbirds, bikers, or skinheads—a mark of infamy, or a language for initiates only—are long gone. Tattoos are visible—they're the new body logos, used by fans as a mark of distinction. The hand made injection, the prick of the needle—Pete knows all about that. Flayed but still alive, he embroiders his own story. A skull on his left arm, a mermaid on the other, Babyshambles on his right breast, Astile (the name of his son) on his neck, and this arrow-pieced heart of K on the left, echoing his late friend, Amy Winehouse his alter ego from rehab, herself the bearer of twelve tattoos.

MADONNA

— LOS ANGELES, MARCH 1985 — KEN REGAN

"Like a virgin/Touched for the very first time." It's 1985, the year Madonna rode the crest of a wave. Released just before Christmas 1984, *Like a Virgin* was Madonna's second album and her first to top the Billboard chart. Madonna Veronica Louise Ciccone was born the day after the Assumption of the Virgin in Bay City, Michigan—a grey suburb of Detroit—the eldest daughter of a first-generation Italian father and a Franco-Canadian mother, who died of breast cancer at Christmas when Madonna was five. The words of the title song, the video where she appears in a virginal wedding dress, and the MTV Music Awards show where she accessorized the dress with a belt whose buckle read "Boy Toy," were the first of many scandals, provoking virulent reactions from Christian organizations and threats to excommunicate the sinful woman for blasphemy. Maripol, a French stylist based in New York, created Madonna's post-punk look: spiky hair, ruffle skirt, leggings cut off below the knees, bustier in place of a shirt, lace bra and gloves, black rubber bracelets, charms, trinkets, and her legendary crucifix—a style soon copied by legions of Madonna wannabes all over the world. The eroticism of the sacristy. A soft bitch beneath the sign of the Holy Cross. *La Madonna*, accused of wearing a crucifix just because there's a naked man on it, told us on the release of *Ray of Light*, "I received a very strict Catholic education which gave me a good dose of discipline, but which also had some very negative effects on me. When you're brought up in the pure Christian tradition, everything you're given to learn about sex has a shameful connotation, linked to the idea of sin.... And when something is systematically presented as forbidden, it necessarily becomes erotic and all the more attractive."[1] The crucifix, at the heart of her image.

Adored relics, caressed rosary in "La Isla Bonita," the stigmata in the mortuary chapel in "Like a Prayer," the confessional tone of "Oh Father." Madonna nude in front of an illuminated cross in her book *Sex*; Madonna crucified during her *Confessions* tour. The Queen of Pop fascinates and manipulates the media at will. Her genius: blending Marilyn, Marlene, Louise Brooks, Betty Boop, Joan Crawford, Jean Harlow, Eva Perón, and Marie-Antoinette into one person. Her body is a weapon, her incendiary remarks well chosen, and her provocation a benediction—the immaculate diva wedded to Avida dollars, with as many "spiritual star" creeds and "material girl" metamorphoses as there are albums. In this year—1985, when she married Sean Penn in Malibu—the singer who would go on to sell more records than anyone else, ever, and who would become the most photographed woman in the world, is twenty-seven years old. In March, just before the opening of *Desperately Seeking Susan*, and while preparing for The Virgin Tour, Ken Regan, founder of the Camera 5 agency, has her pose for the cover of *People* magazine in the Mondrian Los Angeles Hotel (this photo shoot made it to the cover of twenty-four magazines around the world).

On her right wrist, a punk dog collar, on the other, an antishock watch (by Casio?). White nailpolish. An updated medallion hangs from her ear, the lace of her underpants visible at the top of her skirt. A crop top emblazoned with the word "Healthy" (a saintly spirit in a healthy body) covers her covetable breasts. Mother-of-pearl rosary beads swing across the world's navel. White Devil, black virgin. "For the very first time?"

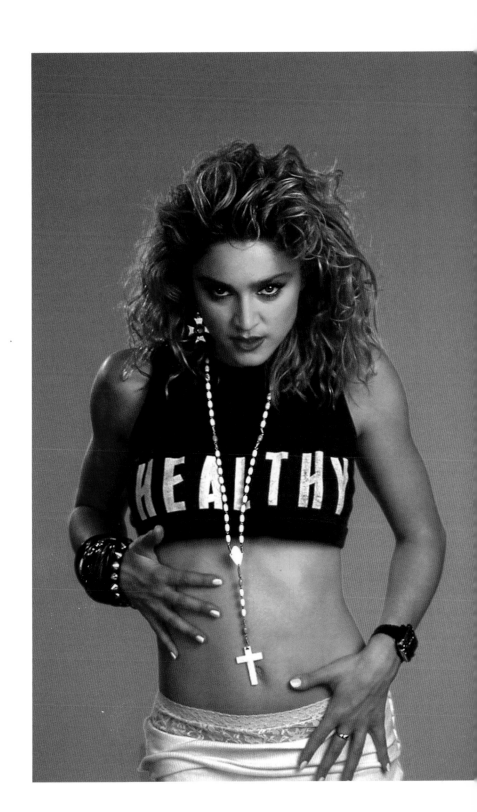

FRANÇOISE
DORLÉAC

— PARIS, 1966 — GIANCARLO BOTTI

She loved gherkins, chips dunked in milky coffee, perfumed talcum powder, and Jadérane, her chihuahua, whom she called "my beautiful beast."[1] As her younger sister, Catherine Deneuve, explained, Françoise, like all drama queens, "wanted to be a nun, but became an actress."[2] The result was twenty movies in eight years, before she died at just twenty-five in June 1967, on a road on the French Riviera, driving at breakneck speed in a rented Renault (which wasn't pink with green stars like the car she drove with Jean-Paul Belmondo in 1964's *That Man from Rio*). Françoise Dorléac was afraid she'd miss the London preview of *Les Demoiselles de Rochefort*, the movie by Jacques Demy that reunited the two sisters—"twin sisters born under the sign of Gemini"—who were perhaps also born under the sign of tragedy. The beautiful girl with a "physique like seaweed or a greyhound" according to François Truffaut, who called her "Framboise" [Raspberry] to make her laugh, was a hard worker, nervy, and a perfectionist, who admitted she was preparing for her forties when she was still just twenty by taking two ice-cold showers a day.[3] Truffaut directed Françoise in his masterpiece, *The Soft Skin* (1964), using her to eroticize the figure of the airline hostess, who is both authoritarian and submissive, protective and servile—a stereotype that would be hard to shake off. The director thought she was "both Hepburns at once, Audrey and Katharine,"[4] that is to say, an explosive combination of romantic sensitivity and insolent stubbornness. Just think of her playing a pain in the ass in *That Man from Rio* (also 1964): Jean-Paul Belmondo indulges all her whims and is crazy about her. An exuberant baby boomer, itching with dreams of fame and the desire to live life to the fullest, she fascinated the photographers of Swinging London, above all David Bailey, as well as the movie makers of the French New Wave. But in reality, Dorléac straddled the '40s (she would have been amazing in the American screwball comedies of Leo McCarey or Howard Hawks) and the twenty-first century. As an ironic, spiritual workaholic, aware of her own neuroses, free and liberated, and sympathetic to environmental issues (she slapped anyone who killed a fly) she would have been wildly popular today.

"Often she said to me, 'It's the photo that's beautiful, not me,'" said Catherine Deneuve.[5] Here, in 1966, in front of Giancarlo Botti's lens, she's a natural beauty in jeans, cotton shirt with a small discreet print, and—what's that—an anklet? Under normal circumstances such a piece of jewelry worn in this location is a matter for the fashion police: it's heresy, a real killer detail. On anyone but Dorléac such a chain would indicate bad taste verging on vulgarity. But on her it's a playful accessory, a benign detail, a cute variation on a baby's wristband. It's the prerogative of complete charm: we can forgive her anything, even ankle chains.

Françoise Dorléac considered herself ugly, so much so that she said, "I remember myself as a kind of dancing flea."[6] But she had great taste: the shooting star of French cinema had been a house model at Dior in 1959 before going to theater school and acting in *Gigi*, the play by Colette starring Audrey Hepburn in 1952, when Miss Raspberry was still dreaming of being a nun. With the intuition of a kindly big brother, François Truffaut quickly understood the angst of the young woman who worshipped Greta Garbo and who, even at the age of twenty-two, feared she would undergo the same eclipse (albeit voluntary in Garbo's case). Moved by so much painful precociousness, Truffaut tried to convince her that "time's on her side," promising her a movie every six years, and making "dates in 1970, 1976, 1980."[7] It was like a trail of breadcrumbs set out in front of her, a tender but futile image that breaks your heart. Destiny caught up with this *demoiselle* too, cutting down Françoise at her promising peak. "If you look at them long enough, the stars give off a flickering, discontinuous clarity, and this light reaches us long after their death. It's a light that doubts itself, and this mysterious trembling, this hesitation between being and nothingness, is what enthralls us."[8]

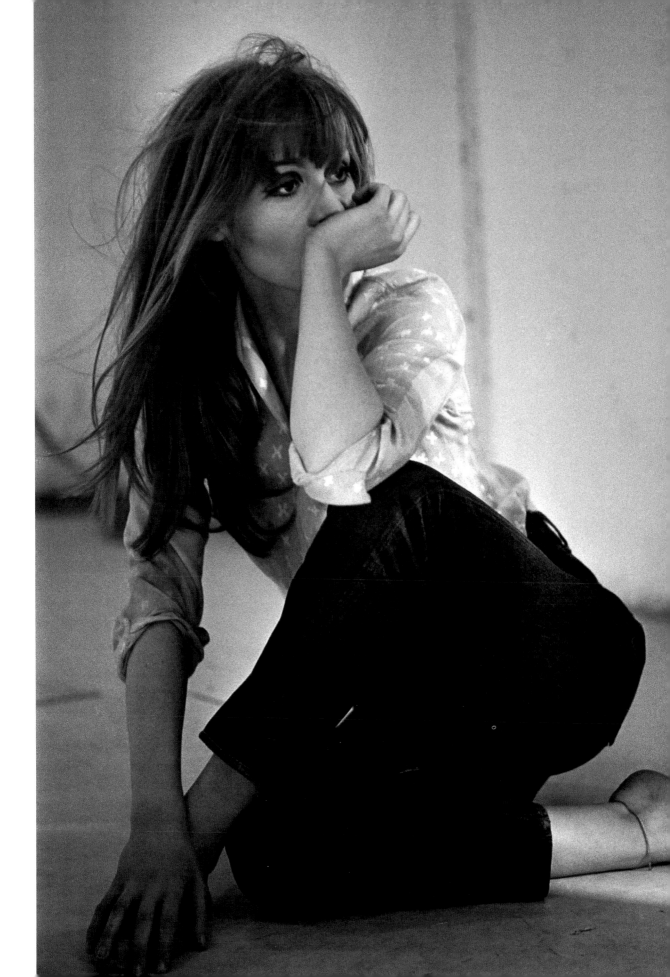

RAYMOND
ROUSSEL

— CARLSBAD, EARLY 1900s — BERNHARD WAGNER

The use of a linking device half-way down the body, either to bind together protective clothing, or to hang a codpiece from, has been known since people started walking on two legs. But what do anthropologists and historians of dress consider to be the idea behind the belt?[1] It marks the separation between the body's upper zone—the location of the soul, of breath, of the word; and the lower parts—the plumbing, the pantry, and the reproductive organs.

Is the belt, then, a moral demarcation line as much as it is a practical one? A kind of anatomical equator? We see one here, buckled around Raymond Roussel, the extravagant literary figure whose thick, rustic leather belt, in this full-length portrait taken by Bernhard Wagner in Carlsbad, contrasts with the refinement of a Belle Époque dandy taking the waters: immaculate homburg hat, pants with cuffs (still controversial at the turn of the century) and front pleats (which appeared around 1880). Then the mismatched belt, a detail concerning a detail, with many meanings.

Raymond Roussel was the most famous "un-read"[2] writer in modern literature. He was born on December 25, 1877 and died on July 14, 1933, a sybarite and wanderer (he discredited popular caravanning forever by inventing the house on wheels, 9 yards 2 feet long by 7 feet wide [9 m long by 2.3 m wide], with built-in quarters for the chauffeur and gentleman's valet), and a dedicated gourmet, who could proceed from one meal to the next without interruption, spending eight hours at the table. Financially, he was a multi-millionaire, thanks to the inheritance from his father.

The author of *Impressions of Africa* (1910) and *Locus Solus* (1914) produced novels and poems like a silkworm produces silk. Jean-Jacques Pauvert, Roussel's publisher, was astonished when *La Seine*, a finished play composed of several thousand alexandrines, resurfaced in 1989.[3] "At the age of seventeen," Roussel wrote, "I decided that in future I would only write verse."[4]

Grieving the loss of a "delightful"[5] childhood, and crazy about chess (his vault at Père-Lachaise cemetery contains thirty-two squares, like a one-sided chessboard), Roussel treated language like a game, deconstructing it and putting it back together like an all-powerful child. Fifty years later this would fascinate linguists, the Oulipo group (Georges Perec), and even Michel Foucault and Michel Leiris, but during his lifetime Roussel was completely unsuccessful. The last words of his autobiography are poignant: "And so I seek solace, for want of something better, in the hope that I may perhaps gain a little posthumous recognition for my books."[6]

What is the relationship between this (chastity?) belt, and "the greatest mesmerizer of modern times," according to André Breton?[7] A belt like this, solid as a girth, was needed to control the character of such a compulsive writer ("It took me seven years to write ... *Nouvelles Impressions d'Afrique*"[8]), to prop up the neurotic body (Roussel was treated by psychologist Pierre Janet) of this boundless but unhappy genius. "My soul is a strange factory/Where fire and water compete/God knows what fantastic cooking/These huge furnaces can produce."

But if the belt provides the finishing touch to a man's outfit, it can also be the means of committing suicide, although Roussel tried to kill himself by opening his veins on July 2, 1933 at the Grand Hotel des Palmes in Palermo, in room 224. He failed, and was saved. "Every day drugged and in an intense state of euphoria,"[9] he went on to take a massive dose of prescription drugs twelve days later. Checkmate. Death of Raymond Roussel in the hotel where Richard Wagner, himself a frequent visitor to Carlsbad to take the waters, finished writing *Parsifal* in 1882. Wagner, the name of the photographer who immortalized Roussel as you see him here. Death in the labyrinth, indeed.

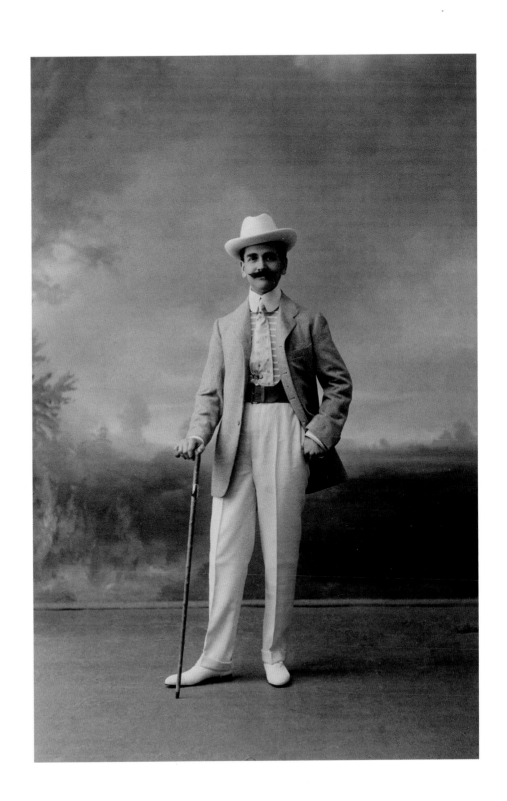

JIM MORRISON

— NEW JERSEY, SEPTEMBER 1, 1968 — FRANK LISCIANDRO

Jim is twenty-four. He has just three years left to live. Born three years earlier, under the auspices of Aldous Huxley and William Blake, The Doors[1] had released their third album, *Waiting For The Sun*, in July. In spring they had taken charge of the recording as well as the filming of *Feast of Friends*, a documentary about their North American tour. The evening this photo was taken, in Saratoga Springs, the last concert of the tour was filmed. They opened with the blues number "Back Door Man"[2] and closed with the long litany of "The End." The ecstatic crowd endured insults, watching the chaos develop until the Lizard King, in a shamanic trance, crawled down the stage and threw himself into the pit. In December 1967, in New Haven, Morrison had been the first rock star to be arrested on stage during a concert, charged with incitement to riot, indecency, and public obscenity. In March 1969, in Miami, he would be accused of exposing his penis on stage and simulating fellatio on guitarist Robbie Krieger. Sentenced to six months in jail, a threat that led to his exile in Paris, he died without being retried on appeal. But this afternoon of September 1, Jim is looking good, his dark hair turning heads (he had cut his lion's mane in May), and the ravages of alcohol and acid haven't yet turned him into a pot-bellied grizzly bear. The night before, The Doors had played Asbury Park. Morrison had missed his flight to Saratoga. On this airfield he's about to board a Beechcraft 18 (a liaison aircraft that his admiral father used while serving in the US Navy) which would take him there. He's accompanied by Frank Lisciandro, who had been a student with Jim and keyboardist Ray Manzarek in the cinematography department of UCLA, and who had been asked by the group to edit their documentary. It's the first time Frank has photographed Jim offstage.

Over a V-neck sweater in fine merino wool worn next to the skin (the same as on the album cover of *Waiting For The Sun*) Jim is wearing a leather jacket. On his shoulder he's carrying two white shirts straight from the drycleaners for the evening's concert. He's wearing his bad-boy black leather pants and his favorite concho belt in Navajo silver. It evokes the memory of a primal scene that haunted him: Jim is four. It's dawn in the New Mexico Desert between Santa Fe and Albuquerque. In his father's car, he witnesses an accident involving a truck full of Native American workers. They are lying bleeding all over the road. "That was the first time I tasted fear.... [and] the souls or the ghosts of those dead Indians ... maybe one or two of 'em ... were just running around freaking out, and just leaped into my soul. And they're still in here,"[3] he chanted on the album *An American Prayer*, and again in "Peace Frog": "Indians scattered on dawn's highway bleeding/ Ghosts crowd the young child's fragile eggshell mind."[4] The concho belt adds to the mystique surrounding the poet, who was passionate about Nietzsche, Rimbaud, Baudelaire, Kerouac, Artaud, and Michael McClure. It's a constellation of rings for a spirit dance, like so many totems caught in the vortex of dead souls.

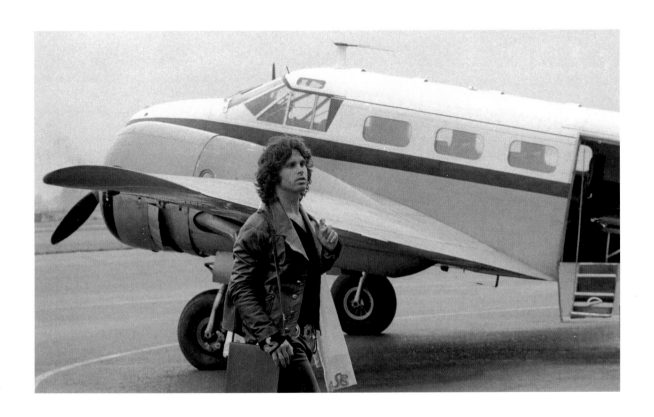

JANE
BIRKIN
AND SERGE GAINSBOURG

— CAP D'ANTIBES, 1969 — JEAN-PIERRE BIOT

"'69 Année érotique."[1] In the gardens of the Hôtel du Cap, away from the hustle and bustle of the Cannes Film Festival, Serge gives Jane a piggyback. He has not yet traded in his loafers for a pair of Richelieu Zizi dance shoes by Repetto (originally created for Zizi Jeanmaire), but already sports a three-day-old beard, and around his neck a long Indian silk scarf, echoing Jane's scarf-dress by Jean Bouquin (the link between Saint-Tropez and Paris's Left Bank). In February 1969 the song "Je t'aime … moi non plus" caused a scandal. Deemed obscene by the Vatican's newspaper, *L'Osservatore Romano* and banned in several countries, the song—whose record sleeve said it was "Not for sale to under twenty-ones," then the age of legal majority in France—was a smash hit in France and the UK. Written over the course of one night, originally for Brigitte Bardot, and recorded with her in December 1967, it had remained in a drawer after the heavy-handed intervention of Bardot's jealous husband, Gunter Sachs. The end of a beautiful, three-month relationship: Bardot left Serge who, still in shock, recorded in May '68 "Initials BB" ("Almost to her hips, she is booted/brimming, like a chalice, with her beauty"). Then Serge met Jane on the set of *Slogan*. Very quickly Gainsbourg and Birkin became the couple that symbolized an era of sexual liberation: of love and provocation, eroticism and advertising, poetry and shamelessness. Their relationship lasted twelve years, producing dozens of songs, millions in copyright fees, tears, and front-page headlines, representing a break with the past and the beginning of a legend. Jane once told us:

> He loved the difference in our ages. For him a song was 'a minor art reserved for minors.' France Gall was the most innocent, the perfect Lolita, as Vanessa Paradis would be later on. Me, I was twenty,

I was an average Lolita, and I had a baby. But I had this wonderful opportunity to embark upon a new childhood with him. He was my Pygmalion. Not only could he do everything with me, I was under his spell. Normally girls are shaped like an hourglass: out-in-out. Not me. And, rather than laughing at me, he said I had the body of a Cranach. So I went along to the Louvre to look at the Cranachs, and they really do have a wide pelvis, no waist, and tiny breasts. He always told me he was terrified of girls with breasts. My mother pointed out to me, however, that he hadn't been afraid of Bardot. But in her case, he'd got the girl he thought was the most beautiful in the world. When I played opposite Bardot in *Don Juan*, I tried to find out what her flaws were. There weren't any: tiny ankles, divinely constructed feet, waist, breasts, small hips like a boy. Upside down, the opposite of me.[2]

Nevertheless, in 1969 the Birkinesque figure of the child-woman emerged. Barefoot, the young English girl clutches her wicker basket, a little luxury that was very hippy-chic at the time. This was fifteen years before Jean-Louis Dumas created the Birkin for her, that large, oh-so-practical tote bag, destined, like the Kelly bag, to become an Hermès classic. *Autres temps, autres moeurs*.

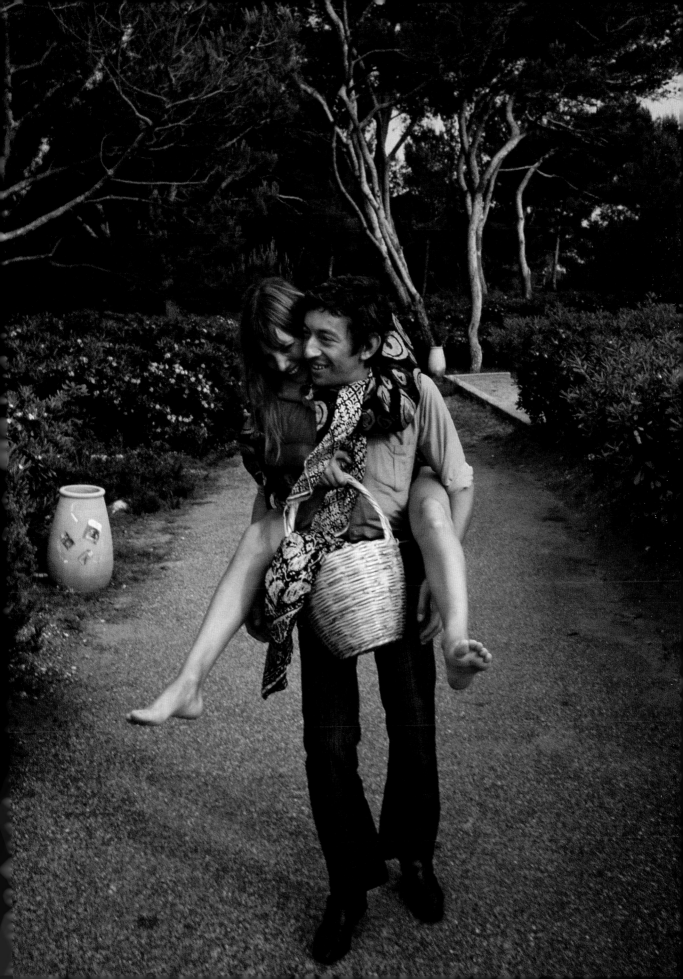

KANYE
WEST

— PARIS, 2009 — MICHEL DUFOUR

Check that! Kanye West and his posse at the Lanvin men's ready-to-wear collection. "B-Boys" sporting obvious signs of wealth: Vuitton, Goyard (the oldest Parisian luxury trunkmaker founded under the Reign of Terror in 1793), Gucci, MCM, Rolex. Kanye Omari West, the son of a Black Panther and an English teacher, the archangel of rap with attitude and a mini-goatee rose to fame in 2000 with the Roc-A-Fella record label. He went from the street to the front row, from the black suburbs of Chicago to European fashion weeks, and, for his fans, he has become a twenty-first century Gatsby. But unlike the impostor in F. Scott Fitzgerald's novel, who was fixated on shirts, Kanye's got a thing for sneakers. Shod in Vuitton and carrying a Goyard attachée case, Kanye is jubilant. His pimp wardrobe sums up thirty-five years of the incestuous relationship between rap music and luxury brands. Logos and logorrhea.

In 1976, a year before Kanye West was born, a new cultural movement emerged in New York's South Bronx: acrobatic street dancing around sound systems playing at full blast, inspired by Jamaican street parties. It was the birth of rap and hip-hop.

Scratching, mixing, break-dancing: the young "B-Boys" (i.e., break-dancers) and "Flygirls" loved it. Within ten years rap had become a phenomenal musical and sociocultural movement, with MCs drawing their fashion style from prison and sports uniforms, and an arsenal of hardware worthy of a pawnbroker, especially necklaces in the shape of dollar signs and knuckledusters. In the mid-'80s, the group Run DMC started a trend for hoodies, baggy pants, boxer shorts with visible branding, and "Dukie Ropes,"[1]

enormous heavy gold chains worn around the neck. In 1986, (Kanye West was nine and living in China with his mother), the single "My Adidas" determined the footwear of the Rap Nation and made the brand's fortune ("My Adidas and me are close as it can be, we make a mean team, my Adidas and me"). The middle class—both black and white—adopted the hip-hop look. The hoodie conquered the world. At the end of the '80s, rappers assimilated the luxury brands Gucci and, especially, their beloved Louis Vuitton. After Black Pride, it was now time for Gold Pride, and time to make money.

Twenty-five years later and the B-Boys have turned into the Bourgeois Boys. Rich and gentrified, Kanye West, Jay-Z, and Pharrell Williams get their suits made to measure by Oswald Boateng on Savile Row, or they favor streetwear, designing their own collections, and working with the brands they dreamed about in the '90s. Chosen as one of the ten best-dressed men in the United States by *GQ* magazine in February 2009, and with twenty-one Grammy Awards under his belt, Kanye West has launched his own clothing collection (DW Kanye West). He designs Air Yeezys for Nike and a line of luxury sneakers for Louis Vuitton, called "Don". Because when he started out, Kanye's nickname was "the Louis Vuitton Don," the godfather of Vuitton. From ghetto to aristo. *Watch the Throne*.[2]

The unsolved riddle: what's in the Goyard attachée case? Gold records or stacks of cash?

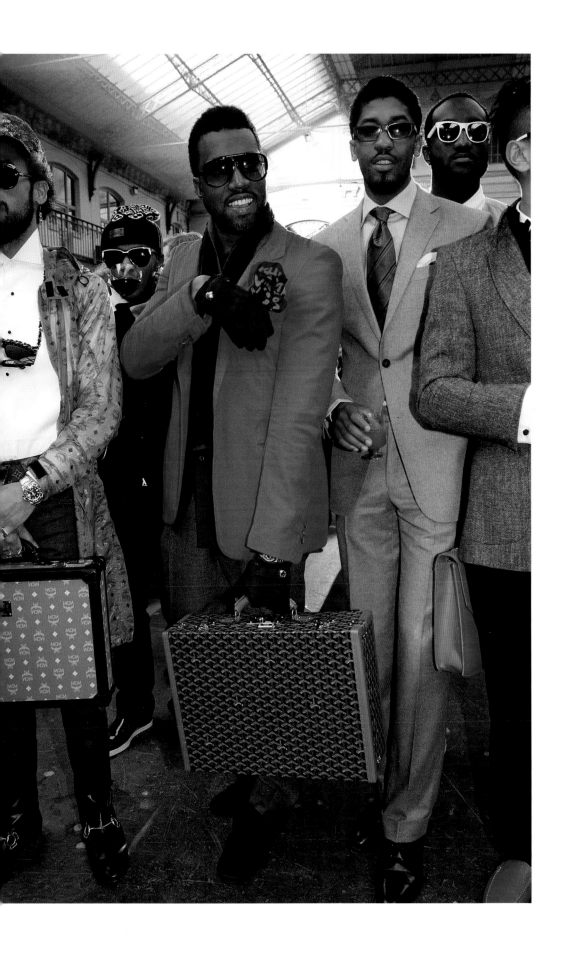

AUDREY
HEPBURN

A funny face on her Roman holiday. The face of a fawn, with a ballerina's pose dreamed up by Degas, taken by a photographer who was always larking around (Philippe Halsman, the inventor of "jumpology"[1]). And she's quiet as a lamb, with the artlessness of a twenty-five-year-old child-woman in the shade of a centuries-old olive tree. The ghost of a detail: a belt knotted at the back of the skirt. We can see it on another photo taken by Halsman on the same day. A glimpse behind the scenes. It looks like the knot in an apron belonging to a child, or to a farmer's wife getting ready to pick her olives.

But let's go back to this picture, taken under the tree of life. The year 1954 was exceptional for Audrey Hepburn: she won an Oscar for *Roman Holiday* (as well as the eternal gratitude of Vespa dealers everywhere, especially of the Vespa 125cc Cambio Flessibile, on which she scoots around Rome with Gregory Peck), and four days later she was awarded a Tony for her performance in *Ondine*, the play by Jean Giraudoux, on Broadway. This year also saw her marriage to actor Mel Ferrer, and the beginning of her friendship with Hubert de Givenchy. It began with Hubert owing Audrey a favor: when they first met in Paris, he was expecting Katharine Hepburn and nearly sent Audrey away. Stunned by her elegance, however, the couturier went on to dress Audrey in all of her films, from *Sabrina* to *How to Steal a Million*. Costume designer Edith Head, who also won an Oscar for *Roman Holiday*, didn't quibble about it.

Let's banish an old cliché. The Hepburn silhouette was so graceful and distinctive that Cecil Beaton spoke about Audrey Hepburn possessing "an almost Oriental sense of the exquisite."[2] However, her slimness (one hundred and ten pounds and five foot seven inches tall) was not the result of drastic dieting, but the consequence of the malnutrition Audrey endured as a teenager due to food shortages in the Netherlands during and after World War II (a diet of lettuce, potatoes, chickpea patties, and even tulip bulbs does not produce a Rubenesque figure).

When *Roman Holiday* appeared on screen, the Hepburn look became all the rage. It was simple, comfortable therefore practical, gracious without fuss: white shirt, little student-style scarf, mid-calf-length skirt, belt cinched around a wasp waist (that Italian *vespa* again), cropped pants, and size 8 (UK 6) ballerina flats. A seductive, androgynous, unaffected style became the epitome of modernity. The *New York Times* drew its own definitive conclusions: "Thanks to their first glimpse of Audrey Hepburn, in *Roman Holiday*, half a generation of young females stopped stuffing their bras and teetering on stiletto heels."[3] Fashion tipped over from the convex to the concave just at the moment when *Gentlemen Prefer Blondes*, the über-busty musical comedy by Howard Hawks, hit the screens. Billy Wilder enthused: "This girl, singlehanded, may make bosoms a thing of the past."[4] Flat and etiolated, this doe-eyed Giacometti (in 1957 sociologist Roland Barthes contrasted Audrey's face with Garbo's, describing Hepburn's as an "event" of the "woman as child, woman as kitten," and Garbo's as an "idea"[5]) suddenly seemed much more modern than the curvaceous figures of Lana Turner, Liz Taylor, Betty Page, Marilyn Monroe, and Jane Russell; much closer to the existentialist *gamines* of Saint-Germain-des-Prés than to the archetypes imposed by Hollywood or *Playboy* magazine. With just a few well-chosen basics—Capri pants, Ferragamo flats designed for her, black or white roll-neck tops, and of course the legendary Givenchy little black dress in *Breakfast at Tiffany's* (1961)—Audrey Hepburn became the symbol, both on the street and on the screen, of an essential aristocratic elegance; her mother, Ella van Heemstra, was a baroness. Add to this oversize sunglasses, "fly" or Ray-Ban, worn with silk headscarves knotted under the chin—she owned thirty or forty[6]—and Audrey Hepburn's Roman look is complete. Three months younger than Audrey, Jackie Kennedy certainly took a leaf out of Audrey's book.

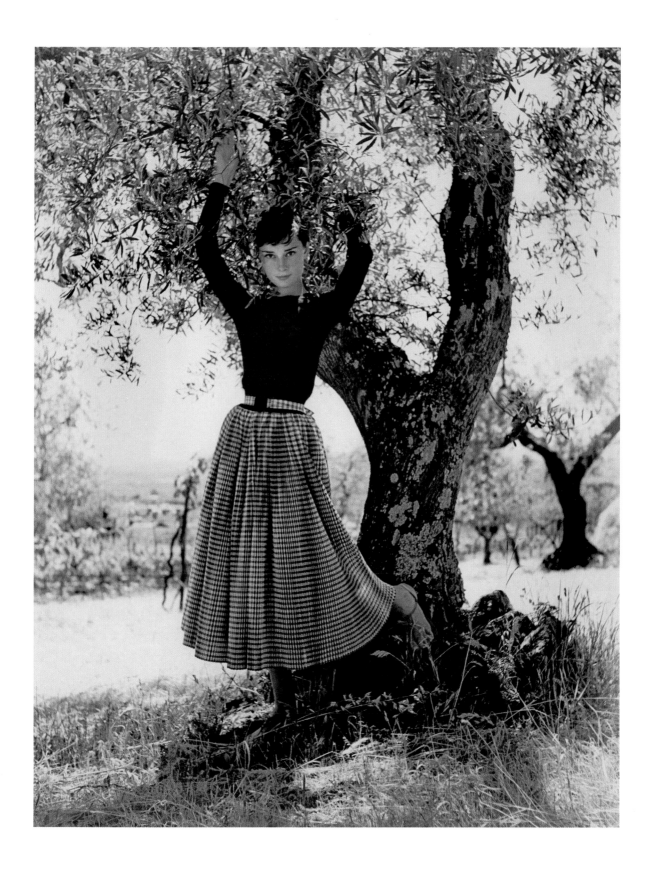

JOAN CRAWFORD

— CULVER CITY, 1935

Let's have a look: eyebrows plucked into the shape of swallows' wings, like Dietrich or Lady Gaga; little round sunglasses, as favored by early twentieth-century artists such as Mahler, Foujita, Mondrian, and Le Corbusier, and made fashionable again by Gandhi, John Lennon, Janis Joplin, and Giorgio Armani; versatile putty-colored gabardine raincoat; openwork strappy sandals, with small heels; sophisticated jumpsuit that looks good anywhere, indoors or out; you'd swear you're looking at the silhouette of an active, independent, perfectionist, self-confident, twenty-first-century woman.

Indeed, Joan Crawford, caught by surprise as she leaves her dressing room in 1935, was seriously ahead of her time. More than any other star of the '30s and '40s she was the incarnation of the gal who hadn't had an easy life, but who would go on to succeed through hard work, perseverance, and discipline. Women movie-goers identified with this tough cookie, who was queen of the box office during the Great Depression. "The women suffer along with Miss Crawford, but are reassured by what they know of her own career, which clearly states that a woman can triumph in a man's world." [1] For Lucille LeSueur—life had been a struggle since she was a child: at nine she worked at a dry cleaner's with her mother; at thirteen she did the dishes and made the beds for her thirty fellow pupils at boarding school, the only kid who was also employed to work there. After jobs as a sales clerk, dance-hall performer, and chorus girl on Broadway, young Joan was signed by MGM at the age of twenty. In *Our Dancing Daughters* (1928), she became the symbol of the flappers, those liberated girls immortalized by F. Scott Fitzgerald. The novelist of the Jazz Age found her swell: "Joan Crawford is doubtless the best example of the flapper, the girl you see in smart night clubs, gowned to the apex of sophistication, toying iced glasses with a remote, faintly bitter expression, dancing deliciously, laughing a great deal, with wide, hurt eyes. Young things with a talent for living." [2] Two years later, Joan shed the fluid, carefree gowns of the silent era in favor of the famous epaulettes that gave her a boxer's build, the armor of the little soldier of poverty. In *The Women* (1939) and *When Ladies Meet* (1941), Crawford goes into battle, all cheekbones and shoulder pads, in partnership with her costume designer, the brilliant Gilbert Adrian. Snappy and mean, she earned the reputation of Supreme Bitch, and she was the model for the wicked queen in *Snow White* of 1937—Joan of Arrgh! *Mildred Pierce* (1945) won her an Oscar (she had ordered her movie wardrobe from Sears, Roebuck & Co., to give Mildred a more authentically middle-class look). The ultimate transformation came in *Johnny Guitar*, Nicholas Ray's 1954 baroque Western: Crawford, "a will of iron behind a face of steel," [3] plays Vienna, the unforgettable saloon-bar owner, castrating but emotional, poured into black jeans and shirts buttoned up to the neck. Her camp performance turned her into a 1950s gay icon.

Did Joan Crawford know about the relationship between the struggle for sexual equality, and the wearing of pants? This fight had motivated suffragettes and feminists throughout history to wear pants, from Théroigne de Mericourt during the French Revolution and Amelia Bloomer in the nineteenth century (whose pants were "detrimental to the sanctity of British households," according to Queen Victoria [4]) to artists George Sand, Rachilde, Rosa Bonheur, and Colette, who played on her bisexuality by wearing pants, all the while commenting ironically on the creature she called "man–woman." [5]

Until the start of the twentieth century, a woman in pants was seen as "an anomaly, asexual, scarcely a person, a monster ... the third type of future humanity." [6] So this elegant pair of pants has come a long way. An instinctive feminist, Crawford wore pants, following Marlene Dietrich and Katharine Hepburn, and didn't make a fuss about it. At the time this photo was taken, in 1935, Joan Crawford was filming *I Live My Life*: a title, a motto.

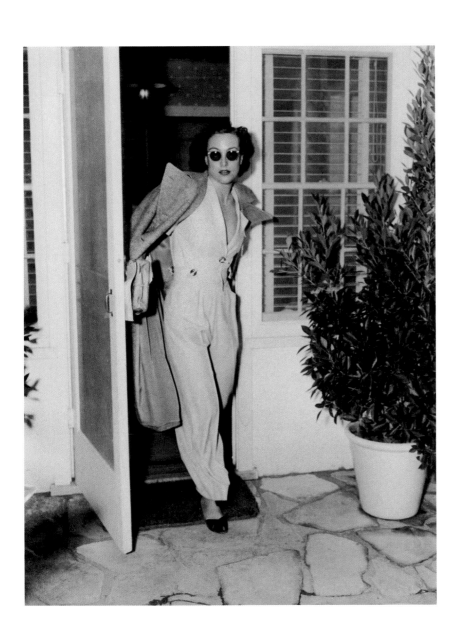

DAVID
BOWIE

— LONDON, 1974 — TERRY O'NEILL

Platform boots, a flamenco dancer's hat, gipsy blouse, dungarees corseting his feminine waist—here's gorgeous David dressed as his new alter ego. After Major Tom, Ziggy Stardust, and Aladdin Sane ("a lad insane"?), Halloween Jack has jumped out of his box. For Bowie, dressing up is second nature. Magnified out of all proportion, a pit bull protests loudly, baring its fangs and its balls. The original sleeve of Bowie's new album, *Diamond Dogs*, with Peellaert's drawing of Bowie with the body of a dog, was censored for showing the hybrid animal's genitals. Terry O'Neill, photographer to the stars, drove the point home. In 1974 Bowie the exhibitionist was showing reclusive tendencies. With his emaciated, coke-ravaged face, he was sinking into the paranoid delusions of his new metamorphosis. Haunted by Orwell's *1984*, Halloween Jack and his gang of Diamond Dogs hang out in the post-apocalyptic town of Hunger City. After giving birth to a generation of androgynous clones, overly made-up mutants in skin-tight jump-suits, platform shoes, sequins, garish satins, and feather boas, Bowie killed off Ziggy, his invasive double, one evening in July 1973 on the stage of the Hammersmith Odeon in London. Long live outrageousness and decadence! Down with good taste! Bolan and Bowie, the two "Bos," had been in charge of the pyrotechnics that launched this whimsical revolution. But Ziggy quickly pushed the Cosmic Crusader into the background. "The seventies came into full effect in January of 1972, when David Bowie reinvented himself as Ziggy Stardust. The role made him an instant megastar and gave him the momentum to stamp his personality across the new decade in the all-imposing way the Beatles had managed in the sixties," wrote Nick Kent.[1] In 1971, Bowie, languishing on a sofa, had already posed dressed as a woman in a virginal gown. On February 22, 1972, on the eve of his first concert with the Spiders from Mars, he made the front page of *Melody Maker* sporting red hair, and declared his homosexual experiences and his bisexuality. In the world of macho rock 'n' roll, this was a first—the revenge of Oscar Wilde, who had been condemned to prison for his "deviant" morality. Ziggy was the incarnation of the death of rock 'n' roll in a society infected with urban violence. Roland Barthes even compared Ziggy to Parsifal, regenerating humanity through his sacrifice. Like a human Xerox machine, Bowie photocopied and mingled the sequins of Broadway with the legends of Hollywood Babylon, Warhol's theories on celebrity, Nietzsche, Berlin cabaret kitsch, mime, the gay underground, space opera, Burroughs's cut-up technique, and avant-garde theater. Bowie asserts the ego, the parody, and the imposture created by art. If *Diamond Dogs* was the swansong of glam Bowie, the next transformation would not be long coming. Exile in Berlin, white soul, and krautrock— make way for the stripped-down aesthetic of the Thin White Duke.

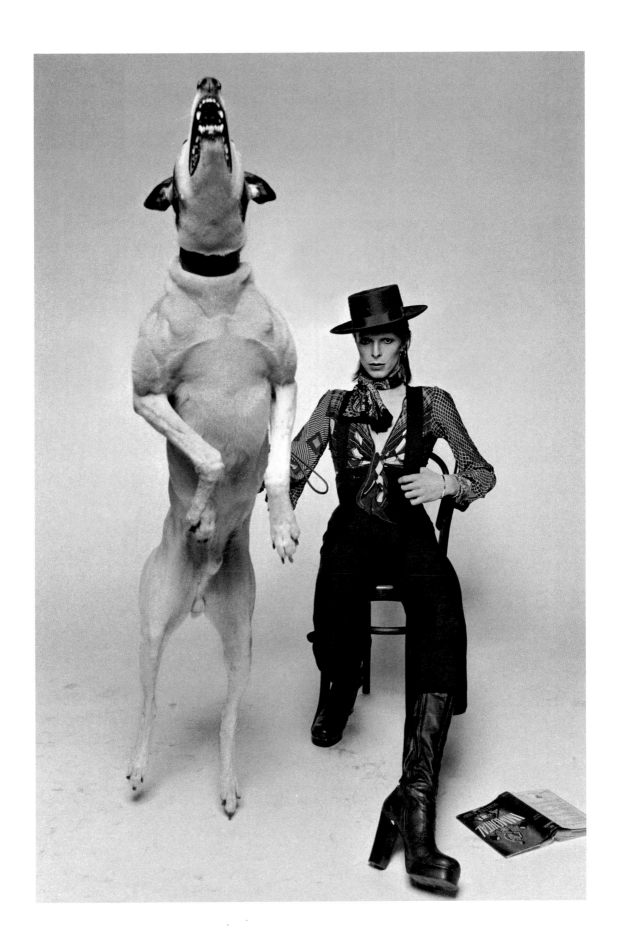

ANNEMARIE
SCHWARZENBACH

— ELBURZ MOUNTAINS, IRAN, 1935

It's the peak of androgyny. She's neither a tomboy nor a girl-who-should-have-been-a-boy, but a young twenty-seven-year-old woman with the stony face of an "inconsolable angel" according to Roger Martin du Gard.[1] Daughter of a rich, pro-Nazi, Zurich industrialist, Schwarzenbach detested her family's opinions and joined the struggle against Nazism (she was banned from entering Germany from July 1934 onwards). "She brings you all the troubles of Europe,"[2] commented the poet Catherine Pozzi, summing up the destiny of the pure, dark adventuress, whose life was a litmus test, revealing all the instabilities the continent of Europe experienced between 1932 and 1942. "When I think of Europe, I can find nothing that might keep me there, or that seems to me to any extent bearable."[3] Istanbul, Aleppo, Baghdad, Kabul, Beirut, Byblos, Persepolis, Shiraz, Tehran in 1933 and 1934, and Iran again in spring 1935, rallying from Beirut in a Buick-Packard in spring 1935. Leaving, returning, with a taste for the Orient: Schwarzenbach's short life took on this insatiable quest, traveling to and fro. "Down there, it's sun and shadow again, dust, solitude, reflection—and that's when the question of one's *aim* arises in its most cruel and most discouraging form."[4] Annemarie was a writer, journalist, and photographer; she worked as an archeologist at Ur in Mesopotamia, fought racial discrimination in the US, and spoke out against the living conditions of Afghan women. This vivacious, tormented woman was the traveling companion of ethnologist Ella Maillart, and, fleetingly, the girlfriend of Carson McCullers who, dazzled by her intensity, dedicated *Reflections in a Golden Eye* to her in 1941.

We can see in her bronze, embittered gaze what Annemarie herself called "die dunkle Seite"[5]—her "dark side." Her clothes are even more intriguing, lending her the appearance of a well-brought-up little boy. Immaculate sports shirt under a V-neck sweater, men's pants, ankle socks, walking shoes in unbleached canvas, and her hair parted carefully on the left. She looks deceptively like Tintin, the squeaky-clean boy reporter, and her overgrown Snowy was called Toufane. Nevertheless, an insolent femininity emanates from her pose. On their first meeting, Thomas Mann exclaimed: "If you were a boy, one would certainly say that you were extraordinarily beautiful!"[6] This confusion of genders was Annemarie Schwarzenbach's stock in trade. Just coming out of a painful separation from Baronness Maud von Thyssen-Bornemisza in 1934: "I have no desire at all to carry on living.... Maud: she's like a child full of tenderness and cruelty, and I'm leaving her with the feeling that it's all 'impossible' and deeply discouraged."[7] The following year she married a French diplomat, Claude Clarac, on May 21 in Tehran; two months after the wedding she scandalized the expat community by starting a passionate relationship with Yalé, the very young daughter of the Turkish ambassador, who died that same year. In *Death in Persia* she wrote: "Mother ... I did something wrong, right at the beginning. But it wasn't me, it was life itself."[8]

What is there to say, then, about the killer detail, the large bandage Annemarie is wearing on her left leg, the symbol of a life consumed by suffering? It looks like it has been applied in haste, and it is obvious that Annemarie couldn't care less. This pathetic little piece of gauze recalls her childhood, or the bandaged wrists following her suicide attempt in January 1935. It shocks us, as if foretelling the cycling accident that would kill her on September 6, 1942, on a Swiss mountain road.

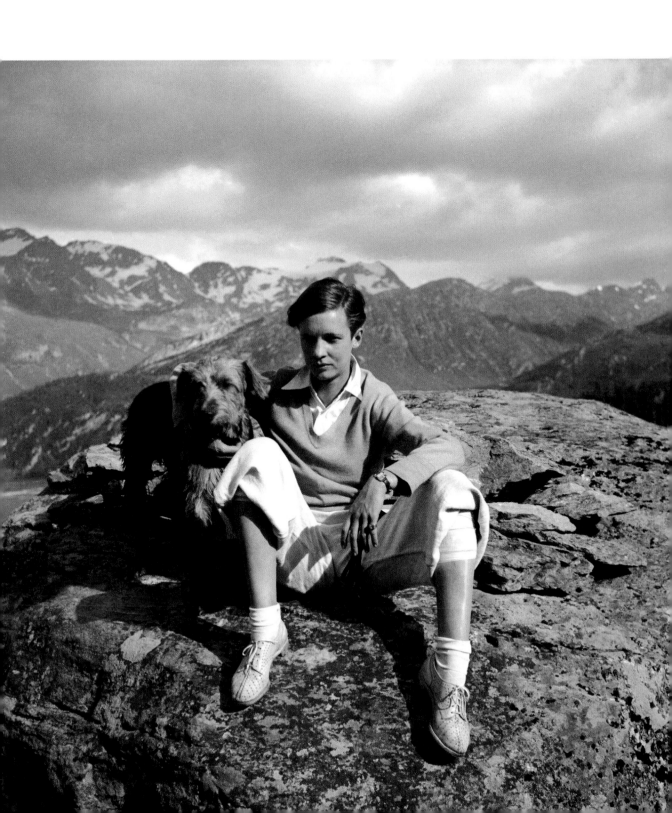

JEAN-PAUL
GOUDE

Caution! This photo demonstrates the use of optical effects: everything is real but nothing you see is authentic. In 1973, Jean-Paul Goude had been artistic director of *Esquire* magazine for four years. Based in New York, the French illustrator and photographer, son of an American music-hall dancer, haunted salsa clubs, fascinated by the appearance of Puerto Rican *salseros*. Goude laid down the laws of style in the quality press and, like a former "minet du Drugstore", a Parisian teenage trendsetter, he dreamed of remaking the badly dressed American man in his own image.

"I've always art-directed my appearance. Naked, I have short legs.... One day I ... visited John Lobb, the boot-maker in Paris. Being conservative, I wanted a traditional shoe with no high heel, so the only solution was to have lifts put in them. I was twenty then. I still go to Lobb's. Now I'm six feet tall!... I like white bucks too, and sneakers, but only with lifts."[1]

The derbies, or bucks, in this photo are in white nubuck with pink soles and are made by Cole Haan, the only possible option. The jacket, tight-fitting but with shoulder pads, makes both his waist and hips seem smaller. Relaxation, deconstruction. The pants recall those worn by Tintin, but they're actually sweats—originally designed for athletes to absorb perspiration, and keep the body warm before a competition, creating a psychologically cozy environment. They were revered by joggers before becoming the uniform for kids hanging out in the city or the suburbs in the 1980s.

In *Cheap Chic*, by Caterine Milinaire, the fashion bible for pre-hippy and hippy chic, Goude insists that a short man must wear fitted clothes: "James Cagney used to; so did Adolphe Menjou, even Fred Astaire. Did you ever see South American diplomats in the '50s, the ones who used to have their clothes made in Savile Row in London? They used to wear real tight jackets.... They were a reduced

version of the tall English dandies, only they had ... straight, shiny black hair.... Porfirio Rubirosa had that look."[2]

In 1972, Goude started writing a hilarious fashion advice column in *Esquire* magazine called "The French Correction," a sly reference to William Friedkin's movie about drug trafficking. In it he taught readers how to make the most of their appearance through the use of shoe lifts, platform soles, false shoulder pads, or false teeth, among other things—lots of handy hints to transform the thirty-something with hang-ups into a fashionable guy.

With his missionary zeal to improve the male silhouette, and as tireless proselytizer and inveterate optimist (improving men, he thought, was not an impossible task), Goude even appeared on American TV, putting his ideas into practice on a brave cowboy who allowed himself to be lifted up and slimmed down. Goude exaggerated his French accent: "Ze French art designer teaches ze American male to be a seduzer." With his turned-up nose and constant fidgeting, Goude looked like a little kid—or a hoaxer.

JOANNE
WOODWARD
AND PAUL NEWMAN

— BEVERLY HILLS, 1958 — SID AVERY

A couple in the kitchen, an ordinary enough image. Only this is *the* iconic couple of American cinema: Joanne and Paul, whose marriage would endure (with no disruption to service) for fifty years. Talk about an anomaly. Fidelity, in Hollywood? As rare as hen's teeth. But not for these two. They met in 1953 on Broadway. Paul Newman was appearing in *Picnic*, a play by dramatist William Inge, Joanne's teacher. But hands off—Paul was married. They met again in 1957, on the set of *The Long Hot Summer,* a drama directed by Martin Ritt. The rapport was incandescent, but no can do—Paul was still married. In 1958, once his divorce came through, the star of Arthur Penn's *The Left Handed Gun* married the actress who received an Oscar the same year for her triple role in *The Three Faces of Eve* (1957). Success and marriage: the Newman-Woodwards made fourteen movies together—four of them directed by Paul—had three daughters, set up a foundation for disadvantaged children called the Hole in the Wall Gang Camp, and celebrated their golden wedding anniversary in 2008, just a few months before Paul's death. What's their recipe? A deep bond and equality, as this photo appears to show: the gentleman is at the stove and the lady is cuddling Rat the dog, whom the couple would later give to Gore Vidal, and whom Greta Garbo would rename Ratzki, because "Rat is so brutal a name!"[1] Is he frying eggs? (Ten years later, in *Cool Hand Luke*, a dreadful indictment of the prison system, Newman would swallow fifty hard-boiled eggs in a row, in what has now become a famous scene.) Or perhaps it's a steak? On this subject Newman came out with a line that was as funny as it was sexist when explaining to *Playboy* magazine why he remained faithful to his wife: "Why should I go out for a burger, when I can have a steak at home?"[2] Years later, Joanne Woodward confessed that her husband's words had made her "want to kill" and could have finished off their marriage.[3] But this year, 1958, there were no clouds on the horizon. The time is morning and the outfits are minimal: the young couple go about their business, apparently unaware of the photographer, who was doing a story on the lives of celebrity families. Joanne sports the perfect Capri look: little linen pants, short-sleeved top, and flats—the uniform of modern young women eager for the emancipation brought by the end of the '50s, inspired by Audrey Hepburn and Brigitte Bardot. Paul Newman is a bit more mismatched: his top half seems to contradict the bottom. His thick cotton blouson jacket by Carhartt, a specialist workwear company since the end of the nineteenth century, corresponds to his Democratic, progressive, humanistic beliefs, while his penny loafers symbolize a more conservative Ivy League tradition. Cool and straight. On the other hand, Newman seems to have forgotten to put on his pants. Perhaps he's in a hurry to get on set of his new movie, *Cat on a Hot Tin Roof*, in which he's playing an alcoholic, tortured husband, who rejects Elizabeth Taylor—the reverse of Newman's own conjugal paradise.

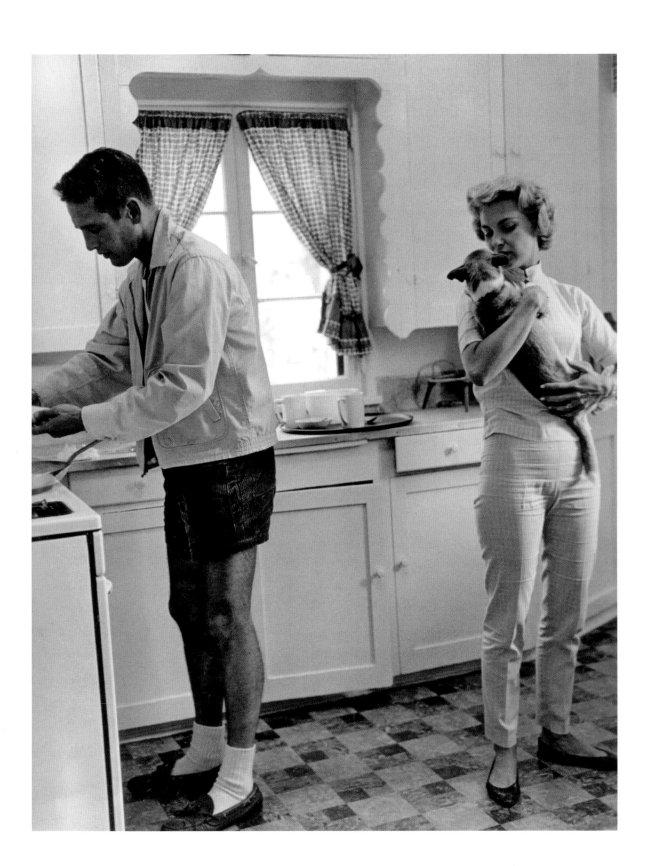

NEIL
YOUNG

— PHILADELPHIA, FEBRUARY 1970 — JOEL BERNSTEIN

With his favorite "Old Black" (a Gibson Les Paul 1952) at his side, a Martin D-45 under his elbow, and a Gretsch White Falcon asleep at his feet, The Loner is lost in thought. He's backstage during a concert with Crazy Horse at the Electric Factory, a former warehouse converted into a concert venue. Neil is young, just twenty-four. Joel Bernstein, the photographer, is eighteen. The image would be used on the inside sleeve of *After the Gold Rush*, the maverick's third solo album. The royalties allowed him to move to Topanga Canyon and buy his hundred-and-fifty-acre (60-hectare) ranch to the south of San Francisco Bay, which he called "Broken Arrow" (like the Western by Delmer Daves). Bernstein, himself a musician, music lover, and future collaborator on the astonishing publication of the Young archives (no mean feat given that Neil is an incurable collector), also took the album's cover photo. On the back cover there's a photo of Young's backside in patched jeans, anticipating by a year the photo (taken by Warhol) that showed Mick Jagger's jeans on *Sticky Fingers.* Long before the recurring fashions for worn jeans—jeans with industrial finishes, artfully torn, and customized, and which sell for a fortune—the patchwork of cashmere and Liberty print (totally Flower Power) on Neil's jeans was sewn by his wife Susan, just in the shot and credited for her work on the sleeve. Neil divorced her after just a year. Young, whose frugal taste for check lumberjack shirts (an inspiration for the grunge style later on) goes back to his Canadian childhood, says in his autobiography that Susan "made all of my patchwork clothes, creating a style that spoke to the times, really the only time I was anywhere near fashionable."[1] Can we see in these jeans the shreds of a love affair that was unraveling? Or the melancholy lacerations of a beautiful child struck down by epilepsy? Or the ghost of the Gold Rush and San Francisco, where jeans were invented a century before?

It was not until the '50s that jeans gradually became the uniform of American teenagers. At the time, the styles were cut to sit on top of the hips, neither low- nor high-waisted. The '60s saw the global spread of jeans, and the proliferation of different cuts. At Levi's, alongside the legendary 500 range (in dark red or light blue denim) there appeared Slim Fits (no. 618), which are cut more snugly, almost like tights, frequently in brightly colored canvas (as worn at the Living Theatre and in *West Side Story*), and the Californian, with a more generous cut, in thicker sateen cotton. Levi's rival Lee, was the creator of two new cuts: in the Rider collection, they created the Slim Fit (narrow but a little more regular than Levi's cut) and as a counterpart to the Californian, they made Westerners. At the start of the 1970s, ideas got bigger, waists dropped, and pants' hemlines broadened. Flares, whether boot-cut or bell-bottom, were all the rage, becoming more and more voluminous. The homemade jeans in this photo look like a modest boot-cut. But Neil Percival Young couldn't care less: "It's better to burn out than it is to rust."[2] The rivets on his jeans aren't rusting yet.

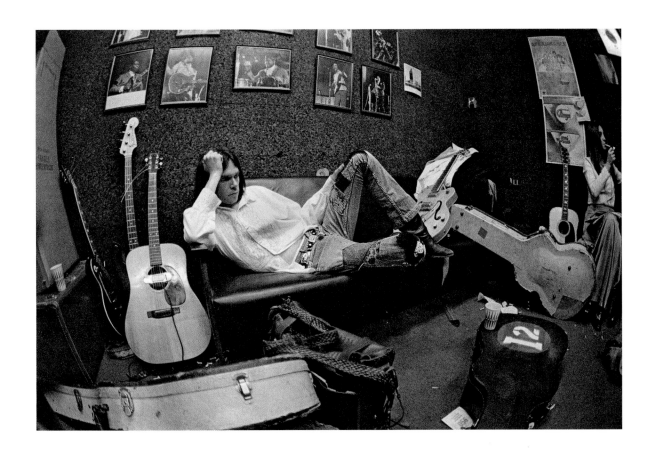

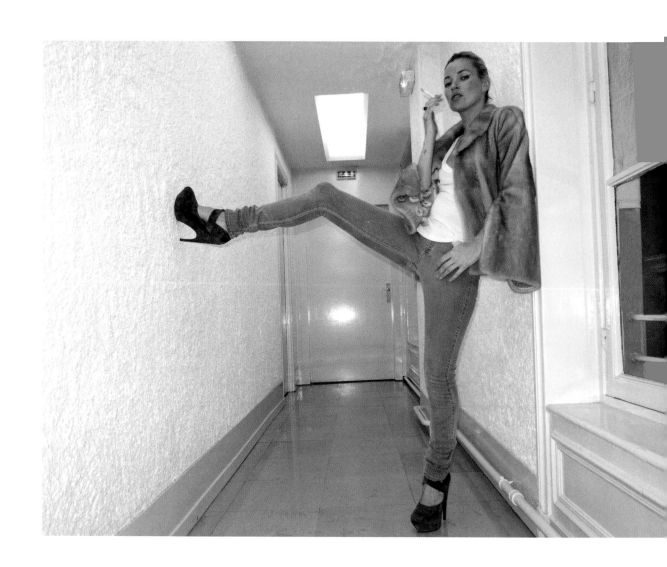

KATE MOSS

— PARIS, MARCH 2009 — OLIVIER ZAHM

Her pose is cool, even über-cool, with that *je ne sais quoi* (but we all know very well what), defiantly provocative in front of photographer Olivier Zahm, who can't help himself. There's also a hint of the self-satisfied gymnast. Don't forget that as a teenager Kate Moss (five foot seven, 33-23-35)—millionaire model, It Girl, international muse, fashion maven, and mother, the subject of many bodies of sociological study—was a skilled sportswoman, good at soccer, horse vaulting, and parallel bars. She was doing splits, as in this photo, ten times before breakfast when she was spotted by a talent scout at Heathrow Airport in 1988, which catapulted the undernourished, colt-legged, pocket-sized girl into the galaxy of international supermodels in scarcely a year.

They called her the superwaif. Just waif and see. And we've certainly seen, witnessing the birth of an icon. Kate was the lost child, the scrawny modern-day Shrimp, the rock'n'roll girlfriend anointed by her magnificent elder sisters Marianne Faithfull and Anita Pallenberg, and within a decade she became the incarnation of hedonism, materialism, and neoliberalism. Kate Moss: both her body and her destiny were flexible, as she evolved, transformed herself, shed her skin, collapsed, and then came back to life again. This Croydon phoenix has good genes. And good jeans—our old friend the skinny, the degenerate cousin of the slim-fit jean, a nightmare to put on (a real second skin, the process of putting on skinny jeans is incompatible with having either a spare tire or any shred of human dignity), and the scourge of the dieter. Media coverage of anorexia nervosa and studies of eating disorders carried out in the English-speaking world first emerged in the '90s, when skinny jeans began their unchallenged reign over teenagers who wanted to look like Kate Moss. They wanted to share her thinness, to be elegant little skeletons. As if bones weren't the degree zero of *eros* or libido.

Kate Moss has regularly been accused of starving herself before shows or shoots, of in effect promoting anorexia. But Ms. Moss has always laughed this off. Skinny jeans are rock'n'roll (and indie rockers sing better wearing skinnies), they make your legs look longer, they feel antibourgeois, rebellious, even anti-aesthetic. In short, skinnies are wicked, so go on, break a leg.

FRANÇOISE HARDY

— PARIS, 1969 — CHRISTIAN SIMONPIETRI

Who wouldn't love to be able to wear such short boot-cut pants, transecting the leg four inches above the ankle? Françoise Hardy has legs (and arms) that go on forever. A Capricorn with Virgo rising, one hundred and fourteen pounds, and nearly five foot eight, with her distinctive air of melancholy, tough androgynous looks, and old-fashioned sweetness, she is naturalness itself. Here, her hair is long, her bangs blowing in the wind, and she wears a long cashmere cardigan over a black T-shirt accessorized with a Chanel pearl necklace. Simple and extremely tasteful. Françoise Hardy once told us: "When I was young I didn't think I was beautiful. All through my childhood and adolescence my grandmother told me I was awful and that no one would ever like me."[1] Photographer Jean-Marie Périer, who adored her like a Pygmalion, was "fascinated by such a photogenic face, all the more so as she had no idea how powerfully seductive she was."[2] But he also remembers that when The Beatles, The Stones, or Dylan arrived in Paris they were all desperate to meet her. In 1964, on the back of the album cover of *Another Side of Bob Dylan*, you could read this poem: "For Françoise Hardy/At the Seine's edge/A giant shadow/Of Notre-Dame...."

This wild singer–songwriter (a rare example during the period of French pop called *yéyé*) was only eighteen when, in fall 1962, she had her first success. The songs of this "lost soul," which all the boys and girls of her age were longing to comfort, went global. Whether in Rome, Tokyo, or London, she was the ideal of French womanhood, and a fashion icon. With her model figure, miniskirts were made for her. The most daring French fashion designers competed to dress her: she was Courrèges's "space girl"; she wore Saint Laurent's tuxedo and Rabanne's chain mail (and donned the "most expensive minidress in the world," made from gold platelets encrusted with diamonds). But Françoise grew tired of all this. In 1969, the year this photo was taken, she released two albums simultaneously, *En anglais* in France, and *One-Nine-Seven-Zero* in Great Britain—the latter with different songs and never to be released in France—but in the end she was relieved to give it all up. Shy but determined: perhaps that's the secret to becoming a timeless icon? Who over the years has become a fixed star in the firmaments of English singer Damon Albarn, French singer Étienne Daho, French novelist Michel Houellebecq, and US rock star Iggy Pop.

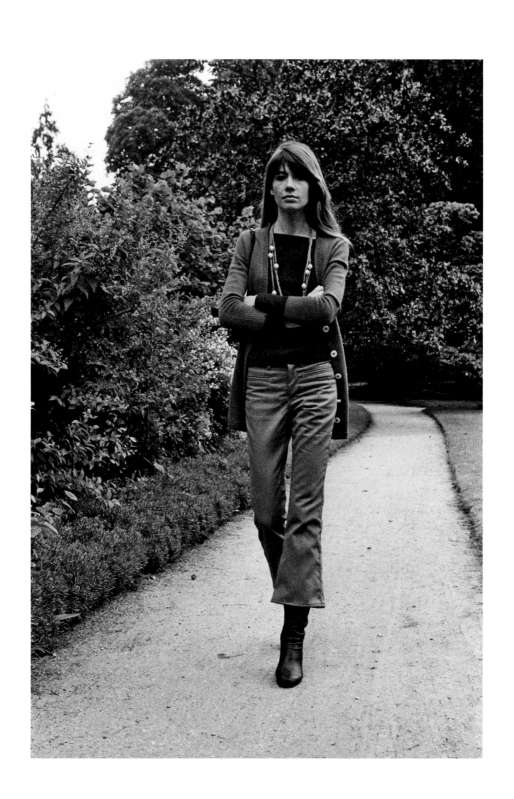

JIM HARRISON

— LEELANAU COUNTY, MICHIGAN, 1969 — JOHN SCHULZ

Out in the fields, bare-chested, arms outstretched, dragging on a Camel (American Spirits had not yet been created), it's *A Good Day to Die*. Jim Harrison is on his farm in northern Michigan. It was in this land of Great Lakes, rivers, and dense forests that the poet of *Plain Song* grew up and came back to settle down. It was here, where the spirits of the Chippewa Indians roam, that the teenage Harrison lost an eye in an accident that he would describe in many different versions. The mare looks relaxed. Jim, a mediocre horseman, liked horse-whispering. He once told us: "I'd happily come back as a bird, but I'd rather be a bear. I dream about bears, particularly when I eat bear meat, preferably a young female.... It's great to dream about bears, and I know an excellent recipe for stewed bear, but an old Chippewa once told me all about the violence inherent in the act of eating bear."[1] This (Indian?) summer in 1969, he had not yet written his novels—it would be ten years before *Legends of the Fall* brought him fame—and he wears, like every self-respecting farmer, a pair of Lee overalls. Unlike their rival Levi Strauss, the H. D. Lee company, from Kansas, has long favored overalls over jeans. So who invented jeans? No one individual. One fine morning in 1871, an obese miner, Alkali Ike, fed up with his pockets ripping under the weight of mined nuggets, walked into the store of Jacob Davis, a small tailor in Carson City, Nevada, and demanded an untearable pair of pants. Davis came up with the idea of putting copper rivets at the points of greatest tension, and he created the prototype: brown canvas pants with a drop-seat, buttons for the straps, and a handwritten label in the small of the back. The tailor, a Russian emigré, stocked up on fabric on Battery Street in San Francisco at the store of Levi Strauss, who was originally from Bavaria, and had settled in the northern Californian town during the Gold Rush. The two men formed a business and, in 1873, registered a patent for the rivets, which guaranteed them an unassailable advantage over their competitors. The same year saw the official birth of jeans. Levi Strauss made the "denim XX 501" (on view at the Smithsonian Institution in Washington, D.C.), a pair of overalls cut off at the waist, and called it the "waist overall" to distinguish it from the "bib overall." The double X indicated extra-resistant material, while 501 was the number of the batch. (The label with two horses urged on by farmers trying in vain to rip apart a pair of jeans only appeared in 1886, and the small red label on the back right pocket only in 1936). The Lee company, founded in 1889, specialized in working clothes, and in the 1920s came up with a new line called Rider, with a round gusset for horse riders (more comfortable) and with zip fastenings. Their slogan: "Western pants approved by leading cowboys, rodeo performers, and cowhands." On the back pockets there's a wavy yellow line of top-stitching symbolizing the horns of the Longhorn bull. You might prefer that to Levi's double arc of top-stitching in orange thread, representing the eagle flying over Jim's beloved Rocky Mountains.

AVA
GARDNER

"She spelled trouble for every guy that made a play for her!" claimed United Artists' publicity department in 1946. Hard to believe it, looking at this adorable schoolgirl in shorts and short-sleeved blouse, a complete Goody Two-shoes. But let's look a bit closer. The predatory smile, high cheekbones, dimple, and fluffy brown hair: could it be the barefoot contessa[1] herself, in sandals? Or a little queen on her chariot? It is indeed Ava Gardner and, according to MGM's publicity department, she was "the world's most beautiful animal," and the prototype of the Hollywood femme fatale—"I'm poison . . . to everybody around me," she says in director Robert Siodmak's *The Killers*. She was too beautiful for them all, too sad (or too perceptive) for this kind of circus. She married Mickey Rooney (was that a joke?), Artie Shaw (a communist band leader who drew out her intelligence), and Frank Sinatra (their marriage was a prison, but he was the love of her life), and she was best friends with Ernest Hemingway and Howard Hughes. She was a vamp, a "1930s playgirl," as Ava herself described her character Pandora in *Pandora and the Flying Dutchman* (1951), casting off her melancholy, mystical power; she was an enchantress, a torch singer, a Torchy Todd bombshell, and a goddess. She was also a tomboy. The daughter of farmers, she was raised with a whole bunch of brothers and sisters—"I loved games, I loved action, and I could match most of the boys."[2] Instead of the feel of mink on her skin and the smell of rice powder, Ava Gardner preferred "the feel of baked earth, green grass, soft mud, and stream water under my feet."[3] And what she liked

when she was ten, she still loved aged thirty, even if opportunities for being in the great outdoors were less frequent on the streets of Hollywood than in North Carolina—which perhaps explains the bicycle. That same love of the sensations of the natural world probably also explained her enjoyment of blood sports with Hemingway in Cuba, Spain, and Africa, not to mention the erotic pull she felt when watching a corrida, and her passionate affair with bullfighter Luis Miguel Dominguin. It also explains her haughty indifference to the bonfire of the Hollywood vanities, and her later exile in London.

But here, in this photo, Ava Gardner is pedaling radiantly, confident of her youthful strength, with tanned legs and bare arms. As an item of sportswear, shorts became popular in the United States in the mid-1930s when Helen Jacobs, a woman tennis player from San Francisco, dared to wear a pair on court instead of the long skirt favored by Suzanne Lenglen. The shorts Ava Gardner is wearing here are the height of modesty: nothing like hot pants, those mini-shorts associated with the Blaxploitation culture of the '70s that James Brown sang about: "Hot pants, make ya sure of yourself, good Lord!"[4]

This is a decent little pair, which she would perhaps take with her on the set of *Mogambo* in Tanzania, and which she could take off as often as she wished, because even when married to Frankie she was still a free spirit. The lady may have been a tramp, but she was also "a gent," as director George Cukor remarked admiringly.[5]

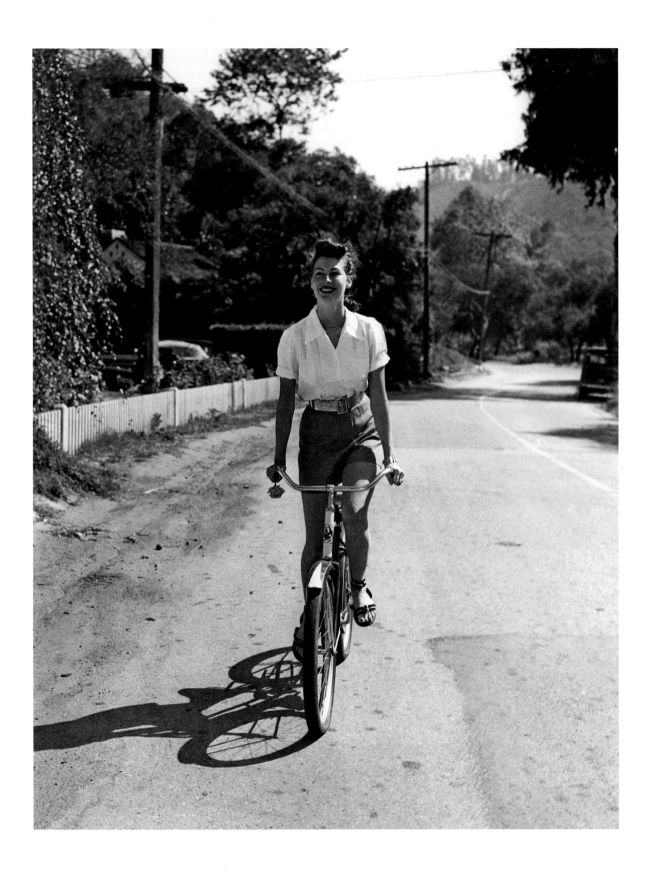

FRANÇOISE
SAGAN AND
ANNABEL SCHWOB

— SAINT-TROPEZ, SPRING 1957

What are they reading? *Var-Martin*—whose front page is no doubt advertising the presence of twenty-two-year-old Sagan and her entourage at the vacation villa of La Ponche. They were a lively bunch of wunderkinder: model Annabel Schwob, novelist Bernard Frank, playboy movie maker Roger Vadim, dancer Jacques Chazot, old friend Florence Malraux, another playboy-actor Christian Marquand, composer Michel Magne, and Popof the dog. In short, Paris by the sea, Saint-Germain-des-Prés in Saint-Tropez. In addition, Annabel's T-shirt is black, the favorite color of the French existentialists, just like Françoise's shirt. One can clearly see where the young novelist did not spend the enormous royalties from her first novel—her wardrobe. Her pants are nothing to write home about, and her shirt is minimal and functional. But this isn't the point. Sagan had been famous since the publication of *Bonjour Tristesse* in 1954. The writer, who François Mauriac called the "little witch on her solid gold broomstick,"[1] had turned old-fashioned morals upside down, and stepped on the gas in a sports car that had taken everyone by surprise. Five foot five and barely one hundred and ten pounds, with a pseudonym that showed an excess of self-confidence (she got it from a character in Proust's novel *Remembrance of Things Past*), Sagan (born Quoirez) influenced her times like a young, featherweight prophet, and transformed them. "Instinctive and sly,"[2] written in six weeks on amphetamines, and published by René Julliard (cult writer Raymond Radiguet's publisher), *Bonjour Tristesse* told a generation traumatized by the war that it had given birth to youths who were egoistic, hedonistic, and amoral—seductive, slightly wicked young people for whom Sagan was the high priestess.

This generation did not want to be respectable just because they were born into respectability, and their female representatives demanded pleasure without marriage, as well as the right to tan their legs in Saint-Tropez. They were making up for lost time. The Vatican rushed to ban the novel, undoubtedly due to the provocative statements made by Cécile, the heroine of the book: "I was fond of repeating to myself sayings like Oscar Wilde's: 'Sin is the only note of colour that persists in the modern world.' I made it my own with far more conviction … than if I had put it into practice."[3]

Annabel Schwob, aged twenty-six, was one of Sagan's closest friends. Her situation in life was more vague, but her dress sense much more assertive. Her short shorts speak volumes. Cut like a girdle, such shorts aren't for sand and beach-ball games, preferring afternoon naps or sexy barefoot dancing to the strains of *Round Midnight* by Miles Davis.

The shadow of Bernard Buffet is hovering over these two young women, but they don't know it yet. Recently separated from Pierre Bergé, who had run off with Yves Saint Laurent, the painter Buffet met Annabel the following year in Saint-Tropez and married her in December 1958. As for Françoise, she went off the road driving her Aston Martin just a few days after this photo was taken. It took the rescue services thirty minutes to free her from the smoldering wreck. She was given the last rites but survived, although during her convalescence she was prescribed Palfium 875, a form of morphine that left her with a taste for drugs. She described this story in *Toxique*, the diary of her addiction, which was published in 1964 and illustrated with poignant engravings by Bernard Buffet.

JAMES JOYCE

— PARIS, 1939 — GISÈLE FREUND

A portrait of the artist as an old man. "Paris rawly waking, crude sunlight on her lemon streets. Moist pith of farls of bread, the froggreen wormwood, her matin incense, court the air."[1] Paris had been James Joyce's adoptive city since 1920. *Ulysses*, his masterpiece begun in 1914 and finished in 1922, was published there in English, then in French, by Sylvia Beach and Adrienne Monnier, the two lovers who owned the Shakespeare and Company bookstore on rue de l'Odéon ("Gentle river of sun which carries on its banks/Our booksellers."[2]). It was Beach and Monnier who helped photographer Gisèle Freund to produce her collection of portraits of great writers of the twentieth century between 1933 and 1940. In the case of Joyce, whom Borges called "almost infinite," the story was utterly bizarre: at the age of fifty-seven, the writer had eye problems and hated the harsh lighting required to take color photos. Gisèle Freund used elaborate tactics to achieve her portrait, which was destined for the cover of *Time* magazine. Sylvia Beach suggested she write to Joyce using her married name, Gisèle Blum, "which happened to be the same as one of the characters in *Ulysses*,"[3] (the pronunciation of Bloom is the same). Joyce was amused, and agreed to be photographed by Freund, but on the day of the session, he was so nervous he hit his head violently against a ceiling light and cried out to Freund, "I'm wounded, you're trying to kill me!"[4] before collapsing into an armchair. Remembering that (great) men are mere babies when it comes to their health, the photographer pressed the two cold blades of a pair of scissors against Joyce's forehead to relieve the pain, then pressed the shutter release. The writer's two hands bear witness to his nervousness: one curled up and the other looking as if it is protecting a small sickly animal. On leaving Nora and James Joyce's apartment, Gisèle Freund got into a taxi, which promptly crashed into another car—windows shattered and the camera was hurled through the air. Shocked, Freund called Joyce and made another appointment for the following day, during which he was just as anxious. In the meantime Gisèle Freund managed to rescue the film from the broken camera. She made two series of portraits and Joyce was delighted with his photo.[5] "Our friend Bloom turned in handy that night."[6]

Although he carried out various assaults on syntax and grammar in *Finnegans Wake*, Joyce's appearance is traditional. One comment he is said to have made to his portraitist is worthy of Sacha Guitry or Oscar Wilde: "Never mind my soul.... Just make sure you get my tie right." Straight as an arrow, the Irishman's tie bears a Scottish motif, and his cufflinks and cardigan buttons display a fierce rejection of casualness. As for the dressing gown with its shawl collar (correct form since the seventeenth century), it is "cocoonfortable," as Joyce would say. Did Joyce happen to read Diderot's ironic meditation on his own dressing gown? *Regrets on Parting with My Old Dressing Gown or A Warning to Those who Have More Money than Taste* (1772) describes a sumptuous "scarlet" dressing gown (like Joyce's) given to the unfortunate Diderot by the grateful hostess of a literary salon he frequented. But in Diderot's heart the new dressing gown, symbol of the compromising behavior of artists tempted by luxury and comfort, can never replace his beloved old coat: "It was used to me and I was used to it. It draped itself so snugly, yet loosely, around all the curves and angles of my body—it made me look picturesque as well as handsome. This new one, stiff and rigid as it is, makes me look like a mannequin.... Oh, Diogenes! How you would laugh if you could see your disciple now, wearing the ornate coat of Aristippus! ... My friends, see to it that you hold fast to your old friends."[7] Joyce did not frequent salons, lived frugally, and never succumbed to the siren call of ostentation. He's just a man, wearing the dressing gown of "Everyman or Noman."[8]

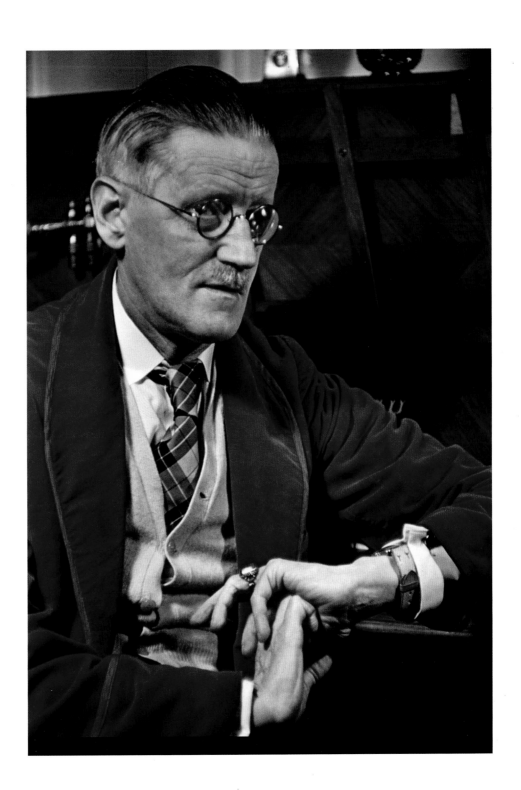

BALTHUS

— ROSSINIÈRE, SWITZERLAND, AUGUST 2, 1993 — DOMINIQUE ISSERMANN

A bed of roses for the king of cats. Ten years after an enigmatic back-view self-portrait, which was exhibited during his huge retrospective at the Centre Pompidou in Paris, here Balthus looks at us face-on, a tad wearily. His pose suggests both surrender and vigilance, presence and absence, as in so many of his disturbing, fairy-tale paintings, where the activities of brazen teenagers seem to be in suspended animation, isolated from the rest of the world, and frozen in suspense. Balthasar Klossowski de Rola (did he invent this noble lineage?) was a protegé of Rainer Maria Rilke. The latter encouraged him to paint and wrote the foreword to his first collection of drawings, *Mitsou*, in 1921. He was adored by Antonin Artaud, André Breton, and André Malraux, who appointed him director of the Villa Medici in 1961. By 1993, he was the high priest of figurative painting, the "reincarnation of the Tuscan painters he revered, such as Piero della Francesca."[1] Alone on the rarefied mountain peaks from where he contemplated with nostalgia Renaissance Italy or the nineteenth century of Courbet, Balthus reveled in his solitude and his status, a living legend in the world of painting. Playing the recluse in a sumptuous chalet in the Swiss canton of Valais, Balthus spent his days dressed in a kimono and surrounded by his cats.

The cosmopolitan Russo-Polish artist was born in Paris in 1908 and had been traveling throughout Europe since his childhood. But it was not a taste for Orientalism that led him to wear this indoor coat, an item of clothing highly regarded by the European élites since the seventeenth century, a period of intense trading between Holland and Japan via the East India Company. Rather he wore it out of love for his second wife, Japanese artist Setsuko Ideta, who herself dressed in the fashions of the Meiji period. An enthusiast of the indoor kimono, Balthus doesn't go so far as to wear getas and tabis, wooden sandals and socks that separate the big toe. He remains supremely Western, the aristocratic incarnation of an acute self-awareness, and an extreme (perhaps feigned?) indifference. Dominique Issermann recalls:

Vogue magazine had asked me to take a portrait of Balthus and to photograph the studio where he painted under conditions of natural light. Since the beginning of the 1980s he'd been living in an amazing, ancient wooden chalet that reminded me of a giant version of Hansel and Gretel's house. The previous owner had had inscribed on the facade in wooden letters: "Oh Mortal, how ridiculous and vain is your pride." When I asked Balthus for permission to photograph his studio, he refused as he was in the middle of a painting. He also didn't want me to photograph him. I was disappointed so I took a huge close-up of the lock of the studio door, another of the lead in one of his pencils that was lying around in a room, and a final one of a palette spattered with dried paint. I had a Hasselblad, and I gave him the three Polaroids I'd taken of the photos. Balthus looked at me with his incredibly sharp eyes and a slight smile. That evening, the Count took dinner. The chalet observed the refined rituals of a minor country house. Entering the dining room I set the Hasselblad on its tripod in front of Balthus and said: "You should let me take a portrait, because you are too handsome!" and I released the shutter four times. Balthus didn't protest, but he was taken aback by my transgression of his ban. Also, in the fourth picture he turned his head away. I found him very impressive. The kimono seemed completely unexotic when worn by him; it was more like an outfit he wore every day around the house. Unfortunately I didn't find out whether Balthus painted wearing his kimono. His wife, Setsuko, wore one too. Balthus claimed to be eighty-five years old. Was that true? He was very magnetic, with his face like a baby bird of prey, his incredibly delicate skin like parchment, and his expression like a secret warning—don't go too far! As I left the chalet I learned that he would have preferred me to photograph just his wife, Setsuko Ideta.[2]

KIRK
DOUGLAS

— ROME, MARCH 1954 — BENNO GRAZIANI

Issur Danielovitch Demsky, who took the name Kirk Douglas when he joined the Navy in 1941, has been a star for five years now. He's played a boxer in *Champion*, a pro-Native American trapper in Howard Hawks's *The Big Sky*, and an odious movie producer in Vincente Minnelli's *The Bad and the Beautiful*. Enchanted by the beautiful eyes of actress Pier Angeli, he went to film in Italy. She left him for James Dean; Kirk left her for producer Anne Buydens, whom he would marry in May 1954. He has just played Ulysses alongside Silvana Mangano as Penelope. For Benno Graziani's photograph he has cast aside the swords and sandals in favor of pajamas. *Paris Match*'s star photographer (married to the model Bettina) immortalized Kirk's athletic body under the spring skies of Rome. A predatory smile, piercing blue eyes, the dimple cutting into his chin, hands in his pajama pockets, jacket fastened with a single middle button. Cotton pajamas, so much chicer than silk. This "ragman's son," born into a family of poor Belarusian immigrants (an anti-McCarthyite, he would remain an active Democrat his entire life) had come a long way. As had pajamas. Derived from the Persian word *payjama* ("leg clothing"), becoming *pajama* in Hindi, the garment was brought to Britain from the Indies by some old British colonialists who adopted them as nightwear at the end of the nineteenth century. Pajamas did not, however, oust the nightshirt as the norm for men's sleepwear until just after World War II. If female bathers of the 1920s made pajamas on the beach fashionable, it was as nightwear for men that they really caught on. By the '70s pajamas had become the Eastern outfit of the moment, lulling Westerners—of both sexes—to sleep.

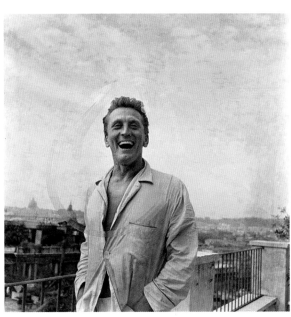

ANGELINA JOLIE

— LOS ANGELES, 1996 — LIONEL DELUY

Paris, France, the late nineteenth century. The French capital, with its gaslights and immaculate, Haussmann-designed streets, considered itself the center of the world, the embodiment of entertainment, luxury, the arts, and technological innovation. The World's Fair of 1889 was the apotheosis of this, with the erection of Gustave Eiffel's fantastic iron lady, which fashion writer Baroness d'Orchamps thought looked like a woman's leg with "the four pillars as the straps of the garter belt." [1] However, another equally universal invention was also on display at the fair: the brassiere, developed by Herminie Cadolle, a Parisian hosiery and corsetry pioneer. Cadolle could trace back to classical times the use of bands to flatten or support the breasts, where the garments were known as *apodesme* and *mastodeton* to the Greeks; *tænia* and *strophium* to the Romans. Madame Cadolle's patent was for a *corselet-gorge*. Healthy living and sport were all the rage at the time, and the demands of the suffragettes—whose message of emancipation would certainly have been taken up by Angelina Jolie—were pertinent and insolent. Concerned with women's well-being, Herminie Cadolle had a simple but brilliant idea and a revolutionary way with scissors: she cut a corset in two, at a stroke altering forever the collective imagination and the language of modern eroticism. Farewell steel stays, strangulating laces, painful busks made of wood, metal, or ivory!

The taxonomy of the brassiere developed in stages: from the *gorgerette,* which sounds like a type of birdsong, to the basic *maintien-gorge,* and finally the *soutien-gorge,* which appeared for the first time in the French Larousse dictionary in 1904.

Two straps fixed to a wide elasticized band—the rubber boom in the far-off Amazon supplied Europe with precious gum rubber, which was used in the manufacture of elastic thread—lifted up breast supports that would eventually become bra cups.

Marie Cadolle designed brassieres for Mata Hari; in 1925 Marguerite Cadolle, her daughter-in-law, created for Coco Chanel a flattening model known as "le boyish form" (an idea as absurd as dry water). The fortunes of the brassiere (and of the Cadolle company) were assured.

Put it on show but keep it off limits; liberate the breasts but constrict them; suggest and hide: this is the obsessive to-ing and fro-ing between opposites in eternal combat, which are also the source of eroticism. And to judge by the flirtatious gaze of the future Lara Croft (photographed at age twenty-one by Lionel Deluy), and in particular by her trashy, pinup pose: cigarette in temptress mouth, smoky-eyed, unwashed hair, breasts perfectly enshrined in an embroidered bra—breasts that she would sacrifice twenty years later in a preventative double mastectomy—these opposites are nothing new to Angelina Jolie.

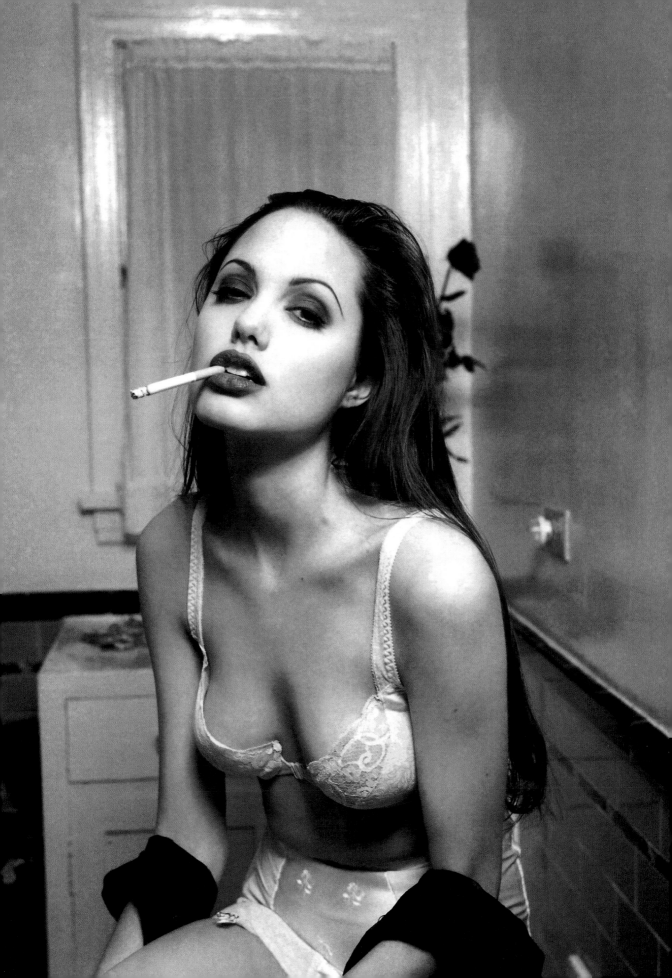

TILDA SWINTON

— PARIS, 2007 — PETER LINDBERGH

Under the black silk of her tuxedo, the white skin of a redhead; and in the V formed by the lapels, her bra's center gore—a piece of black material that joins the two demi cups to form a tiny triangle of desire between the breasts. It offers a hint of the bust of an actress who is idolized by the fashion world as much for her willowy figure and her aristocratic bearing as for her avant-garde tastes. Katherine Mathilda Swinton, daughter of an upper-class Scottish family, studied at West Heath Girls' School in Kent (where she was in the same class as Diana Spencer), earned a degree in social and political sciences at Cambridge (where she joined the Communist Party), and began her career at the Royal Shakespeare Company, before making her name in movies in the role of the blood-spattered Queen Isabella in *Edward II,* then in *Orlando* (directed by Sally Potter, based on Virginia Woolf's novel), where she changed sexes over the course of centuries without aging. For this role Swinton was inspired by Claude Cahun, saying: "Cahun looked at the limitlessness of an androgynous gesture, which I've always been interested in."[1] Swinton's career has taken her from an amoral female executive in *Michael Clayton* to the White Witch Jadis in the *Narnia* movies, and she has always remained supremely independent. Her "flirtation with fashion" began in 2000, just after she had finished filming *The Beach* with Leonardo DiCaprio, when she asked her friend Jerry Stafford for advice on what to wear on the red carpet at film festivals. He introduced her to Viktor & Rolf who, in their 2003 "One Woman Show," sent models looking like Tilda clones down the catwalk. She moved on to Albert Elbaz (Lanvin), Haider Ackermann, Stefano Pilati (Yves Saint Laurent), Phoebe Philo (Céline), Raf Simons (Jil Sander), and Alistair Carr (Pringle of Scotland). These friendships have been her introduction to fashion, as she told *W* magazine: "For someone to know what you need

to make you comfortable, they need to know who you are. Having them make clothes for me is like being cooked for by someone who knows what you like to eat."[2] At the start of 2013, she became the face of the new Chanel collection, photographed in a castle outside Edinburgh; she took part in *The Maybe* at MoMA, New York, as part of a live artwork; and she starred in the video of "The Stars (Are Out Tonight)" as the wife of David Bowie, her androgynous alter ego. In this photo her haunting beauty inspires photographer Peter Lindbergh, whose use of black and white in his sensual but never shocking portraits evokes the look of 1920s Berlin, the expressionism of Murnau and Fritz Lang, Joseph Kosuth's conceptual art, and the Ruhr landscapes of August Sander. In fall 2012, she worked with Olivier Saillard, director of the Musée Galliera in Paris, on the performance piece *The Impossible Wardrobe*, drifting like a timeless muse through the history of high fashion: "She wore a blouse made of beige cotton—the material garment bags are made of,"[3] and was thus able to pretend to "wear" items from the museum's costume collection. "Cléo de Mérode's corset-top, Arletty's hat, the Comtesse de Greffulhe's coat are all waiting, nestled in their cotton garment bags. Without ever putting them on, Tilda Swinton offers up these feathered garments, holding them gracefully against her body.... She makes visible the living memory of life.... In Swinton's arms a fashion show of centuries past comes alive like soft sculptures that seem to contradict all the intentions of fashion.... Tilda Swinton herself becomes the canvas in which one can carefully wrap the everyday shreds of taffetas or muslin.... In her beige blouse, with wraparound skirt and wrapover top, she becomes the slow-breathing wooden mannequin that no fashion museum has ever held in its collection."[4]

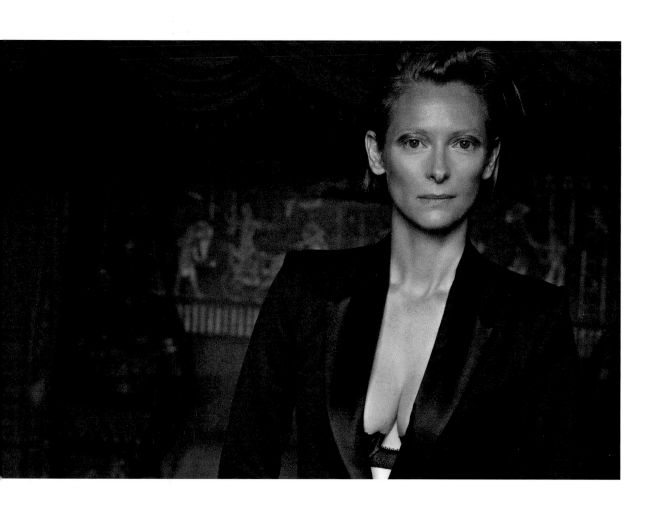

RITA
HAYWORTH

— LOS ANGELES, AUGUST 1941 — PETER STACKPOLE

If you can't take your eyes off Hollywood's most famous contribution to the war effort during World War II, hundreds of thousands of GIs were in exactly the same position—although many were holding the photo with just one hand. It may seem crude to say so, but that was the purpose of pinups: looking at them in a state of arousal allowed the boys to relieve their pent-up sexual energies and go off to the front feeling calm. The glittering world of entertainment was thus transformed into a (hormonal) accessory of the military-industrial complex, and it was unstoppable.

This photo of Rita Hayworth on her bed at home, wearing a silky nightgown, was taken by Bob Landry and published on the cover of *Life* magazine on August 11, 1941. Three days later Roosevelt and Churchill signed the Atlantic Charter; four months later the bombing of Pearl Harbor forced the United States to join the war against Japan and the Axis powers. On the fuselages of fighter planes and bombers, and on airmen's jackets, the pinups paraded their curves, inspired by the drawings of Alberto Vargas, Gil Elvgren, and Milton Caniff, and by their models, Betty Grable, Ava Gardner, and Rita.

The H-bomb in this photo is twenty-two and radiates with a restrained sensuality. Her expression is soft, almost verging on the melancholic. Her elegant pose is an invitation to lust, or eternal sleep. But this serenity is only for show, just a mask. Her life was tainted by abuse. Her incestuous father was a professional dancer who took Rita out of school when she was fourteen so she could perform with him in the dives of Tijuana. Her mother was an alcoholic. Her studio boss, Harry Cohn, was a bully who sexually harassed her. Her violent husband, Eddie Judson, prostituted her for all Hollywood to see. And on top of this, Rita had to suffer the processes of turning herself into an "Anglo" actress, whose looks would be acceptable in Hollywood. (Her metamorphosis, egged on by Judson, made her a martyr to hair removal by electrolysis, molar extraction, diets, and other physical humiliations.) Once tamed, Rita "Hayworth," formerly Cansino, became a star in three movies: *Only Angels Have Wings*, *The Strawberry Blonde*, and *Blood and Sand*. Seeing this photo on the cover of *Life* magazine, Orson Welles is said to have exclaimed: "That's the girl, I'm gonna marry her!" And he did, in 1943. Fitting in with her husband's schedule, Rita cheerfully ran herself ragged in the Mercury Wonder Show, a magic revue produced by Welles to keep up the troops' morale. Around the time of *Gilda*, she was the undisputed patriotic icon, and was officially crowned by the US Navy as "the redhead we'd most like to be shipwrecked with."

On the private front, the breakup of Hayworth and Welles was brewing: fed up with the daily presence of the movie genius, Rita Hayworth started divorce proceedings. Welles created an extraordinary memorial for her in the shape of a parting gift: *The Lady from Shanghai* (1947), a dreamlike psychodrama about adultery and betrayal, which also gave the finger to the conformism of the studio system: Welles got rid of Hayworth's auburn locks—which she tossed so unforgettably in *Gilda*—transforming the torrid "love goddess" into a deadly, platinum-blonde seductress.

The black-satin and white-lace nightgown that had turned on so many men during the war was rediscovered and came up for auction at Sotheby's in 2002, where it was sold to an anonymous admirer for $26,888. Perhaps it was bought by a war veteran, in an echo of Orson Welles's unrealistic vow on the death of Rita's character Elsa Bannister: "Maybe I'll live so long that I'll forget her." [1]

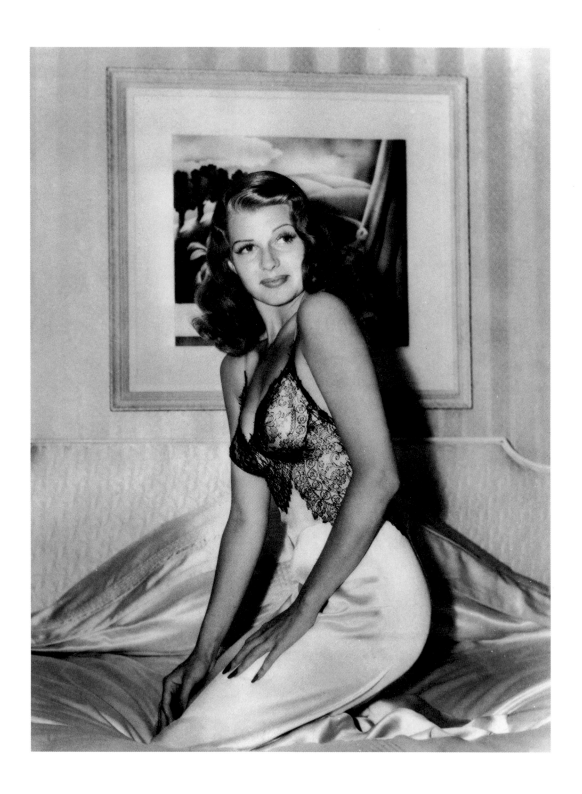

PJ HARVEY

— ENGLAND, 1993 — RANKIN

Tie yourself to me
No one else, no
You're not rid of me
You're not rid of me
Night and day I breathe
Hah hah ay hey
You're not rid of me

The musical sensation of the '90s, on vinyl and on stage, Polly Jean Harvey growls, moans, and pants. Her desolate, visceral singing style delivered a knockout punch to punk rock. Her first album, *Dry*, was hard-hitting. The Madonna of grunge was twenty-three. Her second album, *Rid of Me*, was even better, or even worse. Her words ricocheting and clothes discarded, tortured PJ growled in her bra, posed in her shorties, prayed in her panties.

I beg you my darling
Don't leave me
I'm hurting

Slip, lick, slick. This photo is just as playful too, taken by Rankin, cocreator of *Dazed & Confused* magazine, who worked on advertising campaigns that protested violence against women. Whose idea was it to set up the photo of this panty manifesto? In any case, we're a long way from the innocent, childlike shores of Petit Bateau undies. Founded in 1918, ten years after the death of the corset, Petit Bateau underwear was necessarily white (peaceful?) and necessarily made of cotton (non sexy?).

Lick my legs I'm on fire

Like Polly Jean Harvey, these panties are English. They're made of smooth fabric that slips and slides, making it easy to wear skin-tight clothing ever since the '70s. By contrast, Harvey makes nothing easy. She peels the onion of social and sexual deceit down to the quick. It's harsh, feral, and anything but comfortable. It doesn't slip and slide, it wrenches.

Lick my legs of desire

Underpants are a strange item of clothing: out of all the types of women's lingerie they're the least sexy—utilitarian, standardized, and anonymous. A museum in homage to underpants opened in Brussels in 1990, because "everyone is equal before briefs," according to its founder Jan Bucquoy, a surrealist agitator and prankster film director (*La vie sexuelle des Belges*), who also opened the city's (dressed) women's museum. It's worth noting that PJ Harvey's panties are not part of Bucquoy's collection—twenty-four choice models including those worn by the cream pie flinger Noël Godin. Briefs are ugly. Nevertheless, they express something honest and uncompromising. These undies make no concessions or compromises in silk and lace, nor in humor or sweetness.

I'll make you lick my injuries
I'm gonna twist your head off, see
Till you say don't you wish
you never never met her

MARILYN
MONROE

— LOS ANGELES, MAY 18, 1950

The chrysalis and her chihuahua. A stunning young actress posing like a pinup in the suburban backyard of Johnny Hyde, agent at the William Morris Agency and Marilyn's former lover/stepping-stone to glory. Although it doesn't show, Marilyn Monroe has had a hard life. Shunted from pillar to post, from Tennessee to the Van Nuys suburbs, the little orphan had swapped her ordinary name, Norma Jeane Baker, for a fashionable first name, and dyed her dull red hair photogenic blonde. In 1950, Marilyn was infamous rather than famous. She had not yet become the gorgeous child who inspired Truman Capote to create the character of Holly Golightly in his novel *Breakfast at Tiffany's*. She was light years away from rivers of diamonds and "boo-boo-be-do," from fatal glamour and disastrous beauty. She would still have to dash bravely from photo shoot to photo shoot, selling sodas, swallowing insults, touching flesh far less appetizing than her own, posing lewd in the nude against a purple background for Tom Kelley's Golden Dreams calendar, and appearing in the Marx Brothers' *Love Happy* (in the tiny role of a client of Groucho's detective. Marilyn murmurs to Groucho: "I want you to help me. Some men are following me." To which he responds lecherously: "I can't understand why.") Johnny introduced her to John Huston and then on to Joseph Mankiewicz. In *Asphalt Jungle* (on American screens in 1950), Marilyn had three short scenes, tying herself in knots to nail the part. In Joseph Mankiewicz's *All About Eve* (filming at the time of this photo), she snared a tailor-made role: a bubble-headed starlet using her charms to get ahead. This "graduate of the Copacabana School of Dramatic Arts" asked of theater producers: "Why do they always look

like unhappy rabbits?[1]" Following a screen test for Twentieth Century Fox in December 1950, Darryl F. Zanuck gave her a six-month contract. A week later, Johnny Hyde died of a heart attack. His protégée was launched into the stratosphere.

During the '50s, she wore the famous Obus model of brassiere, designed by aeronautical engineers at Hughes aviation and marketed by Maidenform. In *Gentlemen Prefer Blondes*, Marilyn's chest was busting out of her red sequin dress to such an extent that the famous French critic André Bazin commented: "Her breasts are the only kind of obus I like."[2] In this photo, however, she wears a wrinkled bra top and big undies. Bathing suit or underwear? The jury's out: big nylon granny pants were all the rage in the '40s: practical, comfortable, and above all flattering, creating a slight girdle effect on rounded bellies. Just weeks shy of her twenty-fourth birthday, "The MMM Girl" sure knows how to wear the (under)pants.

JACK KEROUAC
WITH WILLIAM BURROUGHS AND PETER ORLOVSKY

— TANGIER, FEBRUARY 1957 —ALLEN GINSBERG

Are they Beat angels on a desolation beach? Under the winter sun in Morocco, all the musketeers of the Beat movement are here except one—Neal Cassady, hero of *On the Road*. In February 1957, William Burroughs, a junkie to his bones, had been living in Tangier for three years. Allen Ginsberg and Peter Orlovsky, who had been Ginsberg's lover for three years, met up with Burroughs at the Villa Mouneria. Jack Kerouac joined them, followed by Gregory Corso. Ginsberg took this photo with his pocket Kodak Retina camera and wrote the caption underneath. While cosmopolitan Tangier gets on with its business (the docks and customs office can be seen in the background), Jack and Peter make faces at the camera. Hands behind his back to make his chest jut out, standing upright on his muscular legs after a freezing swim in the Atlantic (his talent as a football player earned him a scholarship to Columbia University), Jack has rolled his damp boxers over his hips (the brotherly war between pouch-front briefs with their kangaroo-like fly and boxers began just after World War II; prior to that, long johns reigned). Stretched out on the sand to check out the local boys, and fully dressed with rolled up cuffs on his jeans and an army surplus parka, William turns his head towards Allen. Ginsberg, who had published *Howl* the previous year, dreams of universal homosexuality. Orlovsky is writing his first poems. Kerouac, who had problems tolerating the local hashish, was suffering fits of paranoia as he typed the hallucinatory ravings of *The Naked Lunch*, dictated by Burroughs. It was the first time Jack had set foot outside the American continent. Before he left, he had delivered the *On the Road* manuscript to Viking Press (it would be published in September), a magnificent solo played to the rhythm of bebop—Bird's breathless, hyped-up improvisations, and the controlled energy of jamming—written in three weeks in 1951 on a single roll of paper and under the influence of benzadrine (Jack had written a first draft at high speed in 1948, just after his journey across America with Neal Cassady). There had been nine years of gestation before Jack was eventually crowned King of the Beats, and was immediately misunderstood. Although Jack had brought together the terms "Beat" and "Generation" for the first time in 1948, he didn't identify with beatniks, a word that would not exist until 1958, when it was coined by Herb Caen in the *San Francisco Chronicle* to describe a youth tribe fascinated with the trinity of "sex, drugs, and bohemianism." These baby boomers made *On the Road* their bible and copied the half-student, half-hobo look of the Beat poets: blue jeans, khakis, sweaters, chambray shirts, tartan Pendleton lumberjack shirts (a precursor to grunge), battered leather jackets, etc. This rebel generation who idolized Kerouac and inspired so many careers: Bob Dylan, John Lennon, The Beatles, Jim Morrison, Lou Reed, or Patti Smith. The old clothes worn by the original Dharma Bum died hard. In 1994, twenty-six years after Kerouac's death, Johnny Depp bought one of his old raincoats at auction for fifteen thousand dollars. But by 1960, destroyed by alcohol, the "patron saint of hitchhikers" withdrew to live with his aging mom, becoming sedentary, devout, conformist, reactionary. The icon of the counterculture had settled down, and reached the end of his road.

ELIZABETH
TAYLOR
AND MICHAEL WILDING JR.

— LOS ANGELES, 1954

"They stole my childhood!"[1] Who is speaking? Ironically, given the scene, it's Liz Taylor herself. In *Elizabeth Takes Off*, her autobiography, she evokes a Stakhanovite, lost childhood: lessons in singing, horse riding, and dancing from the age of three; her mother, a frustrated former actress who dashed from casting session to casting session to find work for her child; a first role at the age of nine in *There's One Born Every Minute!* As soon as Sara Taylor had prized open the gates of MGM, Elizabeth had her first successes in 1943 in *Lassie Come Home*, and especially in *Grand National* with Mickey Rooney, a twenty-four-year-old veteran of the film industry. Violet-colored eyes (offset by a double row of eyelashes caused by the genetic condition of distichiasis) and her pinup figure would bring her a lasting and triumphant place in the sun.

But here, it's 1954. A mother cat on a hot (tin?) lawn introduces her petrified kitten to the paparazzi. The wager: to prove to Hollywood's gossips, and columnist Louella Parsons in particular, that this voluptuous body has not been ruined by a first and very recent pregnancy. Divorced from Conrad Hilton Jr. at nineteen, Liz is showing off the fruit of her second marriage to British actor Michael Wilding, whom she met on the set of *Ivanhoe*. Liz poses like a calendar girl (since 1953, Bettie Page had been revealing scenes from the erotic underground in her movies *Striporama* and *Varietease*) and the leopard-print swimsuit—no doubt designed by her friend Frederick Mellinger, founder of Frederick's of Hollywood—underlines the message.

The inventors of the one-piece swimsuit, intended to replace the earlier, more voluminous bathing costumes of the turn of the century, would have found it hard to imagine in the 1930s that this item of clothing—which left the skin exposed for "sunbathing" as popularized by Coco Chanel, the novelist Colette, and art patrons Charles and Marie-Laure de Noailles—would one day abandon its sporting purpose to become a suggestive item of clothing, inspired by strategic ulterior motives, and made sophisticated with diamonds and satin sandals. In short, a swimsuit that no longer has anything aquatic about it.

By showing off her baby swaddled in leopard-print fabric, Liz Taylor, who had suffered so much at being treated like a doll by her own mother, launched, with a steely humor, a tradition of which the "Brangelina" Jolie-Pitt tribe is the most recent example: displays of trophy children, mini-me's produced to heighten the reputation of their star parents.

After the death of his mother at the age of seventy-nine on March 23, 2011, Michael Wilding, himself in his late fifties, said: "My mother was an extraordinary woman who lived life to the fullest, with great passion, humor, and love."[2] We can believe it. But here, in a sun-drenched Californian garden, Michael is only one year old, and the humor of the scene is inadvertently down to him: under Tarzan Junior's swimsuit his diaper is showing.

URSULA
ANDRESS

AND SEAN CONNERY

— JAMAICA, 1962

This swimsuit shouldn't exist. In the script of *Dr. No*—the first movie in the James Bond series that would make actor Sean Connery famous, producer "Cubby" Broccoli rich, and a twenty-five-year-old unknown with a strong Germanic accent one of the legendary sex symbols of Hollywood—there was no bikini. Honey Rider was supposed to exit the water naked, like Eve, wearing only a knife-belt. And God—a.k.a. Ian Fleming, the all-powerful creator of the spy on Her Majesty's secret service—created woman.

However, the Hayes Code, defender of impeccable screen morals, would not have allowed this. So Terence Young asked the first Bond girl to cover up. On the basis of this fortunate piece of frustration, the collective imagination could go to work.

It is February 1962, on Laughing Waters beach at Ocho Rios. Andress is (un)dressed in the most famous bikini of the twentieth century. We know that it was cut from two small pieces of white canvas and hand sewn by the movie's designer.

In this photo, is the bikini as dry as Bond's martinis or totally drenched? Whatever the case, it arouses the irrepressible male desire to show off to the girl with the honey-colored skin.

Orson Welles once declared that there were two unforgettable opening scenes in the history of world cinema: Omar Sharif in *Lawrence of Arabia*, and Ursula Andress in *Dr. No*. Desert desires and Venus emerging fully formed from the waves.

Thanks to director Terence Young's movie, the bikini took off like a thunderball—thanks also to the straightforward opinion of Diana Vreeland, the American style maven, who said: "The bikini is the most important thing since the atom bomb."[1] Nevertheless, the bikini's commercial beginnings were French: encouraged by the end of World War II, which promised the return of beach vacations, a swimwear manufacturer, Louis Réard, introduced a "revolutionary" collection, four days after an atomic bomb test was carried out by the US Army on Bikini atoll in the middle of the Pacific (an incongruously named ocean) on July 6, 1946.

"The bikini, the first anatomic bomb," according to its inventor's slogan, was considered scandalous as it put women's underwear on public display. Patented and sold in a matchbox, the Réard bikini at first came up against problems: the press were shocked, despite arguments that associated exposure to the sun with health-giving properties, and local laws banished the bikini from French beaches.

Illegal in several European countries, the bikini's fate in Spain was enviable, thanks to the mayors of Benidorm and Marbella, who were able to persuade General Franco to allow bikini-wearing as a means of supporting the Spanish tourist industry. In 1956, Brigitte Bardot wore a pink gingham bikini in *And God Created Woman*, and Jayne Mansfield sported one on the cover of *Life* magazine in 1957. From then on nothing could stop the "Itsy Bitsy Teenie Weenie Yellow Polka Dot Bikini," that Brian Hyland sang about all through the summer of 1960.

Did those who censored this work of the devil know that on mosaics in the Villa Casale in southern Sicily, dating from the Late Roman Empire (third century CE) and discovered by archaeologists in 1929, you can already see gorgeous young women dressed in very skimpy two-piece swimsuits running, lifting weights, and playing ball?

But let's return to our cinema bikini, and this head-over-heels image of Ursula Andress in *Dr. No*, Venus rising from the sea in a bikini, a dagger on her hip. Venus is armed, and with a phallic symbol, no less! The modern woman, powerful and nude if she chooses to be, Venus as Diana the huntress is being born before our very eyes.

Thanks to the bikini this modern Venus will gain even more freedom. She'll take off her top, to create the monokini, or she'll burn it, in the '70s. But that's another story.

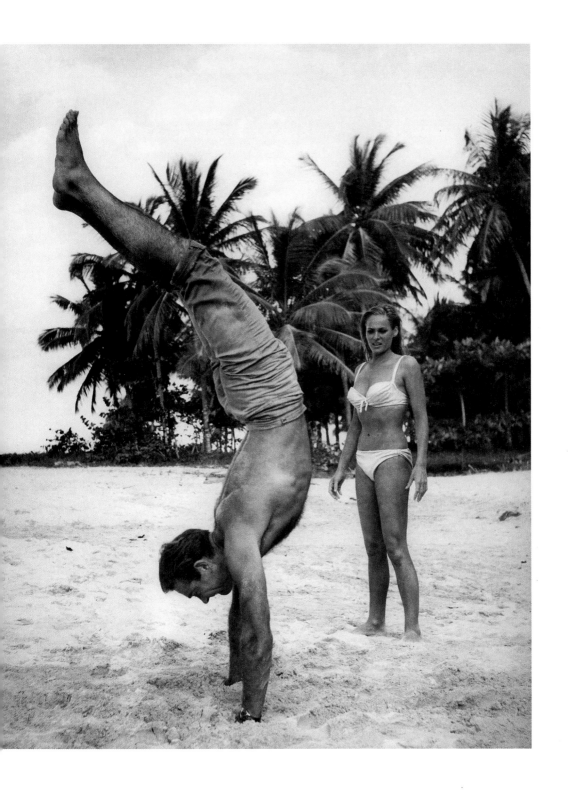

CHARLOTTE RAMPLING

— PARIS, 1982 — HELMUT NEWTON

Charlotte Rampling, photographed by Helmut Newton in 1982, in front of two photos of her, also taken by Newton, in 1973: time has flown. In 1973, Rampling was at the height of her Mephistophelean beauty, her career launched at the age of eighteen by a crazy movie, emblematic of Swinging London, *The Knack . . . and How to Get It*. Her youthful choice of movies had a whiff of sulfur and of suffering: Visconti's *The Damned* and Liliana Cavani's *The Night Porter*. She had a kink for the kinky.

The actress told us: "I discovered both the power of images and the force of the relationship between the photographer and his subject during my first session with Helmut in 1973. He told me: 'We're going to do some nude shots—they'll be my first!' I replied: 'Mine too!' which wasn't true, as I had posed nude at the age of sixteen sitting on a chamber pot! The photo had appeared in the book *Birds of Britain*, but I had suppressed it. Was he lying, too? Helmut didn't offer much in the way of guidance, but he was quick. We were in the Hotel Nord-Pinus in Arles. I got undressed and it was all over. No need to talk for hours, it was just matter-of-fact."[1] Ten years later, in 1982, Rampling had become a star, and played in a Woody Allen movie, *Stardust Memories*, that reflected her own career. Here, as Sacher-Masoch's Venus in Furs, she offers tantalizing torture—down, boy.

Stocking fetishism, which pervades Helmut Newton's work, accompanied the first appearance of stockings in the Middle Ages. The first liturgical stockings, inspired by Scythian gaiters, were sported by men of the Church. The lower portion of leg armor (known as *bas de la chausse* in France) worn in the fifteenth century became the stocking (*bas*) of the sixteenth century, and, thanks to the silk worm imported from China, ultimately the silk stocking. They were enthusiastically taken up by Henry II of France (in a portrait by Clouet the king is depicted wearing hand woven white silk stockings) and by Henry IV, who in 1610 authorized the establishment of the first silk-stocking factory in Rouen. They were then adopted by the French nobility; worn as a second skin, stockings excited the male imagination, as Brantôme wrote: "I've known many a gentleman who, before putting on their silk stockings, asked their ladies and mistresses to try them on and wear them for some eight or ten days before they did."[2] The upper echelons in France wore silk stockings, while the lower orders wore worsted stockings, roughly knitted out of wool. When, in the nineteenth century, stockings became a woman's prerogative, the black versions, so dear to Helmut Newton, were excluded for a time from the wardrobe of the well-bred. Black—the color of luxury, of mourning, and of the devil—was reserved for prostitutes and dancers happy to flash a bit of leg. At the start of the twentieth century, as skirts got shorter, stockings were finally visible, sparking a tortured fetishism, like that of Georges Bataille: "she had black silk stockings on covering her knees, but I was unable to see as far up as the cunt."[3] With the invention of nylon, patented by the American Wallace Carothers in 1937 and produced by DuPont since 1939, stockings became a democratic, economic, universal product, a hindrance to female emancipation but an accelerator of profound erotic fantasies. Are Charlotte Rampling's stockings made of silk or nylon? Whatever they are, they're holding up well.

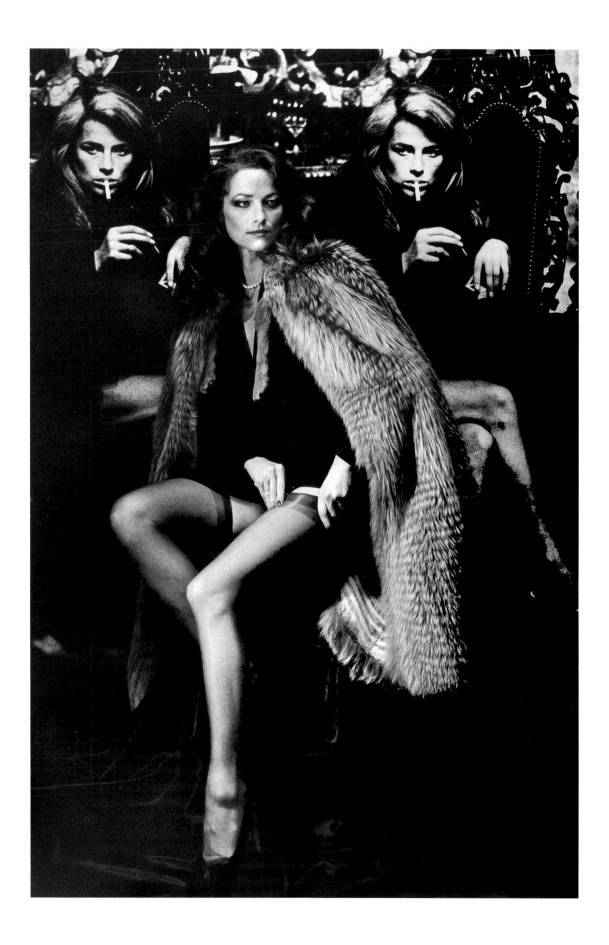

ROMY
SCHNEIDER

— ROME, 1972 — EVA SERENY

Stockings that went right to the top—this is how tights were invented. As free and easy as pie: two stockings attached to high panties, cinched in with an elasticated waist. A man and a woman were behind this invention: Mary Quant, who invented the miniskirt in 1962 in London, and André Courrèges, the lab technician of futurist fashion, who showed a miniskirt in his spring 1965 collection in Paris. Mary wanted to help girls run for double-decker buses, something that was impossible to do in a narrow skirt. André wanted to please the boys who were watching these short-skirted meteors go by. The miniskirt cried out for tights, like the hand for gloves. And with them came movement, emancipation, and youth. *Liberté, Égalité, Yéyé*. In *Elle* magazine, Philippe Sollers invented the sociology of hosiery: "For technical reasons, tights are inevitable and irreversible.... Irony reasserted itself after a moralistic, militant phase. But a further step had to be taken. This step is the miniskirt. Without tights, it is inconceivable."[1] Demonized as agents of male chauvinism and symbols of female submission to patriarchal stereotypes (feminists didn't go in for subtleties), stockings had a hard time with female baby boomers, who went in for mass consumption and mass protest: candy-colored tights (1966), the pill (1967), May 68, Hanes L'eggs with their distinctive egg-shaped packaging (1969), and Dim tights in 1971 with their hugely catchy tune. Stockings were on the wrong foot for two decades, but came back into fashion in the '80s as part of the armory of the "superwoman" who had it all: outfitted like an amazon and provocatively silky. Do we have to choose sides, between stockings or tights? It's a question that puts ancients and moderns at each other's throats. Fans of the functional are looked down upon by those who love mystery. It's a bit like the question of whether you prefer The Beatles or The Stones. Obviously both groups sang about tights: the former in 1968 in "Lady Madonna"—"Thursday night your stocking needed mending, see how they run"—and the latter in 1994's "I Go Wild" with the line "Stay away from blue stockings." Romy Schneider could have brought everyone together. Red shirt half undone across a tantalizing breast, a dreamy look, a little hole in the right foot of her tights echoing the Band-Aid on her right hand—a double allusion to the vulnerability of which the actress was, in a certain way, the symbol, both in her life and in her acting roles: the eroticism of this image is as discreet as its effect is powerful. It's quite simple—it looks as though Romy is wearing black stockings. In 1967, Woody Allen confessed: "I dreamed I was Ursula Andress's body stocking."[2] The poor guy hadn't seen Romy Schneider's.

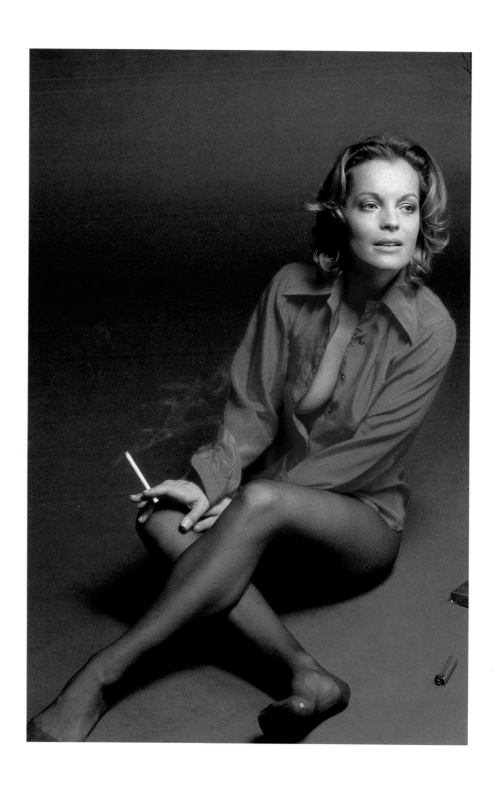

FAYE
DUNAWAY

He didn't want her in *The Thomas Crown Affair*: he wanted the Hitchcock blonde, Eva Marie Saint. But Eva Marie, age forty-four, was considered over-the-hill by the philistines at the studios, so she was out of the picture. Norman Jewison (on the right in this photo) took a closer look at Faye Dunaway, and what he saw captivated him. At the age of twenty-seven, the all-or-nothing heroine of *Bonnie and Clyde* was sophistication personified, the womanly essence of charm and beauty. And, what was more, Dorothy Faye had the same first name as Norman's mother.

Neither Jewison nor Dunaway lived to regret their collaboration. The movie is immoral, incredibly stylish, cool, and highly ironic. It demolishes the American myth of the self-made man through the character of Thomas Crown, a Gatsby gone rogue, a jaded young billionaire who robs his own bank in a splendidly schizoid and onanistic act. The movie provided Faye Dunaway with a fantastic role as a young, modern, liberated woman. She plays Vicky, an investigator who is self-confident, single and proud of it, and a gifted chess player. "Do you play?" Crown asks her. "Try me," Vicky replies flippantly, before bagging his king during a legendary chess game. What follows is some devilish king-side castling, and a brilliant checkmate.

The Thomas Crown Affair heralded an extraordinary decade for Dunaway. Between 1968 and 1978, she played in a long line of starring roles: *The Arrangement* (opposite Kirk Douglas), *Little Big Man* (opposite Dustin Hoffman), *Chinatown* (opposite Jack Nicholson), *The Towering Inferno* (opposite Steve McQueen and Paul Newman), *Three Days of the Condor* (opposite Robert Redford), *Network* (for which she won an Oscar in 1976), and *Eyes of Laura Mars* (opposite Tommy Lee Jones). Not forgetting the most moving, but least known of all her movies, *Puzzle of a Downfall Child*, by Jerry Schatzberg (1970).

"Divine! Her face is bone and stark.... Enormous eyes. And tall. A giant. Thin as telephone wire."[1] With just a hint of masochism, fragile Faye melted into the character of Lou Andreas, a once-idolized model, now forgotten and descending into madness. Was this a case of a movie holding up a mirror to a situation and offering the solution?

Throughout the '60s and '70s, Dunaway's look was iconic. It was a strange mixture of '60s Mod style (minidresses, miniskirts, lots of accessories) and old Hollywood glamour (chignons and updos; broad-brimmed hats worthy of Norma Desmond in *Sunset Boulevard*) tempered with a timeless, patrician, preppy touch (duffle coats and roll-neck sweaters in camel, camel, and yet more camel).

Theadora von Runkle, costume designer on *Bonnie and Clyde*, created her luminously sexy silhouette in *The Thomas Crown Affair*: flimsy, pale pink top, flat-pleated miniskirt, navy blue blazer with large buttons, white gloves, false eyelashes, false nails, clip-on earrings designed by Kenneth Jay Lane, and little strappy shoes. And the killer detail is the white tights. Ever since colored tights appeared in the mid-'60s, white tights had been considered bad taste on anyone older than ten. But here they work, and they look flirty, fresh, and sophisticated. "[Warren Beatty] once told me, 'You've got a lot of class.' That's the compliment that's meant the most to me."[2] First class.

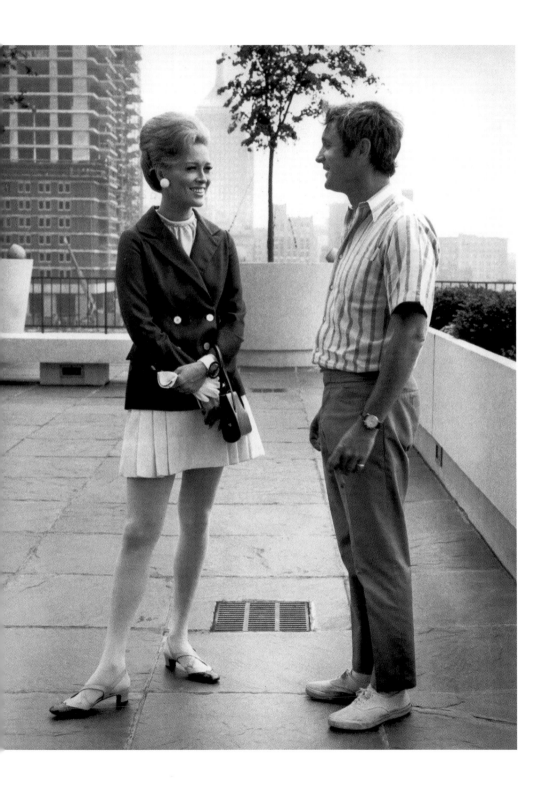

WILLIAM
FAULKNER

— HOLLYWOOD, DECEMBER 31, 1942

The December sun beats down. The former pilot is wearing Ray-Ban Aviators. The man who dreamed about exploits in the French skies, who joined the Canadian Royal Air Force after being rejected by his own country for being too small, finished his training just as the 1918 armistice signaled the end of his hopes of seeing combat. The author of *Pylon* is bare-chested, wearing shorts and white nubuck derbies. Remington at the ready, detective-style pipe lit, the future winner of the Nobel prize for literature is on top form. However, clouds are gathering. Why is he wearing such thick woolen socks? Had the celebrations of the night before New Year's Eve been excessive? Is he hoping to find inspiration in perspiration? Of course, natural wool (in the absence of cotton or lisle) absorbs sweat and prevents embarrassing odors. The knee sock serves to hide the skin when you sit down and your pants ride up, unlike the ankle sock, with its more unfortunate tendency to reveal your (hairy) leg. And what about these funny "sockettes"—with their tired elastic—corkscrewing around at mid-shin level?

In *The Sound and the Fury*, Faulkner wrote: "It always takes a man that never made much at any thing to tell you how to run your business, though. Like these college professors without a whole pair of socks to his name, telling you how to make a million in ten years."[1] Thirteen years have passed. His books have brought him fame. For the past decade Faulkner has worked as a screenwriter in Hollywood, more for the money than for the love of cinema—when he arrived at MGM he asked if he could write for Mickey Mouse cartoons. He worked well with John Ford, and above all with Howard Hawks, who shared his keen love of hunting, alcohol, and flying. So, before once again rewriting the script for *Air Force* that Hawks was going to film, did Faulkner put on polar socks to confront the cold that pilots experience at altitude? Or was he just getting cold feet?

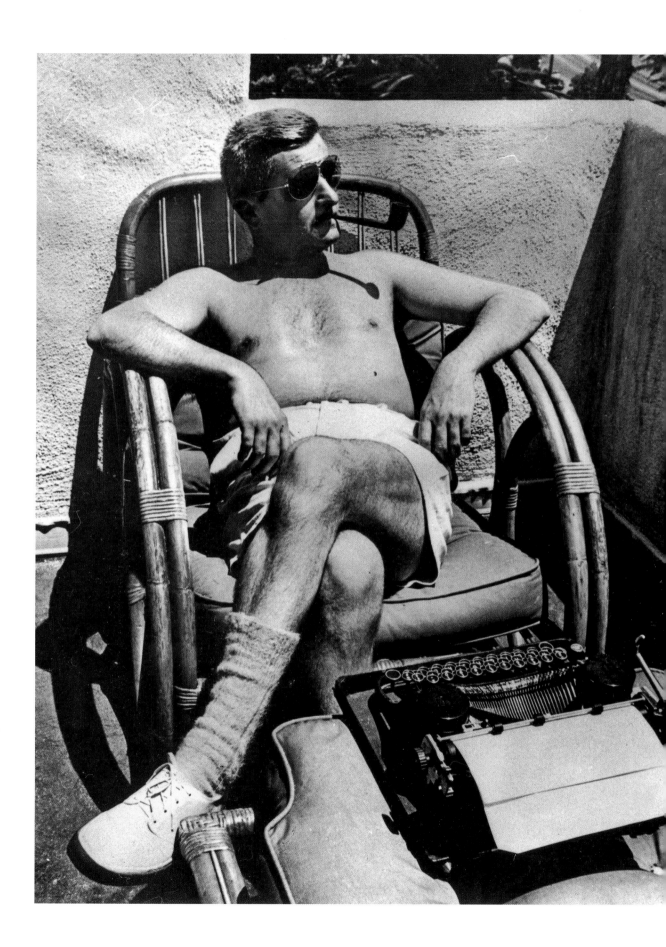

THE BEATLES

— LONDON, SPRING 1969 — LINDA McCARTNEY

Forever our Musketeers: John as Athos of our Four Last Things, George as Aramis, Ringo as Porthos, and Paul as d'Artagnan. Milady Yoko gate-crashed the only official photo Linda ever took of The Beatles. "I had really wanted The Beatles on their own, but Yoko just sat there, and being a timid newcomer I simply didn't have the heart to tell her it was group members only,"[1] wrote lovely Linda, Paul's young wife. It was Paul who had commissioned an emergency portrait of the foursome for the cover of their single "The Ballad of John and Yoko." Linda Eastman, a photographer from New York (not, as is often misstated, the Eastman Kodak heiress), had just married Paul on March 14, a week before John and Yoko wed in Gibraltar following the many journeys recounted in the ballad. Back from their notorious Bed-in for Peace (in suite 902 of the Amsterdam Hilton), John, accompanied by Paul only, recorded the song on April 14 in one quick session at Abbey Road Studios. On May 30, the Fab Four's new single hit the record stores. The days of innocence, when Beatlemania carried everything along on its wake, were long past. Every six months the Liverpool foursome turned music—and fashion—upside down: their mop-top haircuts were imitated all over the world, and their Edwardian collarless suits became the uniform of the British invasion. There were lines outside the store of boot-maker Anello & Davide on Drury Lane, as people waited to buy "Beatle boots," those famous Chelsea boots that the Fab Four had customized by adding a Cuban heel (as worn by flamenco dancers). The short-lived Apple Boutique, which opened to great fanfare on December 7, 1967, at 94 Baker Street, was, according to Paul, "a beautiful place where beautiful people can buy beautiful things," with the emphasis on clothes. It was a financial disaster, since shoplifting—as much by the sales clerks as by the customers—was endemic, and it closed on July 30, 1968, after a clearance sale almost turned into a riot when the entire stock was given away at the rate of one item per person. Here, in Linda's photo, they look like four strangers. John, who had taken to wearing sneakers and a white suit (as on *The White Album* and *Abbey Road*), as much in the spirit of pacifism as because of the influence of Yoko's minimalism, is here wearing black. Behind his famous round, tinted "Lennon" glasses, he was already coming to terms with losing his friends. Yoko wears the hat and tie. Ringo (who, when asked, "Are you a mod or a rocker?" replied, "No, I'm a mocker."[2]) here, seems relegated to the margins, like George. Paul is smiling, but all we notice are his yellow socks, the remembrance of submarines past.

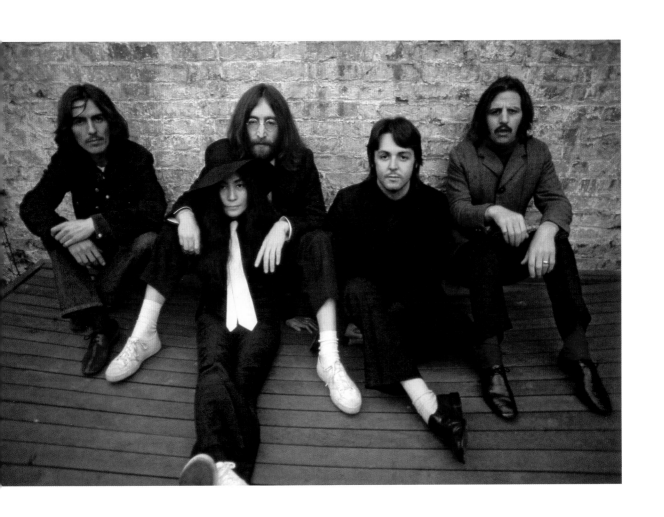

TERENCE
STAMP

— LOS ANGELES, DECEMBER 2008

When he arrived in Los Angeles for the premiere of *Valkyrie*, with his angel face and the scowl of a young hooligan—despite his mature age—did he know that Doug Hayward, the revolutionary tailor of Swinging London, had died a few months earlier? Terence Stamp and Michael Caine, who at the start of the '60s shared the same apartment, the same suburban roots, and the same marked taste in clothes, had been the first customers of a man who, braving the conservatism of Savile Row, had injected a dose of Italian insolence into the British stiff upper lip. Well before he inspired John Le Carré's *Tailor of Panama*, Hayward was Caine's model for *Alfie*. The same year, 1966, he designed Stamp's costumes for *Modesty Blaise*. His Mayfair store, opened in 1967 at 95 Mount Street, doubled as a select club for a long line of models and gentlemen. Thirty years later, in his pale, moss green velvet jacket and matching waistcoat, duck-egg blue and peridot green tartan scarf matching his pants, Stamp maintains his aristo-cockney chic. A successful cocktail of clothes that Stamp freshens up with a touch of British eccentricity—as captivating and untranslatable as the English sense of humor—and tops off, with no thought to what people might say, with electric blue Crocs! It takes courage to flaunt these fluorescent multicolor clogs made of Croslite™ (a resin manufactured from ethylene vinyl acetate), a thermoformed, antibacterial, and antiperspirant material, invented by two chemists from Quebec, bought by three Americans from Colorado on vacation in Canada, and sold by the millions during the first decade of the twenty-first century.

Their success recalls that of "Birks," the now ubiquitous sandals that were discovered by an American woman on vacation in Germany. The century-old company of Birkenstock produced sandals with quasi-orthopedic soles that were loved by the medical profession for their comfort and hygiene before they were adopted by the children of the Flower Power generation. Foot health: it's a lifestyle choice that resonated with Terence Stamp, who at the end of the '60s, after a brief Italian period with directors Pasolini and Fellini and his breakup with the Shrimp, retreated into an ashram in Pune to meditate for a few years. There he abandoned his dandy boots for bare feet like Gandhi, and learned to breathe through the soles of his feet.

LEE
MARVIN

— TUCSON, ARIZONA, 1971 — TERRY O'NEILL

Six foot two, forty-seven years old. Already behind him: *The Killers*, *The Dirty Dozen*, *The Professionals*, *Point Blank*, and *Hell in the Pacific*. Hard-bitten characters, killers, mercenaries, and hotheads held no fear for him. He was not yet twenty when he joined the Navy. He knew the swamps and jungles of the Mariana Islands, had been wounded at the Battle of Saipan, was awarded the Purple Heart and discharged. A war veteran and committed Democrat, he would oppose the Vietnam War. In 1971, Lee was a star and had his pick of jobs, like this minor Western *Pocket Money*, with Paul Newman, written by Terrence Malick and filmed in Arizona, during which Lee bought a house built by architect Josias Joesler in the Santa Catalina foothills, where he would live until he died. The English photographer Terry O'Neill took this photo on the film's set: Lee in T-shirt and chinos (with flap pockets), relaxed, sockless in his tennis shoes, with a hole at the seam between the rubber and the cotton canvas, the usual weak spot. Are they Jack Purcells or a pair of Spring Court G2s (the same as the ones Lennon is wearing on the cover of *Abbey Road*)? In any case they are classic tennis shoes, identical to the '30s originals. Jack Purcells were designed by the Canadian badminton champion for Converse in 1935, while Spring Courts, the first with ventilation holes, were created in 1936 by Frenchman Georges Grimmeisen, a maker of rubber boots, to play his favorite sport on clay. The first tennis shoes, called "sneakers" in the US, as their rubber soles allow you to sneak up on someone, appeared in the nineteenth century with Charles Goodyear's invention of vulcanized rubber, but it was not until the '50s that the baby boomers liberated them from the sports grounds. Later, the '70s jogging trend saw them all over the tarmac, outdoing each other in their inventiveness, and in the '80s they were worn proudly with a tuxedo, or anything else for that matter. Today's urban tribes compete with each other by means of different brands and models of athletic shoe: Stan Smith Adidas for rappers Run DMC, Tiger Asics in *Kill Bill*, Nike Air Max for Jagger on springs, Vans for Pearl Jam, or Reebok Freestyle for Alicia Keys. The days of the tennis shoe—the white canvas sneakers of a Lee Marvin—are over. All that remains of its legacy are the "Sons of Lee Marvin," a bizarre secret society whose members include Jim Jarmusch, Tom Waits, Nick Cave, and John Lurie.

CHARLOTTE
GAINSBOURG

— FRANCE, JULY 2006 — KAI JUENEMANN

She looks relaxed in her sneakers, a convert to Converse. Here Charlotte Gainsbourg is wearing (and wearing well) her favorite pair of blue denim All Stars, one of the first six colorways launched by the brand in 1966, five years before Gainsbourg was born.

Muse of the fashion house of Balenciaga (from 2006 to 2012 she was the inspiration for creative director Nicolas Ghesquière's slender, bold silhouettes), looking magnificent with her grungy don't-care attitude, in old leather riding boots worn down to the bone, the daughter of "Gainsbourg and his Gainsborough"[1] is never more herself than when she's wearing her Converses. Like a humble, modern, French version of Patti Smith, her thoroughbred androgyny liberated a generation of young French girls from the '90s tyranny of curled hair and big breasts, and fits perfectly with the unisex vocation of her sneakers—sneakers that were nevertheless originally designed exclusively for men. In 1908 entrepreneur Marquis Mills Converse (who, despite his name, was no aristocrat) quit his job running a shoe factory to start up his own small business in Malden, Massachusetts, the state where basketball had been invented in 1891. After making canvas and rubber tennis shoes, in 1917 Converse perfected a high-cut basketball shoe, the Converse Canvas All Star, produced first in black, then in white. The buzz was good, and American basketball players who wore them caused a sensation, including

Charles "Chuck" Taylor, the tall beanpole from Indiana who arrived at the Converse Rubber Shoe Company in 1921. The boy was twenty, a hugely talented basketball player, and full of himself. Employed to sell All Stars, he peddled them across the country, where they sold so well that Converse put Taylor's signature on the 1923 model, making Chuck the first sportsman to endorse a consumer product. As an athlete, he suggested various technical improvements, such as better support for the ankles, which were put under pressure during matches. The Chuck Taylor became the regulation training shoe for the US Army during World War II and, in 1949, the official footwear of the National Basketball League, forerunner of the NBA. "Nothing but net!" as Chuck Taylor himself might have said.

Progressing from basketball courts to university campuses, then onto the streets, this odd shoe, which seems to be a cross between boxing shoes, gaiters, and a security blanket, has, in the twenty-first century, become the symbol of international cool, and the favorite sneaker of musicians, athletes, and young people of all ages. And Charlotte Gainsbourg, the girl-next-door with the well-behaved look,[2] has become the other, radiant, symbol of this spirit of cool.

SALVADOR
DALÍ

— PORTLLIGAT, 1953 — JEAN DIEUZAIDE

He hates the water. His aversion to it is well known, flamboyant, and radical. Nothing in the world could entice him to swim. Not even to dive into the inlet at Portlligat for a few minutes to collect the sea urchins he so adored. Dalí and water—they don't mix. Nevertheless, in just a few moments, the photographer Jean Dieuzaide would manage to plunge Salvador Dalí into the water, immortalizing the painter in a famous photo with two white flowers sprouting from the tips of his iconic mustache. For the aquaphobic dandy, the enhancement of his own legend was well worth the sacrifice. Meanwhile, Dalí poses on dry land with his facetious theatricality that had delighted photographers since the end of the '20s, from Man Ray to Brassaï, from Carl Van Vechten to Cecil Beaton. Arms crossed coyly, with a dash of irony, Dalí—the provocative exhibitionist who turned his life into a delirious work of art—is not lacking in style, despite the simplicity of his attire. Moreover, as confidant of Coco Chanel, with whom he designed the sets for *Bacchanale*, the first "paranoiac-kinetic" ballet; as inventor of the "lobster dress" for Elsa Schiaparelli and of the "Costume for 1945" for Christian Dior; and as creator of footwear with springs and of musical shoes, Dalí had always adored fashion for its unlimited possibilities. And the Marqués de Dalí de Púbol (as he was dubbed by King Juan Carlos in 1982) never lacked elegance, even if his attire was extravagant, verging on costume.

As soon as he arrived in Paris in 1928, Dalí regularly succumbed to crises of doubts concerning his elegance, to which he abandoned himself with exemplary creativity. For example, to tame his jet-black hair, he concocted a mixture of wood varnish and brilliantine that could only be removed with turpentine.

For fifty-two years, and despite their initial dire poverty, Dalí and Gala's motto was sublime: "Genio y figura hasta la sepultura"

(Genius and allure [from the cradle] to the grave). But let's go back to that day in 1953. The most famous surrealist painter in the world since producing *The Persistence of Memory* (in which time, memorably, is a melting Camembert cheese) was forty-nine years old. He was at the center of the universe, and this umbilicus was called Portlligat. Banished from Cadaqués by Dalí Senior in the '30s, Salvador and Gala (ex-wife of Paul Éluard) bought a tiny fisherman's hut from Lydia "la Ben Plantada,"[1] an eccentric (perhaps insane even) inhabitant of the village of Portlligat. The hut—initially decorated with a single tooth that had dropped from Dalí's mouth and which hung from the ceiling—was expanded over the years into a house of practical jokes, with a phallic pool covered with bronze sea urchins, an unreadable library, a sofa in the shape of Mae West's mouth, and a wall covered in tires. It looked like the repetitive externalization of the inside of Dalí's mind—his haven, or rather his shell. Here the days went by beautifully, and the pair, wearing their espadrilles, received visitors from all over the world.

Besides Dalí, many others have worn espadrilles, including Ernest Hemingway, Grace Kelly, Jackie Kennedy, Yves Saint Laurent, Pope Jean Paul II, and Gaston Lagaffe (the clumsy hero of an iconic French comic strip). None, however, has worn those wonderful shoes made of jute rope (or braided hemp) and jute canvas as well as Dalí, that self-described "Catalonian peasant, naïve and cunning, with a king in [his] body."[2] The *espardenya*—spotted in the thirteenth century on the soldiers of the king of Aragon; indispensable since the nineteenth century for peasants, fishermen, and mine workers; adopted and claimed by the Basques who called it the *vigitane*—combines the nobility of natural materials, humble origins, and Catalan pride. Didn't the espadrille become popular shortly after the Renaixença, the birth of Catalan nationalism? Each region has its own type of espadrille. Salvador Dalí is photographed wearing the Empordà style, white espadrilles decorated with five rows of black ribbons on the uppers, made since 1859 by the *alpargatero* (espadrille maker) Florenci de Figueras. Dalí cuts a regal figure, comfortable in his shoes.

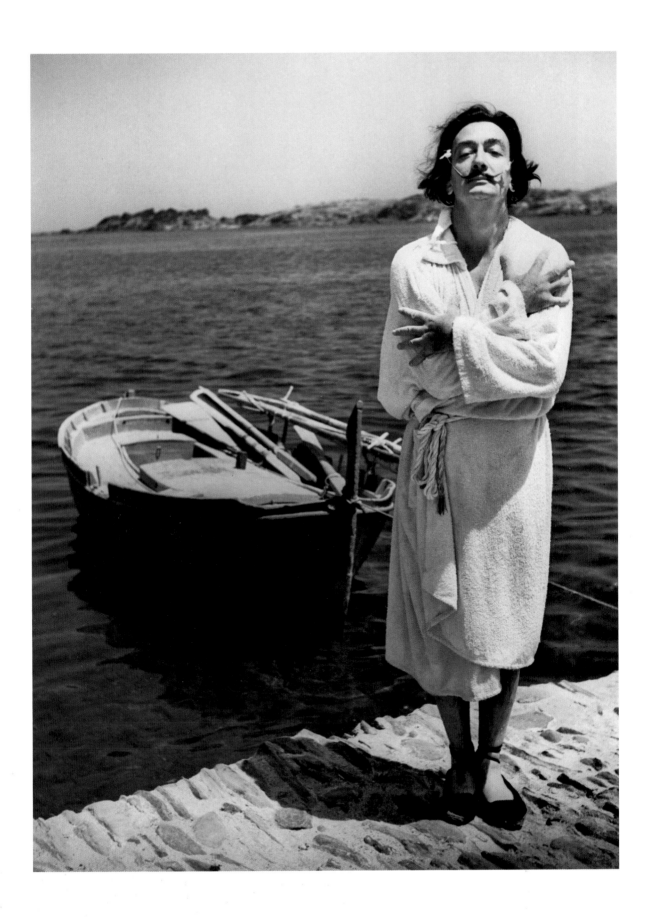

JACQUES PRÉVERT

— SAINT-PAUL-DE-VENCE, AUGUST 1950 — WILLY RIZZO

It looks like Jacques has "jack" to do: like Rodin's *Thinker*, like a bar-room smoker—or the other way around. What is France's national poet thinking about?

Perhaps he's thinking about his famous poem *Cortège*, which creates surreal phrases by switching nouns and adjectives, and applying them to his solitary, whimsical self, "a spiritual scavenger with a dog-end guide, a whipping hussar with a death boy, a china teacher with a philosophy repairer."[1]

Is he thinking about his four-year-old daughter Michèle, known as Minette, who's frolicking in the sunshine out on the square in Saint-Paul-de-Vence, blissfully unaware that's she's playing hoop and making sandcastles on the earth "that turns and turns and turns/with its great streams of blood"?[2]

Or is he reflecting on the twentieth century, where he found his own reflection, and which witnessed him trying to conjure bloodthirsty gibberish out of words and poems? In 1925, he invented "exquisite corpses" for the surrealists; he wrote sparkling, heartbreaking dialog for *The Children of Paradise* and for the lovers in *Port of Shadows*, songs and odes to dunces and ranted at "our Father who art in heaven," telling him to "stay there." Prévert's twentieth century produced poems dedicated to barrel organs and girls called Barbara.

Or perhaps Jacques is playing the tragic hero, an albatross made rigid with existential sadness, propped up on the counter of La Colombe d'Or, all for the sake of creating a memorable (and publishable) shot for photographer Willy Rizzo? Rizzo appeared in Hergé's later *Tintin* albums as the character Walter Rizzoto, photojournalist for the magazine *Paris-Flash*; at the time of this photo he had not yet turned himself into the jet-set photographer and amateur celebrity designer he became in the '70s. But since he'd started working for *Paris-Match*, he had collected artists like other people collect butterflies.

The photographer had mixed feelings about their encounter: "one isn't always intellectually enlightened after a meeting with a poet. That day, Prévert greeted me with a half-hearted 'bonjour' followed by 'how long are you going to bother me?' I think he'd been at the bar for a while."[3] Prévert has shown up in his summer uniform: shorts, jeans jacket (by Levi's?), and some sandals that tie around the ankle and look simply strapping. The proximity of Saint-Paul-de-Vence to Saint-Tropez, where two legendary shoemakers, Dominique Rondini and Jacques Keklikian, fought over who invented the Tropézienne sandal (advantage Rondini, as his company was founded in 1927, six years before Jacques K), might lead us to think that Jacques's sandals, with their handmade look in natural leather and their lack of frills, could be an early kind of Tropézienne. A wisp of a sandal for the fleet of foot with a philosophical approach to life, until 1977, when cancer carried off this fanatical smoker. It's a simple sandal, made for gambolling and picnicking, which chimes well with his pretty little ditty, dazzling like the secret epitaph of a great fatalist:

"Eat on the grass
Hurry up
Sooner or later
The grass will eat on you."[4]

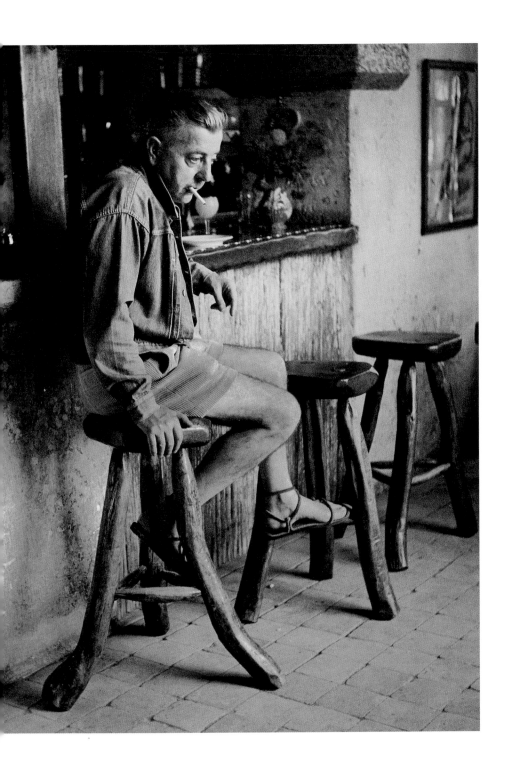

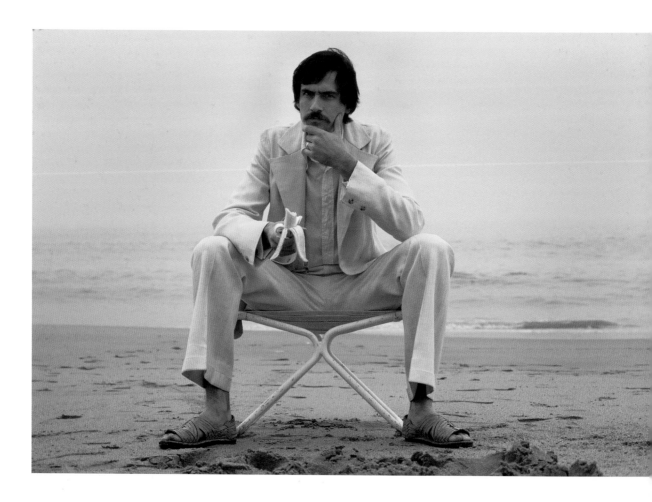

JAMES
TAYLOR

— LOS ANGELES, 1975 — NORMAN SEEFF

Pacific foam on the sand at Malibu. He's got the blues. Sitting on a folding stool, his back to the ocean, James Taylor looks thoughtful, a banana in his hand. It's not some Warholesque reference. This exotic fruit refers to *Gorilla*, the title of his new album. Just arrived in New York in 1969, South African-born Norman Seeff had photographed James building his house on Martha's Vineyard then, three years later, he had opened a studio in California on the Sunset Strip, stomping ground of the West Coast's musical aristocracy. He was the photographer working on Taylor's album cover. "Sweet baby James"—whose earlier friendships with the lovely ladies of folk music, Joni Mitchell and Carole King, had made headlines—had been married to Carly Simon for three years now. Her Jagger-esque lips had previously turned the heads of both Kris Kristofferson and Warren Beatty. The party after their wedding was considered the biggest showbiz event since the marriage of another Taylor (Elizabeth) to Richard Burton. James, whom *Time* magazine had compared to Goethe's character of Young Werther, was back on heroin, experiencing withdrawal symptoms that ate him up like an infected wound, and that junkies call having a monkey on your back. After a fight with Carly, he went to Central Park Zoo, and, in a moment of inspiration as he watched an angry gorilla, imagined that this might be how he looked to his wife.

But let's get back to civilization. In his beige poplin suit, he looks repentant. His jacket lapels are much too big, but they're typical of the '70s, a decade that often made its mistakes loudly. By contrast, his hard-wearing Indian sandals in woven leather, with soles made of recycled tires from the hippy trail between Woodstock and Goa, strike an ethnic chord. Just watch out for that gorilla.

INGRID
BERGMAN

— ITALY, 1952 — DAVID SEYMOUR

The sandal serves us well: just a sole with interlaced thongs or fixed strap—noble in its simplicity. People have been wearing sandals since ancient times. In 3,200 BCE, the Egyptians who built the pyramids made them out of braided papyrus. In Ancient Rome, fortune and rank were signified by sandals: gilded soles for the Empress Poppea, semiprecious stones for patricians, and bare feet—no sandals at all—for slaves. In the Middle Ages penitent monks brought a degree of ethics to sandal-wearing: this simple piece of leather symbolized a welcome discomfort and permanent moralistic self-flagellation. The sandal does not lie: it reveals the humble truth of the foot. Every culture, every religion, has its version of the sandal. Most of the time its sole is flexible, but in Japan, the wooden-soled *geta*—the traditional sandal with two "teeth" (*tengu* sandals have "one tooth"; *mitsu-ashi* have "three teeth")—creates a gait that looks somewhat panic-stricken, with the wearer appearing to be permanently on the verge of catastrophe (it was eroticized in literary works that celebrate the geishas, as well as in Kenji Mizoguchi's movies). Nothing like the scene in this photo, where Ingrid is enjoying the sunlit uplands of fertile motherhood.

Ingrid Bergman seems to be having fun with the symmetrical effect created by the two bassinets containing her twins, Isabella and Isotta (who was the elder by thirty-four minutes). What better than these soft sandals, guarantees of balance and elegance, for toting around two times fifteen pounds (six kilos) of noisy gurgling? With Isotta and Isabella, this was Ingrid Bergman's third time as a mother, but this time, motherhood came with violent criticism: the star of *Casablanca* was pilloried by Hollywood, its gossipmongers, and the majority of international public opinion (a Colorado senator, Edwin C. Johnson, accused her of being "a powerful influence for evil"[1]) for leaving her husband Petter Lindström and

daughter Pia for director Roberto Rossellini, who she worked with on *Stromboli* in 1950. (The letter sent by the thirty-three-year-old Bergman to Rossellini in 1948 is a classic of its kind: "If you need a Swedish actress who speaks English very well, who has not forgotten her German, who is not very understandable in French, and who in Italian knows only 'ti amo,' I am ready to come and make a film with you"[2]). The smoldering, charred slopes of the volcano that Bergman climbs at the end of this great, mystical movie about downfall and rebirth seem like a bed of roses compared to the disapproval the actress had to suffer. With the padlock attached to her Hermès dog collar belt, Ingrid blatantly thumbs her nose at the bigots who would like to lock her up in a chastity belt. She endured six years of purgatory—which she turned to her advantage by filming several masterpieces in Europe: *Journey to Italy*, *Fear*, *Joan of Arc*, and *Europa '51*, all directed by Rossellini, and *Elena and her Men* by Jean Renoir—before she was accepted back into Hollywood and rewarded with an Oscar for her role in *Anastasia*. Sandals and scandals. One thing is certain: these are not the sandals of a penitent that the glowing young mother is wearing on the terrace of her Roman villa, captured on camera by her friend, photographer David Seymour; they are practical, elegant *sandali*—Italian style.

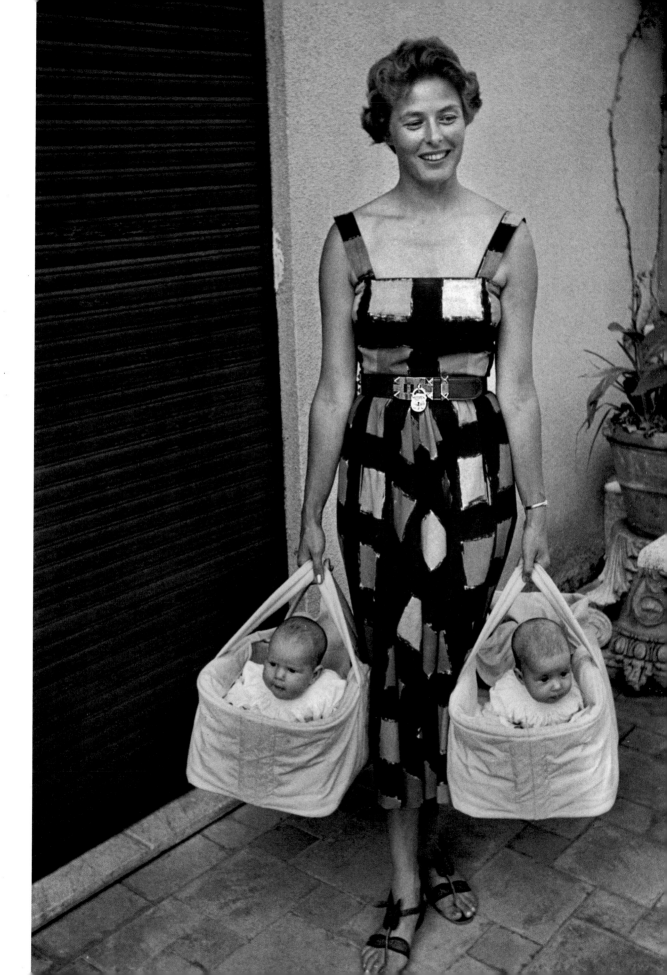

ANDRÉ
GIDE
AND JEAN-PAUL
SARTRE

— CABRIS, ALPES-MARITIMES, AUGUST 25, 1950 — ALBERT HARLINGUE

Appearances can be deceptive. Seated (one could even say sprawling) in director's chairs, these are not two nitpicking movie directors discussing the making of a documentary on the potters of Vallauris, but two intellectual giants of the twentieth century. On the left (natch) Jean-Paul Sartre, existentialist philosopher and champion of "committed" literature (who turned down the Nobel Prize in 1964), is wearing walking shoes, designed to resist hostile agents both vegetable and mineral along the road (along *The Roads to Freedom*?). Perhaps they are Paraboots, favorites with Sartre's spiritual offspring, the existentialists and denizens of the Tabou club in Saint-Germain-des-Prés. On the right, we see André Gide, founder of the *Nouvelle Revue Française*, recipient of the 1947 Nobel Prize for Literature, and vigilant global witness (anticolonialist, antifascist, and opposed to the Communists since his 1936 *Retour de l'URSS*)—"I shall probably not relinquish indignation until I relinquish life."[1] However, Gide usually behaved with more detachment than Sartre (with the exception of his sexual habits: when talking about the publication of his *Carnets d'Égypte*—in which he details his homosexual adventures with very young bellhops, kitchen boys, gardeners, and street urchins—he said: "I have to publish this text. It's my duty. Thanks to me, these creatures will cease to be denigrated."[2]) Gide is wearing sandals. They seem to be distantly related to those worn by nuns and ascetics: pastoral sandals in braided leather that cover the toes and fasten with a strap, made for walking tirelessly upon the earth (while awaiting heaven)—Congo, Lebanon, Italy, Egypt, or North Africa.

Perhaps these penitent's sandals would have been a comfort to Paul Claudel, who dreamed of converting Gide to Catholicism, but who fell out with him when Gide published *The Vatican Cellars*: "If you are one, unhappy man, heal thyself.... The Book of Revelation also teaches us that this vice is particularly abominated by God."[3]

As for Sartre and Gide, we can tell from their shoes that one of them is used to sidewalks, while the other is at home in those sunny lands, used to savoring warm air on bare skin. What are they doing in the South of France in the middle of August? André Gide is starring in a documentary on, of all people, André Gide, directed by his former lover Marc Allégret. The latter's contract, signed with the producer Pierre Braunberger, guaranteed Gide twenty-five percent of any profits the movie made. Intended to cover the important events in the life of this great "contemporary of his time" (as writer André Rouveyre called Gide), filming started on August 24 with a conversation between Gide and Sartre, who was himself vacationing at Juan-les-Pins. Spread over two days, the informal exchange was regularly interrupted by technical and meteorological problems. But we shall never know what subjects they addressed in their discussion, as the interview ended-up on the cutting room floor.

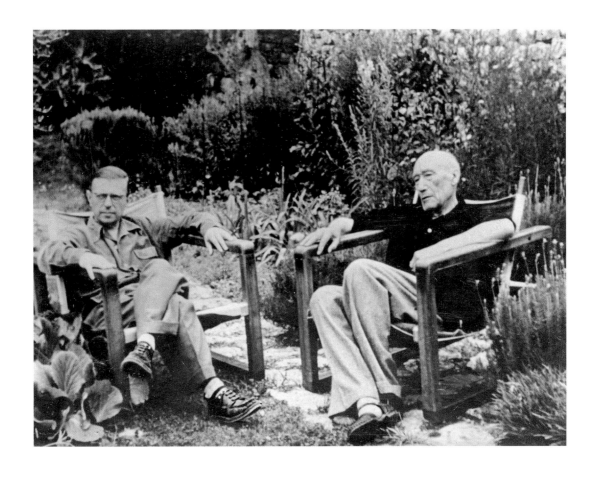

BRIGITTE
BARDOT

"One night I arrived at Maxim's, my hair blowing in the wind, wearing a skintight dress and ballet flats that I could take off easily under the table, and, as a brooch, an enormous lollipop."[1] She was a force of nature that arrived at just the right time: a blonde tornado, a barefoot hurricane, a scorchingly hot gust of wind come to disrupt, horrify and, ultimately, cast a spell on prudish, conformist, '50s France. She was Brigitte Bardot.

Libra with Sagittarius rising, neither well-balanced nor straight as an arrow, Bardot must have been visited as a babe-in-arms by a Baudelairian fairy, who offered her the most precious of gifts: "the gift of pleasing."[2] A sex symbol of female emancipation, she became a national body and an international star who was overexposed then a recluse—Garbo and Bardot: same eclipses. Bardot was a solar revolution, with a pout to send her straight to hell and a sweet, gap-toothed look (known in France as "lucky teeth"). On top of that, she talked to the animals like Saint Francis of Assisi in a gingham dress.

"Woe to her who brings scandal! Woe to me, as the scandal has arrived!"[3] This wonderful scandal occurred in 1956 in the shape of *And God Created Woman*, a minor movie, which Jean-Luc Godard nevertheless considered "relevant," and the equivalent, in its moral significance, of Françoise Sagan's 1954 novel *Bonjour Tristesse*. The shame that had strangled a generation of women like a corset vanished, revealing the liberated girl, teasing and sensual, the man-eater; this was Bardot, ten years before "free love," the slogan of the sexual revolution.

If this bombshell is wearing the slippers of her childhood ballet class, as she does in the scene where she dances an incendiary mambo in front of Roger Vadim's infatuated lens, doesn't that make it even more disturbing? She was known as "the initials B. B." (pronounced bébé—baby—in French), but it might as well stand for Beautiful in Ballet slippers, which was just one of B. B.'s style innovations. For two decades the star was a one-woman style icon. Among her signature looks: the revival of the striped sailor shirt thirty years after Coco Chanel; the beehive hairdo, that capillary Himalaya inspired by the chignons of the *ancien régime*; doe eyes contoured with eyeliner in the '50s, then rimmed in kohl in the late '60s. She pioneered the gingham dress, and "like a chalice with her beauty,"[4] she gave us thigh-high boots. Watching the Bardot show on December 31, 1967, there was fear and trembling in French living rooms at the sight of the actress, wearing black thigh-highs designed by Roger Vivier, suggestively mounting a perfectly phallic Harley Davidson, with Serge Gainsbourg as her "guest lover."

As for the ballet slippers, they are Bardot's Proustian madeleines: her real passion was not the cinema, but dancing, which she began at the age of seven at the Bourgat dance school. At sixteen, she began modeling for magazines as a "modern young girl."[5] The perfect posture she displayed on the cover of a magazine, the product of years of ballet discipline, was noticed by Marc Allegret, a friend of Vadim, and it changed her life. From 1950 on, Mademoiselle Bardot wore Repetto flats, their soles made using the "stitch and return" technique. At Bardot's request, Rose Repetto (mother of dancer Roland Petit) made a pair of flats for her dance scene in *And God Created Woman*, the "Cinderella" model, perfect for a girl with multiple Prince Charmings.

This photo, taken in Italy, is like a distillation of the legend: the famous way she held her head, the dancer's stance, tiny waist, cropped pants (another wardrobe favorite), the laugh, the beehive hairdo with the addition of two Valkyrie-style braids, the loneliness. And her feigned indifference to the swarming paparazzi (a rabble Bardot hated, and a portmanteau word invented by Fellini from *pappatacci* meaning little mosquitoes, and *ragazzi*, meaning lads[6]). Scrutinized, spied on, objectified, predator turned prey, Bardot carried on, smiling like the eternal dancing girl.

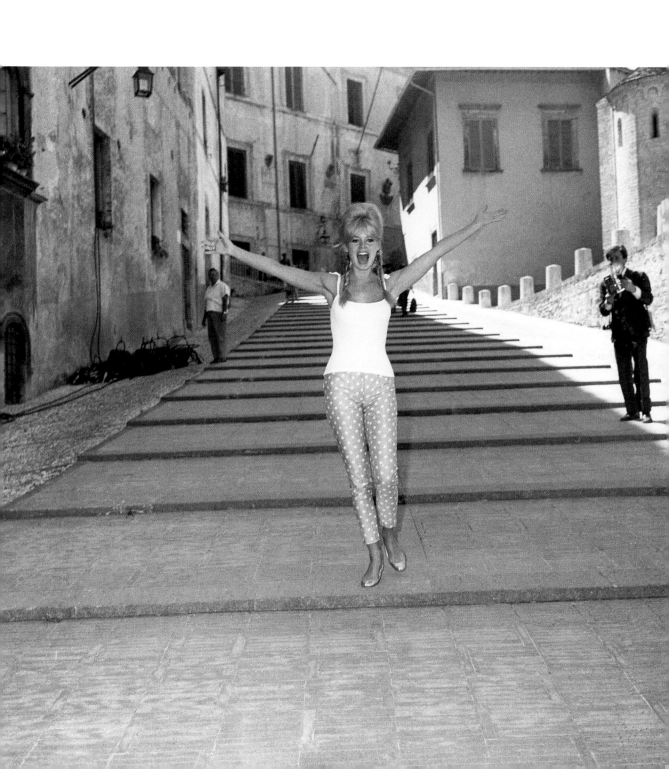

JAYNE MANSFIELD

— CALIFORNIA, AUGUST 11, 1959

If you had been born in Pennsylvania during the Depression, and your father had died when you were three, making it in Hollywood when you grew up would mean making the Cinderella story come true a century and a half after the original was written. After a series of lowly jobs—selling popcorn in movie theaters, posing for publicity photos rejected by General Electric, taking part in low-rent beauty pageants such as Miss One for the Road and Miss Fire Prevention Week—periods of loneliness, and a frantic search for recognition, Jayne Mansfield suddenly met her Prince Charming—or a series of Prince Charmings—who would direct the story of her life, choosing her and her alone. Jayne Mansfield's prince, however, was a three-headed Hydra: her first was manager James Byron, who got her a role in *Female Jungle* (1954); her second was agent William Schiffrin, who put her on Broadway in the smash hit *Will Success Spoil Rock Hunter?* in 1955; and her third was Frank Tashlin, who directed her in *The Girl Can't Help It* in 1956, launching the "phony Hollywood blonde"[1] into the stratosphere—in 1957 Mansfield won the Golden Globe for New Star of the Year. Cinderella became the Cleavage Queen. The vital statistics of this "overgrown Marilyn Monroe"—40-21-36—were on everyone's lips, to the extent that the crazy preacher Billy Graham condemned her, saying "This country knows more about Jayne Mansfield's statistics than the Second Commandment."[2] She lived in a palace, the Pink Palace, at 10100 Sunset Boulevard, drove a pink Cadillac, collected furs, chihuahuas, children, and lovers. Like her rival Marilyn Monroe, she also "borrowed" President Kennedy. And she wasn't without a sense of humor: "I don't know why you people like to compare me to Marilyn, or that girl, what's her name, Kim Novak. Cleavage, of course, helped me a lot to get where I am. I don't know how they got there."[3]

The blow-up doll came to a bad end: a has-been by 1960, consigned to the catalog of old-fashioned buxom bosoms by Audrey Hepburn, Jean Seberg, and all the other fashionable child-women of the day, reduced to performing in seedy nightclubs, Mansfield died when her skull was crushed in an automobile accident in 1967.

But to return to Cinderella, we should clear up one thing: was the famous slipper a mule or a high heel? When the wild girl ran down the palace staircase at the first chimes of midnight, did her shoe make the fun, playful clack-clack-clack of the mule, or a heavy clunk-clunk? The mule—a unisex item from the sixteenth century up until the French Revolution, becoming an exclusively female item in the twentieth century (except the flat version called the indoor slipper worn by househusbands)—seems to be the favorite in this race: the foot has escaped, as if by magic. The foot is both inside and out, teasing the shoe and the viewer with its suggestive to-and-fro, as the mischievous Mansfield seems to have understood in this photo. What would the actress, who boasted an IQ of 163, have thought of that other argument on the nature of the slipper: was it made of glass or fur? Perhaps the fairy godmother was equipped with gray squirrel fur, as Anatole France thought: "Slippers made of squirrel's skin would be much more conceivable."[4] Or perhaps we should trust Charles Perrault, the author of *Cinderella* and of the preface to the dictionary of the Académie Française in 1694, who deliberately chose glass, a meta-signifier of fragility. Three centuries later, Bruno Bettelheim reinterpreted the glass slipper as a metaphor for the vagina, and its loss symbolic of the loss of virginity, "something that is easily lost at the end of a ball."[5] Even for Mansfield, "it's a man's, man's world."

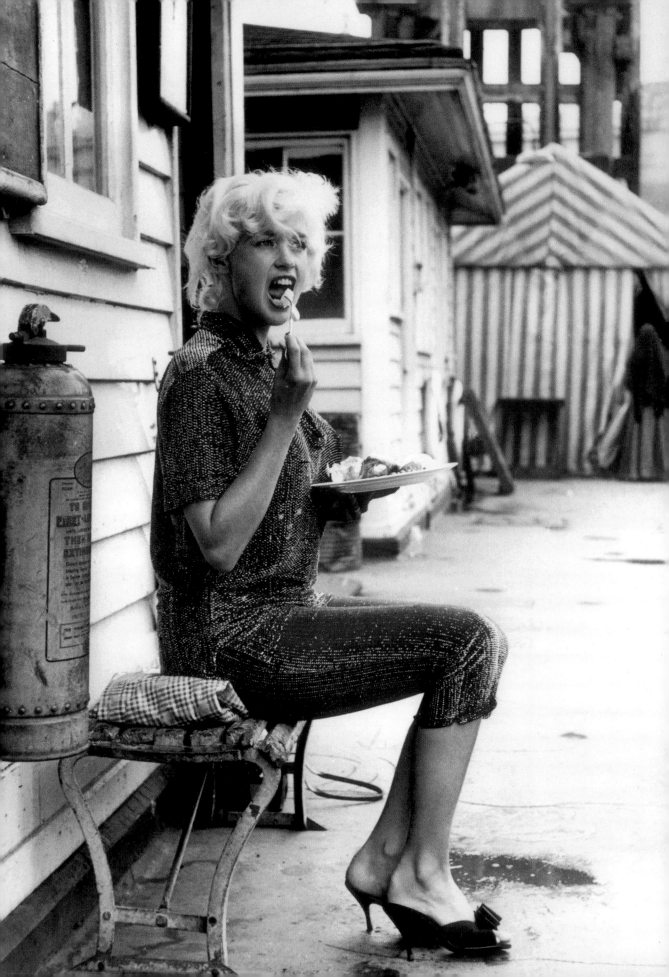

KATHARINE
HEPBURN

Katharine Hepburn in platform sandals—these lofty shoes raised more than just eyebrows. The style could have been invented for her. Inspired by sixteenth-century Venetian chopines, whose platforms could be as high as twenty inches, the platform heel was developed by Salvatore Ferragamo in 1937. Can you imagine this wonderful, statuesque girl perched on common stilettos, like any old pinup? It's not only impossible, it would be too unequivocally feminine. The platform heel is a well-thought-out compromise between sensuality and practicality, between conquering sexuality and advanced intelligence. Hepburn (who as a child insisted her family call her Jimmy) was all bones, angles, and wit ("There's not much meat on her, but what there is, is first choice," said Spencer Tracy in the movie *Pat and Mike*). She pushed back the boundaries and upset gender stereotypes. "In some ways I've lived my life like a man, made my own decisions."[1] From the 1930s, the cross-dressing star of *Sylvia Scarlett* mixed up archetypes and developed female attributes like no other actress before her. ("*Sylvia Scarlett* reveals the interesting fact that Katharine Hepburn is better looking as a boy than as a woman," quipped *Time* magazine in 1933.) In Hollywood at the very same time, Marlene was importing men's suits, pants, and an arrogant style of androgyny created by Josef von Sternberg, which she expressed in a theatrical, calculated way. By contrast, the red-headed Hepburn brought about her own revolution in the most spontaneous way, like a good American pragmatist, smart and independent, with no need for a Pygmalion to tell her what to do. Miss Hepburn dressed like a guy not for reasons of strategy, but to be true to herself. "Skirts are hopeless. Anytime I hear a man say he prefers a woman in a skirt, I say, 'Try one.'"[2] Hepburn still fascinates us today; she is the symbol of freedom, intellectual sophistication, with an astute understanding of the role of women in society. Miss Hepburn

wore the pants, no doubt about it. But in the '30s, her antics and her (über) feminist stance were misunderstood. Proclaiming loudly that she didn't want children, seen as too "la-di-da" by women moviegoers traumatized by the Great Depression, Hepburn earned the nickname "Katharine of Arrogance," and between 1935 and 1939 her popularity plummeted. The last straw was when the Independent Theatre Owners of America put her on their blacklist of "box-office poison." She had just finished filming *Bringing Up Baby*, directed by Howard Hawks and costarring Cary Grant; the movie is the epitome of screwball comedy in which her skills as a comic are stunning. Hepburn's resurrection happened in stages, beginning with her 1939 theatrical triumph in *The Philadelphia Story*, written for her by Philip Barry (this time Dorothy Parker didn't mock as she had done in 1933, saying "Katharine Hepburn runs the gamut of emotions from A to B"). She followed this success by buying the movie rights with money from her lover Howard Hughes, and foisting the 1940 George Cukor movie adaptation on MGM. And finally, by meeting Spencer Tracy in 1941, whom she had insisted on having as costar in *Woman of the Year*.

Their first meeting has now gone down in legend. Following an introduction by Joseph L. Mankiewicz, Hepburn looked Tracy up and down and wisecracked: "Mr. Tracy, I believe I am too tall for you," to which Mankiewicz retorted: "Oh, don't worry. He'll soon cut you down to size." Their battle of the sexes may have been playacting, but their loving relationship was real and lasted twenty-seven years, punctuated with great movies that epitomized the notion of equality. Katharine's mannishness was offset by Spencer's tenderness—in a word, it was all about balance.

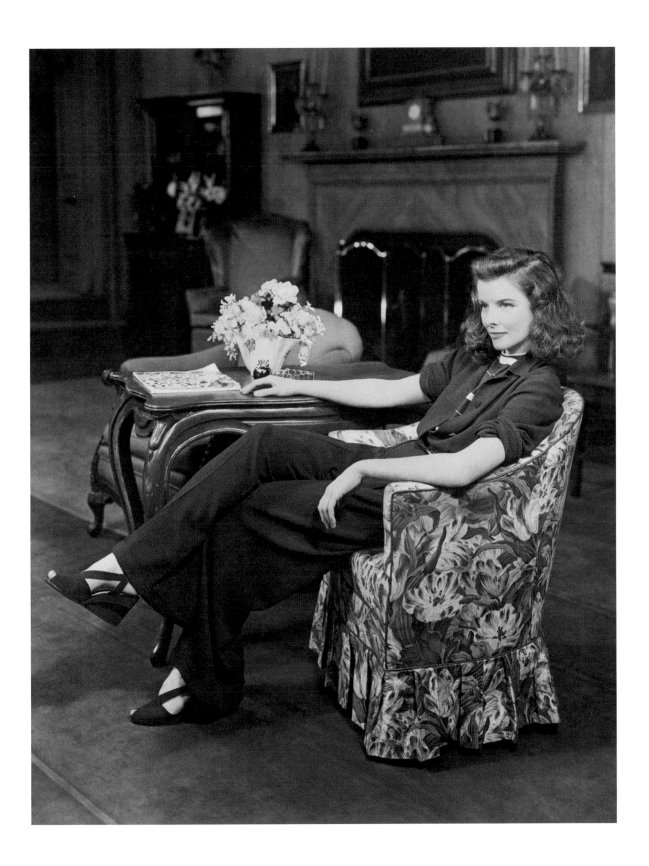

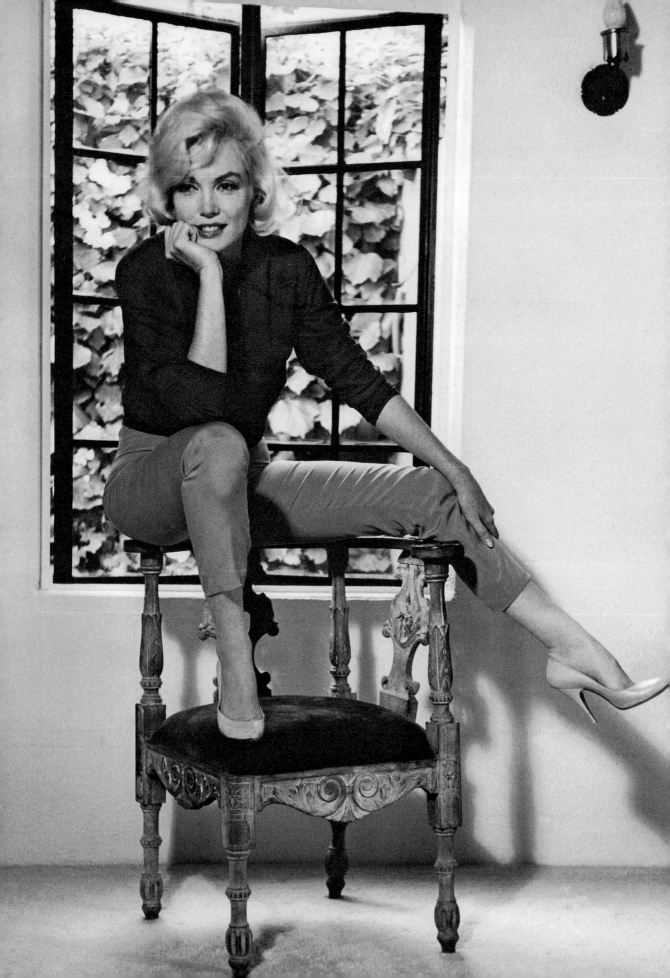

MARILYN
MONROE

— BRENTWOOD, JULY 4, 1962 — ALLAN GRANT

Venus[1] wears size seven shoes. And she looks dreamy in a tight black sweater, beige cropped pants, and Ferragamo stilettos. It's July 4, 1962. Children are setting off firecrackers in neighboring backyards. But Venus has other fish to fry. In this modest hacienda in Brentwood (the address, 12305 Helena Drive, and the inscription on the entrance tiles, "Cursum Perficio,"[2] would become famous the world over on August 5th of that year) the only crackling noises come from the tungsten flash. A long photographic session is underway: "Operation Reconquista." With the help of the great *Life* magazine reporter, Allan Grant, Marilyn has to convince Twentieth Century Fox, the national press, and the whole world that she's still a good actress, capable of delivering her lines in the right order, and arriving on set on time. At the age of thirty-six, she was the most adorable sex symbol, the "first star that went beyond the star system,"[3] but the most unpredictable—when she murmured "Happy Birthday Mister President" to JFK in her temptress's voice at Madison Square Garden, nude under a transparent sheath dress, was that the act of a reasonable woman? At the height of her fame, she was nevertheless dangerously close to the abyss. Marilyn had been a broken woman since her 1961 divorce from Arthur Miller, who had described her loftily as "a poet on a street corner trying to recite to a crowd pulling at her clothes."[4] Since then she had been reliant on psychoanalytical and chemical crutches, ricocheting between euphoria and melancholy, some days looking for a Shakespeare play to perform in, on others attempting suicide, doing absolutely anything—in short, crying for help.

The situation was serious: Marilyn had just been kicked off the set of her latest movie, *Something's Got To Give* (a prophetic title, like her role as a ghost, a woman who comes back to life to find her husband has remarried). Twentieth Century Fox, Darryl F. Zanuck's studio, had earned tens of millions of dollars

thanks to Marilyn, ever since she had made *Monkey Business* in 1952, but the company had always underpaid her. The studio was even considering taking legal action against her. That was out of line. The actress decided to go on the counteroffensive using the press and one fatal weapon: the high heel, the (four-inch-high) yardstick of femininity. Did she know that the heel of her Ferragamo stiletto (the shoemaker to the stars provided her with footwear throughout her life, on set and off) was reinforced with a fine steel blade, just like the very long, very deadly swords used by sixteenth-century Italian swashbucklers, which gave the style its name? First launched immediately after the war by the Franco-Italian troika of Roger Vivier, André Perugia, and Salvatore Ferragamo, stilettos were designed for Marilyn and her undulating, voluptuously comical way of walking (remember her arrival at the station in *Some Like it Hot*?). "Marilyn does two things beautifully—she walks and she stands,"[5] wisecracked Billy Wilder. In this photo, Marilyn is working a little black sweater and cropped pants with kid-leather stilettos. We have to go along with feminist writer Gloria Steinem, who thought Marilyn had a split personality.[6] It's true. On top she's dressed like Audrey Hepburn; on the bottom like Marilyn Monroe. A split personality, or one that reconciled the sophisticated glamour typical of the '50s (the *femme fatale*) with the modernity of the '60s. Blowing in the wind, Marilyn hesitates, and it's stunning. Which path would she have followed wearing '60s ballet slippers; which kind of femininity would she have explored wearing low-heeled shoes, if she hadn't been found dead at home, barefoot, on the night of August 4, 1962, the day after the article appeared? Twentieth Century Fox had just agreed to rehire her on the movie, with a new director, her friend Jean Negulesco. "Not a scared lonely little girl anymore/Remember you can sit on top of the world (it doesn't feel like it)."[7]

JACK
LEMMON

— LOS ANGELES, JANUARY 1, 1964 — JULIAN WASSER

Billy Wilder's favorite actor was born with a silver spoon in his mouth. A Bostonian, son of a donut company president, Harvard graduate, World War II Navy conscript, gifted pianist (his album *A Twist of Lemmon/Some Like it Hot* is worth a listen)—John Uhler Lemmon III was the quintessential Ivy Leaguer. Dressed impeccably at all times, he was the poster boy for the "tailor of Beverly Hills" Dick Carroll—a former Navy pilot, Warner Bros. employee, and screenwriter whenever he had the time, who reinvented himself and, from 1953 in his famous Rodeo Drive store, dressed all the most elegant stars of Hollywood: Clark Gable, Fred Astaire, Gregory Peck, Frank Sinatra, Dean Martin, James Stewart, Rock Hudson, Robert Redford, even Billy Wilder and Walter Matthau. Carroll, who went on to open a studio division for cinema costumes in 1947 (he's mentioned in the credits of some three hundred movies), built his reputation on the "natural shoulder" cut of his jackets. He traveled regularly to Europe, buying stock from the best suppliers. From Scotland, and particularly from Hawick in the Borders, he brought back cashmeres of which Lemmon, a great fan of cardigans, was very fond. In Julian Wasser's photo, enjoying a Havana cigar in his bachelor pad, the unforgettable Daphne from *Some Like it Hot* has slipped on over his polo shirt an alpaca cardigan whose striped edges give the illusion of a shawl collar. Life is sweet. The wool from the alpaca (a small camelid of the llama or vicuña family) owes its lightness to the delicacy of its fibers. It's simple: the more delicate each strand, the more luxurious the wool. On the scale of wools, measured (in microns) by the average diameter of each fiber, the prize goes to the vicuña. Then comes cashmere (wool from the pashmina goat that lives on the high Mongolian and Himalayan plateaus was introduced to Europe by French manufacturers at the start of the nineteenth century and then spread, based on French craftsmanship, to Scotland in 1830), closely followed by alpaca, then camel-hair, and then, far down the list, lamb's wool and finally Shetland (the rough wool from sheep of the Shetland Islands). So which do we prefer: the "pullover," which is put on over the head, or the cardigan? The latter, the front-buttoning knitted jacket, owes its name to the 7th Lord Cardigan, who, in the mid-nineteenth century, suffocating in his pullover, is said to have sliced it from waist to collar in a single stroke of his saber. The same Cardigan who, during the Crimean War, was in command of the absurd Charge of the Light Brigade on the orders of Lord Raglan (the cut of whose overcoat, incidentally—adapted to accommodate the fact that he had lost an arm at the Battle of Waterloo—gave his name to this style of sleeve). But what we love most about this portrait of Jack Lemmon in a cardigan are his magnificent slippers, worn in such aristocratic Bostonian style: slippers that fashion today says you can wear on the street like common loafers, but that Jack wears in a spirit of peace and goodwill on this New Year's Day.

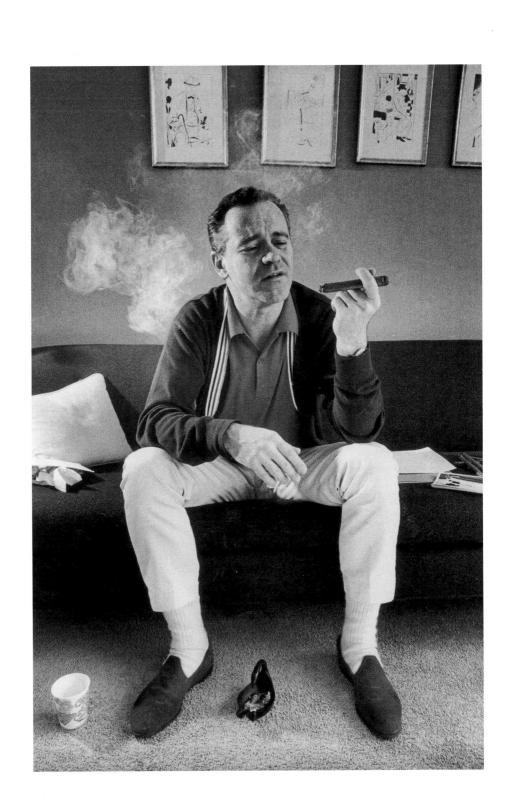

ANTHONY
PERKINS

Young Anthony looks troubled. Although he'd been parading his brand of nervy shyness in movie after movie, and proved he could seduce like a crooner (in 1957, his hit *Moonlight Swim* was on everyone's lips—four years before Elvis sang it in *Blue Hawaii*), he hasn't yet portrayed Norman Bates in *Psycho*, the double role that gained him entry to the pantheon of cinema but that would haunt him for the rest of this life, typecasting him as a character that he would reincarnate three more times (in *Psycho II*, *III*, and *IV*). In 1962, two years after the first *Psycho*, his performance as Joseph K. in Orson Welles' *The Trial* was once more riddled with anxiety. To rid himself of this image he crossed the Atlantic. In Europe, his appearance, like a gawky teenager, was an inspiration. *Goodbye Again* won him the Best Actor award at Cannes. Brigitte Bardot, his co-star in *Agent 38-24-36*, tried in vain to undermine his modesty. Living in Paris during the Kennedy era, Perkins's chic, gangling charm made him an idol among the happy few. But this was nothing out of the ordinary for this scion of the American East Coast, descendant of *Mayflower* pilgrims, who studied at Brooks School and Columbia University. Anthony was the epitome of preppy style, named after the students in prep schools, hoping to enter one of the eight Ivy League universities (seven founded by the British before independence), whose vine-covered walls symbolize the idea of roots and permanence. Ivy League style came to dominate American campuses in the '50s: button-down-collar shirts, madras or seersucker jackets, white nubuck shoes with pink rubber soles (by Cole Haan), and canvas tennis shoes with antislip rubber soles (by Sperry Top-Spider). Popular colors were almond-green and pink. Legendary suppliers were J. Press (established in Yale since 1902) for club ties and their famous "three-button sack" suit (the third button obscured and only two used), and especially Brooks Brothers,

an institution created by Henry Sands Brooks in New York in 1818. Brooks dressed and continues to dress almost all American presidents, from Lincoln (the lining of the made-to-measure overcoat he wore that fateful night in the theater bore an eagle design and the inscription "One country, one destiny") to Obama, who also wore a Brooks Brothers' overcoat for his 2009 inauguration. Brooks Brothers also provided wardrobes for Cary Grant, Clark Gable, James Stewart, even Andy Warhol and the modern heir to Norman Bates, the deranged antihero of *American Psycho*—Patrick Bateman.

This photo of Anthony draws attention to his shoulders, square as a coat-hanger and from which everything hangs beautifully, emphasized by the raglan seams of his Shetland crew neck, which, like his white Shetland socks, could well have come from the shelves of the Brooks Brothers' temple on Madison Avenue. His jeans are slim-fit corduroy. His moccasins, an essential part of the Ivy League wardrobe, have been fashionable since the '30s, through the efforts of Spaulding and G. H. Bass, who brought a soft suede shoe back from Norway and called his loafers "weejun." It wasn't until 1952 that Alden invented the tasseled loafer, and Sebago created the "beef roll," which features a roll of leather either side of the snaffle. In 1958, the "penny loafer" was ubiquitous on college campuses—students put a coin (a copper penny for the boys, a silver dime for the girls) into the slit on the front of the shoe. Anthony's suede moccasins feature leather laces. As comfy as slippers—a preppy's dream before the psychotic nightmare begins.

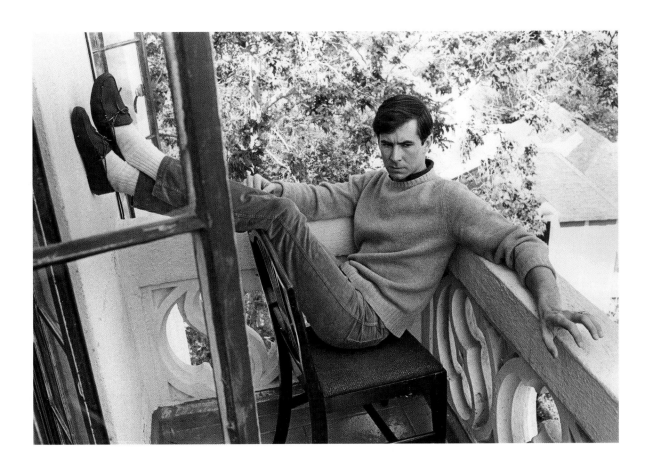

ERROL
FLYNN

— BURBANK, CALIFORNIA, 1945

Mustachioed, spirited, brave, impetuous, muscular: his master's portrait? Arno, Flynn's beloved schnauzer, went everywhere with him, on his yacht or on set, and stopped barking as soon as he heard the word "Action!" Here, in the Warner studios, filming *Never Say Goodbye* (the story of a divorced couple and their little girl's attempts to reconcile them) Errol looks bored to tears. Yet, he is at the height of his stardom. *Objective, Burma!*, his sixth movie with Raoul Walsh (after *They Died with Their Boots On* and *Gentleman Jim*), released at the beginning of the year, is one of the best war movies ever made. Walsh, one of the four "one-eyed men of Hollywood" (alongside Fritz Lang, André De Toth, and John Ford) and Errol's drinking pal, had picked up the baton from Michael Curtiz, with whom Flynn had made twelve movies, and who, ten years earlier, had brought him fame with *Captain Blood*, before making him the king of the swashbucklers in *The Adventures of Robin Hood* and *The Sea Hawk*. Flynn was born on the island of Tasmania, of Irish descent on his father's side, and was first spotted in 1933 in Tahiti, on the set of *In the Wake of the Bounty* (on his mother's side, he was a descendant of one of the *Bounty* mutineers). A long distance adventurer, Flynn worked as a tobacco planter, a copra seller, a gold digger, a blast fisher, a pearl diver, a dealer in all sorts, even a slave trader. "The only real wives I have ever had have been my sailing ships,"[1] he wrote in *My Wicked, Wicked Ways*, an autobiography published just after his death at the age of fifty. Flynn was a brawler and had controversial political opinions (he was wrongly accused of Nazi sympathies, took the Republican side in the Spanish Civil War during an episode as a war correspondent in 1938, and then advocated Castro's revolution). Add to the formidable portrait a skilled sportsman (boxing, gymnastics, and cricket), a relentless playboy, a party animal, and an inveterate drinker who wondered: "Why did most other things pall on me, but vodka never?"[2] (His best buddies reportedly put a case of Irish whiskey in his coffin.) By 1945, alcohol and drugs had prematurely aged the thirty-six-year-old (becoming a naturalized American in 1942, he tried to join the Army, but was rejected once they'd seen his medical records), but beneath his hangdog appearance, the panache is still there, with all the charm of a depressed devil-may-care in his silk pajamas. He's barefoot in his loafers. They're black and white, like spectators, those two-tone brogues made fashionable in the '20s and '30s by the jazzmen who were breaking down racial barriers (a mixed-race shoe brought back thirty years later by the Two-Tone and Ska tribes), before becoming the signature footwear of gangsters during Prohibition. Here, it's highly likely that he's wearing shoes by J.M. Weston, the company that invented their famous loafers in the '40s, thus mixing Anglo-Saxon comfort with French elegance—a devilish combination typical of Errol Flynn.

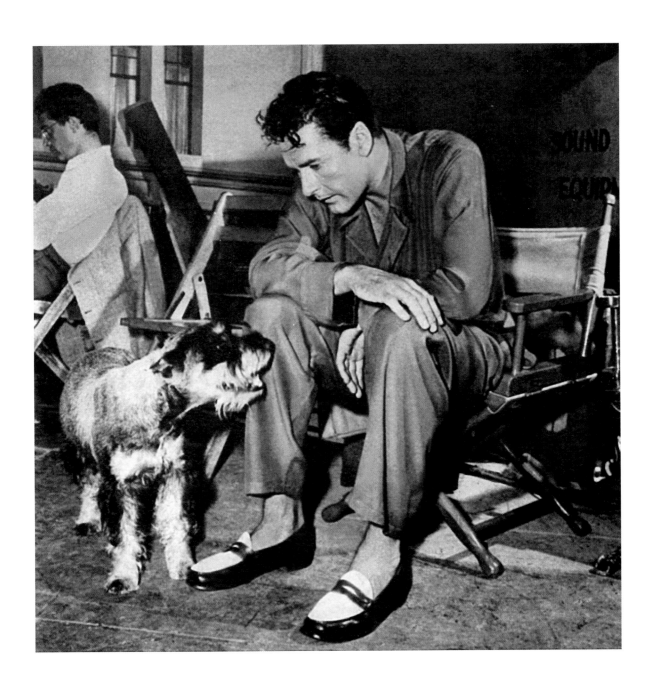

WES ANDERSON

— ROME, APRIL 12, 2010 — ERNESTO RUSCIO

He wasn't even born when Clarks Wallabees were invented, those honey-colored, crepe-soled suede shoes designed by Lance Clark in 1965, but he won't wear anything else. As comfortable as a slipper, as supple as an Apache's moccasin, with a simple two-hole lace just below the ankle. Whether there's a cool breeze or intense heat, Wallabees adapt to the terrain, and also to your outfit, as in this photo, where they match the soft russet velvet suit worn by Wes Anderson, in Rome in the spring to promote his movie, *Fantastic Mr. Fox*. The Texan moviemaker—whose elegantly nipped-in suits, with their too-short sleeves and 7/8 pants, were the subject of many discussions with his tailor—is a fussy kind of guy. An admirer of Satyajit Ray, François Truffaut, and Jacques Tati, and a fan of The Kinks and The Small Faces, Anderson oversees the wardrobe and accessories of all his movies. For him, clothes maketh the man, and style is the key to character. Just take a look at the outfits on the puppets in *Mr. Fox*, the clothes worn by the three brothers in *The Darjeeling Limited*, or the shawl-collar sailor's sweater in *The Life Aquatic with Steve Zissou*, and you'll see what we mean. In *The Royal Tenenbaums*, Wes Anderson designed Gwyneth Paltrow's dresses, and for Bill Murray, a velvet jacket (with just two buttons). Only after giving a pair of Wallabees to Murray, his favorite actor, did the director himself adopt them definitively. That was in 2001—when Clarks were selling some thirty million pairs every year. Up until the mid-'90s, the shoemakers, based in Somerset, England and founded in 1825 by brothers Cyrus and James Clark, had remained a family-owned company. The two leading products of this English brand, the Desert Boot and the Wallabee, had been invented by their descendants: in 1949 Nathan Clark designed the peerless Desert Boot, inspired by the shoes worn by officers in the British Eighth Army during the Western Desert Campaign. The shoes have the color of warm sand, and the aura of the Battle of El Alamein, when Monty defeated Rommel, the Desert Fox, and his Afrika Korps. The Desert Boot's moment of glory arrived in the '60s, when it was taken up on both sides of the English Channel by English Mods and the Parisian Right-Bank dandies. New colorways swiftly followed, with Clarks becoming available in chestnut brown, black, or verdigris bronze. The Wallabee is waiting its turn. Whether on the King's Road or the Champs-Élysées, Wes Anderson himself would have fit right in.

EDWARD
NORTON

— UNITED STATES, 1999 — HERB RITTS

In August 1999, on the occasion of his thirtieth birthday, he made the cover of *Vanity Fair*. He had shot to fame at lightning speed in two ultraviolent roles—a neo-Nazi skinhead in *American History X* and a psychotic warrior in *Fight Club*. Herb Ritts, who took this photo, took the opposite approach, showing us instead Edward Norton the Yale art history graduate, the arch-Bostonian, smiling. He's wearing a pair of chevron-pattern tweed pants, a sweater vest over a white shirt, and a pair of perfectly polished black Oxfords. But he's barefoot in his city shoes. Uncomfortable, even painful. It's a curious mismatch, but heralded a fashion among yuppies who think you have to suffer to be beautiful. For any shoemaker who knows his stuff, it's an aberration. Making shoes is an art, whether you prefer Derbies or Oxfords, the two basic models of low-heeled shoes. They're a dueling duo, as a glance at the details shows: the Oxford (known as the *Richelieu* in France, after the famous cardinal, and the Balmoral in the UK, after the queen's Scottish residence) is laced in the vamp itself and the toe is stitched under the shoe's uppers. The Derby (named after Lord Derby), sometimes known as a Blucher (after the field marshal), does the opposite, with an "open-lacing" style, where the shoestrings bring together eyelet tabs on either side, and the toe sits over the uppers. But let's get down to the nitty-gritty: a bespoke shoe requires whole days of work, and six different skilled craftsmen at the very least. First there's the fitter and last-maker, who carves the wooden model, or last, on which the shoe will be constructed. Then the pattern cutter designs all the details of the model on the last, and cuts out the different sections of the shoe's uppers. The clicker chooses the pieces of leather that create an envelope for the foot; then he assembles the uppers including the lining. Once the uppers are assembled (and fitted on the last), the maker adds the soles and heels;

he also molds all the pieces to the exact shape of the client's foot. Then the tree maker makes a shoe tree that corresponds to the client's last. Finally, the polisher refines the final details— the ultimate waxing and shining.

So should we go for off-the-shelf shoes or bespoke boots? If your feet are generally unproblematic and you put them in the hands of good manufacturers who have existed for at least one hundred years, who offer half-sizes and no less than five widths, there is very little difference. In the entire world, the kings of shoemaking can be counted on the fingers of two hands. On Madison Avenue, there's Johnston & Murphy, founded in 1884, as was Alden, an expert in shell cordovan leather (a kind of tough maroon or black horsehide); then there's Allen Edmonds, founded in 1922. On Jermyn Street in London you'll find Foster & Son (established in 1840), Crockett & Jones (1879), Church's (1873), and John Lobb (1866), who later set up shop in 1902 on Faubourg Saint-Honoré in Paris. And on the banks of the Seine, there's Berluti (established 1895), the duke of patina, and J.M. Weston (Édouard Blanchard founded the Limoges workshop in 1891), the only boot-maker in the world to have its own sole leather tannery. Who would win if they duked it out? It's a question of personal taste: a crazy, impossible decision, worthy of Edward Norton, the perfectionist.

GEORGE BERNARD SHAW

He was an animal-loving vegetarian, pictured here, playing with his cat, Bunch. They are outside the Brocket Arms, a fourteenth-century inn, believed to be haunted, in Ayot St. Lawrence, the village to the north of London where he had lived since 1906 and where he would end his days, at the age of ninety-four, after falling off a ladder while pruning a tree. In this photo, Shaw, at eighty-two, was the only person to win both a Nobel prize and an Oscar. (Shaw won the Nobel in 1925, but refused the monetary prize that accompanied it, just as he had refused a knighthood in 1923, and he received an Oscar for the screenplay of his own play *Pygmalian* the year this picture was taken. The musical adaptation, *My Fair Lady*, would go on to win eight Oscars in 1964.) The Irishman had a scathing sense of humor, was a passionate socialist, a fiery pacifist, an orator, and formidable pamphleteer, cofounder of the London School of Economics, a playwright (sixty-three works), a novelist, and a peerless music critic. He was also a skilled photographer, taking twenty thousand photos! Here, the weather is mild: he's wearing a linen suit, rather than one of his perennial Norfolk suits in Harris or Donegal tweed. Such rustic wool suits were designed in tones of rust, peat, tobacco, and moss, colors redolent of nature, and had become fashionable during the late Victorian era by the Prince of Wales on his country pursuits. The suit comprises the Norfolk jacket (named for the county in which Sandringham House and its royal hunting estate is located), belted or half-belted, with two box pleats front and back, and a pair of generous breeches, fastened above the calf, and known as knickers or knickerbockers. ("Knickerbocker" was the pseudonym used by Washington Irving to pen *A History of New-York*, and it soon came to designate the city's aristocracy of Dutch founding fathers,

then subsequently its baseball players—the New York Knickerbockers, now Knicks.) Knickerbockers were not worn more widely until the '20s, but Shaw was one of the earliest converts.

In 1885, as a corseted, starched, and strait-laced century was coming to an end, Shaw became an advocate of the hygienic dress reform movement of the German physician, Dr. Jaeger. The doctor was particularly concerned about the dangers caused by the modern trouser, claiming that the design "sucked in drafts of air that, like so many evil spirits, undermined men's health . . . [and] hindered the circulation of blood."[1] To overcome the threat such garments might cause, Dr. Jaeger promoted the wearing of breeches and stockings, with the breeches' knee fastening amply protecting the leg from drafts. Dr. Jaeger also insisted on pure wool, and the company bearing his name opened shops in all the major European capitals. Having been brought up wearing "sanitary clothes," Shaw remained faithful to knickerbockers and good woolen socks that let the skin breathe. And rather than brogues (derived from the Gaelic word, *brog*), shoes whose perforations were originally designed to allow water to escape when walking across the rain-soaked Irish countryside, he preferred stout golf derbies whose fringed tongue folds back over the vamp to protect the laces from getting damp in the rough. The Nobel prizewinner always thought on his feet.

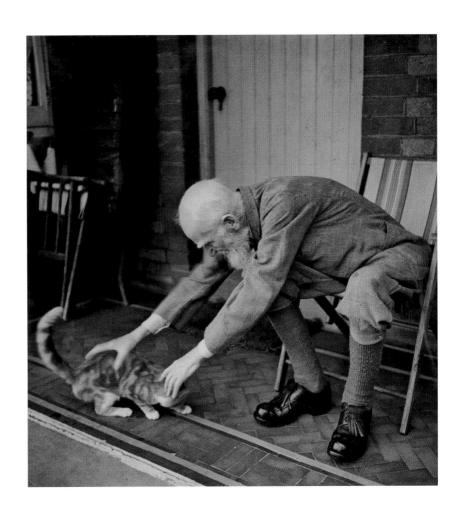

JACQUES
DUTRONC
AND CATHERINE DENEUVE

— PARIS, APRIL 1968 — JEAN-MARIE PÉRIER

He's sitting on Catherine's lap—and the "Belle de Jour" is wearing a "Mini, mini, mini" dress, as Jacques once sang. They are both twenty-five, and both perfect French-style Mods, or *minets*, captured just before Paris came to life in May '68. The previous year, Catherine had separated from David Bailey and Jacques had moved in with Françoise Hardy after they'd been introduced by photographer Jean-Marie Périer. Dutronc, singer of "J'aime les filles" [I love girls], and nicknamed "Sex" by Périer (a reference to his instrument, perhaps?) would always remain the photographer's best friend and favorite model (alongside Françoise). "I was fascinated by his ability to provoke states of collective madness. He just had to turn up somewhere and all the crazies in the neighborhood would show up. He had that strange gift of being able to turn an ordinary event into a party, into epic performances of songs that glorified his joyous pessimism."[1] In 1968, Dutronc had been enjoying hit after hit for almost two years (all written by his old friend Jacques Lanzmann). Along with Michel Polnareff, Nino Ferrer, and Ronnie Bird, he was one of the few Frenchman to feature on the soundtrack of those small-time Parisian dandies known as Drugstore Mods. "I'm not afraid of those little pussy Mods/Eating their MiaoMix in the Drugstore," he sang in "Les Playboys." Dutronc may have been the archetypal hunch-shouldered, tight-suited Mod, but he was never part of the Drugstore crowd, who regarded him with a kind of resentful admiration. You remember the Drugstore: it's up there, right next to the place de l'Étoile on the Champs-Élysées, and it burned down in a suspicious fire in 1972. Shadowy arbiters of baby boomer fashion, the crowd hung out there between 1960 and the last days of 1967. In the middle of the boring, monotonous '60s, right in the heart of the chic Parisian districts and in the shadow of the Arc de Triomphe, the Drugstore crowd was the Mods' holy grail. Are you in or out? The first person to claim he was "in" would have been cast out forever and branded a "phony." The Drugstore guys were nasty little Gods—showing off and lashing out. Not losing face. The rage of destruction, the brutal charm of adolescence, the cruelty of provocation—they made no exceptions and took no prisoners. By definition the scene was all about posturing and imposturing. The Drugstore Mods continually destroyed their own fashion creations as soon as they were adopted by the "phonies." This unending quest for the insignificant detail, time spent looking for ways to differentiate themselves from others, ad nauseam, ended up making the crowd disappear into oblivion just a few months before spring 1968, and consigned the Paris Mods to the trashcan of history. In "Les Playboys," "MiaowMix" was a reference to a favorite cat food of the period, but in fashion terms Dutronc's lyrics got it all wrong when he sang: "Dressed by Cardin with shoes by Carvil...." In reality the Drugstore Mods would have been "dressed by Renoma with shoes by Weston." As for Dutronc, he was a regular visitor to "Auld Reekie" (a.k.a. Edinburgh, famous for its Shetland-wool and cashmere garments), a Mod store on Paris's place Saint-Augustin (now gone), a stone's throw from the Berteil store that sold Alden tasseled loafers. In this photo, Dutronc's Cuban-heeled Chelsea boots by Anello & Davide were brought over by Jean-Marie Périer—who had been told about the London boot-maker by none other than The Beatles.

DAVE
DAVIES
AND THE KINKS

— LONDON, 1966 — DEZO HOFFMANN

His blazer—like a minidress—just covers his buttocks, and the turtleneck collar of his cashmere sweater marks him out from the other Mods, who are wearing neat ties. Instead of Chelsea boots or the obligatory Hush Puppies, he wears black thigh-high boots in soft suede. In the era of Swinging London, Mary Quant had just invented the miniskirt, and sexy boots like these would soon be enhancing the thighs of Twiggy and the Shrimp. Displaying a daring attitude worthy of Beau Brummell himself, Dave Davies made these boots his own. He was the glamorous solo guitarist of The Kinks, the accursed brother of Ray, the irascible writer/composer/singer who played in the foursome, and whose unrivalled gift for composing social satire in three catchy minutes made them the only real rivals to The Beatles and The Stones. That year Ray wrote "Dandy" inspired by Dave, and "Dedicated Follower of Fashion" in which he mocked the young fops of the "Carnabetian army" as they strutted up and down the new fashion street: "He flits from shop to shop just like a butterfly." But it was Dave, the little prince with the angelic smile, who was popular.

He invented heavy metal before Led Zeppelin (he created the distorted sound on "You Really Got Me" by slicing the membrane of his amp with a razorblade); turned-up in a frilled shirt, scarlet velvet riding jacket, schoolboy's cap, or clown hat; and lived for a time with Brian Jones in a *ménage à trois* with Anita Pallenberg. He exasperated his elder brother. Well before the brawls between the Gallagher brothers of Oasis, The Kinks would go out on stage sporting black eyes and bloodied lips. One day, Dave was almost scalped by the drummer's cymbal; another time he smashed his guitar over Ray's head—pathological rivalries that would destroy The Kinks. It was written in the stars. Dave Davies had the poise of a ballerina and the boots of a musketeer—like Aramis, the most elegant musketeer of them all.

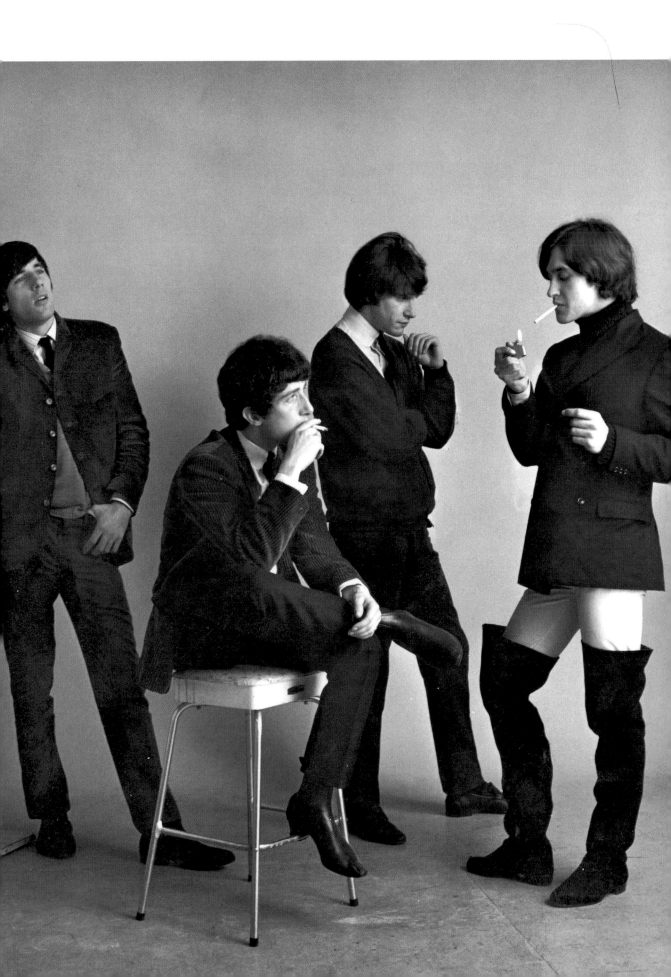

RAMÓN NOVARRO AND ROBERT MONTGOMERY

— LOS ANGELES, AROUND 1930 — JOHN SPRINGER

The scene is probably a dressing room at Metro-Goldwyn-Mayer studios, in 1929 or 1930 perhaps, just as silent movies became the talkies. But maybe it's 1931, when Ramón Novarro and Robert Montgomery were taking turns as Garbo's on-screen lover. In *Mata Hari*, Ramón played Russian lieutenant Alexis Rosanoff, who led the courtesan astray; in *Inspiration*, adapted from Alphonse Daudet's novel *Sapho*, Montgomery played the young diplomat hopelessly in love with the divine Garbo.

At the time, Ramón Novarro was the highest-paid actor at MGM. Born in Durango, Mexico, to a rich and influential family, whose home was called "The Garden of Eden," and who fled the Mexican revolution to live in Los Angeles, Novarro made his screen debut in 1917, and his Latin lover looks were soon all the rage. Attracting attention in 1925 with his part in *Ben Hur*, he took over the role of sex symbol following the death of Rudolph Valentino in 1926. He successfully made the perilous transition to talking pictures because he sang well, which meant he could make in quick succession *In Gay Madrid* and *Call of the Flesh* (which he also directed) in 1930. As for Robert, also born with a silver spoon in his mouth, he experienced tragedy when his father, president of the New York Rubber Company, committed suicide by throwing himself off the Brooklyn Bridge. He made his screen debut in 1929, his playboy good looks earning him a place on Joan Crawford's arm in her first talkie. Here we see him in Rámon's dressing room, bare-chested under his white dressing gown, with slicked-back black hair and polished black boots. Perhaps Robert is offering more than just a cigarette. He's sitting sprawled on the couch in his turtleneck sweater, tweed jacket, and jodhpurs. The latter are riding pants made fashionable in 1897 by the son of the Maharaja of Jodhpur in Rajasthan, a polo player, during Queen Victoria's Diamond Jubilee. Savile Row soon began producing an English version, while in the '20s they were adopted by the daring Coco Chanel. And Robert is wearing the same boots as Ramón, but in dark brown. What are they talking about? Boot-makers? John Lobb? The impressive collection of two-tone brogues lined up by Ramón's feet? Robert's stunning wardrobe, which he spent a fortune on? Their favorite Savile Row tailor, Anderson & Sheppard (established 1906), whose popularity in Hollywood had been spearheaded by Rudolph Valentino, Fred Astaire, and Douglas Fairbanks?

In 1935 the wind changed. Ramón, accused of being a Communist, fell victim to a Hollywood witch hunt. Worse, he refused the arranged marriage offered by MGM to cover up his homosexuality, and mogul Louis B. Mayer didn't renew his contract. His career went into free fall, and Ramón, torn between his Catholic faith (he often considered taking holy orders) and his homosexuality, drank heavily. It all ended for him in 1968 when he was tortured and murdered by the Ferguson brothers, escorts he had invited to his home, as described by Kenneth Anger in *Hollywood Babylon*. As for Robert, he became president of the Screen Actors Guild in 1935 and carried on with his career. After World War II, during which he served with distinction in the Navy, he became a director, making two film noirs, the highly original *Lady in the Lake* (filmed using the point-of-view, or subjective camera, technique), and *Ride the Pink Horse*— with its rather suggestive title.

DENNIS
HOPPER

Dennis Hopper by Dennis Stock. Around the two Dennises, who died a mere four months apart in 2010, hovers the ghost of James Dean. Stock, a leading light of the Magnum Agency, captured the photo of Jimmy walking in Times Square in the pouring rain, cigarette in his mouth, collar up, shoulders hunched under his long overcoat in 1955, prior to the actor's death later that year. Nineteen-year-old Hopper made his screen debut that same year alongside Dean: a small role in *Rebel Without a Cause*; a second, more noteworthy role followed in *Giant*, playing rich-kid Benedict, who rebels against his father by marrying a poor Mexican girl. A violent dispute with Henry Hathaway on the set of *From Hell to Texas* severed his ties with Hollywood. Dennis wrote poems, left for New York to study at the Actors Studio, returned to California, painted, sculpted, and proved his chops as a photographer (producing some remarkable portraits of his artist friends, such as Rauschenberg, Ruscha, Rosenquist, and Lichtenstein—Hopper had a connoisseur's eye for contemporary art, buying one of Warhol's first Campbell's Soup can prints for only seventy-five dollars—along with the royalty of the West Coast music scene, from Jefferson Airplane to the Grateful Dead). He worked in mixed media (matter painting, collage) and dipped a cautious toe back into cinematic waters. *Easy Rider*, a divine surprise, came out in 1969. Its phenomenal success allowed Hopper to direct *The Last Movie* the following year in Peru, resurrecting an old project he had written with Stewart Stern (screenwriter on *Rebel Without a Cause*): an apocalyptic Western and ghostly commentary on film fakery, where Dennis plays a horse wrangler named Kansas (he was born in 1936 and raised on his grandparents' farm in Dodge City, Kansas). Pagan forces, shamanism, LSD paranoia—it was a trip of a shoot involving all of the '60s counterculture outlaws (Peter Fonda, Kris Kristofferson, Mamas and Papas singer Michelle Phillips, who Dennis married and then divorced ten days later). The hallucinatory editing took place on his ranch, the refuge he had just bought at Taos, New Mexico. *The Last Movie?* A resounding failure.

Photographed on set in a striped Pat Garret-style suit, shoestring bolo tie, and cowboy hat (Stetson or Resistol) does Dennis worry that this may be his last movie? One pointed toe of his Texan boot, with beveled, mid-height heel and simple stitching, is on the threshold between the tiled floor and scuffed concrete. Were they made by a local boot maker or one of the great manufacturers, such as Lucchese of San Antonio, Justin (Fort Worth), Tony Lama (El Paso), or Nocona (Nocona, naturally)—all European transplants to Texas who forged the reputation of the American cowboy boot?

Originally, it was just a Mexican-style high boot that had been adopted by cowboys. The toe is narrow for slipping easily into the stirrup and for prodding cattle, and its opening is wide so the wearer can slip out easily and won't get trapped in the saddle. The high shaft protects against rattlesnakes, prickly shrubs, and friction from the stirrups. The high heel creates an anchor in the ground when bull taming, and wedges into the stirrup, preventing it from slipping off when mounting a horse. The original Mexican influences quickly blended with boot-making traditions from Europe to create walking boots. Boot-makers Lucchese and Justin arrived from Europe around 1880, and Tony Lama and Nocona around the beginning of the '30s. Cosimo Lucchese, the son of the Italian founder for whom the brand is named, said just before he died: "We made boots that worked a stirrup; today they're made to work the accelerator of a Cadillac."[1] Enid Justin's description of a good boot was: "Perfectly tanned hide, two rows of lemon-wood pegs either side of the steel-plate shank, leather lining, good top-stitching and seams, but above all a well-fitting item of footwear."[2] The range of leathers available reflects the US taste for excess, and it's a veritable bestiary: kid, calf, and horse; exotic skins such as ostrich, crocodile, various lizards (Javanese, or East Mojave), snake, badger, antelope (some of the sturdiest leathers), elephant, kangaroo, catfish, shark, anteater, gazelle, reindeer, and eel, among many others. But today, Dennis keeps it sober.

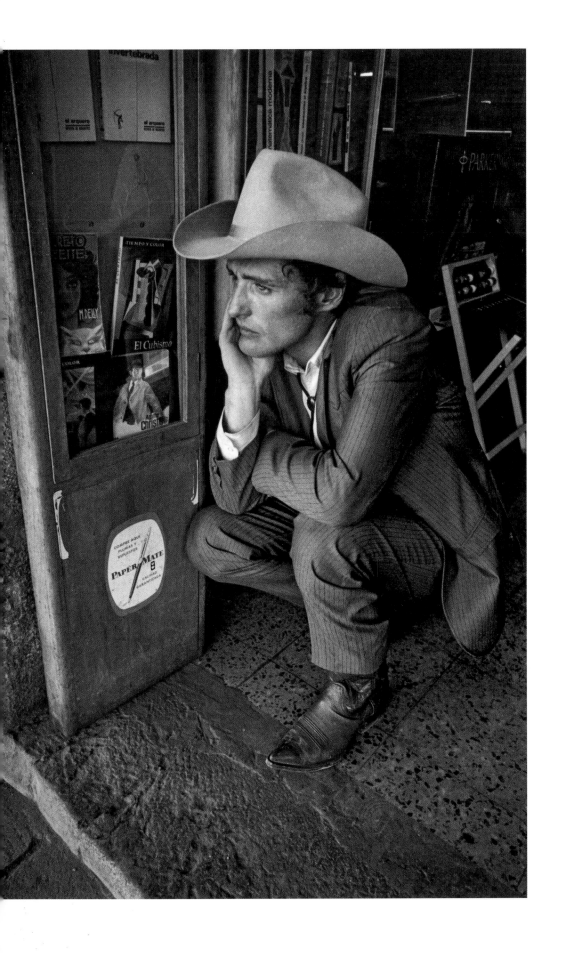

BIBLIOGRAPHY

Bard, Christine. *Une Histoire Politique du Pantalon*. Paris: Seuil, 2010.

Bardot, Brigitte. *Initiales B. B. Mémoires*. Paris: Grasset, 1995.

Béhar, Henri. *André Breton. Le Grand Indésirable*. Paris: Calmann-Lévy, 1990.

Booth, Stanley. *Dance with the Devil: The Rolling Stones and Their Times*. New York: Random House, 1984.

Chaplin, Julia. *Gypset Style*. Paris: Assouline, 2009.

Chenoune, Farid. *A History of Men's Fashion*. Translated by Deke Dusinberre. Paris: Flammarion, 1996.

Chenoune, Farid. *Beneath It All: A Century of French Lingerie*. New York: Rizzoli, 1999.

Dalí, Salvador. *The Secret Life of Salvador Dali*. New York: Dial Press, 1942.

Darwen, James. *Le Chic Anglais*. Hermé, 1990.

Deneuve, Catherine and Patrick Modiano. *Elle s'Appelait Françoise*. Paris: Canal+, 1996.

Douin, Jean-Luc. *Le Cinéma du Désir: Dictionnaire*. Paris: Joëlle Losfeld/Gallimard, 2012.

Duras, Marguerite. *Yann Andréa Steiner*. New York: Scribner, 1993.

Duval, Jean-François. *Kerouac et la Beat Generation*. Paris: PUF, 2012.

Enthoven, Jean-Paul. *La Dernière Femme*. Paris: Grasset, 2006.

Evin, Guillaume. *James Bond est Éternel*. Paris: Moment, 2012.

Flusser, Alan. *Clothes And The Man*. New York: Villard Books, 1985.

Fonda, Jane. *My Life So Far*. New York: Random House, 2005.

Forestier, François. *Un Si Beau Monstre*. Paris: Albin Michel, 2012.

Freund, Gisèle. *Photographs and Memoirs*. Munich: Schirmer/Mosel, 2008.

Gaignault, Fabrice. *Les Égéries Sixties*. Paris: J'ai lu, 2008.

George, Sophie. *Le Vêtement de A à Z: Encyclopédie*. Falbalas, 2011.

Kennedy, Sarah. *Vintage Style (Iconic Fashion Looks and How To Get Them)*. London: Carlton Books, 2011.

Kent, Nick. *Apathy for the Devil*. Paris: Payot & Rivages, 2012.

Lagerfeld, Karl and Carine Roitfeld. *The Little Black Jacket*. Göttingen, Germany: Steidl, 2012.

Lelièvre, Marie-Dominique. *Brigitte Bardot plein la vue*. Paris: Flammarion, 2012.

Lestringant, Frank. *André Gide l'inquisiteur*. Paris: Flammarion, 2012.

McCartney, Linda. *Linda McCartney's Sixties*. London: Reed Consumer Books Limited, 1992.

Martin, Richard and Harold Koda. *Jocks and Nerds: Men's Style in the Twentieth Century*. New York: Rizzoli, 1989.

Miermont, Dominique-Laure. *Annemarie Schwarzenbach ou le mal d'Europe*. Paris: Payot, 2004.

Miles, Barry. *London Caling: A Countercultural History of London since 1945*. London: Atlantic Books, 2010.

Milinaire, Caterine and Carol Troy. *Cheap Chic*. New York: Harmony Books, 1975.

Mishima, Yukio. *Confessions of a Mask*. Translated by Meredith Weatherby. London: Peter Owen, 2007.

Nourmand, Tony and Graham Marsh. *Hollywood and the Ivy Look*. London: Reel Art Press, 2011.

Périer, Jean-Marie. *Jean-Marie Périer*. Paris: Chêne, 2008.

Périer, Jean-Marie. *Rencontres*. Paris: Chêne, 2012.

Polhemus, Ted. *Street Style*. London: Thames and Hudson, 1994.

Remaury, Bruno and Lydia Kamitsis, eds., et al. *Dictionnaire international de la mode*. Paris: Éditions du Regard, 1994–2004.

Richards, Keith. *Life*. New York: Little, Brown and Company, 2010.

Roussel, Raymond. *How I Wrote Certain of My Books*. Boston: Exact Change 2005.

Santucci, Françoise-Marie with Elisabeth Franck-Dumas. *Monroerama*. Paris: Stock, 2012.

Schatzberg, Jerry. *Bob Dylan par Jerry Schatzberg*. Published in conjunction with the exhibition at the Galerie Luc Bellier, in coedition with Galerie Dina Verny, Paris, 2006.

Sherwood, James with a foreword by Tom Ford. *The Masters Tailors of British Bespoke*. London: Thames and Hudson, 2010.

Schiffer, Daniel Salvatore. *Le Dandysme: La création de soi*. Paris: Éditions Françoise Bourtin, 2011.

Sims, Josh. *Icons of Men's Style*. London: Laurence King Publishing Ltd, 2011.

Smith, Patti. *Just Kids*. London: Harpers Collins/New York: Ecco, 2010.

Smith, Zadie. *Changing My Mind*. London: Hamish Hamilton, 2009.

Springsteen, Bruce. *Bruce Springsteen Songs*. New York: Avon Books, 1998.

Stewart, Tony. *Cool Cats: Twenty-Five Years of Rock'n'Roll Style*. Richmond, UK: Eel Pie Publishing, 1981.

Sunshine, Linda. *Lovers*. London: Virgin Books, 1992.

Tadié, Jean-Yves. *Marcel Proust*. New York: Viking 2000.

Toussaint-Samat, Maguelonne with a foreword by Yves Saint Laurent. *Histoire Technique et Morale du Vêtement*. Paris: Bordas, 1990.

Young, Neil. *Waging Heavy Peace*. New York: Blue Rider Press, 2012.

Yourcenar, Marguerite. *Mishima: A Vision of the Void*. Translated by Alberto Manguel. Chicago: University of Chicago Press, 2001.

And the wonderful cloud that is Wikipedia; prodigious encyclopedia and endless source of discovery (along with the occasional error).

NOTES

PAUL BOWLES — p. 8
1. Paul Bowles, interview by Daniel Halpern, 1970, available on the Paul Bowles website: <www.paulbowles.org>.
2. Paul Bowles, *Without Stopping: An Autobiography* (New York: Putnam, 1972).
3. Jay McInerney, "Paul Bowles in Exile," *Vanity Fair*, September 1985.
4. Ibid.
5. Paul Bowles cited in Jay McInerney, "Paul Bowles: The Art of Fiction," *The Paris Review*, 1981.

FRANK SINATRA — p. 10
1. James Ellroy, *American Tabloid* (London: Random House, 1995), p. 453.
2. Frank Sinatra cited in Bill Zehme, *The Way You Wear Your Hat: Frank Sinatra and the Lost Art of Livin'* (New York: William Morrow Paperbacks, 1999), p. 117.

AMELIA EARHART — p. 13
1. Amelia Earhart cited in Donald Goldstein and Katherine Dillon, *Amelia: The Centennial Biography of an Aviation Pionner* (Washington, D.C.: Brassey's, 1997).

MARGUERITE DURAS — p. 14
1. Marguerite Duras, *Yann Andrea Steiner*, trans. Barbara Bray (London: Hodder & Stoughton, 1993), p. 58.
2. Marguerite Duras cited by Dominique Issermann, interview by Élisabeth Quin, December 9, 2012.
3. Ibid.
4. Michelle Porte and Marguerite Duras, *Les Lieux de Marguerite Duras* (Minuit, 1977).
5. Duras cited by Issermann, interview by Quin.
6. Duras, *Yann Andrea Steiner*, p. 108.
7. Marguerite Duras, *Écrire* (Paris: Gallimard "Folio," 1995).
8. Paul Éluard, *Le Dur désir de durer* [1946] trans. Stephen Spender and Frances Cornford as *The Dour Desire to Endure* (London: Faber, 1950).

MARIANNE FAITHFULL — p. 18
1. Marianne Faithful cited in Bill Harry, *The Ultimate Beatles Encyclopedia* (New York: Hyperion, 1992).

JACKIE ONASSIS — p. 22
1. "Touched by the Sun" is a song about Jackie O by Carly Simon from her album *Letters Never Sent* (1994).
2. Truman Capote at his Black and White Ball, November 28, 1966, cited in Harry Benson, *Los Angeles Times*, March 28, 2008.

GRETA GARBO — p. 24
1. Klaus Mann cited in Jean-Luc Douin, *Le Cinéma du désir* (Paris: Joëlle Losfeld, 2012).
2. Zadie Smith, *Changing My Mind* (London: Hamish Hamilton, 2009), p. 164.
3. Norma Shearer on Greta Garbo cited in Mark A. Vieira, *Irving Thalberg: Boy Wonder to Producer Prince* (Berkeley, CA: University of California Press, 2010), p. 70.
4. "The Great Garbo" in *Life*, vol. 38, no. 1 (January 1955).

MARVIN GAYE — p. 26
1. Renaldo Benson, Al Cleveland, and Marvin Gaye, "What's Going On," 1971.

LAUREN BACALL — p. 30
1. Robert Capa, *Great Themes* (Alexandria, VA: Time-Life Library of Photography by Time-Life Books Editors, 1970.)
2. A reference to Bacall's line to Bogart in *To Have and Have Not* (1944), directed by Howard Hawks.
3. Ibid.

THE KILLS — p. 32
1. Bayon, "The Kills à mort," *Libération*, March 7, 2008.

CHRISTOPHER ISHERWOOD AND W. H. AUDEN — p. 34
1. Christopher Isherwood and W. H. Auden, *Journey to a War* [1939] (London: Faber & Faber, 1973), p. 49.
2. See Farid Chenoune, *A History of Men's Fashion*, trans. Deke Dusinberre (Paris: Flammarion, 1993).
3. Christopher Isherwood, *Christopher and his Kind* (Minneapolis, MN: University of Minnesota Press, 1976), p. 2.

BRIAN JONES — p. 38
1. Keith Richards, *Life* (New York: Back Bay Books, 2011), p. 212.
2. Ibid., p. 191.
3. Percy Bysshe Shelley, *Selected Poetry* (Harmondsworth, UK: Penguin, 1956), p. 238.

LOUISE BOURGEOIS — p. 40
1. Louise Bourgeois cited in *Éros dans l'art moderne*, exhibition catalog, (Basel: Fondation Beyeler, 2007).
2. Maguelonne Toussaint-Samat, *Une histoire technique et morale du vêtement* (Paris: Bordas, 1990).
3. Bourgeois cited in *Éros dans l'art moderne*.

CARY GRANT — p. 42

1. Alfred Hitchcock cited in Nancy Nelson, *Evenings With Cary Grant: Recollections in His Own Words and By Those Who Knew Him Best* (New York: W. Morrow, 1991).

2. Translator's note to Lord Byron, *Don Juan*, in *Œuvres*, trans. Amédée Pichot (Paris: Furne, 1830), vol. VI, p. 147.

JAMES BROWN — p. 44

1. Jean-Marie Périer, *Jean-Marie Périer* (Paris: Le Chêne, 2008), p. 252.

2. Statement by Cassius Clay on the eve of his fight against Sonny Liston, February 25, 1964, when he became heavyweight champion of the world.

3. *Look* magazine, February 18, 1969.

MARLENE DIETRICH — p. 48

1. Janet Flanner, *Paris Was Yesterday, 1925–1939* (Boston, MA: Mariner Books, 1988), p. 97.

2. Lilou Marquand, *Chanel m'a dit* (Paris: Lattès, 1990).

3. Christine Bard, *Une histoire politique du pantalon* (Paris: Seuil, "L'univers historique," 2010).

4. Quotation attributed to Jean Cocteau.

LEONARD COHEN — p. 50

1. Dominique Issermann, interview by Élisabeth Quin, October 2011.

2. Issermann, interview by François Armanet, *Le Nouvel Observateur*, January 26, 2012.

3. Issermann interview by Quin, October 2011.

4. Issermann, interview by Armanet.

THE WHO — p. 54

1. Pete Townsend, "My Generation," 1965.

JIMI HENDRIX — p. 56

1. General Lasalle cited in Charles Mullié, *Biographie des célébrités militaires des armées de terre et de mer de 1789 à 1850* (Paris: Poignavant, 1851).

MARTIN AND KINGSLEY AMIS — p. 58

1. Martin Amis, interview by François Armanet, *Le Nouvel Observateur*, May 14, 2008.

JEAN COCTEAU — p. 60

1. Quotation attributed to Jean Cocteau, who may himself have taken it from Coco Chanel.

2. Quotation in "Morale de la mode" for the magazine *Arts-spectacles* (1956) and also in "Feu Saint-Trapèze," published in the magazine *Rives d'azur* (1958).

BRYAN FERRY — p. 62

1. Bryan Ferry, interview by François Armanet, *Libération*, November 6, 1987.

2. Ibid.

JOHNNY ROTTEN — p. 65

1. Barry Miles, *London Calling: A Countercultural History of London Since 1945* (London: Atlantic Books, 2011).

2. Ibid.

DIANA ROSS — p. 66

1. *Billboard* magazine, 1976.

2. "Dirty Diana" is a track by Michael Jackson on his 1988 album *Bad*.

3. The video for "Where Did Our Love Go" by The Supremes was filmed in April 1965.

JULIE CHRISTIE — p. 68

1. *The Knack and How to Get It* (1965) is a movie by Richard Lester. The knack means the sparkle, charm, influence, something extra—an intangible but desirable quality.

2. Julie Christie, interview by Tim Adams, "The Divine Miss Julie," *The Observer*, April 1, 2007.

3. Ibid.

JEANNE MOREAU — p. 70

1. Michel Pastoureau cited in Patrick Mauriès, "Anatomie du noir," *Vogue*, September 2012.

2. F. Scott Fitzgerald, "Bernice Bobs her Hair," in *Flappers and Philosophers* (New York: Charles Scribner and Sons, 1920).

3. US *Vogue*, October 1, 1926.

4. Henry Ford, *My Life and Work* (1922) (CreateSpace Independent Publishing Platform, 2010), p. 40.

5. US *Vogue*, November 1926.

BIANCA AND MICK JAGGER — p. 72

1. In *Melody Maker*, March 14, 1964.

2. "You Can't Always Get What You Want" is a track from The Rolling Stone's *Let It Bleed* (1969).

3. Headline in US *Vogue*, March 1974.

4. "Soul Survivor" is a track from The Rolling Stone's *Exile on Main Street* (1972).

GRACE JONES — p. 76

1. Alexandre Vialatte, *Chroniques de La Montagne* (Paris: Robert Laffont, 2001).

2. Ibid.

3. Interview with Grace Jones by Liza Sewards, "It's Hard Being a Freak," *Daily Mail*, November 7, 2008.

4. Farid Chenoune, *Hidden Femininity: Twentieth Century Lingerie* (Paris: Assouline, 2005), p. 28.

5. Rousseau cited in Chenoune, *Hidden Femininity*, p. 38.

6. Grace Jones cited by Lynn Norment in *Ebony*, 1979.

7. Joan Juliet Buck, "Little Big Man," *New York Times*, February 26, 2006.

CHLOË SEVIGNY — p. 82

1. Jay McInerney, "Manhattan Diary: 'Chloe's Scene'," *The New Yorker*, November 7, 1994.

2. Chloë Sevigny, interview in US *Playboy*, January 2011.

3. Sevigny, interview by Brandon Voss, "Second Wife's Club," *The Advocate*, April 1, 2010.

4. Ibid.

5. Sevigny, US *Playboy*, January 2011.

ELVIS PRESLEY — p. 85

1. Quotation attributed to John Lennon, a huge Elvis fan, who also went on to say, on his death: "Before Elvis, there was nothing."

JANE RUSSELL — p. 86

1. Jane Russell cited in *Christianity Today*, March 3, 2009.

2. "What are the two great reasons for Jane Russell's success?"

3. Jane Russell cited in *Christianity Today*, March 3, 2009.

BRUCE SPRINGSTEEN — p. 88

1. Bruce Springsteen interview by François Armanet, *Le Nouvel Observateur*, May 1997.

F. SCOTT FITZGERALD — p. 93

1. F. Scott Fitzgerald, *The Last Tycoon* (New York: Charles Scribner and Sons: 1941).

BOB DYLAN — p. 94

1. Jerry Schatzberg, interview by Michel Ciment, *Bob Dylan par Jerry Schatzberg*, exh. cat. (Paris: Galerie Dina Vierny/Galerie Luc Bellier, 2006).

PATTI SMITH — p. 96

1. Patti Smith *Just Kids* (London: Bloomsbury, 2010), p. 200.

2. Ibid., p. 258.

3. Ibid., p. 140.

4. Ibid., p. 140.

5. Ibid., p. 118.

6. Ibid., pp. 249, 251.

7. Ibid., p. 271.

GRACE KELLY — p. 98

1. Serge Koster, *Les Blondes Flashantes d'Alfred Hitchcock* (Paris: Léo Scheer, 2013).

2. Cary Grant, cited in Nancy Nelson, *Evenings With Cary Grant* (New York: Citadel Press, 2000).

3. Alfred Hitchcock cited in François Truffaut, *Hitchcock by Truffaut: A Definitive Study of Alfred Hitchcock*, (New York: Simon and Schuster/Touchstone Books, 1967).

SIGOURNEY WEAVER — p. 102

1. Rankings taken from *Entertainment Weekly* and the American Film Institute respectively.

2. See F. Scott Fitzgerald, *The Great Gatsby*, chapter III.

ANAÏS NIN — p. 104

1. Anaïs Nin, *Inceste*, trans. Béatrice Commengé. Le livre de poche. (Paris: LGF, 2002).

2. Anaïs Nin, *Incest: From "A Journal of Love": The Unexpurgated Diary of Anaïs Nin, 1932–34* (London: Peter Owen, 1993), p. 119.

3. Nin, *Inceste*.

4. Ibid.

5. Ibid.

6. Anaïs Nin, Preface to *Delta of Venus* (London: W.H. Allen, 1978), p. XII.

7. Ibid., p. XVII.

8. Nin, *Inceste*.

9. Nin, *Delta of Venus*, p. 165.

10. Anaïs Nin, unpublished diary entry for August 22, 1940.

11. Nin, *Incest: From "A Journal of Love"*, p. 110.

12. Anaïs Nin and Henry Miller, *A Literate Passion: Letters of Anaïs Nin & Henry Miller, 1932–53* (New York: Mariner Books, 1989), p. VII.

FRED ASTAIRE — p. 106

1. Fred Astaire, interview with Richard Hublar, *GQ*, August 1957.

CHET BAKER — p. 112

1. "I'm Old Fashioned," music by Jerome Kern, lyrics by Johnny Mercer on *Chet Baker Sings (It Could Happen to You)*, 1956.

SACHA GUITRY — p. 114

1. Both quotations are from Sacha Guitry, *Pensées, maximes et anecdotes* (Paris: Cherche-Midi, 1992).

SIMONE DE BEAUVOIR — p. 116

1. Simone de Beauvoir, *Memoirs of a Dutiful Daughter*, trans. James Kirkup (Cleveland: World Publishing Company, 1959).

2. de Beauvoir, *The Second Sex*, trans. Constance Borde and Sheila Malovany-Chevallier (New York: Vintage, 2011), p. 10.

3. Ibid., *The Second Sex*, p. 17.

4. Roger Stéphane, *Tout est bien* (Paris: Quai Voltaire, 1989).

5. François Mauriac, *Nouvelles Lettres d'une vie (1906–1970)* (Paris: Grasset, 1989).

6. de Beauvoir, *The Second Sex*, p. 283.

YUKIO MISHIMA — p. 118

1. René Char, *Fureur et mystère* (Paris: Gallimard, 1948). This quote trans. Mary Ann Caws.

2. Yukio Mishima, *Confessions of a Mask*, trans. Meredith Weatherby (London: Peter Owen, 2007), p. 37.

3. Quoted in Henry Scott Stokes, *The Life and Death of Yukio Mishima* (New York: Cooper Square Press, 2000).

JOHN UPDIKE — p. 120

1. John Updike, interview by François Armanet, *Le Nouvel Observateur*, September 8, 2005.

MEL GIBSON — p. 123

1. Mel Gibson, interview by François Armanet, *Libération*, July 11, 2000.

2. Ibid.

JANE FONDA — p. 124

1. Jane Fonda, *My Life So Far* (New York: Random House, 2005), p. 318.

2. Ibid., p. 461.

MARLON BRANDO — p. 126

1. *Candy*, directed by Christian Marquand (1968).

2. François Forestier, *Un si beau monstre* (Paris: Albin Michel, 2012), p. 85.

PABLO PICASSO — p. 130

1. Odilon Redon in *Le Mercure de France*, 1903.

2. "[To] search means nothing in painting. To find is the thing." Pablo Picasso cited in Roland Penrose, *Picasso: His Life and Work* (Berkeley: University of California Press, 1981), p. 245.

3. Adrian Stokes, *The Critical Writings of Adrian Stokes* (London: Thames and Hudson, 1978).

DEBBIE HARRY — p. 132

1. Cynthia Rose, *Cool Cats, 25 Years of Rock'n'Roll Style* (New York: Delilah Books, 1982).

2. Debbie Harry, *No Exit Tour Book* (New York: Blondie Music, 1999).

ANDY WARHOL — p. 134

1. *Marilyn Diptych* (1962), Tate, London.

2. Giovanna Zaperi, *Stratégies artistiques et masculinité. Marcel Duchamp et son entourage entre avant-garde et culture de masse* (Paris: EHESS, 2005).

3. *The Lord Gave Me My Face But I Can Pick My Own Nose* (1948), Warhol Museum, Pittsburgh, PA.

4. Derek Jarman, *Kicking the Pricks* (London: Vintage, 1996), p. 75.

5. Wayne Koestenbaum in *Artforum* (1998).

PETER FONDA — p. 137

1. "She said, 'I know what it's like to be dead/I know what it is to be sad.'" Song lyrics from "She Said, She Said" by John Lennon and Paul McCartney.

2. "Don't Bogart the Joint, My Friend" by Fraternity of Man from the *Easy Rider* soundtrack.

3. "Born to be Wild" by Mars Bonfire for Steppenwolf, featured on the *Easy Rider* soundtrack.

ANDRÉ BRETON — p. 138

1. André Breton, letters to Tristan Tzara, April 4 and 20, 1919.

2. Tristan Tzara, *Cinéma, calendrier du coeur abstrait/Cinema: Calendar of the Abstract Heart*, trans. Mary Ann Caws (Ann Arbor: Thomas Press, 1983).

3. Tristan Tzara, *Dada Manifesto 1918*.

4. Arthur Conte, *Le Premier Janvier 1920* (Paris: Plon, 1976).

5. See Paul Morand in *Venises* [1971] (Paris: Gallimard, "L'Imaginaire," 1987).

6. Tristan Tzara, *Approximate Man and Other Writings*, trans. Mary Ann Caws (Detroit: Wayne State University Press, 1973), p. 110.

7. Robert Benayoun, "Le Rire des surréalistes," *Bougie de sapeur*, 1988, p. 45.

8. See Sarane Alexandrian, *André Breton par lui-même* (Seuil, 1971).

9. André Breton, "Après Dada" in *Comoedia*, March 2, 1922.

10. Louis Aragon, *The Libertine* (Parchment, MI: RiverRun Press, 1987).

11. André Breton, "L'entrée des médiums" in *Littérature*, 1922.

12. André Breton, "Les mots font de l'amour" in *Littérature*, 1922.

13. André Breton, *Manifestoes of Surrealism* (University of Michigan Press, 1969), p. 36.

FRIDA KAHLO — p. 140

1. André Breton, "Souvenir du Mexique" in *Le Minotaure*, nos. 12–13 (May 1939).

2. Frida Kahlo cited in Salómon Grimberg, *I Will Never Forget You*, (San Francisco: Chronicle Books, 2006) and in "Mexican Autobiography," *Time*, April 27, 1953.

3. Kahlo cited in J. M. G. Le Clézio, *Diego et Frida* (Paris: Stock, 1993), p. 169.

MARCEL PROUST — p. 142

1. Jean Cocteau, cited in Daniel Salvatore Schiffer, *Philosophie du dandysme* (Paris: PUF, 2008).

2. André Maurois, *Le Monde de Marcel Proust*, (Paris: Hachette, 1969) and Léon-Pierre Quint, *Marcel Proust, his Life and Work*, trans. Sheila Miles (New York: A.A. Knopf, 1927).

3. Léon Daudet, *Salons et journaux. Souvenir des milieux littéraires, politiques, artistiques et médicaux de 1880 à 1908* (Paris: Nouvelle Librairie nationale, 1917).

4. Noted on August 8, 1838.

5. Auguste de Villiers de L'Isle-Adam, "Le convive des dernières fêtes" in *Contes cruels* [1883], edited by Pierre Citron (Paris: GF-Flammarion, 1980), p. 139.

6. Marcel Proust, *Jean Santeuil* (London: Weidenfeld and Nicholson, 1955).

7. Jean-Yves Tadié, *Marcel Proust*, trans. Euan Cameron (New York: Viking, 2000), p. 163.

8. Marcel Proust, *Swann in Love*, trans. C.K. Scott Moncrieff (New York: Vintage, 1984), p. 67.

9. *The Proust Questionnaire*, 1886.

MADONNA — p. 146

1. Madonna, interview by François Armanet, *Le Nouvel Observateur*, March 5, 1998.

FRANÇOISE DORLÉAC — p. 148

1. Jean-Paul Enthoven, *La Dernière Femme* (Paris: Grasset, 2006).

2. Catherine Deneuve and Patrick Modiano, *Elle s'appelait Françoise...* (Paris: Éditions Canal +, 1996).

3. François Truffaut, "Elle s'appelait Françoise..." in *Cahiers du cinéma*, no. 200–201 (April 1968), reprinted in the preface to Deneuve and Modiano, *Elle s'appelait Françoise...*.

4. Documentary by Anne Andreu cited in Deneuve and Modiano, *Elle s'appelait Françoise...*.

5. Deneuve and Modiano, *Elle s'appelait Françoise...*.

6. "Celle qui fait penser à Garbo," conversation between Françoise Dorléac and Pascal Thomas, *Le Nouveau Candide*, no. 294 (December 12, 1966).

7. François Truffaut, "Elle s'appelait Françoise...".

8. Deneuve and Modiano, *Elle s'appelait Françoise...*.

RAYMOND ROUSSEL — p. 150

1. Maguelonne Toussaint-Samat, *Une histoire technique et morale du vêtement*, (Paris: Bordas, 1990).

2. "Roussel, the Un-Read," *Times Literary Supplement*, 1995.

3. Jean-Jacques Pauvert, contributor's statement for the TV program on Roussel, *Un Siècle d'écrivains*, broadcast May 15, 1996 on France 3.

4. Raymond Roussel, *How I Wrote Certain of my Books* [1935], trans. Trevor Winkfield (New York: Exact Change, 2005).

5. Ibid. / **6.** Ibid.

7. André Breton, *Anthology of Black Humor* (San Francisco: City Lights Publishers, 2001).

8. Roussel, *How I Wrote Certain of my Books*.

9. Michel Foucault, *Death and the Labyrinth*, trans. Charles Ruas (New York: Continuum, 2007).

JIM MORRISON — p. 152

1. The group took their name from Aldous Huxley's *The Doors of Perception*, whose title was itself a reference to William Blake's *The Marriage of Heaven and Hell*: "If the doors of perception were cleansed every thing would appear to man as it is, infinite."

2. "Back Door Man" is a song by blues musician Willie Dixon, the title being an allusion to the lover who uses the "back door," or anal sex.

3. Words from the song "Dawn's Highway" on the posthumous album *An American Prayer*: "Me and my mother and father—and a grandmother and a grandfather—were driving through a desert, at dawn, and a truck of Indian workers had either hit another car, or just—I don't know what happened—but there were Indians scattered all the highway, bleeding to death.... That was the first time I tasted fear. I musta' been about four—like a child is like a flower, his head is just floating in the breeze, man. The reaction I get now thinking about it, looking back—is that the souls or the ghosts of those dead Indians ... maybe one or two of 'em ... were just running around freaking out, and just leaped into my soul. And they're still in here."

4. Words from the song "Peace Frog" on the album *Morrison Hotel*.

JANE BIRKIN — p. 154

1. Song composed by Gainsbourg in 1968 and performed as a duet with Birkin.

2. Jane Birkin, interview by François Armanet, *Le Nouvel Observateur*, February 1, 1996.

KANYE WEST — p. 156

1. Ted Polhemus, *Streetstyle: From Sidewalk to Catwalk* (New York: Thames & Hudson, 1994), p. 107.

2. *Watch the Throne*, Kanye West's sixth album, with Jay-Z, 2011.

AUDREY HEPBURN — p. 158

1. Philippe Halsman, *Jump Book* (New York: Simon and Schuster, 1959).

2. Cecil Beaton, "Audrey Hepburn," *Vogue*, November 1, 1954.

3. Helen Markel Herrmann, "Half Nymph, Half Wunderkind," *The New York Times*, February 14, 1954.

4. Sam Wasson, *Fifth Avenue, 5 A.M.: Audrey Hepburn, Breakfast at Tiffany's, and the Dawn of the Modern Woman* (New York: Harper Perennial, 2011), pp. 216–17.

5. Roland Barthes, *Mythologies*, trans. Annette Lavers (New York: Farrar, Straus, and Giroux, 1972), p. 57.

6. "She had, like every woman, maybe 30 or 40," Luca Dotti, Audrey Hepburn's son, cited in *Vanity Fair*, May 2013, p. 113.

JOAN CRAWFORD — p. 160

1. Richard Schickel, *The Stars* (New York: Dial Press, 1962).

2. F. Scott Fitzgerald, *Flappers and Philosophers* (New York: Charles Scribner and Sons, 1920) and cited in Bob Thomas, *Joan Crawford: A Biography* (New York: Bantam Books, 1978).

3. François Truffaut, *Arts*, February 23, 1955.

4. Cited in Christine Bard, *Histoire politique du pantalon* (Paris: Seuil "L'univers historique," 2010).

5. Colette, *The Pure and the Impure* [1932], trans. Herma Briffault (Harmondsworth: Penguin, 1968), p. 62.

6. Charles Turgeon, *Le Féminisme français* (Paris: L. Larose, 1902) cited in Bard, *Histoire politique du pantalon*.

DAVID BOWIE — p. 162

1. Nick Kent, *Apathy for the Devil: A 1970s Memoir* (Cambridge, MA: Da Capo Press, 2010) p. 59.

ANNEMARIE SCHWARZENBACH — p. 164

1. Dominique Laure Miermont, *Annemarie Schwarzenbach ou le Mal de l'Europe* (Paris: Payot, Petite Bibliothèque, 2012), p. 13.

2. Ibid.

3. Letter from Annemarie Schwarzenbach to Klaus Mann, April 3, 1934.

4. Letter from Schwarzenbach to Mann, July 4, 1934.

5. Annemarie Schwarzenbach cited in Klaus Mann, *The Turning Point* (Princeton, NJ: Markus Wiener, 1984).

6. Letter to Claude Bourdet, July 14, 1934.

7. Letter from Annemarie Schwarzenbach to Claude-Achille Clarac, 1934, cited in Miermont, *Annemarie Schwarzenbach*.

8. Annemarie Schwarzenbach, *Death in Persia*, trans. Lucy Renner Jones/Transfiction (London/Calcutta: Seagull Books, 2013).

JEAN-PAUL GOUDE — p. 167

1. Caterine Milinaire and Carol Troy, *Cheap Chic* (New York: Harmony Books, 1975), p. 69.

2. Ibid., pp. 69–70.

JOANNE WOODWARD AND PAUL NEWMAN — p. 168

1. Judy Balaban, "The Gore They Loved," *Vanity Fair*, February 2013, p. 120.

2. Paul Newman cited by Steve Winn, *San Francisco Chronicle*, September 28, 2008.

3. Joanne Woodward in a TV interview with Connie Chung, cited in Linda Sunshine, *Lovers* (Nashville, TN: Turner Publishing, 1992), p. 159.

NEIL YOUNG — p. 170

1. Neil Young, *Waging Heavy Peace* (New York: Blue Rider Press, 2012), p. 176.

2. Lyrics of "Hey, Hey, My, My (Into the Black)" from the album *Rust Never Sleeps*.

FRANÇOISE HARDY — p. 174

1. Françoise Hardy, interview by François

Armanet, *Libération*, April 29, 2000.

2. Jean-Marie Périer, interview by François Armanet, *Le Nouvel Observateur*, December 22, 2011.

JIM HARRISON — p. 176

1. Jim Harrison, interview by François Armanet, *Le Nouvel Observateur*, September 16, 2004.

AVA GARDNER — p. 178

1. Of the eponymous film, directed by Joseph L. Mankiewicz in 1954.

2. Ava Gardner, *Ava: My Story* (New York: Bantam, 1990), p. 8.

3. Ibid., p. 7.

4. "Hot Pants" is a song by James Brown, 1971.

5. Elizabeth Gouslan, *Ava. La Femme qui aimait les hommes* (Paris: Robert Laffont, 2012).

FRANÇOISE SAGAN AND ANNABEL SCHWOB — p. 181

1. See Élisabeth Quin, *Bel de nuit, Gerald Nanty* (Paris: Grasset, 2007).

2. According to Françoise Sagan in *Derrière l'épaule*.

3. Françoise Sagan, *Bonjour Tristesse* [1954], trans. Irene Ash (London: Penguin, 2008), p. 26.

JAMES JOYCE — p. 182

1. James Joyce, *Ulysses* [1922] (London: Wordsworth Editions, 2010), p. 39.

2. "À Sylvia Beach" in Adrienne Monnier, *Les Poésies* (Paris: Mercure de France, 1962).

3. Gisèle Freund and Christian Caujolle, *Photographs and Memoirs* (Munich: Schirmer Mosel, 2008).

4. Ibid.

5. "When Joyce saw the picture on the cover of *Time*, he was very pleased. He told his friends: 'Gisèle is stronger than the Irish. I didn't want to be photographed in color but she took possession of me, not once, but twice!'" Ibid.

6. Joyce, *Ulysses*, p. 241.

7. Denis Diderot, "Regrets on Parting with My Old Dressing Gown or A Warning to Those who Have More Money than Taste" [1772] in *Rameau's Nephew and Other Works*, trans. Jacques Barzun and Ralph H. Bowen (Indianapolis: The Bobbs-Merrill Company, Inc., 1964), pp. 309–10; originally published in French in 1772.

8. Joyce, *Ulysses*, p. 631.

BALTHUS — p. 184

1. Jean Pierrard, "Balthus le Grand" in *Le Point*, February 13, 2001.

2. Balthus quoted by Dominique Issermann in an interview with Élisabeth Quin, January 18, 2013.

ANGELINA JOLIE — p. 188

1. Baronne d'Orchamps, *Tous les secrets de la femme* [1907] (Paris: Albin Michel, 1960).

TILDA SWINTON — p. 190

1. Tilda Swinton cited in Diane Solway, "Planet Tilda," *W*, August 2011.

2. Ibid.

3. Olivier Saillard in *L'Express styles*, September 29, 2012.

4. Ibid.

RITA HAYWORTH — p. 192

1. The last line in *The Lady from Shanghai* with Rita Hayworth and Orson Welles, (1947).

MARILYN MONROE — p. 196

1. A line from the film *All about Eve* (1950).

2. "Entomologie de la pin-up girl" in *L'Écran français*, no. 77, cited by Jean-Luc Douin in *Le Cinéma du désir* (Paris: Joëlle Losfeld, 2012).

ELIZABETH TAYLOR — p. 200

1. Elizabeth Taylor, *Elizabeth Takes Off: On Weight Gain, Weight Loss, Self-Image, and Self-Esteem* (New York: Putnam, 1997).

2. Michael Wilding on ABC News on March 23, 2011 in an official statement given by Sally Morrison, Liz Taylor's publicist.

URSULA ANDRESS — p. 202

1. Diana Vreeland in *Harper's Bazaar* in 1946, cited in Eleanor Dwight, *Diana Vreeland* (New York: Harper Design, 2002).

CHARLOTTE RAMPLING — p. 204

1. Charlotte Rampling, interview by Francois Armanet and Élisabeth Quin, Paris, February 10, 2013.

2. Pierre de Bourdeille de Brantôme, *Vie des dames galantes*, edited by Claude Pinganaud (Paris: Arléa, 2007).

3. George Bataille, *Story of the Eye* [1928] (Harmondsworth: Penguin, 1989).

ROMY SCHNEIDER — p. 206

1. Philippe Sollers in *Elle*, 1965.

2. "During the filming of *Casino Royale*, I dreamed I was Ursula Andress's body stocking." Woody Allen in *Playboy* magazine, May 1967.

FAYE DUNAWAY — p. 208

1. Dialogue from *Puzzle of a Downfall Child* directed by Jerry Schatzberg (1970).

2. Faye Dunaway, interview by Stephen Rebello, *Movieline*, June 1, 2002.

WILLIAM FAULKNER — p. 210

1. William Faulkner, *The Sound and the Fury* [1938] (London: Vintage, 1995). p. 212.

THE BEATLES — p. 212

1. Linda McCartney, *Linda McCartney's Sixties: Portrait of an Era* (New York: Bulfinch, 1993).

2. Ringo Starr, cited in *A Hard Day's Night* directed by Richard Lester (1964).

CHARLOTTE GAINSBOURG — p. 218

1. "Gainsbourg et son Gainsborough" is a lyric from the song "69, Année erotique" by Serge Gainsbourg (1969).

2. Unlike Converse All Stars, Charlotte can go off the rails, delivering very edgy movie performances, such as in Lars von Trier's 2009 movie *Antichrist*.

SALVADOR DALÍ — p. 220

1. Salvador Dalí, *The Secret Life of Salvador Dalí*, trans. Haakon M. Chevalier (London: Vision Press. 1976), p. 297.

2. Ibid., p. 339.

JACQUES PRÉVERT — p. 222

1. From Jacques Prévert, "Cortège" in *Paroles* (Paris: Gallimard, 1976).

2. Jacques Prévert, "Song in the Blood" in *Selections from "Paroles"*, trans. Lawrence Ferlinghetti (Harmondsworth: Penguin, 1958), p. 55.

3. Willy Rizzo, as recounted by Dominique Rizzo, June 2013.

4. From Jacques Prévert, *Fatras* (Paris: Gallimard, 1966).

INGRID BERGMAN — p. 226

1. Ingrid Bergman and Alan Burgess, *Ingrid Bergman: My Story* (London: Michael Joseph, 1980), p. 263.

2. Ibid., p. 14.

ANDRÉ GIDE AND JEAN-PAUL SARTRE — p. 228

1. André Gide, *Journals*, vol. 4, 1939–49, trans. Justin O'Brien (University of Illinois Press, 2000).

2. Robert Mallet, *Une Mort ambiguë* (Paris: Gallimard, 1955), p. 37.

3. Letters from Paul Claudel to André Gide, March 2 and 9, 1914.

BRIGITTE BARDOT — p. 230

1. Brigitte Bardot, *Initiales B. B. Mémoires* (Paris: Grasset, 1996).

2. Charles Baudelaire, "Fairy Gifts" in *Paris Spleen: Little Poems in Prose*, trans. Keith Waldrop (Middletown, CT: Wesleyan University Press, 2009).

3. Bardot, *Initiales B. B. Mémoires*.

4. Lyrics to Serge Gainsbourg's song "Initials B. B.," trans. Mick Harvey.

5. Cover of *Elle* magazine, May 8, 1950.

6. Origin of the word "paparazzi" cited in Marie-Dominique Lelièvre, *Brigitte Bardot. Plein la vue* (Paris: Flammarion, 2012), p. 113.

JAYNE MANSFIELD — p. 232

1. Mae West cited in Raymond Strait, *The Tragic Secret Life of Jayne Mansfield* (Washington, D.C.: Regnery, 1974).

2. Strait, *The Tragic Secret Life of Jayne Mansfield*.

3. Ibid.

4. Anatole France, *My Friend's Book* [1885] (Rockville, MD: Wildside Press, 2008), p. 291.

5. Bruno Bettelheim, *The Uses of Enchantment: The Meaning and Importance of Fairy Tales* (New York: Vintage, 2010), p. 265.

KATHARINE HEPBURN — p. 234

1. Katharine Hepburn in *All About Me*, a documentary by David Heeley (1993).

2. Ibid.

MARILYN MONROE — p. 237

1. Nickname given to Marilyn by Salvatore Ferragamo in his autobiography, *Shoemaker of Dreams* (Milan: Guinti, 1985).

2. Literally "my journey ends here." Cf. Gary Vitacco-Robles, *Cursum Perficio: Marilyn Monroe's Brentwood Hacienda* (New York: iUniverse, 2000).

3. Edgar Morin, *Les Stars* (Paris: Le Seuil, 1957).

4. Arthur Miller, *Timebends: A Life* (Franklin Center, PA: Franklin Library, 1987), p. 532.

5. Billy Wilder and Charlotte Chandler, *Nobody's Perfect: Billy Wilder, A Personal Biography* (New York: Simon & Schuster, 2002).

6. Gloria Steinem and Georges Barris, *Marilyn* (New York: Holt and Co., 1986).

7. Stanley Buchthal and Bernard Comment (eds.) *Marilyn Monroe, Fragments: Poems, Intimate Notes, Letters* (London: Harper Collins, 2010), p. 81.

ERROL FLYNN — p. 242

1. Errol Flynn, *My Wicked, Wicked Ways* (London: Heinemann, 1960), p. 14.

2. Ibid.

GEORGE BERNARD SHAW — p. 248

1. From Farid Chenoune, *A History of Men's Fashion*, trans. Deke Dusinberre (Paris: Flammarion, 1993), pp. 98.

JACQUES DUTRONC — p. 250

1. Jean-Marie Périer, interview by François Armanet, *Le Nouvel Observateur*, December 22, 2011.

DENNIS HOPPER — p. 256

1. Cosimo Lucchese cited in François Armanet, *Libération*, December 26, 1983.

2. Enid Juston cited in François Armanet, *Libération*, December 26, 1983.

INDEX

ACKNOWLEDGMENTS

The authors and publisher warmly thank

Azzedine Alaïa
Mary Alfieri
José Alvarez
Gilles Anquetil
Alix Armanet
Marion Armanet
Max Armanet
Clive Arrowsmith
Marie Audet
Laurence Benaïm
Pierre Bergé
Joel Bernstein

Pierre Caizergues
Ronnie Chammah
Tessa Codrington
Michael Costes
Jean Coulon
Iannis Domon
Caroline Fabre-Bazin
Aurélie Foucher
Charlotte Gainsbourg
Jean-Paul Goude
Cécile Guilbert
Florette Hayot

Jim Herrington
Sue Hodson
Frantz Hoez
Dominique Issermann
Dorothée Joly
Clémence Kzrentowski
Alain Lehana
Peter Lindbergh
Sylvie Matton
Jean Luc Monterosso
Jean-Marie Périer
Oona Propper-Quin

Charlotte Rampling
Maurice Renoma
Yann Rzepka
Olivier Saillard
Patti Smith
Harriet Spurlin
Jean-Sébastien Stehli
Anne Strack
Patrizia Tardito
Laurent Vanhoegaerden
Olivier Zahm

PHOTOGRAPHIC CREDITS AND COPYRIGHTS

Translated from the French by
Philippa Hurd
Design and Typesetting:
Lot49 / Mateo Baronnet
Copyediting: **Lindsay Porter**
Editorial Assistance: **Samuel Holdstock**
Proofreading: **Marc Feustel**
Color Separation:
Arciel Graphic, Paris
Printed in Portugal by
Printer Portuguesa

The running text in this volume was composed in Slimbach and printed on 170 gm Condat Silk paper.

Simultaneously published in French as
Le Détail Qui Tue: Petit Précis de Style,
de Marcel Proust à Kate Moss
© Flammarion, S.A., Paris 2013

English-language edition
© Flammarion, S.A., Paris, 2013

13 14 15 3 2 1
ISBN: 978-2-08-020153-9
L.01EBTN000624.N001
Dépôt légal: 10/2013